DOREEN VALIENTE
WITCH

By The Same Author:

Skyways and Landmarks Revisited
(with Jimmy Goddard and Paul Baines) (1985)

Earth Mysteries: An Exploratory Introduction
(with Brian Larkman) (1985)

Tony Wedd: New Age Pioneer (1986)

The Elements of Earth Mysteries (1991)

Secret Places of the Goddess (1995)

Earth Mysteries (1995)

Mirrors of Magic (1997)

Magical Guardians (1998)

Leylines: A Beginner's Guide (1999)

Wiccan Roots (2000)

Gerald Gardner and the Cauldron of Inspiration (2003)

Newland Avenue School 1896-2006 (2006)

Witchfather: A Life of Gerald Gardner (Vols. 1 and 2) (2012)

DOREEN VALIENTE
WITCH

by
Philip Heselton

Published by The Doreen Valiente Foundation
in association with The Centre For Pagan Studies

Published by The Doreen Valiente Foundation
in association with The Centre For Pagan Studies

Design, Layout & illustrations: Ashley Mortimer

Printed by Lightning Source International

ISBN Paperback 978-0-9928430-6-9
ISBN Hardback 978-0-9928430-7-6

www.doreenvaliente.org
www.centre-for-pagan-studies.com

For John and Julie Belham-Payne

Contents

Illustrations

Picture Credits

Philip Heselton 1, 2, 8, 20, 22, 23, 26, 29, 30, 35, 36, 40, 42, 45, 60, 63, 71;
Doreen Valiente Foundation 6, 7, 9, 10, 11, 12, 13, 14, 15, 16, 17, 18, 19, 24, 28, 31, 33, 34, 48, 49, 52, 54, 55, 59, 64, 65, 66, 67, 68, 70, 72, 73, 74, 75, 76, 77, 78;
James Blunden Prior 21;
Ashley Mortimer 51;
Hazel Hall 25;
Patricia Crowther 57, 58, 59;
Ian Stevenson 62;

The author and publishers have made every effort to identify copyright holders and to obtain their permission but would be glad to hear of any inadvertent errors or omissions.

Author's Acknowledgements

To bring any biography to something approaching a state of completion requires a particularly large number of people, and this book is no exception.

I must single out several for special attention, however.

First and foremost, John and Julie Belham-Payne have not only commissioned this work, but have made the Doreen Valiente archive open to me, and they were most hospitable when I stayed with them. It is certainly true to say that, without their support, this book would not have been written.

Ashley Mortimer and Sarah Louise Kay have been equally helpful in giving advice on the text, particularly the poetry, and in preparing the book for publication.

Patricia Crowther has given very generously of her time in telling me about her friendship with Doreen and making helpful comments on my various drafts.

Professors Ronald Hutton and Grevel Lindop have taken time out
of their various commitments to read the text and to make help-
ful comments.

Janet Farrar allowed me to copy the correspondence which she
and Stewart had with Doreen, gave me her memories of Doreen
and, together with Gavin Bone, was most hospitable when I was
staying with them whilst doing this research.

Jon Cape gave me the breakthrough information about Doreen
and Bletchley Park, and made helpful comments.

Amanda Greenwood gave me some very valuable observations,
particularly on Doreen's poetry.

I must especially thank Alan Thorogood for his excellent and de-
tailed proof-reading.

I am grateful to Nigel Bourne, Kevin Carlyon, Vivianne and Chris
Crowley, Marian Green, Sally Griffyn, David Hall, Hazel Hall,
Rufus and Melissa Harrington, Ralph Harvey, Ray and Lynda
Lindfield and Suzanne Rolfe for making time to answer my ques-
tions and to give me their own memories of Doreen.

Others who made valuable contributions include Peg Aloi, Geral-
dine Beskin, Sophia Boann, Brian Buss, Hilary Byers, Siusaidh
Ceanadach, Sarah Gould, Raven Grimassi, Clive Harper, Nigel and
Susan Heselton, Michael Howard, Alice Hutcheson, Prudence
Jones, Graham King, Richard Le Saux, Gary Massingham, Sara
McMahon, Claudia Mernick, Elaine Munday, Sharon Rawdon,
Mike Slater, Ian Stevenson, Jonathan Tapsell and Olive Young.

If I have missed anyone, this is a result of my failing memory
rather than any reflection on their contribution.

Introduction

by John Belham Payne

This is the book I should have written. I did start to write Doreen's life story ten years ago but I quickly realised I had bitten off far more than I could chew. When I read Philip Heselton's books on Gerald Gardner I realised just how much research lay ahead of me and I thought it best to pass it on to an expert. I also think that Doreen's story is so attached to Gerald Gardner's that this book was the next natural step for Philip in his research. He had demonstrated that he could be impartial but sensitive even when there were areas about Gerald that might make uncomfortable reading and I am not sure that I would have been so definitive or discerning when it came to any bad bits about Doreen. I will give you an example later.

My wife Julie and I have kept Doreen's name in people's minds ever since she died on September 1st 1999 and now, with the Doreen Valiente Foundation, there will always be others who will continue to do the same. When we eventually asked Philip to write Doreen's biography he said that he would do this for us but only if he could tell the story "warts and all". We were delighted, as we would not want it any other way.

Doreen was the most remarkable person I have ever met, but her place in history was, I feel, not so assured in 1999 when she passed away. You see, for Doreen, it was the work itself that was important, not the person doing it and certainly not any adulation for doing so. She preferred to stay in the wings rather than take centre stage and she actually believed that she had been all but forgotten by the public even though her books still sold regularly all over the world. She was rumoured by some to be a recluse or an eccentric and this is but one of many untrue rumours I have heard about her throughout the years. According to these she

went around Brighton shouting at people in the street, she hated all men, she became a born again Christian and rejected Witchcraft altogether in her later years ... oh, and she was a drug user! All absolutely untrue! But I believe that because she was not so visible she became an easy target for "Chinese whispers" which can and do get out of hand. I had heard some of these things myself as far back as the 1980's.

I too was guilty of believing these things because one day, in the middle of winter, I saw her struggling with two shopping bags in a gale on the sea front in Brighton. She was dressed in a long black cape blowing horizontal behind her as she fought to walk against the wind. I had never met her, but recognised her from photographs. I drove past, slowed down and then remembered she had gone mad and hated all pagans, so I just drove on. Had I not recognised her I would have stopped to see if I could be of any assistance to a rather elderly lady struggling in the wind. When I did get to know her I told her this story and she said what a shame that was as we had missed all those years in between. I wish now that I had just stopped and not believed the rumours.

So with these things in mind and while there are still some of us that knew her and loved her and she loved back I am absolutely delighted that the first biography of Doreen is here. We can breathe a sigh of relief that someone reading this book in a hundred years' time will have a chance to hear about the real Doreen. There are more of my own personal anecdotes about my times with Doreen throughout the book and in the appendix.

I realise I've diverged from the introduction and wandered into anecdotes but that's just the effect that Doreen still has on me, I have so much to say about her and I think this is because there is so much to say about the most remarkable person I have ever met. This book, I hope, will begin to explain why ...

John Belham-Payne
August 2015

Foreword

Ronald Hutton, Professor of History at the University of Bristol, calls Doreen Valiente "... the greatest single female figure in the modern British history of witchcraft".[1]

That alone is justification enough for this current biography, for there is no doubt whatever that Doreen Valiente is a very important influence in the development of what is now generally called "Wicca", though she always referred to it as witchcraft. And her influence on the growth of a wider Paganism has been considerable.

Doreen Valiente is important because she turned what had been a rather poorly interpreted set of practices and beliefs under Gerald Gardner into a mature and intellectually rigorous religion, which she placed firmly in the land from which it grew.

When John Belham-Payne, of the Doreen Valiente Foundation, asked me to write this biography, I was both delighted and apprehensive. Delighted, because I had long admired Doreen's writing and it would be a natural follow-up to the two-volume biography of Gerald Gardner which I had recently completed. Apprehensive, because it felt presumptuous to undertake such a venture when I was surrounded by people who knew Doreen well, whereas I had never met her.

So, it was a daunting task, but one that I have enjoyed tremendously.

[1] Ronald Hutton, Foreword to *Where Witchcraft Lives*, Second Edition (Whyte Tracks 2010)

The need for a biography was highlighted by Ashley Mortimer at the ceremony for the unveiling of a plaque to Doreen in 2013, when he said:

> *Doreen is going to pass from a person in living memory to a historical figure ... and it is our duty to see to it that when she does pass into history the place she takes is a rightful one.*[2]

I was encouraged in my task in the certain knowledge that this would not be the last biography of Doreen Valiente. She is a significant enough figure in the history of the Craft to attract future writers to look at her life.

And there is plenty that I have either not covered at all or only mentioned briefly to make a further biography a fruitful study. I am sure that someone will be willing to take up the challenge to explore her life and work further.

For I have done little more than lay some foundation stones for others to build on. And there is far more in Doreen's life still to be discovered, particularly about her childhood and exactly what she did during the war; her early writings, both articles and poetry; and her other interests as evidenced by her scrapbooks, to name but a few.

Indeed, I have only managed to scratch the surface of the vast archive that Doreen left, and I am convinced that there are many secrets lying hidden therein. In particular, Doreen had a very large library and a detailed examination of its contents, including annotations, could, I am sure, be revealing.

Yet this book does illuminate some previously dark corners of her life, and indicates at least some of the factors which influenced the growth of her interest in the occult.

[2] Ashley Mortimer, speech at unveiling of plaque to Doreen Valiente, Brighton 21 June 2013

Doreen Valiente's writings have been providing a good and sensible introduction to the Craft ever since the 1960s. And a measure of her importance is that the first ever commemorative plaque to a witch has now been unveiled at the block of flats where she lived in Brighton.

I hope that this book will contribute in some way to its readers' understanding and appreciation of the individual behind those writings who was known to those who met her as Doreen Valiente: Witch.

Philip Heselton
September 2015

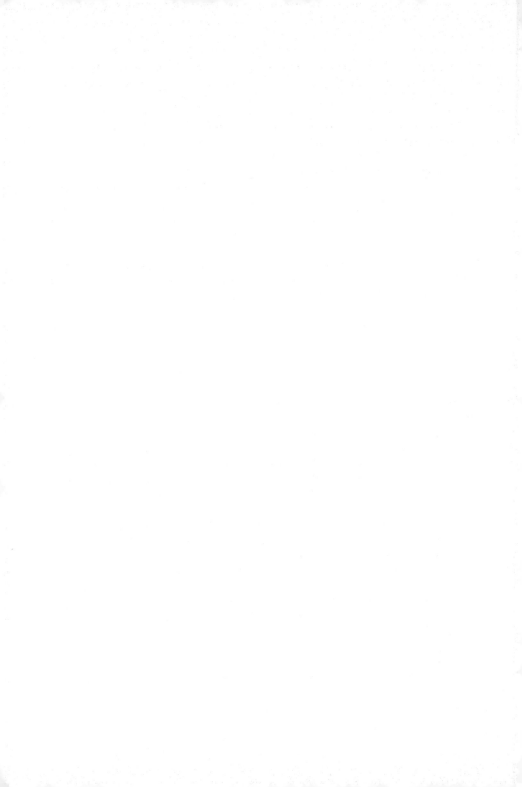

1

From the Land of the Giant and the Forest

It is perhaps no surprise that the ancestors of the most influential witch of the 20th Century lived for generations within sight of a huge image of a naked man on a Dorset hillside, the main feature of which is an enormous erect phallus. The 180-foot high Cerne Giant was long thought to be prehistoric, although latest thinking suggests that it dates only from the 17th Century. It is, nevertheless, a prominent and impressive feature, overlooking the village of Cerne Abbas.

Indeed, it is possible that the Giant's name may be revealed in the very name of the village. The name 'Cerne' is thought by many to be derived from the Celtic horned god, Cernunnos. Doreen had her own theory about the origin of the name:

> *Have you ever heard the cry of a fallow deer stag in rut? You hear this all the time in the autumnal rut of the deer in the New Forest, and it sounds just like "HERR-NN ... Herr-rr-nn ..." repeated over and over again. It is a most thrilling sound and one never forgotten. Now, from the cave-drawings and statues that we have of him, Cernunnos was pre-eminently a stag-god. So how would mortals have*

best named him? Surely from the sound that most vividly reminds one of the great stags of the forests - "Herr-rr-nn herr-rr-nn ... Herne!"[1]

The 'Abbas' part comes from the Benedictine abbey, which was founded there in 987 CE. This combination of Christian and pagan beliefs is manifest physically in the two major features of the place - St. Mary's church in the heart of the village and the Giant on Trendle Hill, looking down on it all.

Professor Ronald Hutton quotes that great Dorset writer, Thomas Hardy, who, in *The Return of the Native* (1878), when writing of a Dorset village, states that:

> *... the impulses of all such outlandish hamlets are pagan still: in these spots homage to nature, self-adoration, frantic gaieties, fragments of Teutonic rites to divinities whose names are forgotten, have in some way or other survived medieval doctrine.*[2]

2. Cerne Abbas

[1] Letter Doreen Valiente to Stewart Farrar 1 September 1982

[2] Ronald Hutton *The Triumph of the Moon* (Oxford 1999) p 27

Cerne Abbas lies in the valley of the River Cerne in the midst of the North Dorset Downs - the most south-westerly outcrop of chalk in England. This part of the south coast county of Dorset is sparsely populated and, in some respects, has changed surprisingly little from the landscape which forms the background to the novels of Hardy, who referred to the village as 'Abbot's Cernel' in *The Woodlanders* and *Tess of the d'Urbervilles*. It is also thought by some that the great barn in *Far From the Madding Crowd* is based on the tithe barn in the village. Cerne Abbas grew up around the abbey and later had a thriving market. It was particularly known for the brewing of beer, for which its water was ideal.

Doreen's surname before she got married was Dominy and there was a family tradition that her family, who in more recent years had settled in Southampton, had originated in Cerne Abbas. Dominy was a prominent name in the village for several hundred years. Doreen refers to Dominys who were swearing "No Popery" there in the 1680s, during the reign of James II, who was the last Roman Catholic English monarch, and who was deposed because he favoured the return of Catholicism.

In a survey in 1798, a maltster named John Dominy seemed to own substantial property in the village, including more than one public house.

Gibbons[3] refers to the continuation of East Street in the village towards Alton Hill which was known informally as 'Blood and Guts Lane'. The origin of this name seems to derive from what he describes as "an acrimonious public-house interchange of words":

> *The butcher of East Street named Dominy, was advocating the renaming of Duck Street. As a new title "Bridge St." had his preference. If, said Mr. Tiger Curtis, his unwilling listener, Mr. Dominy despised the descriptive honesty of*

3 A O Gibbons *Cerne Abbas Notes and Speculations on a Dorset Village* (privately published 1962) p 81

Duck Street his own street should be demoted and would be better known as Blood and Guts Lane.[4]

It is interesting that Doreen's grandfather, Harry Dominy, and great-grandfather, William Dominy, were also butchers, so it seems to have been a family trade.

About the name 'Dominy', Doreen writes:

This name is frequent in the Hants-Dorset border area, but in variants like "Dominey" or "Domony". Cerne Abbas is the place in which the name is found in its probable original spelling - "Dominy".[5]

And she elaborates on this:

I have often sought in books about the origin of surnames for the history of this name; but I have never seen any satisfactory explanation given. It is simply the Anglicised version of the Latin Domini, meaning "Of the Lord". Some writers say that it means "born on the Lord's day", i.e. Sunday; but this would be Dominicus, shortened to "Dominic", not "Dominy". My own belief is that the "lord" whose people the Dominys were in the distant past is the old god on the hill; and that the name is Romano-British, perhaps referring to an ancient priesthood.[6]

Doreen speculated:

Why is the name Latin? Perhaps because it dates back to the pagan Romano-British and their fertility cults (possibly mystery cults).[7]

I am not an expert etymologist, but it does strike me that 'Dominie' is a Scots language term for a schoolmaster[8] and that there

[4] ibid.

[5] Doreen Valiente *notebook no. 29* 9 June 1964

[6] Doreen Valiente *I am a Witch* unpublished manuscript 1966

[7] Doreen Valiente *notebook no. 29* 9 June 1964

[8] A S Neill *A Dominie's Log* (Herbert Jenkins 1917)

may be some connection. If so, then it is surely most appropriate that Doreen, as the most outstanding teacher of modern witchcraft, should have borne that name.

Doreen's great great-grandfather, Isaac Dominy, had been born in Cerne Abbas in 1802 to Joseph and Elizabeth Dominy. He married Mary Ann Francis from Fontmell Magna, a village some 25 miles away in the Shaftesbury direction, in 1826 and settled there.

Doreen's great-grandfather, James William Dominy, was born there in 1827, married Mary Ann Francis (presumably some relative of his mother) in Shaftesbury in 1850, but before then had moved to Southampton, in fact to Church Street, Millbrook, where the family lived for the next hundred years.

Doreen's grandfather, Harry Dominy, was born there in 1856. 'Harry' is the name on his birth certificate rather than 'Henry', of which 'Harry' is the usual diminutive. This may be for the same reason that maritime painter, Harry Hudson Rodmell was named as he was: his father decided that it was pointless naming him 'Henry' since everyone would call him 'Harry' anyway![9]

The New Forest in Hampshire is already well known in the history of the modern witchcraft revival, since it was in Highcliffe, on the edge of the Forest, that Gerald Gardner was initiated in 1939. And it was in the Forest that the great ritual to help stop the invasion in 1940 took place.

Peckham is a common New Forest surname, known today through the work of Barry Peckham, who has been called "one of the few artists to capture successfully the essence of this magical place."[10]

[9] Arthur G Credland *Shipping Posters and Graphic Works: Harry Hudson Rodmell 1896-1984* (Hull City Museums and Hutton Press 1999)

[10] Barry Peckham *Barry Peckham's New Forest* (Halsgrove 2001)

Doreen's great-grandfather was Charles Peckham, a gardener by trade, who was born in Lyndhurst, in the heart of the Forest, in 1835. At the age of 24 he married Charlotte Grant, a close neighbour, who was a laundress. They lived nearly all their life in the Forest, in Lyndhurst. They had five children, their only daughter being Charlotte, born in 1853. She became a domestic servant and in 1878 married Harry Dominy, Doreen's grandfather.

The most interesting members of the Peckham family were those who Doreen's parents referred to as "Great Gran'fer Peckham and Great Aunt Nance". These were George Peckham, Doreen's great great-grandfather, born about 1800, and his daughter, Ann, born about 1841, who lived in Pike's Hill, Lyndhurst. Doreen says about them that they:

> ... were supposed to have been able to see ghosts, and to have been on good terms with the fairies, called in the New Forest "pixies". These little elemental spirits would appear chiefly at twilight, but sometimes at the height of summer they would appear in broad daylight, especially when there was a mist of heat over the countryside. According to family tradition, they were "like a lot of little moving lights among the trees". There was one particular ring of fir-trees in the New Forest where Great-Aunt Nance used to go to commune with the pixies. Great-Gran'fer used to keep bees; and he was one of those people who "could do anything with bees", even to picking them up in handfuls without being stung.[11]

Doreen tells of one story handed down in the family as to what 'Great-Gran'fer' thought about education:

> "Eddication?" he said once. "I don't think much o' eddication. Look at the strawberry. They'm eddicated the strawberry today till he be so big as a turmit, and he got about as much flavour". A "turmit" is a turnip; and anyone who has picked and eaten the sweet little wild strawberries

[11] Doreen Valiente *I am a Witch* - unpublished manuscript 1966

off a sunny bank will know just what Great Gran'fer meant.[12]

Doreen's parents rather disapproved of what they considered this "murky past of the family". If they discussed them at all, it was in whispers within Doreen's hearing, for they said "little pitchers have long ears", in other words that Doreen would understand more than they thought. As Doreen says:

> *Of course, the exploits of these two old country people were not approved of by my parents, who were both "brought up Chapel", and thought them not quite respectable. Hence the hasty changing of the subject when they saw that I was listening.*[13]

They referred to the old folk as being able to "see further through a deal door than most", in other words to have psychic ability. They also practised what Doreen refers to as "spells":

> *The curious thing was ... that my mother admitted to having used one of the old spells to cure some warts on her hand, with a broad bean pod; and it had worked. You had to rub the warts well with the furry inside part of the pod, preferably in the waning moon, and then bury the pod in the garden; and you must tell no one about it until the spell had worked, which in my mother's case it did.*[14]

There may be some connection in that Doreen's grandfather had many Romany friends, who used to leave their caravans and horses in his field. They taught him some of their language, and possibly other skills. He passed that knowledge down to Doreen's father, who taught it in turn to Doreen.

[12] ibid.

[13] ibid.

[14] ibid.

Harry Dominy followed his father, William, and entered the family business as a butcher at 3 Church Street, Shirley, now a suburb of Southampton. He married Charlotte Peckham on 15th December 1878 in the local Freemantle parish church. Their son, also Harry, who became Doreen's father, had been born two months earlier, on 17th October 1878.

The elder Harry continued his butcher's business at 3-5 Church Street, Shirley. The younger Harry lived there with his brothers, Frederick (b. 1883), Alfred (b. 1886) and Frank (b. 1892).

Harry did not follow in the family business, and by his early twenties he is described as a building surveyor. In the early 1900s he seems to have been in partnership with Henry Dover Masters, an architect, in the firm of Dover Masters and Dominy.

This seems to have been a short-lived enterprise, however, because by 1906 Harry was working for Stansfield C. Greenwood, an architect and surveyor, and was with him for several years.

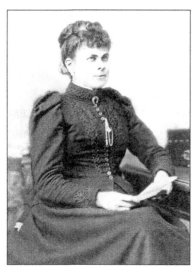

3. & 4. Ann Richardson & Henry James Richardson: Doreen's Grandparents

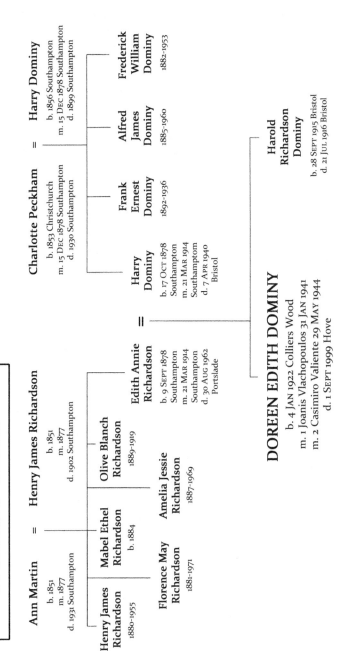

DOREEN VALIENTE FAMILY TREE

The Peckhams had been New Forest residents for generations

The Dominy family originated in Cerne Abbas, Dorset

Ann Martin
b. 1851
m. 1877
d. 1931 Southampton

=

Henry James Richardson
b. 1851
m. 1877
d. 1902 Southampton

Charlotte Peckham
b. 1853 Christchurch
m. 15 DEC 1878 Southampton
d. 1930 Southampton

=

Harry Dominy
b. 1856 Southampton
m. 15 DEC 1878 Southampton
d. 1899 Southampton

Henry James Richardson
1880-1955

Mabel Ethel Richardson
b. 1884

Olive Blanch Richardson
1889-1919

Edith Annie Richardson
b. 9 SEPT 1878 Southampton
m. 21 MAR 1914 Southampton
d. 30 AUG 1962 Portslade

Harry Dominy
b. 17 OCT 1878 Southampton
m. 21 MAR 1914 Southampton
d. 7 APR 1940 Bristol

Frank Ernest Dominy
1892-1936

Alfred James Dominy
1885-1960

Frederick William Dominy
1882-1953

Florence May Richardson
1881-1971

Amelia Jessie Richardson
1887-1969

=

DOREEN EDITH DOMINY
b. 4 JAN 1922 Colliers Wood
m. 1 Joanis Vlachopoulos 31 JAN 1941
m. 2 Casimiro Valiente 29 MAY 1944
d. 1 SEPT 1999 Hove

Harold Richardson Dominy
b. 28 SEPT 1915 Bristol
d. 21 JUL 1916 Bristol

On 21st March 1914, Harry married Edith Annie Richardson at the Register Office in Southampton. Her father, Henry James Richardson, was a general builder and contractor, and the family lived at 3 Chapel Street, Shirley.

Perhaps because of his marriage, on the certificate of which he is described as a land surveyor and architect, Harry applied for a new job in Bristol as an engineer's draughtsman at the Avonmouth Docks. Greenwood gave him a reference, which stated that he had known Harry for the previous eight years and that:

> *... during the time he was in my employ, important work was carried out at my office, and I found him to be a very trustworthy and reliable assistant. He is a good draughtsman, and thoroughly understands construction. He is also capable of taking off quantities accurately and is well versed in levelling and surveying. He also has a practical knowledge as regards the supervision of works. Since he left my employment he has had experiences in construction of Cold Storage Buildings. I should consider him to be a fit and proper person for the position he is applying for.[15]*

Harry and Edith moved to Bristol and rented a flat at 125 Cromwell Road in the Montpelier area of the city. During this time, Harry worked on the design of a 600,000 cubic foot cold store building for Avonmouth Docks.

On 28th September 1915, a son, Harold Richardson Dominy, was born. However, he only lived a few months, for on 21st July 1916 he died of a gastric ulcer and haematemesis (the vomiting of blood), by which time the Dominys were living at 45 Nevil Road, Bristol, near the Gloucestershire County Cricket Ground.

At some time, probably in the 1918-1919 period, Harry and Edith moved to Drogheda, a town on the River Boyne in County Louth, Ireland, presumably after he had obtained the promise of work

[15] reference by Stansfield C Greenwood dated 1 July 1914

there. This was a time when demands for independence were prominent and violence was not unknown. Doreen writes that her mother "well remembered seeing a railway bridge ornamented with the slogan 'Hang Lloyd George'".[16]

It was therefore not surprising that, to start with, many of the locals were rather suspicious of them, and in fact the only place where they could find lodgings was the Custom House. However, they later became quite friendly with the local Sinn Fein leaders and Harry seemed to become sympathetic to their cause.

Harry was employed as an architect and quantity surveyor. We don't know who his employers were but, as Doreen says, "there's a good chance that there is still some building standing in Drogheda that was designed by him." [17]

The area around Drogheda has many important Neolithic sites, including the passage tombs of Knowth, Dowth and Newgrange. The Dominys had time to visit the latter, for Doreen says that when she was a child her mother told her about a visit:

> She said that they (my mother and father) went into this cavern-like place, which in those days was quite unlighted by any artificial light, and the custodian of it was a queer old dame who showed them round by the light of a candle. My mother said it was very spooky and I think it rather scared her.[18]

Doreen describes Harry as a "failed architect", and, indeed, Greenwood's reference makes it clear that Harry's main work involved draughtsmanship, quantity surveying, general surveying and levelling, as well as being a clerk of works. No mention of architecture. Indeed he was not a member of the RIBA (Royal Institute of British Architects), nor any of the other architectural or surveying bodies in existence at that time.

[16] letter from Doreen Valiente to Janet and Stewart Farrar 10 November 1982

[17] ibid.

[18] ibid.

At some stage, the job in Drogheda came to an end, and Harry's sights fell upon London. Here, surely, in all the construction projects taking place after the war, he could get a job.

2

Child of the Goat-God

Doreen seems to have been the sort of person to attract 'highly coloured' stories:

> *I've had rumours circulated about me for years. The one I like best is that I'm the illegitimate daughter of Aleister Crowley - I really rather fancy that one. My mother is supposed to have been a dashing 1920's deb of high family, and I was farmed out to foster parents who brought me up as their own because their own child had died. Unfortunately it clashes with the other story that I am a Polish Jewess who came here in wartime as a refugee, having been initiated into the darker secrets of the Qabalah in my own country. The New Forest gypsies took me in, and that is where Gerald Gardner found me. (I've had this one told to me in total solemnity by someone who didn't know who he was talking to - and I didn't let on!)*[1]

The truth, which I shall try to tell in this book, turns out to be far more interesting, as is often the case!

[1] letter from Doreen Valiente to Janet and Stewart Farrar 14 October 1982

Doreen Edith Dominy was born at 10.45 pm on Wednesday 4th January 1922 at 1 High Street, Colliers Wood, Mitcham, Surrey.

This was a building, now unfortunately demolished, on the southern corner of High Street, Colliers Wood and Robinson Road in South London. The Dominys probably had a flat above a shop, which they had moved into the previous year.

Doreen states that she was "brought into the world by a doctor in full evening dress and Masonic regalia".[2] His identity is not known but he may well have been a member of Mitcham Masonic Lodge No. 2384, which met at Vestry Hall, Lower Green, Lower Mitcham.

After giving Janet and Stewart Farrar her time of birth so that they could calculate her astrological chart, Doreen states:

> *I can be fairly precise about this, because I was expected around Christmas, but nothing happened. Then on the night of January 4th, I decided to get a move on, and the doctor was hastily summoned from a Masonic dinner.*[3]

7. Doreen aged 6 weeks with her mother at Blagdon House

[2] synopsis for projected autobiography *Have Broomstick Will Travel*

[3] letter from Doreen Valiente to Janet and Stewart Farrar 2 November 1984

Whilst her middle name, Edith, is presumably taken from her mother, the name 'Doreen' has an interesting derivation. It is a combination of the name 'Dora' with the suffix -een, which is commonly used in Irish names. In Irish it would be spelt Dhoire-ann. The name Doreen was probably first used in the novel *Doreen: The Story of a Singer* by Edna Lyall.[4]

It is a story set during the Fenian agitations of late 19th Century Ireland, featuring a young girl, Doreen O'Ryan, who is very much involved in the cause of Irish Home Rule. Harry and Edith may well have read the book, and their sympathy for the Irish cause may have resulted in this choice of name for their daughter. Certainly the popularity of the name Doreen increased significantly in the 1920s.

When Doreen was less than a year old, the Dominys moved into a terraced house, 56 Pitcairn Road, on the borders of Colliers Wood and Tooting, about half a mile away from their previous flat. They lived there for about four years until Doreen was of an age to start going to school.

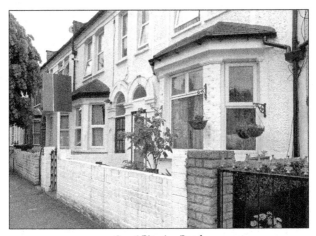

8. 56 Pitcairn Road

4 Edna Lyall (Ada Ellen Bayly) *Doreen: The Story of a Singer* (Longmans Green 1894)

Then, in 1927, they moved to a flat at No. 4 Renshaw Corner, Mitcham. This was an impressive building dating from the 18th Century built out of the typical yellow brick of the area. Indeed, it is probably one of the most impressive houses in that part of Mitcham, with a large garden fronting onto Streatham Road, incorporating a curved driveway up to the front door, which has a projecting mid-19th Century pilastered porch. The garden facade of the building has an ornate iron canopy, which can be seen in some of the photographs on page 18.

9. Doreen and her mother at Renshaw Corner

We only have glimpses of Doreen's childhood, but from an early age there were hints that she was a somewhat unusual child. Doreen realised in later life that she had been a great disappointment to her parents because she wasn't a boy. Perhaps they had been hoping for someone to take the place of young Harold, or perhaps they simply felt, probably correctly in those days, that a boy could make his way in the world more easily than a girl. Indeed, Sally Griffyn remembers Doreen saying to her that she didn't experience any love as a child.

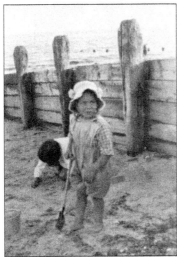

10 - 13. Doreen and her parents at Worthing beach 1924

Doreen describes her parents as being very conventional people, and that her mother was a prude and a snob. She says it was "the era of ghastly good taste, when social climbing was a religion". Indeed, their religion is not straightforward. The Dominys were

Methodists and the Richardsons were Congregationalists, yet Doreen says that she was never baptised because her mother "had a row with the vicar". And later she was sent to a convent school.

14 - 17. Doreen in the garden of Renshaw Corner

I suspect that Doreen's father only had intermittent work, but that her mother wanted to live somewhere prestigious, as Renshaw Corner undoubtedly was. Doreen says that they lived in "genteel poverty" and mentions that her father "outwitted the bailiff", which certainly sounds as if they were trying to live beyond their means.

 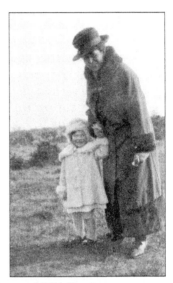

18. & 19. Doreen and her parents, Harry and Edith Dominy

It is likely that, at the age of five, in 1927, Doreen was sent to elementary school. There were two schools about equally distant from Renshaw Corner - St. Mark's Church of England School in Mitcham town centre and Gorringe Park School on the corner of Streatham Road and Sandy Lane, a local authority school which had opened in the 1920s. As Doreen's mother had had a row with the vicar, I think the latter is the most likely. Indeed, it was on the walking route from their former house in Pitcairn Road to Mitcham town centre, so they would undoubtedly have been familiar with it.

20

It is clear that Doreen was very unhappy at school. Her notes state:

> *Days of misery at school. What 'council schools' were like in those days. Smallpox and rickets. Self-defence and how I rejected Christianity and kicked the teachers in the shins.*[5]

In this, we see that, even at a young age, Doreen was prepared to think for herself and refuse to co-operate. One reason for this is, I suspect, that she was highly intelligent. This was reflected in her reading ability:

> *I'll tell you another odd thing. It's that nobody ever taught me to read. They sent me to school in the usual way, of course, and we had all the boring lessons of C-A-T, cat, and 'the fat cat sat on the mat', and there were all the kids spelling this out.*[6]

One day, Doreen had had enough! "What am I doing this for? I can read!". And, to prove it to herself, she picked up her father's copy of *The Daily Mail* and promptly sat down and read it! And since that day she never looked back.

So much of this echoes my own experience of rebellion and of being able to read already!

20. Gorringe Park School, Mitcham

[5] *Have Broomstick Will Travel*

[6] interview by Kevin Carlyon

There were other activities that Doreen got involved in which were perhaps indicators of her future life. She told Kevin Carlyon:

> ... one of my favourite childhood occupations was galloping about on a broomstick. I obviously used to terrorise the neighbourhood ... Not the actual witch's broom, of course, because we didn't have one. Just the ordinary brush. Well, why I used to do this I don't know. I just did it. I didn't consciously associate it with witchcraft then, or anything like that. It was just a bit of childhood fun.[7]

She wrote:

> It was only years later that I learned how witches did indeed ride broomsticks in this way, in a kind of dance over the fields to make the crops grow tall Was I reliving the wild, carefree witch-dance of a previous incarnation, when as a small child I so enjoyed my broomstick gallops?[8]

Doreen also told Carlyon that she kept on drawing pictures of a horned head:

> This was just a simple childish sketch, you know, of this horned face with a beard and two horns sticking up, with ears. And I never used to draw it with a pencil or a pen or a crayon or anything like that. I used to get a stick and char it in the fire and draw it with the charred end of the stick. And I never used to know why I did this but I did. ... Looking back on it now it makes me wonder if it was something to do with a previous incarnation.[9]

This feeling about reincarnation is perhaps emphasised by the time when she identified some pictures in a book as "Sheena and Kishna". Were these, she thought in later life, her memories of Shiva and Krishna?

That Doreen "had the sight" is demonstrated by an occasion when she went up to London with her parents just before Christ-

7 ibid.

8 *I am a Witch*

9 op. cit.

mas to look at all the shop windows. While her parents were gazing in a window that held no interest whatever for her, Doreen looked down a dimly-lit side street. She recounted what happened next:

> And then I saw her! From the opposite side of the road came a beautiful lady, just like someone out of a picture. She was dressed in a wide-hooped skirt of shimmering satin, of a pale blue colour, which she held up with her dainty hands as she stepped across the street, to reveal elegant high-heeled, buckle shoes of matching blue. On her head was a little hat with blue ribbons hanging down, and beneath it I could see her hair dressed in curls and ringlets, and either very fair or powdered.
>
> She was so lovely that I just stared! She crossed the street diagonally, away from me, moving with graceful unconcern for the wet, muddy pavement or the cold night, though her dress was low-cut and her hands ungloved. I remembered afterwards that she made no sound of footsteps as she moved, and there seemed to be more light about her figure than the dim old street lamps could have given. But at the time, all I could do was to cry in my excitement, 'Oh, look, Mummy! Look at the pretty lady!'
>
> Mummy, dragged abruptly from the inspection of the special Christmas household offers, looked round and said, 'What pretty lady? Where? I can't see any lady.'
>
> Nor could I any more. The street was empty. The lady was gone, suddenly and soundlessly, just as she had appeared.[10]

Harry Dominy was always on the lookout for work and he entered a variety of competitions, including one for a cold store in Tallinn, Estonia in 1929. By that time, he had started to call himself "Henry Inkerman Dominy", presumably because it sounded more

[10] Doreen Valiente *My Christmas Ghost* (*Prediction* December 1970) pp 13 & 18

impressive and appropriate for an architect than "Harry". He was, however, soon to come into contact with an architect with an even more impressive name!

We know from Doreen's account that Harry took *The Daily Mail*, and thus may well have attended the Daily Mail Ideal Home Exhibition every year, looking for possible opportunities. In 1924 and again in 1926, houses were on display that had been designed by the architect, Blunden Shadbolt (1879-1949), who lived and practised in Horley, Surrey. He specialised in designing so-called "wibbly-wobbly" houses, using where possible old and recycled materials.

David Schenke, a historian who has studied Blunden Shadbolt's life and work, states that he was a religious man with a deep love of nature:

> *Having observed that nothing in nature was completely straight, he determined that his timber-framed houses should be likewise and so be in complete harmony with the trees around them. ... Only ancient bricks, stone, tiles and oak beams were used and every effort was made to avoid a 'mechanical' appearance. ... The vertical accuracy of the construction depended entirely on the judgment of the eyes. Similarly, rows of bricks were deliberately set out of line and the ridges of roofs distorted to give the appearance of having sagged with age. Any moss growing on the old tiles was carefully preserved, so that on the day of completion, his timber-framed houses appeared in a style aptly described by one historian as 'wibbly-wobbly'. These homes not only appeared ancient, but were genuinely ancient on the very day of their completion.*[11]

It seems that Harry Dominy worked for Blunden Shadbolt for a while, and Doreen speaks of going to live near Horley when she was nine, which would have been in 1931. Shadbolt was really the

[11] Dan Carrier *Historian who lives in house designed by anti-Modernist architect issues a plea for listing* (*Camden New Journal* Property News) 2 December 2010

21. Blunden Shadbolt

only architect of any note in the Horley area, and James Blunden Prior tells me that his mother, Joy, who was Blunden Shadbolt's daughter and who died in 2012, may have mentioned him, as the name 'Harry Dominy' sounded familiar.[12] And David Schenck tells me that she told him about someone who worked for Shadbolt but who had not quite made the grade as an architect.[13] This sounds very much like Harry, who may well have persuaded Shadbolt to employ him, but who wasn't really up to the job.

Anyway, in 1931, the Dominys were registered as living in Parkhurst Road, Horley. No more detailed address is given. Doreen told Rufus Harrington:

> ... they sent me to school in this little village, because they had to of course. I thoroughly hated school.[14]

Doreen also comments:

> I can remember being stopped by the teacher from playing "Sally Go Round the Moon" in a school playground ... We were told when we got back into the classroom, "I saw you playing a silly game out there. You're not to play that game." No reason was ever given why the game was forbidden. It consisted of joining hands and dancing round in a circle, singing:
>
> > Sally go round the moon,
> > Sally go round the sun,
> > Sally go round the chimney-pots,
> > And then the day is done.

[12] James Prior email to the author 18 April 2013

[13] David Schenck email to the author 14 April 2013

[14] Rufus Harrington *Interview with Doreen Valiente - Pagan Dawn no. 117* Samhain 1995 pp 18-22

I suspect now that the original version of the last line was "When the day is done", and the original "Sally" was a night-flying witch on her broomstick.[15]

Whatever the circumstances, Doreen told Rufus Harrington:

... I went out one evening. It was in the country. I hadn't been in the country before, because I was born in London. I must have been something like nine years old. I looked out of the window one night and it was just as though the garden was covered in silver. It was the first time I had ever really seen moonlight. And for a while I didn't know what it was, I was such a town kid. I thought something strange had fallen from the sky. I had never really seen the effect of moonlight before. I always remember that experience. It was quite amazing to me. There was something there, something strange: the effect of moonlight.[16]

This led on to what Doreen called "an indescribably mystical experience - when the veil trembled":

... I went down to the bottom of the garden, one twilight, a beautiful summer twilight. I was just standing there leaning on a gate, and I had what I suppose people would call today a mystical experience. I looked at the surroundings in the twilight, and it was as if everything I could see became unreal and was the veil of something else.[17]

I saw what people would call the world of everyday reality as unreal, and saw behind it something that was real and very potent. I saw the world of force behind the world of form. ... Just for a moment I had experienced what was beyond the physical. It was beautiful, wonderful. It wasn't frightening. That, I think, shaped my life a lot.[18]

[15] Doreen Valiente *notebook no. 47* 16 January 1969

[16] Rufus Harrington, op. cit.

[17] ibid.

[18] Kevin Carlyon, op. cit.

Doreen went on to tell Rufus:

> *I remember years later reading something which I think Shelley or Keats wrote about the painted veil, and I realised that painted veil in those moments. I realised that there was (as Dion Fortune came to talk about when I started reading her books) a world of forces and a world of form. When I was nine years old I realised that. It's not at all an easy thing to describe, but it's very, very real to me and it had an effect on me which lasted for the rest of my life. How I came about this I don't know.*[19]

Doreen concludes by saying: "And from then on I started to do all sorts of queer things."

I thought it would be interesting to try to find exactly where Doreen had this life-changing event, so I went to Parkhurst Road, Horley, to investigate. My guess is that the absence of a house number in that road in the electoral register was because in 1931 there were very few houses there and they had not been officially numbered.

There are two olderpairs of semi-detached houses towards the eastern end of Parkhurst Road near its junction with Meath Green Lane and I was drawn to a pair of semi-detached houses which were built somewhat in front of the building line. In other words they had shorter front gardens.

I think it may be significant that Doreen refers to moonlight without referring to the moon itself. This suggests to me that she was looking out of an upstairs window on the north side of the road, where the moon itself would be hidden by the bulk of the house. By her own account, she then went to the bottom of the garden and leant on a gate. The view from that position would be over rough ground, probably with mature trees and then over open countryside.

[19] Rufus Harrington op. cit.

My own feelings, and they are nothing more, incline towards the left-hand one of the pair, no. 85 Parkhurst Road, named "Ringwood" (a town on the edge of the New Forest, of which the Dominys were likely to have had fond memories), as being their residence in 1931.

22. 85 Parkhurst Road, Horley

23. 18 Walsingham Road, Mitcham

It is still unclear to me exactly where Doreen was living during the rest of the 1930s. After the unsuccessful job with Blunden Shadbolt, Harry and Edith were by 1933 back living in Mitcham, at 18 Walsingham Road, a terraced house rather similar to the one they had in Pitcairn Road.

One problem is that everyone seems to agree that Doreen possessed a distinctive West Country accent. My own opinion is that it was from East or South Devon, and indeed there is some evidence that the family may have lodged at 1 Fortescue Road, Exeter, for less than a year in 1933-34. However, the family did live in Bristol before Doreen was born, her writings indicate that she was familiar with that city, and Edith and Harry were back in Bristol before he died.

Would there have been enough time for Doreen to acquire such an accent? Certainly these were some of her most formative years and it is likely that the young girl with the South London accent would very quickly have learned to fit in with her fellow school pupils in the West Country.

Was her accent in fact a mixture of South London, Surrey, Devon, Bristol and Southampton? For the latter city was where she ended up living for several years in the mid to late 1930s. I will leave it to future researchers to clarify the chronology and investigate this phase of Doreen's life in more detail.

We know that in late 1934 or 1935, Edith Dominy took Doreen and travelled to the family home in Southampton. For whatever reason, she said that she could no longer live with Harry. It is likely that he had become mentally disturbed, for Hazel Hall, Doreen's cousin's daughter, told me:

> I don't know if it's true or not, but she [i.e. Edith] said she
> was frightened of him. He used to take an axe to bed with

him. He was so clever he was weird, and they couldn't live with him any longer.[20]

She thought that he might have been suicidal, and it seems as if his unusual behaviour was put to her as resulting from his being very clever. She remembers that they used to call him "the professor".

Perhaps his lack of success as an architect had affected Harry's mental state. Anyway, clearly Edith thought that it would be better for Doreen if they moved away.

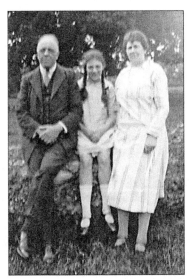

24. Doreen and her parents, Harry and Edith Dominy

Initially, Edith and Doreen came to stay with Edith's sister, Florence, at Rutland Lodge, 118 Waterloo Road, Freemantle, a suburb of Southampton, but Florence's husband, Charles, was not altogether happy with this arrangement for he persuaded his son and daughter-in-law, Charles and Mabel Hall, to take them in to their house at 6 Claremont Crescent, Millbrook, Southampton.

[20] Hazel Hall, in conversation with the author - March 2013

25. Rutland Lodge, 118 Waterloo Road, Freemantle, Southampton

26. 6 Claremont Crescent, Millbrook, Southampton

Charles and Mabel's daughter, Hazel Hall, who was aged about four at the time, has memories of Doreen seeming rather lost during this period and also of being very bossy to her. This may have been because Hazel was so much younger than Doreen and that Doreen had in her turn been bossed and bullied at school and, I suspect, at home.

Hazel Hall gives a glimpse of Doreen's mother. She told me:

> *We had to get on the bus with our gas masks and she got off it at Redbridge because she wanted to see Ernie*

Newman ... and she made us get off the bus there and made us walk home from there, because she said she couldn't leave us on the bus. I don't know why! She was a very strict, very strict lady.[21]

In 1935, Charles and Mabel and family moved to Hounsdown, and it seems as if Edith and Doreen moved back in with Florence and Charles at Rutland Lodge.

Edith needed to support Doreen and herself and got a job as a housekeeper. This was not a very pleasant experience, however, as she was constantly being harassed and persecuted. John Belham-Payne recounts what happened:

She confided in her daughter that a particular unpleasant woman had been picking on her. In response Doreen asked her mother to obtain a lock of hair belonging to the bullying colleague and intimated that she would work a charm to solve the problem once and for all. Whether Mrs Dominy went along with this out of amusement, desperation or simple curiosity is not actually known but she did bring back a few strands of hair belonging to her persecutor.

Using black-ended pins and a few traditional herbs, Doreen made a figurine of the woman in question and wound the strands of hair around the doll. She then cast a spell to protect her mother from further interference. Shortly afterwards, the woman who was causing so much trouble to Mrs Dominy was herself harassed - by a blackbird! The creature began tapping on the window every time she entered a room and followed her around the house, pecking on the glass. The woman was absolutely terrified as the stalking blackbird continued to pester her for some time. Doreen maintained that the bullying of her mother abruptly ceased.[22]

[21] ibid.

[22] John Belham-Payne Doreen Valiente Foundation website

By the age of thirteen, then, Doreen had acquired knowledge of sympathetic magic, herbalism and the making of poppets, and sufficient confidence to use these skills in conjunction with her natural psychic ability, of which she had become aware at the age of seven.

Where had she acquired this knowledge and these skills? One answer would be in the school playground while she was living in Devon. Of course, she may have met a witch who taught her those things, as Cecil Williamson has claimed to have done while living in the same county. However, Doreen has never claimed such a thing, but then, if she had been sworn to secrecy, she wouldn't! Devon is, however, one of the counties where traditional remedies and magical spells have survived to the present day.

There is also evidence that Doreen used the time-honoured route to gaining information: using the local library. She told Raven Grimassi:

> *I have always been interested in the witchcraft of Italy, ever since I found a copy of Aradia in, of all places, the Public Library, way back when I was a young girl ...* [23]

The influence of such a book is likely to have been strong, and one is bound to wonder what else Doreen may have read in such a place.

———————— ··➤◆⬤·· ————————

It was about this time that Doreen was sent to a convent school. We really know little more, but Doreen gives a clue in her notes, which referred to "the convent school that produced two witches, Arnold Crowther and myself." [24]

[23] Letter from Doreen Valiente to Raven Grimassi 10 June 1997 - included in Raven Grimassi *The Witches' Craft* (Llewellyn Publications 2005) pp 245-250

[24] *Have Broomstick Will Travel*

Now, Arnold Crowther (1909-1974), husband of Patricia Crowther, was brought up in Wimbledon, south-west London, where his father was an optician. Wimbledon is only some two miles from Mitcham, where Doreen lived until she was seven, so I strongly suspect that the "convent school" was somewhere in that vicinity.

And, indeed, there is a convent school on the very road, Worple Road, where Arnold lived in his youth.

The Ursuline Sisters of the Roman Union set up a private school in Worple Road, Wimbledon in 1892. Children of both sexes were admitted and in 1895 the school moved to larger premises in The Downs. In 1901, the school moved to the Claremont building on The Downs and also acquired other adjacent properties, as can be seen in the photograph. This would have been the school which Arnold attended in the years after the First World War.

27. Ursuline Convent, Wimbledon

Entry to the school as a grammar school was by means of examination, and Doreen refers to "the great scholarship". My guess is that Doreen would have been a boarder, and that because of her mother's financial circumstances a grant would have been obtained from somewhere to allow Doreen to attend. She had obviously passed the entrance examination with flying colours.

Doreen did not fit in at the school. As she wrote later in life:

Witches are those who do not conform. In school, they are not the child who can answer all the questions; they are

the child who asks all the questions, especially the ones teacher can't answer.

I remember when I went to school (which I hated), being distrusted by my class-mates because my eyebrows met above my nose. Nobody seemed exactly to know why this was undesirable; though all agreed that it was. One child said it meant I told lies; another that I had a bad temper; another nice little girl said confidently that it meant I'd grow up to murder somebody.

Then one day a group of them surrounded me in the playground, and demanded to know straight, yes or no; was it true that I could read people's thoughts? I told them their thoughts weren't worth reading, and the teacher broke up the fight. It was only years later that I found out what it was all about. A copy of Witchcraft and the Black Art, by J.W. Wickwar[25], came into my possession, and I read in it the statement that the meeting of the eyebrows above the bridge of the nose was long considered a sure sign that such a person would die either a witch or a vampire![26]

Doreen says that the days spent at the convent school were "the most miserable days of my life" and that her best childhood memory was "the day I bit the prefect". She told Rufus Harrington that it was one of the happiest moments of her childhood:

Amongst all the misery, that stands out in a golden glow ... the day I bit the prefect.

She was an enormous girl. Well, at least she seemed enormous. I came up to about her waist. She was one of these 'English roses'; she came from a good background, and I'm sure daddy was a company director or something ... She was one of those people who was always in the right and I was always in the wrong. I had got on the wrong side

[25] J W Wickwar *Witchcraft and the Black Art* (Herbert Jenkins 1925)

[26] *I Am A Witch*

of her. She was the prefect in charge of trying to keep reprobates in some sort of order.

She made the mistake one day ... I can't remember if she hit me or only threatened a bit. But anyway her forearm came into close contact with my teeth, and it came into such close contact that I couldn't resist the opportunity ... Her arm was of course very white, beautifully washed, and smelt of scented soap ... and I sank my teeth into her like a young bulldog and hung on. She screamed, and the sound of that scream echoes down the years and warms my black old heart to this day.

...Yes, and nobody in that school ever dared raise their hand to me again. Why I didn't get expelled I don't know, but I do know I went up before the Mother Superior and she looked at me in a very sort of 'why do you do these sort of things; you come from quite a good home?' way. I did it on general principle.[27]

But, at the age of fifteen, having been there for less than two years, Doreen walked out and refused to go back. She told Rufus:

I got to the point where I would have no more, and they could put me in a home if they wanted ... which I had been constantly threatened with, by my mother. They could do that sort of thing in those days. I got to the point with this convent school where at the age of fifteen I walked out and said I was not going to [go] back and they could do what they liked. It was the first time in my life I really defied authority. The convent school was probably bloody glad to see me go ...[28]

Whilst it was an acutely unpleasant time for her, Doreen obviously did learn a lot from her time there, particularly judging from her skills later in life - art and languages. It may be of no relevance whatever to the circumstances eighty years previously, but the current school specialises in modern foreign languages.

[27] Rufus Harrington op. cit.

[28] ibid.

So, we can imagine Doreen, fed up with school, walking out early one morning in 1937, having saved up enough money for the train fare home, walking the mile or so to Wimbledon station and taking one of the frequent direct trains through to Southampton.

One can imagine Edith remonstrating with her daughter, about the waste of the scholarship and telling her that she would never amount to anything. But Doreen was adamant: she would not return to the school. There was thus only one thing to be done: Doreen would have to get a job.

Melissa Harrington told me that Doreen had revealed to Shelley Rabinovich that her father had "clipped her round the ear", that she had then clipped him back and that this incident was the one that caused her to leave home.

Doreen wanted to go to art school, but her parents would not support her. Her mother seems to have wanted her to go into an office and learn secretarial work and shorthand/typing. Doreen hated that, and said she would rather work in a factory, which she did, though we don't know where. She writes that there was an uproar when she tried to get a job in a factory. Ronald Hutton states that: "... in later years she regarded the lack of higher education as an intellectual asset, promoting independent thought." [29]

It seems as if at some stage she specialised, since Hazel Hall told me that Doreen was a linguist and could speak a lot of languages, though she didn't know whether she did that for a job. It is quite likely that she did for, Southampton being an important seaport, including being a terminal for ocean-going liners, there would have been a demand for language skills in the normal commercial activity of the place.

Certainly at some stage she seems to have acquired a Polish boyfriend. Hazel remembers that the family liked him very much and he fitted in with them. She just knew him as "the Pole".

[29] Ronald Hutton *Valiente, Doreen Edith (1922-1999) Oxford Dictionary of National Biography* entry

Our next glimpse of Doreen is in August 1939, the month before the Second World War started. We find her working for the Unemployment Assistance Board as a Clerk/Typist. This was listed in a notice in *The London Gazette*[30] as someone whose Certificate of Qualification had been issued the previous month. Thus her statement: "I hated office work. But I was doomed to it nevertheless".

By 1939, Harry Dominy was back in Bristol, living at 117 Cromwell Road, just a few doors down from where he had been living in 1915. What he had been doing during the previous five years I do not know, but Edith was back living with him. Possibly she felt that with Doreen in a secure job she did not need her mother any more. But I think the main reason was that Harry was ill.

On 7th April 1940, Harry died in Southmead Hospital, Bristol, of pancreatic cancer, the same disease that Doreen was to die from some sixty years later. Following Harry's death, Edith seems to have gone to live with her sister, Jessie, in Bournemouth.

We now come to one of the most intriguing episodes in Doreen's life - what she did during the war.

[30] *The London Gazette* 22 August 1939 p 5772

3
Glimpses through the Shadows
(*or* What Doreen did during the War)

Whatever Doreen did during the war it was shrouded in secrecy. She never said anything about it herself. The most we get are odd hints to set us on what becomes a fascinating trail. Hazel Hall told me:

> *I remember Bubbles* [Doreen's cousin, Eileen Paxton] *saying to me 'There's a lot of things about Doreen that's secret' and maybe she did something and had to keep it quiet. ... She used to disappear and they didn't know where she was, not even her mother.*[1]

Those who have known Doreen well, such as Janet Farrar and John Belham-Payne, have also been intrigued by unusual things with which she was familiar and have speculated that she may have done something interesting but highly secretive during the war.

[1] Hazel Hall, in conversation with the author March 2013

For the rest of her life she never revealed what that was. She did provide clues, though.

The fact that Doreen was a linguist and was in Government service at the start of the war does point strongly to the possibility that her skills may have been recognised and used in the war effort. The top-secret code-breaking establishment at Bletchley Park in Buckinghamshire seemed a distinct possibility, particularly as the author, Janet Farrar, told me that Doreen seemed to know all about the first computer, Colossus, Bletchley Park and the Enigma code as if she had been there herself.

Jon Cape, who currently works at Bletchley Park, checked their records for me, which revealed that Doreen had indeed worked there as a Foreign Office Civilian Temporary Senior Assistant Officer. She was a translator. No dates are given, but he provided me with the following information:

> *Elmers School, Hut 18 and Block G. ISOS, Berkeley Street, Distribution and Reference.*[2]

This set me on a line of investigation which revealed something of what Doreen did during the war, but even so there are plenty of mysteries remaining, which is probably as it should be.

29. Hut 18, Bletchley Park

[2] Facebook message Jon Cape to the author 22 March 2013

As a shorthand typist, Doreen had demonstrated her ability to work accurately, and her work for the Unemployment Assistance Board in a seaport like Southampton would be likely to have made use of her skills as a linguist. These twin skills would probably have drawn attention to her from those looking for young, preferably female, staff already in Government employment to work at Bletchley Park:

> *Linguistic skills not only gave a beginner immediate entrance into intercepts by way of translation, but the skills of a linguist include a facility in guessing meanings from context, word-frequency, letter patterns, the spotting of cipher errors, and the identification of special vocabularies.*[3]

30. Bletchley Park, Buckinghamshire

How soon Doreen was invited to go and work at Bletchley Park I do not know. The fact that she was a Temporary Senior Assistant Officer suggests that she must have been there for several years in order to advance from the entry level Temporary Junior Assistant Officer.

She would probably not have been in the first round of what McKay has called 'the Brightest and the Best',[4] often university mathematicians and debutantes. McKay quotes Gordon Welchman as saying:

[3] Robin Denniston *Thirty Secret Years* (Polperro Heritage Press 2007) p 90

[4] Sinclair McKay *The Secret Life of Bletchley Park* (Aurum 2010) p 21

> *Recruitment of young women went on even more rapidly than that of men ... I believe that the early recruiting was largely on a personal-acquaintance basis, but with the whole of Bletchley Park looking for qualified women, we got a great many recruits of high calibre.*[5]

The process of selection seemed to vary but probably a letter for Doreen would have arrived from the Foreign Office, asking her to attend for an interview. There would have been a language test, probably not too rigorous, which Doreen would have passed easily. On arrival at Bletchley Park, Doreen would have had to sign the Official Secrets Act, in an experience probably similar to that of John Herivel:

> *The very first thing I had to do on arrival there ... was swear an oath. About not revealing a single detail to anyone. I remember there was a fearsome looking naval officer there - presumably to instil a measure of fear!*[6]

As Ashley Mortimer remarked to me:

> *Despite her individuality and independence, she wasn't a rebellious-for-the-sake-of-it and buck-the-system sort of person. She would have respected signing the Official Secrets Act super-rigorously.*[7]

There was a great expansion of the numbers of staff working at Bletchley Park in late 1939 and early 1940. Doreen probably arrived during this period, as she was initially working in Elmers School. As Michael Smith writes:

> *It was very soon clear that the house and its adjoining buildings were too small to accommodate the number of people for whom office space was needed. Elmers School, a neighbouring boys' school, was acquired and the Commercial and Diplomatic Sections were moved there*

[5] McKay op.cit. pp 28-29

[6] McKay op. cit. pp 26-27

[7] Ashley Mortimer - personal communication with the author June 2015

with such speed that the owner had no time to move his furniture out.[8]

With the limited information available we can piece together something of Doreen's activities at, or associated with, Bletchley Park.

The abbreviation ISOS stands for Intelligence Section Oliver Strachey, or alternatively Illicit Services Oliver Strachey. Strachey (1874-1960) was the brother of the writer Lytton Strachey. He had been in Military Intelligence in the First World War and in the inter-war years he was in the Government Code and Cipher School. Hugh Trevor-Roper describes him as: "a long-serving epicurean professional cryptographer, not easily ruffled by such passing inconveniences as the outbreak of war."[9]

At Bletchley Park, Strachey was appointed to head the section (ISOS) which bore his name. The background to this is that the German military intelligence (information gathering) organisation, Abwehr, meaning 'defence', was sending agents to Britain to carry out espionage in a variety of places. Some were parachuted in or landed by submarine, but most arrived via neutral countries, often pretending to be refugees.

Now, fairly early in the war, the hand ciphers used by the Abwehr, which were more easily decrypted, had been cracked by Strachey's ISOS section and this had been followed fairly soon afterwards by the deciphering of the Abwehr Enigma ciphers, which used a special version of the Enigma machine.

Doreen's role was as a translator and she was therefore probably involved in translating from German into English the messages that had been decoded.

[8] Michael Smith *Station X - The Codebreakers of Bletchley Park* (Pan 2004) p4

[9] Hugh Trevor-Roper *The Secret World: Behind the Curtain of British Intelligence in World War II and the Cold War* (I B Tauris 2014) p 38

As a result of the decryption of the messages to and from the German agents and their general lack of training, they were very quickly identified and apprehended. They were then given the choice between execution and working as double agents. Most chose the latter.

This was the so-called 'Double Cross' system, where agents were being fed misinformation in amongst some genuine material to transmit to their German handlers. This project was a success, in that no agents were undetected and that the misinformation helped to convince the Germans that the D-Day invasion would be in the Pas de Calais area.

It is frustrating that we don't know the exact dates that Doreen was at Bletchley Park because during the time she was there she also spent a considerable amount of time in South Wales. We know this partly because in January 1941 she married a Greek able-seaman, Joanis Vlachopoulos, in the East Glamorgan Register Office. At this time, Doreen was living in a boarding house, now demolished, at 17 Dock View Road, Barry, a seaport a few miles from Cardiff.

What was Doreen doing in South Wales when she was supposed to be working at Bletchley Park? John Belham-Payne provided a clue when he told me:

> ... she said that she was asked to go there as part of her job for a while to help out ... When I asked her what she was doing there for work she said Oh war stuff but interesting work.[10]

She told John about one frightening but amusing occurrence which happened while she was in South Wales:

> ... she was sharing the flat she had with another girl and one night they were bombed out. After the explosion and the smoke started to clear, her friend screamed "my leg has

[10] John Belham-Payne email to the author 23 March 2013

been blown off!" Doreen went to the rescue, and immediately burst out into laughter - and pointed out to her friend that in the hurry to get cover she had put both legs down the same knicker opening and that was why it was flapping around. She then said: "We wore bigger knickers in those days!"[11]

Since ISOS was the only part of Bletchley Park which dealt, indirectly, with German agents in Britain, it is possible that Doreen, with her communication skills in various languages, may have been sent to Cardiff and Barry, both of which were major merchant seaports, to see whether she could pick up any useful information amongst the foreign citizens of the area.

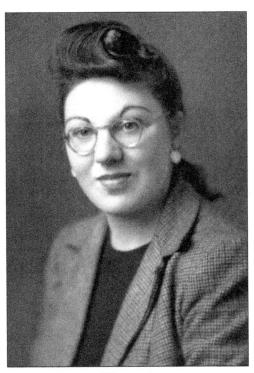

31. Doreen - 1940s

[11] Julie Belham-Payne - email to the author 15 February 2015

In later life, Doreen was certainly a dogged and determined investigator of injustice, gradually teasing out pieces of information until she arrived at a solution. Whether she brought this approach to her work at Bletchley Park, or whether she acquired it there, I really do not know.

And whether Doreen knew Joanis Vlachopoulos before moving to South Wales, or met him after she took up residence there, I do not know, but I suspect the latter. Probably her knowledge of languages enabled her to communicate with various people, including merchant seamen who may have known very little English. Indeed, it was probably part of her job.

There has been some speculation that, as Joanis did not appear to be Doreen's intellectual equal, the marriage may have been one of convenience or a cover for some secret activity that she was involved in. But, as Ashley Mortimer told me, he thought it "more likely she was young and simply fell in love with him".

Joanis seems to have had lodgings in Cardiff at 166 Bute Road in between sailings of his ship, the Greek steam merchant ship, the *Pandias*, usually with convoys across the Atlantic. We don't know exactly how Doreen and Joanis met or what attracted them to each other, but they married on Friday 31st January 1941 at the East Glamorgan Register Office. He was 32 years old and a widower. His father, Nicholas Vlachopoulos, had been a general labourer. Joanis himself could not write and made a mark on the marriage register. He had at least some compatriots to hand, since N. Stratikis and James Lindakis, probably fellow shipmates, were witnesses to the marriage. Doreen was 19 years old.

Interestingly, the marriage certificate gives 'Rachel' as an alternative to her given names of Doreen Edith. Was this an undercover personality or perhaps, more likely, a name that she liked and, wanting to get away from an unhappy childhood, adopted as the name by which she liked to be known? She would not have been the first, nor the last, teenager to have done so.

I do not know which part of Greece Joanis came from, although his surname is very common in Corfu and the Paxi islands in the north-west. There is also the village of Vlachopoulo in Messinia (City of Kalamata region), south-west Peloponnese.[12]

Less than five months after the marriage, Doreen learned that Joanis had been lost at sea, presumed drowned. On 13th June 1941, the *Pandias* was off the West African coast when she was spotted by the crew of a U-boat. She was unescorted and sailing from Newport in South Wales to Alexandria around Africa, up the Red Sea and through the Suez Canal. She was carrying 4894 tons of coal and 1050 tons of military goods, including 11 Spitfires.

Just before mid-day, she was hit amidships by a torpedo and sank from the stern. Of the 34 crew, there were 23 survivors: Joanis was one of the eleven who died.

32. The '*Pandias*', in which Joanis Vlachopoulos was drowned June 13 1941

According to the survivors, who had managed to launch the lifeboats, the U-boat surfaced and provided them with cigarettes, water and rum! I do not know whether this was a common event, but the U-boat (U-107) was commanded by Günter Hessler and it was on a patrol (from 29th March to 2nd July 1941) which was the most successful of the entire war against Allied merchant shipping.

[12] Nicholas Vlachopoulos – email to the author 25 February 2013

After more than a year in Allied captivity, Hessler was commissioned by the Royal Navy to write a history of the U-boat war in three volumes.[13]

As Joanis was a merchant seaman, one is bound to wonder how much of their five-month marriage they spent together. Possibly very little.

Following Joanis' death, Doreen probably moved back to Bletchley Park or, because we know she had spells of working in South Wales in 1943, this pattern of moving between the two places may have continued on a regular basis throughout 1941 and 1942.

The reason we know that Doreen was working in South Wales during 1943 is that she was required to register her address and place of work with the police. This was because she was considered to be an alien for having married Joanis. The Aliens Order 1920 required her to carry a Certificate of Registration in which those details had to be entered. Unfortunately we only have the entries for part of 1943 as the other pages are missing. However, these show an interesting pattern.

The entries read as follows:

> 6 Aug 1942 - Commenced employment at Messrs. Johns(...)
> 31 May 1943 - Employed at Capital Cafe, Queen Street, Cardiff
> 26 Jun 1943 - Unemployed
> 10 Jul 1943 - Living at 32 Beauchamp Street, Cardiff
> 15 Jul 1943 - Employed at Lancashire Books (?), Leckwith Place, Cardiff
> 24 Jul 1943 - Living at 98 Kings Road, Cardiff
> 12 Aug 1943 - Reports being Unemployed

Whilst the records are incomplete, Doreen seems to have twice in 1943 taken a job for less than a month and then registered as unemployed. She also seems to have moved address frequently.

[13] Captain Günter Hessler and Lt Cdr Andrew J Withers (eds.) *German Naval History - The U-boat war in the Atlantic 1939-1945* (HMSO 1989)

This does not seem to be in accord with her character as we know it - determined and dogged - and rather suggests that her jobs were a front for certain undercover activity.

Perhaps we shall never know what she was doing, but at least some of the time between March and October 1943 she was back at Bletchley Park.

In March 1943, the ISOS section moved into Hut 18 (which had previously been known as Hut 8 and which had been occupied by Alan Turing's section). Denys Page (1908-1978) had taken over from Oliver Strachey in 1941:

> ... with his excellent German, which he had learned in Vienna, [he] proved to be so efficient in the job that, when Oliver Strachey went to Canada at the end of 1941 to help their cryptographers, he was appointed head of the section.[14]

McKay gives a vivid description of what working in such a hut was like:

> Even though the word 'hut' implies a cramped construction, these were long structures, with central passageways and rooms off either side. There were plain windows (shuttered at night for blackout purposes), floors of squeaky lino, basic desks and chairs. Green-shaded lights hung from the ceiling. A great many people worked side by side among plain filing cabinets; the rooms were suffocating in the summer sun, and draughty and cold in the depths of winter. As one cryptologist commented: 'Nothing ... seemed less likely to house great matters than the ramshackle wooden building (its atmosphere nauseating at night when the blackout imprisoned the fumes from leaky coke-burning stoves) to which I reported ...'[15]

[14] James Thirsk *Bletchley Park - An Inmate's Story* (Galago 2008) p 157

[15] McKay op.cit. pp 52-53

Block G was constructed in October 1943. This was a more substantial building than the wooden huts, being made of reinforced concrete, and was two-storey in parts. The ISOS section moved there from Hut 18 that same month, and Doreen appears to have moved with them into a single-storey spur to the west.

In the period approaching D-Day in 1944, the ISOS section was particularly concerned with monitoring the response to the misinformation which was being fed by Allied intelligence to the German High Command.

At some time after October 1943, Doreen was transferred to an establishment at 7-9 Berkeley Street, in the fashionable Mayfair district of London, "above Peggy Carter's hat shop", often simply known as "Berkeley Street". The operation, which has been described as "diplomatic eavesdropping", was run by Alastair Denniston (1881-1961), who had been head of Bletchley Park until 1942, when he was demoted, or "exiled", to Berkeley Street, which was officially the diplomatic and commercial section of the Government Code and Cipher School, the military section being at Bletchley Park.

The section at Berkeley Street dealt with diplomatic and Abwehr intercepts. A report filed in 1943, before Doreen arrived, described Berkeley Street as having:

> ...none of the hectic atmosphere of [Bletchley] Park but rather gives impression of well established operation that goes along through wars and peace. General impression is typified by the two ladies who receive and sort incoming traffic. ... These little birdlike old ladies receive and register all incoming material and they have acquired such great familiarity with it that they can do everything except actually decipher it. Whole organization is very simple and they seem to accomplish a great deal with quite limited personnel. Whole outfit consists of two hundred.[16]

[16] Denniston op. cit. p 123

The number employed by the time Doreen arrived may have increased to some extent. The work concentrated on diplomatic and commercial messages from enemy, neutral and Allied countries. With her linguistic abilities, Doreen may well have worked in one or more of these 'geographical' sections, but at some stage she was moved to the Distribution and Reference section. In 1943, there were only five people in this section which, nevertheless, seems to have had a pivotal role. After the messages were decrypted, the results were:

> ... passed to the Head of Section, who sets aside what he thinks not important enough to give to anybody and sends the rest to distribution and reference section, which is heart of organization ... This section decides whether material is worth circulating and if so gives each item to be circulated its proper serial number and send uncirculated items back to geographical sections for filing or destruction. Up to this point everything is done in longhand. Only what is going outside is typed up. ... what impressed us was the pains that are taken to see that all information gets out to those who can make use of it.[17]

The report later states of the Distribution and Reference section:

> These people are in effect a reference bureau for crypt people, and in addition they determine what shall be circulated and to whom it shall go in cases of doubt, and they supervise mechanical operation of getting it out.[18]

The section was headed by Eric Earnshaw Smith (1888-1972). His assistant was Ore Jenkins, Professor of Mediaeval and Modern Greek at Cambridge. Because of the nature of its work, the filing system was particularly important:

> Earnshaw Smith's section has most simple filing system imaginable. Material is simply laid in folders in serial number order, unbound. There are three files - one is

[17] Denniston op. cit. p 125

[18] Denniston op. cit. p 128

master file and another is spare file, both in straight serial number order. The third and important file is called 'Subject and Country' ... Most startling fact about this section is that it receives daily, shows to geographical sections where interesting to them and then puts in its files all incoming and outgoing communications of Foreign Office, Dominions Office, Colonial Office and India Office, and all but purely operational material of the three service ministries.[19]

During late 1943 and early 1944, there was a lot of communications traffic connected in part with the run-up to D-Day. Doreen was kept busy with this, but in her spare time she had got to know a Spaniard called Casimiro Valiente.

Casimiro had been born in Valencia, Spain on 24th January 1918. His father, also Casimiro, was a greengrocer. The younger Casimiro seems to have trained as a cook until he joined the Spanish Republican Army when he was eighteen. He served with that army until February 1939 when he had then, apparently, been captured by the Franco forces and condemned to death. He managed to escape and cross the border into France. Knowing that he could never return, the following month he decided to join the French Foreign Legion, "as they did not ask too many questions", according to Doreen.

He seems to have joined the 13th Demi-Brigade, which was sent to Finland in January 1940 to help the cause of Finnish Independence from the Soviet Union. Following the armistice between Finland and the Soviet Union in March 1940, the 13th Demi-Brigade, numbering some 1,984 legionnaires, was sent to Norway to help deny the Germans access to Norwegian ports and the railway to iron ore deposits in Sweden.

[19] ibid.

On 13th May they were landed and seized the high ground north and south of Narvik. On 28th May they attacked the German posts in the town, and had some success before being called on to withdraw because of the situation in France with the evacuation from Dunkirk.

Casimiro was amongst those injured and was evacuated to England, arriving on 10th June 1940. Doreen writes that: "He had been badly wounded ... and allowed to leave the forces and take a civilian job."[20] He does not seem to have been one to take things easy, however, for he seems subsequently to have been involved in what is described as "sea service", probably as a cook and probably on the Atlantic convoys.

His Certificate of Registration as an alien, which had been suspended while he was at sea, was re-issued in March 1943 at Barrow-in-Furness, a seaport. By August 1943 he was in Glasgow, where he was permitted to work provided he got consent from the Ministry of Labour.

By the end of that month he was living at 8 Wyndham Crescent, Holloway, North London, and in October 1943 he obtained work as a kitchen porter at Casa Pepe Spanish Restaurant, 52 Dean Street, London.

On 10th March 1944, Casimiro moved to 14 Harrington Square, Mornington Crescent. Five days later, Doreen registered under the Aliens Order 1920 at the same address. This was a new registration, with a new certificate. I suspect that, when Doreen came to London, she had let her old certificate lapse. Certainly she was known by her maiden name of Dominy while she was in Bletchley Park and Berkeley Street. It seems to me that marriage to Casimiro was already being planned and that Doreen's new Certificate of Registration was filled in with her intended marriage in mind.

[20] Doreen Valiente *The Rebirth of Witchcraft* (Hale 1989) p 36

By 15th March 1944, Doreen had probably left Berkeley Street, for she was registered as working as a shorthand typist for Messrs. J.V. Rushton Ltd., of Whitcher Place, Rochester Road, London NW1, who were electro-platers, anodisers and metal finishers, mainly for the aircraft industry "where perfect protection from corrosion is of vital importance". The firm had factories in Wolverhampton and Birmingham as well as London, and advertisements of the time stated that "the Rushton 24-hour service is as speedy-efficient and as reliable as science and skill can make it".

Anyway, on 29th May 1944, just one week before the D-Day landings, Doreen married Casimiro at the St. Pancras Registry Office in London.

33. Casimiro Valiente 1943

But when and how did they meet? Was it just a coincidence that they moved in to the same lodging house or did they know each other before? At the moment, this must remain one of many wartime mysteries.

4
Bournemouth: Gateway to the Occult

Following their marriage, I doubt whether there was much time, money or inclination for a honeymoon. If there was one at all, it may well have been a few days in Bournemouth, which is where Doreen's mother lived, with Aunt Jessie and Miss Green, at Lydden Dane, 35 Strouden Avenue, Queens Park. If so, the attractions of Bournemouth as a place to live may have loomed large to both of them. Casimiro would surely be able to get a job in one of the numerous hotels and restaurants in the town. And Doreen would be near her mother.

But Doreen may have had other reasons for wanting to get out of London. The main one was that she had had a rather strange dream. It was in early June 1944:

> *I had this dream that I was down on the south coast, where I actually had an old aunt living, and she was running around packing things frantically, shoving things into suitcases, and when I asked her what was the matter, what*

she was doing, she said 'You have got to get out of London. The Germans are going to start to shell us from the coast on the 13th'. This made a very strong impression. I was so concerned about it. I told the girls in the office about it and they said 'Oh, rot! You have been reading something about Big Bertha (the famous legendary gun which the Germans were supposed to have had in the first world war). It was all rot. You've been reading something like that.' So I almost put it out of my mind, because ... the D-Day landings happened around then. And then I went into work one morning, and the place was all agog with tales of a small German plane which had crashed somewhere in London. It was the 13th June and that small German plane was the first V1.[1]

It is interesting, if nothing more, how this date, 13th June, recurs in Doreen's life. It was, of course, on that date, three years previously, that her first husband was drowned at sea. And, although this would not have been known to Doreen at the time, the first V1 fell on the 60th birthday of her future mentor: Gerald Gardner.

35. 106 Ensbury Park Road, Bournemouth

Doreen and Casimiro decided to move to Bournemouth, staying with Doreen's mother until they found a flat of their own at 108 Evelyn Road, Winton, a suburb of Bournemouth. Casimiro got a job as assistant at Bobby's Cafe, The Square, Bournemouth. In April 1945, Doreen and Casimiro moved to the Upper Flat, 106 Ensbury Park Road, Winton, where they stayed for eight years un-

[1] Rufus Harrington op. cit.

til 1953, when they moved, with Doreen's mother, to a flat at 1 Post Office Buildings, Cardigan Road, Winton. Doreen got a job in November 1944 as a 'handworker' at Messrs Maples Ltd, Christchurch Road, Boscombe. This was a branch of the furniture firm. I am not quite sure what a 'handworker' was, but it appears to have been a skilled job.

36. Post Office Buildings, Winton, Bournemouth

Perhaps then for the first time in her life Doreen had time to think about what she was interested in and what she believed. She had gradually become aware that she had certain abilities and powers that were out of the ordinary. The experiences of her childhood had convinced her that there was something behind everyday reality. The dream about the flying bomb caused her to become interested in dreams: "I had always dreamed in colour and took it for granted that everyone else did too." [2] She also says: "I had left the convent school a confirmed atheist. Now I wasn't so sure".[3] The incident also made her realise that there was something in the occult and she began to study it. As she told Rufus Harrington: "I could not deny this was a precognitive dream. From then on I became very interested in the occult because I knew there was something in it. And in a sense I went on from there." [4]

[2] *Have Broomstick Will Travel*

[3] ibid.

[4] Rufus Harrington, op. cit.

As a first step, she joined the local library in Wimborne Road, Winton, though she would have undoubtedly gone to the Bournemouth Central Library, Lansdowne, for rarer or more esoteric books. Starting with her interest in dreams, Doreen began to study subjects such as Spiritualism, Theosophy, magic, reincarnation and the Tarot.

Some of these subjects were easier to study than others. For a start, she tried Spiritualism. There was a Spiritualist Church in Charminster Road, Charminster, not far from where Doreen was living, which was built in 1926. However, the services consisted mostly of hymn-singing and Bible-reading, which did not appeal to her. Doreen was, however, asked to lead the prayers on one occasion, and she gave them an invocation by Aleister Crowley, which, apparently, they loved.[5] She was obviously at that time familiar enough with Crowley's works to choose such an invocation.

Following her encounter with witchcraft, Doreen was later quite forthright in her views on Spiritualism:

> *If I say that witches have links with Spiritualism, this will probably upset some Spiritualists; but it is nevertheless true. In fact, every genuine phenomenon connected with modern Spiritualism can be found occurring in ancient witchcraft; mediumship, clairvoyance and clairaudience, psychic healing, levitation, astral projection, materialisations, even the formation of the circle by placing men and women alternately to balance the power. Witches, however, seldom frequent Spiritualist churches, because they are repelled by all the hymn-singing and Bible-reading that one has to sit through, in front of a cross-adorned altar, in order to get a little genuine clairvoyance at the end (sometimes!). Other seekers are repelled by it too; and often people who start their enquiry into the Unknown with Spiritualism, end by coming to witchcraft, because witchcraft is honestly pagan, instead of paying lip-service to Christianity.*[6]

5 *Have Broomstick Will Travel*

6 *I Am A Witch*

During the course of her reading, or with her contacts at the Spiritualist Church, Doreen became aware of Theosophy and that there was a local Bournemouth branch of the Theosophical Society. Theosophy (from the Greek 'theo' - of the gods; and 'sophia' - wisdom) is, to quote from the Theosophical Society website:

> ... sometimes known as the Ageless Wisdom, is the Light which shines through the many coloured lamps of religion. It is the thread of truth in scriptures, creeds, symbols, myths and rituals.[7]

The Theosophical Society had been founded in 1875 and soon had branches in many parts of the world, including Bournemouth, a branch which had been active since the late 19th Century, and of which astrologers Alan Leo and Charles Carter had been members:

> As Bournemouth grew into a fashionable Victorian health resort, attracting the rich and infirm, it was not only physicians and hoteliers that thrived. Un-numbered clairvoyants, palmists, card-readers, phrenologists - and astrologers - quietly flourished behind the lace curtains. While other sea-side towns enjoyed the spice of the "naughty nineties", this Pisces area was less openly brash. In parts a romantic retirement haven away from the world; it was also imbued with an aura of mystery that the occult-loving Victorians and Edwardians found irresistibly attractive.[8]

Whilst she was very impressed with the writings of Madame Blavatsky, the founder of Theosophy, Doreen felt that Theosophy in her own time was not attractive. As she put it, it was "a cult for old women of both sexes".

In her investigations, however, what really interested Doreen was magic. But, as she says:

7 www.theosophicalsociety.org.uk

8 www.charlescarter.co.uk/spirit-of-place.html

Information on the subject was ... very hard to come by. Those who knew anything about it would not only refuse to help an outsider, especially a woman: I found that they would actively hinder one's quest if they could.[9]

This demonstrates that she was meeting real people on her quest and not just reading books. Doreen commented:

When I first started upon the occult path I had all sorts of misinformation given to me, and all sorts of obstacles put in my way, when I wanted to study the Qabalah. Things are different nowadays, of course; but there are still people who want to keep power in their hands, and for no better reason.[10]

Doreen told Sally Griffyn that she lived the life of a very ordinary suburban English woman, working as a clerk. However, somehow she met a woman who used to have little parlour meetings where esoteric matters were discussed, and this seemed to awaken something in her.

It seems clear that Doreen had tried to get help from various local (and perhaps further afield) occultists and ritual magicians without success. However, the Bournemouth Public Library did have some occult and esoteric books, perhaps the legacy of the enthusiasm of an earlier generation. One book that caught her eye was *The Mystical Qabalah* by Dion Fortune,[9] which had just been reprinted in 1948.

Dion Fortune (1890-1946) was born Violet Mary Firth. She was a prominent occultist and practitioner of Western Esotericism. Her *The Mystical Qabalah*, first published in 1935, was long considered the best exponent of the Hebrew magical system, though her works of fiction, such as *The Goat-Foot God* (1936) and *The Sea Priestess* (1938) are perhaps more accessible to the general reader.

[9] *The Rebirth of Witchcraft* p 35

[10] letter from Doreen Valiente to Janet and Stewart Farrar 10 November 1982

[11] Dion Fortune *The Mystical Qabalah* (Williams and Norgate 1935)

As is the way with books, reading one leads on to another, and Doreen, in the course of reading Dion Fortune's book, noticed that the author had frequently referred to Aleister Crowley and how "previously unpublished secret knowledge had been published by the notorious Aleister Crowley".[12]

So, in 1951, when a biography of Crowley by John Symonds[13] came out, she ordered it from the library and read it avidly. Also in the library was a very rare book entitled *Magick in theory and practice* by the Master Therion (Aleister Crowley) which had been published privately in Paris in a strictly limited edition in 1929. Doreen writes:

> *How on earth it got there I shall never know. I believe it was removed once the library authorities realized what it was; but it stayed there long enough for me to copy from it what was then a revelation, namely the real correspondences of the cards of the Tarot to the Hebrew alphabet and the signs of the Zodiac, the planets and the elements.*[14]

This made a very strong impression on Doreen:

> *I shall never forget how I rode home on the bus glowing with triumph. I remember looking at the sunset clouds in their glory and knowing somehow that I was destined for a career in magic. In spite of all the snubs and of all the wasted hours sitting in boring lectures listening to what I knew was nonsense, at last I had got somewhere. After reading through volumes of platitudinous piffle*[15] *written by those who had pretended to knowledge, I had seen among the rubbish the gleam of gold.*[16]

[12] *The Rebirth of Witchcraft* p 35

[13] John Symonds *The Great Beast: the life of Aleister Crowley* (Rider 1951)

[14] *The Rebirth of Witchcraft* p 35

[15] Ashley Mortimer informs me that "platitudinous piffle" is a direct quote from Crowley and that he used such alliterations frequently.

[16] *The Rebirth of Witchcraft* pp 35-36

It was about this time that Doreen had what turned out to be a very fruitful conversation with her bank manager.

Back in the 1950s, life was much simpler and more direct - a time when one of the major adventures in Doreen's life could start with a chat with her bank manager. It would seem that in that more leisurely age they chatted on a regular basis, for Doreen tells us that they shared a love of books, and he obviously knew that she had a particular interest in magical works.

So, in their latest encounter, some time in January 1952, he had a piece of news in which he was sure she would be interested. As part of his job he had been valuing for probate things belonging to a doctor who had recently died. He told Doreen that the doctor had a lot of magical manuscripts which his widow was intending to burn.

Doreen was aghast! The bank manager told her that he had tried to buy them, but, he said, "She is adamant. She hates them, is afraid of them, and she is going to burn them." [17]

Being aware of the rules of professional confidentiality, Doreen could not very well ask him for the doctor's name, but she managed to steer the conversation round to the locality in which the doctor had lived, which turned out to be the Parkstone area of Poole, the neighbouring town to Bournemouth.

On her next free day, she took the bus to Parkstone and began asking around in likely places such as local shops whether they knew of a doctor in the area who had died recently. She was soon given the name of Dr. Henry D. Kelf, of 214 Sandbanks Road, Parkstone. She went there intending to talk to his widow, but there was no-one in. Disappointed, she turned away but, noticing that

[17] J L Bracelin *Gerald Gardner Witch* (Octagon 1960) p 179

a pebble from the pebble-dashed wall had fallen onto the grass and, being aware of the power of sympathetic magic, she picked it up in case it might come in useful.

On her way home Doreen devised a plan. Bracelin says: "She called in some friends that night, and they did what was necessary, and then she went to sleep."[18] This is an intriguing if vague statement. We really have no idea who these friends were, but it is likely that they were members of a local spiritualist circle to which Doreen belonged. Doubtless they included 'Zerki': we will meet him shortly.

Anyway, it seems that they used the pebble to try to create some sort of psychic link with Kelf's widow, Clara. That they were successful in this is clear from what Bracelin tells us happened next:

> *She woke up after a while, and felt that she was out of her body, naked. Her nose seemed to be pressed against something. She was out in the open air, and it was dark. Against the sky she saw the outline of the porch of the front door of the pebble-dashed house ... She willed hard and suddenly she was inside the house. She could see a hand pointing to a green satin divan, with a lot of dark-coloured books lying upon it.*[19]

Doreen seemed to hear a voice saying "Now are you satisfied?" before she found herself sitting up in bed, not sure about it but hoping that something had been accomplished.

Next morning, Doreen's bank manager phoned her to say that the widow had telephoned him earlier saying that she knew he had a lady friend who could take away the manuscripts that she was afraid to have in the house. The bank manager gave the address to Doreen, who did not let on that she had already discovered it independently.

[18] ibid.

[19] Bracelin pp 179-180

Doreen arranged to visit Clara Kelf that same afternoon. The room was exactly as in her dream, down to the green satin divan and the pile of notebooks on it. And, as in her dream, Clara said: "Now are you satisfied?" and went on: "I tried to burn them, but something made me take them out of the fire. I am very frightened. Will you please take them away?" [20]

Not only were there twenty-eight hard-backed notebooks, but also two swords, two pentacles and other paraphernalia. How Doreen managed to get them all home I do not know! The swords would have been awkward in more ways than one to carry on the bus. She probably went to the expense of ordering a taxi!

When Doreen got the collection home, she was able to examine the notebooks in more detail. They were lined mostly hard-back small size notebooks containing hand-written material that seemed to be a course of magical instruction. They date from 1902 to 1908, at which time Kelf was a pharmaceutical chemist dispenser living in London. Each notebook had a label on its cover which read:

> *Hermetic Order of the A.O. These papers are private, and have been lent to me on trust, to return on demand. They contain nothing of pecuniary value, and nothing personal to myself. I hereby direct my legal representatives whomsoever, in case of my death or incapacity, to return the same at once, unread and unopened, to ...* [21]

There then followed an address in London.

Doreen had read enough about ceremonial magic to realise that these purported to belong to the Hermetic Order of the Alpha et Omega, which was a splinter group from probably the most well-known of all magical orders, the Hermetic Order of the Golden Dawn. Founded in 1887, this was probably the most influential magical order of the late 19th and early 20th Centuries.

[20] Bracelin p 180

[21] Henry Kelf notebook label (notebooks in the Toronto collection)

In her book, *The Rebirth of Witchcraft*, Doreen writes: "I had been a student of the Golden Dawn system of magic for years, long before I ever met Gerald Gardner." [22]

Now, Doreen only acquired the magical notebooks less than a year before she met Gerald Gardner, so the implication of her statement is that she fully recognised the significance of the notebooks and what they contained.

Records show that she was never formally initiated into any Golden Dawn temple, and that therefore the most likely way that she could have obtained her prior knowledge of the Golden Dawn would have been through reading Israel Regardie's four-volume *The Golden Dawn - An Account of the Teachings, Rites and Ceremonies of the Order of the Golden Dawn*, which had been published in America in the late 1930s.

Whilst solitary magical practitioners do exist, there is some merit in having a magical partner, and this is what Doreen proceeded to acquire. He was an artist, his magical name was 'Zerki' and he wanted to start a coven. I do not know his everyday identity or how Doreen got to know him. He may well have been an attender at the Spiritualist or Theosophical meetings whom Doreen had recognised as a kindred spirit.

Anyway, it is clear that, not long after she had acquired the Golden Dawn documents, Doreen was working with Zerki, always at his flat not her own, probably because Casimiro had no interest in such matters and, indeed, may have been to some extent actively hostile. To quote Gerald Gardner, whom she was soon to meet and tell what she had been doing:

> *They have the Golden Dawn rituals, and a lot of the Golden Dawn instruments. They have been mostly using magnetised black mirrors to get prophetic visions and, she claims, with success.* [23]

[22] Bracelin p 200

[23] letter from Gerald Gardner to Cecil Williamson 14 December 1952 - in Boscastle Museum of Witchcraft archives - spelling etc. corrected.

66

However, things did not always run smoothly:

> ... *the last time they tried it, in the middle the friend* [i.e. Zerki] *suddenly remembered* [that he] *had left something boiling on the kitchen stove.* [He] *rushed wildly to take it off, thus breaking the circle, a locked door violently burst open, and loud noises and almost* [unreadable word] *phenomena occurred, and they've done nothing since. Apparently neither seems to have realised that in this sort of work the circle is for protection and it is highly dangerous to break it (if you have succeeded in calling up anything, that is).*[24]

It was, however, at this time that Doreen chose her magical name, Ameth, which was to remain with her for the rest of her life. This choice is, perhaps, an indication of her interests at the time, since 'Aemeth' is a symbol in the Enochian magic of John Dee, and means something like 'the truth of God'. She probably noted the name as it is mentioned in the Golden Dawn manuscripts which she had obtained.

And so matters stayed until later that year, when Doreen paid a visit to her local corner newsagent's shop.

37. Doreen 1950s

[24] ibid.

Chapter 5
Doreen meets Gerald Gardner and becomes a Witch

Whether Doreen regularly bought the weekly magazine, *Illustrated*, I do not know. It certainly had a large circulation and consisted of articles which were illustrated (hence its name) with large higher-quality photographs, some of them in colour, at a time when these were lacking in ordinary newspapers.

Certainly the mention on the front cover of the 27th September 1952 issue of an article entitled "Witchcraft in Britain" would have attracted her attention, and she would have made quite sure that she bought a copy. It was probably on sale about the time of the Autumn Equinox, as although the issue bears the weekend date, it actually came on sale a few days earlier.[1]

The article, by Allen Andrews, was a bit of a mixture. Part of it was focused on a 'witchcraft consultant' called Cecil Williamson. It gave a description, accompanied by photographs, of how Williamson had been asked to remove a spell which had been made against someone together with his methods of doing so.

[1] Doreen Valiente *notebook no. 22* 16 September 1962

What particularly interested Doreen was mention of the 'Southern Coven of British Witches', which had performed a ritual in the New Forest in 1940 to try to stop the threatened invasion of Britain. It was also quite clear from the article that there were witches around at the present day and it gave certain details of their beliefs and practices.

This fascinated Doreen. Bournemouth was right on the edge of the New Forest and: "... there was a chance that witchcraft was still going on [there]".[2] She wrote to Cecil Williamson, the only individual mentioned in the article, which also gave his address on the Isle of Man. She told him of her occult studies so far and asked if he could put her in touch with what the article had called "the witch cult". Williamson passed her letter on to Gerald Gardner, who had been initiated as a witch in the New Forest in 1939, and was running a museum of magic and witchcraft with Williamson at Castletown on the Isle of Man.

I suspect that Doreen had, in fact, been very interested in witchcraft before that time, however, as her scrapbooks contain newspaper cuttings dating back to 1951 about preparations for and the opening of a museum on the Isle of Man[3] which was to be called the Folklore Centre of Superstition and Witchcraft. Indeed, she told Janet and Stewart Farrar that she had been "collecting press cuttings about witchcraft and the occult since 1951".[4] So it is highly likely that Doreen already knew of the museum on the Isle of Man.

On reading this, I was suddenly reminded of a passage in Gerald Gardner's *Witchcraft Today*:

> ... I received a letter dated September 29, 1952, telling me of a meeting held in a wood in the south of England about two

[2] *The Rebirth of Witchcraft* p 37

[3] Barrie Harding *He Plans a Jamboree for the Witches of the world* (*Sunday Pictorial* 29 April 1951); Allen Andrews *Calling All Covens* (*Sunday Pictorial* 29 July 1951)

[4] letter Doreen Valiente to Janet and Stewart Farrar received 24 April 1978

*months before, in the traditional nude (luckily the weather
was warm). They cast the circle with the Athame, did the
fertility dances on broomsticks, performed the proper
seasonal as well as other rites, and had some of the old
dances. The letter also mentioned three indoor meetings
in the last few months where everything had been done very
satisfactorily and spells performed which worked!*[5]

It occurred to me that the initial correspondence between Doreen
and Gerald would fit exactly with this account. It was obviously
written by someone who was introducing themselves to Gardner,
and I now believe this to have been Doreen. If so, it would con-
firm that she had not only been interested in witchcraft before she
read the article in Illustrated but that she had, with others, been
performing skyclad rituals in the New Forest, as well as indoor rit-
uals with an athame-cast circle where spells had been performed.
The mention of old dances, particularly fertility dances on broom-
sticks, suggests some familiarity with the works of Margaret
Murray.

39. Gerald Gardner

[5] G B Gardner *Witchcraft Today* (Rider 1954) p 54

Could Doreen perhaps have obtained a copy of Gardner's *High Magic's Aid* on a visit to Atlantis Bookshop some time before she met him? And had she been working with Zerki, and perhaps others, in the Forest and in his flat? We do not know, but the coincidence of dates is very suggestive.

Some correspondence passed between Doreen and Gerald Gardner, and then he suggested that they meet. He would shortly be staying near Bournemouth at the home of his friend, Edith Woodford-Grimes, known to him as 'Dafo', who was in fact the one who had initiated him back in 1939. He wanted to visit Doreen to see how she carried out her magical workings, but the place where these occurred, which was Zerki's flat, was not available at a time that Gerald could visit. So, particularly as there had been a bad fog and he didn't want to travel, Gerald invited Doreen to visit him at Edith's house, 22 Avenue Road, Highcliffe, near Christchurch.

40. Avenue Cottage, Highcliffe - Dafo's home

The weather had improved by the day of Doreen's visit. She probably took the Lymington bus from Bournemouth, getting off at Highcliffe and walking up to Avenue Road in good time for her meeting. She describes it as follows:

... one sunny afternoon, as autumn was fading into winter in 1952, I found myself in Dafo's pleasant, well-appointed house shaking hands with a tall, white-haired man who rose to greet me as I entered the drawing room. We seemed

to take an immediate liking to each other. I realized that this man was no time-wasting pretender to occult knowledge. He was something different from the kind of people I had met in esoteric gatherings before. One felt that he had seen far horizons and encountered strange things; and yet there was a sense of humour about him and a youthfulness, in spite of his silver hair. ... His clothes were informal but of good quality - Harris tweed, if I remember rightly. He wore a large silver ring with some strange signs upon it, which I learned later represented his witch-name, 'Scire', in the letters of the magical Theban alphabet. On his right wrist was a heavy bronze bracelet, with symbols upon it denoting the three degrees or grades of witchcraft.[6]

41. Edith Woodford-Grimes ['Dafo']

Edith (who, for reasons best known to himself, Gerald had introduced to Doreen as 'Elsie'[7]) told Doreen that of recent years her health had been such that she no longer took an active part in witchcraft activities. Also, she had to be rather cautious as her job as a teacher of elocution would, she felt, be severely compromised

6 *The Rebirth of Witchcraft* pp 37-38
7 letter Doreen Valiente to the author 24 August 1998

if there was any whisper locally of her connection with witchcraft. This also applied to her daughter's husband, who was a dentist. Doreen added: "I do not think she was really happy that Gerald had arranged our meeting at her house, though she made herself welcoming enough to me."[8]

Doreen went through all the usual misgivings:

> ... as I sat that sunny late autumn afternoon taking tea in Dafo's drawing room and trying to weigh up the situation I found myself in. Were these really the people whose forerunners had been burned at the stake? ... Would they require me to sell my soul to the Devil?[9]

She continued:

> To be willing to sell one's soul to the Devil was a state of mind which prolonged residence in Bournemouth at that period, when poor and the subject of general social disapproval, might naturally induce. Nevertheless, I had enough knowledge of the occult to realize that it would be a bad bargain. But these people did not seem in the least sinister. On the contrary, they seemed kind and intelligent.[10]

Before she left, Gerald gave Doreen a copy of his novel, *High Magic's Aid*,[11] about mediaeval witchcraft. He told her to read it carefully, as it would tell her a lot about the witch cult and mediaeval magic. She learned later that Gerald often gave copies to likely initiates to judge how they reacted to his descriptions of ritual nudity and scourging.

Although Doreen only mentions her own visit to Gerald and Dafo, it seems likely that Zerki attended as well, since, in her notes, Doreen refers to Zerki as having been initiated at the same

[8] *The Rebirth of Witchcraft* p 38

[9] op. cit. p 39

[10] ibid.

[11] 'Scire' (G B Gardner) *High Magic's Aid* (Michael Houghton 1949)

time as herself, and I am sure that Gerald and Dafo would want to have at least met him prior to such a step.

Things went rather quiet after their initial meeting. Certainly, as Doreen says, Gerald made no attempt to rush her into joining the witch cult. Indeed, it was not until midsummer the following year, when Gerald was staying with Edith in order to attend the Druid ritual at Stonehenge, that he initiated Doreen and Zerki at Edith's house.

Doreen deliberately says little about her initiation, but does say that the ritual closely resembled that to be found in Gerald's novel, *High Magic's Aid*. There was, however, one addition to the ritual which Gerald had included, entitled 'The Charge'. It is clear that Doreen was no typical neophyte by the time Gerald initiated her. She was well-read in magical and occult subjects generally, and so she recognised that this was taken partly from Aleister Crowley's *The Book of the Law* and partly from Charles Godfrey Leland's *Aradia or the Gospel of the Witches*.[12] Doreen says: "I told Gerald so afterwards. I think he was none too pleased at my recognition of its source."[13]

She does, however, give a vivid impression of Gerald during the ritual:

> *In my mind's eye, I can seem to see him now, standing by our improvised altar in that candle-lit room. He was tall, stark naked, with wild white hair, a suntanned body, and arms which bore tattoos and a heavy bronze bracelet. In one hand he brandished 'Old Dorothy's' sword while in the other he held the handwritten 'Book of Shadows' as he read the ritual by which I was formally made a priestess and witch.*
>
> *One odd thing happened as I stripped off my clothes for the ritual. Some instinct told me to keep on the necklace I was*

[12] Charles Godfrey Leland *Aradia or the Gospel of the Witches* (D. Nutt 1899)

[13] *The Rebirth of Witchcraft* p 47

*wearing. I found subsequently that this was correct wear
for a witch priestess, a fact quite unknown to me at the
time. Had I done something like this before?* [14]

Doreen told Janet and Stewart Farrar that:

*... when I was initiated I was brought in with another man
[Zerki] whom Gerald hoped that I would work with, but
who actually dropped out not long thereafter. He came
down to see us, and we formed the Circle according to his
directions. (Gerald's, that is). Then Gerald brought me in
and then prompted me, just as Pat describes, to bring in
this man.* [15]

"Pat" is Patricia Crowther, whose book, *Lid off the Cauldron,* [16] was
about to be published when Doreen wrote that letter. In that
book, Patricia says: "Gerald initiated me and I initiated my hus-
band." [17]

After giving Doreen his magical books, because he was afraid to
continue, Zerki dropped out. Doreen writes that he had had
frightening experiences with trying to work *The Book of the Sacred
Magic of Abra-Melin the Mage.* She noted: " ... this book is noto-
rious for its danger when meddled with, as I had previously
warned him." [18] They had been working together, because Doreen
states that: " ... he got cold feet when we began getting magical re-
sults (blue aura over altar) and backed out." [19]

Gerald had attended the annual Druids' Midsummer ritual at
Stonehenge regularly for several years, always making sure that he
brought with him a magical sword he had inherited from a witch
High Priestess (probably the one he had used during Doreen's

[14] ibid.

[15] letter Doreen Valiente to Janet and Stewart Farrar 7 May 1981

[16] Patricia Crowther *Lid off the Cauldron* (Frederick Muller 1981)

[17] op. cit. p 31

[18] *Have Broomstick: Will Travel*

[19] ibid.

initiation). This sword fitted into the cleft of the Hele Stone at Stonehenge and was an important element in the ceremony.

Doreen went with Gerald and Edith to this ceremony at Stonehenge the day after her initiation:

> I had never been to the great stones before, but it seemed very appropriate to me that my initiation (which had taken place the previous day) should be sealed, so to speak, by this visit to one of the great spiritual centres of Britain. Also, it provided a valuable cover story for my family. I had not dared to tell either my husband or my mother the truth about my being initiated as a witch. My husband had never shared my interest in the occult, although he was not actively hostile to it; but my mother, unfortunately, was implacably and blindly opposed to anything of an occult nature. She had been caught young by the Congregational chapel. However, the Druids seemed comparatively respectable to her. Well-to-do people belonged to them, and she was a terrible snob. So I quite calculatingly gave the impression that what Gerald and I shared was an interest in Druidism. I had long ago given up the effort either to persuade or reason with her. Moreover, she had been impressed by being told that Gerald was a Doctor of Philosophy. My lack of academic distinctions had long been a subject of reproof, caused by the fact that I had walked out of my convent school at the age of fifteen and flatly refused to return.[20]

Unlike modern-day practice, it was only later in the year that Gerald invited Doreen to come up to his London flat to meet the rest of the coven. His flat was at 145 Holland Road, near Shepherd's Bush, but we don't really know who all the members of the coven were. Doreen says: "There were about eight or ten of them, mostly people who were fellow members of a naturist club he was interested in." I have previously carried out investigations into who may have been in this group, and the names of Gilbert and

[20] *The Rebirth of Witchcraft* pp 40-41

Barbara Vickers, James Laver, Eda Collins and Mary Dowding are possible candidates.

Whoever they were, Doreen wrote that: "They made me welcome and I felt that a whole new life had opened up before me."

42. 145 Holland Road, Shepherd's Bush - Gerald Gardner's flat

Chapter 6
Gerald's 'Myopic, Stalky Nymph'

It is likely that Doreen sometimes met other members of the coven at the Witches' Cottage. This had originally been an apple store which had been saved from demolition by being moved to a 'folk park' at New Barnet in north London. Those running the park had gone bankrupt, however, and Gerald Gardner had acquired the cottage, re-erecting it on land that he owned adjacent to the Five Acres naturist club in Bricket Wood, Hertfordshire. The half-timbered single-storey building had reclaimed tiles on the roof and a heavy oak door acquired from the local gaol.

It was here, in the depths of a wood, that Gerald Gardner's coven met. Patricia Crowther gives a very vivid account of the coven gatherings at a slightly later date: "There was a wonderful atmosphere in the cottage. It was like stepping back in time, and the aroma of incense seemed to permeate the very walls."[1]

Following her initiation, one can imagine that Doreen attended at least the Lammas (August Eve) and Halloween (November Eve) rituals at the cottage, as well as perhaps others. She would

[1] Patricia Crowther *One Witch's World* (Hale 1998)

have to have got a train from Bournemouth to Waterloo, cross London by the Underground to Euston and then two further trains to Bricket Wood, followed by a mile or so walk. She would also have had to have stayed the night, probably in accommodation in the naturist club.

This Doreen was certainly prepared for, facing up to her husband's lack of interest and her mother's outright hostility.

However, Gerald, after a working life in the tropics, felt the cold and I imagine that he could not contemplate a ritual in the cottage in the depths of winter. It really had no insulation, and the paraffin and portable gas heaters which they had were not very effective.

So he decided to hold the forthcoming Yule ritual in his London flat. In the spirit of encouraging new initiates to take a full part in the proceedings, Gerald had asked Doreen if she would conduct the ritual. Doreen takes up the story:

> *As we were sitting there in his flat having tea, about two hours to go to the ritual, I said to Gerald that we'd better rehearse this ritual, hadn't we? And he said in his funny little way 'Well, I haven't got a ritual: you can write one!' I realised later that perhaps the cunning old devil had deliberately thrown me in at the deep end to see what I could do, but at the time I was rather horrified!*

> *So I skated hastily around in his library (he had a fine library of occult books) and I found Alexander Carmichael's 'Carmina Gadelica' [first published 1900], which was a collection of old Celtic songs, ballads and ritual prayers, and things like that, sort of half Pagan, half Christian, which Alexander Carmichael had collected among the Celtic peoples of the Highlands and Islands back in the 19th Century. And I thought 'now, this could be a good source to find something.' And I found what seemed to be a suitable prayer and adapted it.[2]*

[2] Doreen Valiente interview with Kevin Carlyon 14 April 1990

She told Janet and Stewart Farrar:

If he had told me directly to write a ritual, I would probably have said "Oh, no, I couldn't. I'm not capable of it", and so on. But being presented with an apparent emergency, I did the best I could, and in practice it worked very well; so we kept what I'd written and I was encouraged to write more.[3]

The words that Doreen adapted were from a Christmas carol which Carmichael collected from Angus Gunn, a cottar of Lewis, and which goes as follows:

God of the Moon, God of the sun,
God of the globe, God of the stars,
God of the waters, the land, and the skies,
Who ordained to us the King of promise.

It was Mary fair who went upon her knee,
It was the King of life who went upon her lap,
Darkness and tears were set behind,
And the star of guidance went up early.

Illumed the land, illumed the world,
Illumed doldrum and current,
Grief was laid and joy was raised,
Music was set up with harp and pedal-harp.[4]

The revised version that Doreen came up with was as follows:

Queen of the Moon, Queen of the Sun,
Queen of the Heavens, Queen of the Stars
Queen of the Waters, Queen of the Earth,
Who ordained to us the Child of Promise!

It is the Great Mother who gives birth to him
It is the Lord of Life who is born again.
Darkness & tears are set behind
And the Star of Guidance comes up early.

[3] letter Doreen Valiente to Janet and Stewart Farrar 12 July 1978

[4] Alexander Carmichael *Carmina Gadelica Vol 1* p 133 (Norman Macleod 1900)

Golden Sun of Hill & Mountain.
Illumine the Land, Illumine the world
Illumine the seas, illumine the rivers.
Grief be laid and joy be raised.

Blessed be the Great Mother
Without beginning, without Ending.
To everlasting, to eternity.
I.O. Evoh. Blessed be.[5]

She says: "I thought, well, the Winter Solstice is the time when the Sun is reborn and that would be the symbol of the cauldron and the womb of the Great Mother and the fire within it - the fire and the candle - so making the wheel of the Sun turn again."[6]

This is the version which Gerald Gardner included in his last Book of Shadows (that which is sometimes known as 'Text D'). At some stage, when she had more time, Doreen revised the text further to the following:

Queen of the Moon, Queen of the Sun,
Queen of the Heavens, Queen of the Stars,
Queen of the Waters, Queen of the Earth
Bring to us the Child of Promise!

It is the great mother who giveth birth to him,
It is the Lord of Life who is born again.
Darkness and tears are set aside
When the Sun shall come up early.

Golden Sun of the Mountains,
Illumine the Land, Light up the World,
Illumine the Seas and the Rivers,
Sorrows be lain, Joy to the World.

Blessed be the Great Goddess,
Without beginning, without end,
Everlasting to eternity.
I.O. EVO.HE Blessed Be.

[5] Gerald Gardner's 'Text D' (in Toronto collection)

[6] Doreen Valiente – interview with Kevin Carlyon 14 April 1990

This is the version that appears in Gerald Gardner's *Witchcraft Today*.[7] His comment about it in the book is typical of his tendency to tell the literal truth whilst giving a misleading impression. He is writing about the practices of the witches that he had met, and in introducing the above verses, he comments: "The chant I heard was as follows ...". Undoubtedly he **had** heard it, and indeed commissioned it himself, though the impression he intended to convey was that it was an old chant used by the witches in times past.

As Doreen became more familiar with the rituals and the practices of the coven, she became more and more sceptical about their provenance.

Following her initiation, Gerald had given her his Book of Shadows to copy. This is a handwritten book of rituals and magical techniques which newly-initiated witches are supposed to copy from the book of their initiator. There is some evidence that Gerald copied at least part of his from that owned by his initiator, Edith Woodford-Grimes (Dafo), but it soon became obvious to Doreen, who was reasonably well-read, particularly in esoteric subjects, that much of Gerald's Book of Shadows had its origins not in some ancient text that had been passed down the generations, but in much more recent times.

Doreen quickly identified the main sources, which she listed as follows:

1 - The words of Margaret Murray and R. Lowe Thompson

2 - The O.T.O. rituals of Aleister Crowley

3 - The Merry Order of St. Bridget

4 - The Key of Solomon, translated by MacGregor Mathers

5 - The rituals of Co-Masonry

6 - Naturism

[7] op. cit. p 25

There was one source that Doreen spotted immediately: "It became obvious to me as soon as I had been given Gerald's 'Book of Shadows' to copy that it owed a good deal to the works of Aleister Crowley."[8]

At first, it seems as if Gerald tried to dismiss Doreen's identification of the origins of the Book of Shadows, but, as she said:

> As time went on, I had in practice become Gerald's High Priestess. He had got over his discomfiture at realizing that I could spot all the Crowley material in the rites we used. He explained this to me by saying, firstly, that as the holder of a Charter from Crowley himself to operate a Lodge of the OTO, he was entitled to use it; secondly, that the rituals he had received from the old coven were very fragmentary and that in order to make them workable he had been compelled to supplement them with other material. He had felt that Crowley's writings, modern though they were, breathed the very spirit of paganism and were expressed in splendid poetry. That was why he had used them.[9]

This is perhaps most evident in a part of the Book of Shadows known as the Charge of the Goddess. In rituals, the Goddess is invoked into the body of the High Priestess. The Goddess then charges, sometimes spontaneously, sometimes silently, but there is also a form of words in the Book of Shadows which can also be used.

The contents of the Book of Shadows, copied by each witch following their initiation, is often considered to be secret, but the Charge of the Goddess is so well known, has been published so many times and is clearly a major contribution to world spiritual and religious literature that I feel it appropriate to look at it in some detail, particularly in the contribution which Doreen made to the version that is now in common use.

[8] *The Rebirth of Witchcraft* p 54

[9] op. cit. p 57

Gerald Gardner's version of the Charge starts as follows:

Whenever ye have need of anything, once in the month, and better it be when the moon is full. Then ye shall assemble in some secret place and adore the spirit of me who am Queen of all Witcheries.[10]

This and several following sections are taken, almost word for word, from the book by Charles Godfrey Leland entitled *Aradia, or the Gospel of the Witches*,[11] which Leland claims were given to him by Maddalena, a hereditary witch from the Tuscany region of Italy.

The version of the Charge of the Goddess that Gardner was using then includes the following:

For I am a gracious Goddess. I give unimaginable joys, on earth certainty, not faith while in life! And upon death, peace unutterable, rest, and ecstasy, nor do I demand aught in sacrifice.

Hear ye the words of the Star Goddess: 'I love you: I yearn for you: Pale or purple, veiled or voluptuous, I who am all pleasure, and purple and drunkenness of the innermost senses, desire you, put on the wings, arouse the coiled splendour within you. Come unto me.[12]

These are taken, again almost word for word, from Aleister Crowley's *The Law of Liberty*.[13]

From her previous reading, Doreen realised immediately the sections that were taken from Crowley's writings and suggested to Gerald that he should remove them. It was not, she hastened to explain, that she did not admire Crowley's poetry:

[10] Gerald Gardner 'Text A' (in the Doreen Valiente Collection)

[11] op. cit.

[12] 'Text A'

[13] Aleister Crowley *The Law of Liberty* (Blue Equinox - The Equinox Vol III No 1)

Aleister Crowley, in my opinion, was a marvellous poet and he has always been undervalued in English literature simply because of the notoriety which he made for himself and revelled in.[14]

So, Doreen told Gerald she felt that this Crowley material "... was not really suitable for the Old Craft of the Wise, however beautiful the words might be or how much one might agree with what they said".[15]

She went on:

Look, so long as you've got all this stuff from Aleister Crowley in your liturgies, you're not going to get accepted as being anything connected with white magic, because his reputation is such ... that people are just not going to accept this and take it seriously so long as they think you're an offshoot of Crowley's O.T.O.[16]

Gerald seemed to accept the criticism. As Doreen said:

What he said, in effect, was 'if you think you can do better, get on with it', and that's just what I tried to do. I did the best I could with what I had available, and no one has been more surprised than myself to see the influence that the Charge has had.[17]

So, Doreen rewrote the Charge of the Goddess, incorporating most of the Leland material, and she even left in one or two lines of Crowley's, but she added substantial parts herself to create what has become the best known and most loved piece of ritual writing for present-day witches throughout the world. I therefore make no apology for quoting it in full:

The High Priest says: *'Listen to the words of the Great Mother; she who of old was also called among men*

[14] *FireHeart* No. 6 - Doreen Valiente (www.earthspirit.com/fireheart/fhdv2.html)

[15] Janet and Stewart Farrar *Eight Sabbats for Witches* (Hale 1981) p 42 footnote 8

[16] *FireHeart* op. cit.

[17] ibid.

Artemis, Astarte, Athene, Dione, Melusine, Aphrodite, Cerridwen, Dana, Arianrhod, Isis, Bride, and by many other names'.

The High Priestess says: 'Whenever ye have need of any thing, once in the month, and better it be when the moon is full, then shall ye assemble in some secret place and adore the spirit of me, who am Queen of all witches. There shall ye assemble, ye who are fain to learn all sorcery, yet have not won its deepest secrets; to these will I teach things that are yet unknown. And ye shall be free from slavery; and as a sign that ye be really free, ye shall be naked in your rites; and ye shall dance, sing, feast, make music and love, all in my praise. For mine is the ecstasy of the spirit, and mine also is joy on earth; for my law is love unto all beings. Keep pure your highest ideal; strive ever towards it; let naught stop you or turn you aside. For mine is the secret door which opens upon the Land of Youth, and mine is the cup of the wine of life, and the Cauldron of Cerridwen, which is the Holy Grail of immortality. I am the gracious Goddess, who gives the gift of joy unto the heart of man. Upon earth, I give the knowledge of the spirit eternal; and beyond death, I give peace, and freedom, and reunion with those who have gone before. Nor do I demand sacrifice; for behold, I am the Mother of all living, and my love is poured out upon the earth'.

The High Priest says: 'Hear ye the words of the Star Goddess; she in the dust of whose feet are the hosts of heaven, and whose body encircles the universe'.

The High Priestess says: 'I who am the beauty of the green earth, and the white Moon among the stars, and the mystery of the waters, and the desire of the heart of man, call unto thy soul. Arise, and come unto me. For I am the soul of nature, who gives life to the universe. From me all things proceed, and unto me all things must return; and before my face, beloved of Gods and of men, let thine innermost divine self be enfolded in the rapture of the infinite. Let my worship be within the heart that rejoiceth;

for behold, all acts of love and pleasure are my rituals. And therefore let there be beauty and strength, power and compassion, honour and humility, mirth and reverence within you. And thou who thinkest to seek for me, know thy seeking and yearning shall avail thee not unless thou knowest the mystery; that if that which thou seekest thou findest not within thee, thou wilt never find it without thee. For behold, I have been with thee from the beginning; and I am that which is attained at the end of desire'.[18]

As Professor Ronald Hutton states:

What Doreen did was to keep the Leland, which she thought more authentic, put in a new framework, and write the "White Moon Charge", which is wholly original in its words, although its basic form, of a universal nature goddess identified with the moon and addressing her devotees, is based on Apuleius's "Metamorphoses", from ancient Rome. Nothing like Doreen's words for the White Moon Charge have been found in any older text, and they gave Wicca a theology as well as its finest piece of liturgy. I think that Doreen's way of composing was to take an idea, a word or even a single phrase (never more) from an older text and then to create a completely new piece of work underneath it. So it was with her half of the Charge.[19]

It seems that initially Doreen wrote the Charge in verse, but most people seemed to prefer the prose version, and that has certainly become the most popular.

In time, Doreen re-wrote the whole of the Book of Shadows, cutting out much of the Crowley material and adding some material of her own. Following Doreen's first attempt at this, Gerald, in turn, copied parts of Doreen's revised book, which then became the volume which scholars know as 'Text D', the first and only one of Gerald's handwritten books, incidentally, to be given the title 'Book of Shadows'.

[18] Janet and Stewart Farrar *Eight Sabbats for Witches* (Hale 1981) pp 42-43

[19] Ronald Hutton *The Origins of The Charge of the Goddess* in *The Charge of the Goddess: The Poetry of Doreen Valiente* (The Doreen Valiente Foundation 2014)

Doreen very quickly became useful to Gerald in many ways, acting almost as his secretary. I think her value to Gerald was that Dafo was increasingly reluctant to remain involved in any Craft activities, and Gerald's first initiate, Barbara Vickers, had also moved "up north" and had a baby in March 1952. So Doreen may have been the only available witch for him to call upon.

In 1953, Gerald had made contact with Gerald Yorke, who worked for the publishers, Rider and Co. and who had offered him a contract for a book, which came out the following year as *Witchcraft Today*.

I suspect that Yorke was not totally convinced by Gerald's story of the surviving coven of witches into which he claimed to have been initiated back in 1939. I think he may well have asked Gerald whether he could meet a witch. Gerald had to agree, and Doreen was the only one available.

Initially, Doreen wrote a letter to Yorke which I suspect was largely dictated by Gardner. The letter is not dated, but it is probably autumn 1953. It runs as follows:

> *Dear Mr. Yorke, My friend Gerald Gardner tells me that you would like to hear from me, and has passed on to me a couple of letters he received from you, about some G.D.* [Golden Dawn] *manuscripts in my possession.* [These are the manuscripts to which I refer in Chapter 4] *We of the Craft are not, as you know, fond of discussion and publicity, and hence I was frankly somewhat reluctant to enter into correspondence. However, it has come to my knowledge that it has been suggested that I am a mythical personage, a mere figment of Gerald's imagination. This, of course, is not so. I, and others known to me, have been followers of the Old Gods for many years though we see no reason to make announcement of the fact to the world at large.*

The story which Gerald tells - rather indiscreetly - of how the manuscripts were obtained is in the main true, though he does not know some of the details. It is not the first time that the Craft has acted to prevent manuscripts and ritual objects from getting into the wrong hands, and I do not expect that it will be the last. The disappearance of the ritual mask commonly known as the Dorset Ooser was another such instance.

It is most kind of you to offer to let me see some of your manuscripts, and I should be pleased to make your acquaintance. However, at the moment I see no likelihood of my coming to London at least in the near future. Perhaps you would care to communicate with me through Gerald. You need waste no time drawing conclusions as to my whereabouts from the postmark on this letter. It has, in accordance with custom, been sent to another friend in the Craft to be posted. Yours sincerely, Ameth.[20]

Doreen was obviously persuaded to meet Yorke in December 1953, probably on the same occasion that she went up to London for the Yule ritual. We have Gerald Yorke's account of the meeting, which was attached to the letter quoted above. It reads:

Letter from Ameth, the female head of one of the only three covens of the old witch cult that survive in England, and still worship the horned god of death, and the moon goddess of fertility. She told me that A.C. [Aleister Crowley] was an initiated member of their Southern Coven - not her own. As a result several extracts from the Book of the Law relating to the worship of Nuit, and of sex, are now included in their ritual. They practise IX [degree] O.T.O., but of course claim that they knew of this prior to A.C. joining them, it being a traditional secret and the main basis of their cult. This is probably correct. Ameth states that A.C. left them because he would not be ruled by women. This is in character. Ameth in Dec 1953 proved to be a woman in her early thirties and physically well

[20] Warburg Institute, Yorke Collection *Scrapbook EE2*

endowed. She is in 'the Craft' because brought up in [it] by
her parents. She has therefore not been baptised. Her
husband however is not in the craft himself.[21]

There are obviously several blatant untruths in this statement, and
it seems clear that Doreen was primed by Gardner as to exactly
what to say. That she was prepared to do this is perhaps an indi-
cation of the influence that Gardner had over her, an influence
that, in time, wore off.

During the summer of 1954, Gerald was busy during the tourist
season at his museum on the Isle of Man and he seemed to be re-
lying on Doreen more and more for a variety of duties and there
was certainly one occasion when Gerald used Doreen to "sound
out" a possible contact, one which didn't end very well.

In August 1954, Gerald wanted the magical services of Austin
Osman Spare, a magical artist living in Brixton, south London,
who had strong psychic abilities and who had developed a deep
interest in the occult. He sent Doreen up to visit Spare. She told
Spare that her name was Diana Walden, witch name Ameth, and
that she was the head of the witch cult in Britain. Exactly what
Gerald had told Doreen and exactly what she herself believed is
difficult to say. Perhaps by then she felt that she was indeed head
of the witch cult.

Spare recount's Doreen's visit in a letter to Kenneth and Steffi
Grant dated 25th August 1954:

> *Dr. Gardner of the Isle of Man sent along his deputy, a*
> *myopic stalky nymph ... with two magicial [sic] Knives that*
> *she insisted on showing me! Harmless & a little tiresome ...*
> *what she was **really** interested in I don't think she herself*
> *knew. She believed the 'Witches' Sabbath was a sort of Folk*
> *dance of pretty young things ... I agreed that a Maypole*
> *may have symbolism.*[22]

[21] ibid.

[22] Kenneth and Steffi Grant *Zos Speaks!* (Fulgur 1998) p 86

Elsewhere Spare refers to Doreen as 'the lanky one'. What he leaves out of his account of the meeting is hinted at by Doreen in the synopsis of her autobiography which was to have been called "Have Broomstick, Will Travel". Her note simply reads: "How I met Austin Osman Spare - and he threatened to kill me!" What the story behind this is, I really don't know. I suspect that any threat on Spare's part was not intended to be serious, but Doreen certainly took it seriously!

Anyway, Gerald Gardner subsequently met Spare and obtained a talisman from him.

—————————————————————

Perhaps one of the most valuable ways in which Doreen was able to help Gardner was connected with a practice which she had carried out since before she had met him: she kept a scrapbook.

From as early as 1951 for most of the rest of her life, Doreen kept press cuttings on subjects that interested her: witchcraft, of course, but also black magic, folklore, superstitions, naturism, sexual liberation, UFOs, ancient sites and civilisations, psychic phenomena, strange abilities, and so on. The cuttings were from a variety of different newspapers and magazines, and I suspect that she must have asked her neighbours to save copies for her to go through. They are a rich source of information for future chroniclers of Doreen's life and interests.

Immediately Gerald's first non-fiction book on witchcraft, *Witchcraft Today*, had been published, he was keen to write another one. He had always had help in getting his books into a form suitable for publication, sometimes considerably more than that, and the new book was no exception. It is quite clear, on reading the book that the individual helping him on this occasion was Doreen, who writes:

For some time Gerald and I had been collaborating on a new book to follow Witchcraft Today. We proposed to call it The Meaning of Witchcraft. The book did eventually appear under that title, in 1959. I suggested to Gerald that we should incorporate in the new book a detailed analysis and debunking of all this newspaper sensationalism, showing how flimsy and lacking in real evidence it was. He agreed to this, and throughout 1956 I worked hard investigating and writing. I like to think that this book opened people's eyes about reporters' methods of cooking up a good story out of very scant ingredients - and also of the way in which anything which did not fit in with the story was suppressed. But, alas, by the time the book appeared, Gerald and I had ceased working together.[23]

This almost suggests that the book was intended to have a joint authorship. Indeed, I am reasonably sure that Doreen wrote the three chapters entitled "Some Allegations Examined" and parts of at least two others. I have not carried out any formal literary analysis, but the style of writing and the ideas expressed in those chapters are very similar to her later writing. I am fairly certain, for example, that the clear and concise summary of Aleister Crowley's life and work which appears on pages 101 to 103 is by Doreen.

Certainly Doreen mentions, in a letter to Janet and Stewart Farrar, that she had been to Colindale (the Newspaper Library section of the British Library) to carry out some research for Gerald, adding that the staff there were most helpful.[24]

The three chapters entitled "Some Allegations Examined" seem to have been written by Doreen some time in late 1956 or early 1957 as a single report to Gardner, who seems to have incorporated it into the book relatively unchanged, though subdividing it into three chapters for reasons of length.

[23] *The Rebirth of Witchcraft* pp 68-69

[24] letter Doreen Valiente to Janet and Stewart Farrar 7 May 1981

Doreen's report focused on certain of the hostile press reports which appeared in daily and Sunday newspapers from 1951 to 1956. Early newspaper articles in the 1951-1955 period tended to confuse witchcraft with black magic and voodoo. The first chapter successfully demonstrated that there were very few facts behind reporters' allegations and that their accusations had no basis. In response to the *Sunday Pictorial's* June 1955 articles, Doreen submitted a reply on Gerald's behalf to the paper, but they refused to print it. It subsequently appeared in *Psychic News* on 23rd July 1955 under the title "Witchcraft in Britain" and it is reproduced in *The Meaning of Witchcraft*. This is Doreen's earliest published piece of writing that I have so far found.

The last chapter in the book is entitled "The Future". The style of writing and the topics it focuses on suggest to me quite strongly that part of it is by Doreen. For one thing, it goes on at great length about the so-called Aquarian Age, which was one of Doreen's favourite themes. It is certainly more hopeful than Gerald was when he wrote *Witchcraft Today*, where he was writing about saying "goodbye to the witch".[25] The view expressed, and I am pretty sure it was written by Doreen, is that the "craft of the Wica" can make a contribution because it is part of the coming Age of Aquarius.

The latest newspaper report referred to is dated 1956. Yet *The Meaning of Witchcraft* was not published until 1959. It is almost as if the manuscript was shelved at the beginning of 1957. This fits in with what we know about what was happening in the coven: a storm was about to blow up.

[25] op. cit. p 129

Chapter 7
A Ripe Seed-Pod

In 1956, Doreen and Casimiro moved to Brighton, a town which was to be her home for the rest of her life.

Brighton is situated in the county of Sussex, on the south coast of England. It is only an hour by train from London and it has long been one of the most popular seaside resorts in the country. It was a favourite of the Prince Regent in the early 19th Century and has since attracted residents of all kinds, some remarkably eccentric, over many years. At the time of writing it sends the country's only Green Party member to Parliament.

What the impetus for Doreen and Casimiro moving to Brighton was, I do not know, but it was probably his work. The couple, together with Doreen's mother, moved to the Basement Flat at 20 Lewes Crescent, a grand early Victorian terrace overlooking gardens on the sea front about a mile east of the town centre. They moved on 29th March 1956 (I never have to look that date up - it was my 10th birthday!), and the same day, Casimiro took up employment as a cook at the White Horse Hotel, Rottingdean, a village about three miles east of their new home. It seems clear

that the job had been lined up before the move. Doreen, however, would not have been averse to living in Brighton, as we shall see in the next chapter.

45. 20 Lewes Crescent, Brighton

Brighton was, however, little nearer to the coven meetings than was Bournemouth, but Doreen attended rituals as and when she could. It is difficult to be certain of the coven membership during the 1955-early 1956 period. Apart from Gerald and Doreen, we know that Barbara Vickers had left, certainly by 1953. The coven meetings were held either at Gerald's flat in Holland Road or in the Witches' Cottage at Bricket Wood. Doreen says that most of the coven members were also members of the Five Acres naturist club where the cottage was situated, and several names have been suggested as coven members.

First of these was Ned Grove. He was born in 1891, so was considerably older than Doreen and, indeed, the rest of the coven except Gerald. He was well-to-do, owning land in County Tipperary in Ireland. He lived in London quite a lot of the time, however, and was a director of a bank.

James Laver (1899-1975) was Keeper of Prints and Drawings at the Victoria and Albert Museum, and was also a naturist. He wrote the Foreword to the biography *Gerald Gardner Witch*.[1]

[1] op. cit. p 6

Derek Boothby (b. 1909) was also a coven member, as was a re-tired Army officer and his wife. Almost certainly, there were also other members.

How often the coven met is unclear. Gerald Yorke, in July 1955, wrote "... Gardner's new London coven hardly ever meets now, so I have no gossip about it".[2]

The adverse publicity to which I referred in the previous chapter did, however, result in some interest from those who could see past the emotive language to the essence of what Gerald Gardner was trying to do. Two individuals who took things further and read *Witchcraft Today* were Jack Bracelin, a 28-year old paint sales representative, and his girlfriend, whom I shall call 'Dayonis'. They contacted Gardner, who took to them immediately and, very soon after, offered them initiation.

One would imagine that Doreen, as Gerald's "deputy", would, at the very least, have been consulted over such potential initiations and be invited to meet the candidates, if not play a central role in the initiation ritual. Apparently none of this happened and Ger-ald, whether deliberately or by accident, chose the very same weekend to hold the ritual that Doreen was moving to Brighton.

It was almost as if Gerald didn't want Doreen's involvement be-cause he knew she wouldn't approve. But he needed a priestess to carry out the ritual and so, I think rather against her better judge-ment, he persuaded Barbara Vickers to come out of "retirement" and perform that role. Doreen, of course, was not very pleased and, as Gerald suspected, she did not approve of Jack Bracelin and his girlfriend, "... than whom a more squalid pair of spivs it would be hard to find indeed."[3]

I think Doreen's opinions about Jack Bracelin and his girlfriend were at least partly influenced by the fact that Gerald, in her view,

[2] letter from Gerald Yorke to Cecil Williamson 1 July 1955

[3] letter from Doreen Valiente to Dafo 17 July 1958

had "foisted" the couple onto the coven without even prior con-sultation. It is, however, fair to say that her views on the couple were not shared by others who joined the coven later. Lois Bourne writes that Jack Bracelin "... appeared to have a degree of sup-pressed nervous energy. I felt he would be a good judge of character; he spoke in a very direct manner and gave the impres-sion of honesty and integrity"[4]. She described 'Dayonis' as being "... warm and friendly, articulate and self-possessed, and there was a charismatic quality to her presence".[5]

'Dayonis' told me about the very occasional times when Doreen attended coven meetings. She and Jack always referred to her by her magical name, Ameth, and 'Dayonis' was in the habit of call-ing Doreen behind her back "she who must be obeyed"! When Doreen did make one of her rare visits, 'Dayonis' remembers that they "pulled out all the stops to make it nice for her". She likened it to "the Goddess come to earth"!

Doreen made quite sure that Gerald knew how she felt about bringing new members into the coven. Indeed, when Frederic La-mond expressed an interest in the Craft in June 1956, Gerald made it quite clear to him that he would have to discuss matters with the coven before issuing an invitation, as he was "... already under pressure from the coven not to invite people on his own ini-tiative"[6].

Lamond hints at another reason why Doreen had been attending coven meetings less frequently:

> Since meetings could last until fairly late members without cars or with long distances to cover slept in a hut neighbouring the witches' cottage. Gerald liked to cuddle up with whoever had been his high priestess: he was too old to engage in penetrative sex but would have enjoyed affectionate caresses.

[4] Lois Bourne *Dancing with Witches* (Hale 1998) p 20

[5] ibid.

[6] Frederic Lamond email to the author 17 April 2008

Doreen found this very embarrassing. Temperamentally monogamous she was also married to a very jealous Spanish husband who did not belong to the Craft. She obviously didn't inform him of the details of what happened at coven meetings - her oath of secrecy would have forbidden this anyway - but she must have imagined that any knowledge of cuddles with Gerald would have endangered her marriage. So she frequently stayed away from coven meetings: she was not present at my initiation and it was the Maid Dayonis who initiated me.[7]

So, there was a certain amount of resentment on Doreen's part about the new members of the coven. The other members were probably more concerned about Gerald's keenness for publicity. There was obviously some discussion between Doreen, Ned and Derek about their dissatisfaction with the coven, and at some point a decision was made not to attend any more coven meetings, the last one they went to being at the February 1957 Full Moon.

It is likely that Doreen, Ned and Derek held their own rituals and, indeed, considered themselves still part of the Craft and felt a responsibility for it as a whole. They wanted to do what they could to limit what they saw as Gerald's harmful publicity-seeking and initiation of those whom they considered unsuitable. They tackled Gerald, pointing out that his publicity-seeking was, as Doreen put it, "adding fuel to the fire of the national press witch-hunt". Gerald said that he would behave, but before long an article appeared in the popular illustrated magazine, *Weekend*, in its June 24-30, 1957 issue.

The article was to my mind a reasonably positive view of witchcraft. Gerald relates the story of how the witches worked a ritual to stop a blackmailer and another to secure the purchase of Gerald's house in the Isle of Man. It also has an interesting story about the witches performing a healing ritual.

7 Frederic Lamond *Fifty Years of Wicca* (Green Magic 2004) pp 10-11

Doreen was not pleased with this article, however. She wrote that Gerald had "prattled away" to "a particularly silly popular magazine" and complained that he had "posed for a ludicrous picture which showed him sitting cross-legged in the magic circle and pointing a magic sword at what the caption called a 'weird image' of a bat-winged demon!" She tackled Gerald about it, who claimed that the interviewers had been sent up to see him in the Isle of Man by his publishers, Riders. Doreen was sceptical about this and went to see Riders' manager, who confirmed that they had done nothing of the sort. She relayed that information to Gerald and received, in her words, "an incoherent and rather abusive letter which was notable only for its absence of straight answers about anything".[8]

Doreen and Ned felt strongly that they had all been sworn to secrecy when they were initiated and yet here was Gerald apparently breaking that oath with abandon! This spurred them into action. They felt responsible for the survival of the Craft as they knew it, and, together, they drew up some 'Proposed Rules of the Craft'. This had been drafted by Ned, but with undoubted contributions from Doreen.

There were, as befits a witchcraft document, thirteen rules. They were to apply, not just to members of the Craft (the ordinary coven members) but also to the elders. I'm not quite sure who is included here, but it is clearly intended to include Gerald himself, as well as Doreen and Ned. As the document is fairly long, I shall quote extracts from it, as follows:

> *Rule 1 - No member of the Craft will initiate any person unless that person has been interviewed by at least two Elders and accepted as suitable.* [This was obviously intended to prevent Gerald from initiating individuals without even telling the rest of the coven.]

> *Rule 4 - As it is essential for the successful working of a ritual by a group that there should be unity of purpose and*

[8] *The Rebirth of Witchcraft* p 71

an harmonious psychic atmosphere, members who create dissention and discord within the Craft will be asked to resign. [This suggests that there had been some disagreements which had spilled over into their rituals, with predictable undesirable consequences.]

Rule 10 - Members will endeavour to acquaint themselves with the traditions of the Craft, and will not introduce innovations into the workings without the Elders' approval. Nor will the Elders give approval to any important innovation without first asking the approval of the rest of the Craft. [This seems to have been in response to innovations agreed between Gerald and the younger members of the coven, following the split, such as the introduction of eight sabbats.]

Rule 13 - It will be understood by all members that these rules are equally binding upon all Grades of the Craft, including the Elders, and that serious and/or persistent breach of these rules will be grounds for expulsion. [This made it quite clear that the rules applied as much to Gerald as to any other member.]

The full "Proposed Rules" can be seen in my book *Witchfather*.[9]

Having agreed them with Ned and Derek, Doreen typed up the "Proposed Rules" and, in July 1957, sent a letter to past and present coven members enclosing a copy. The most important consultee was, of course, Gerald himself, and they sent the document off to him in the Isle of Man.

After a few weeks Gerald replied, saying that there was no need for such a document since the Laws of the Craft already existed. His letter was accompanied by a document known as The Old Laws. These were typed but used archaic language and word forms, such as 'Alther' and 'loveth'.

Doreen's immediate thought was that these had been concocted by Gerald in response to their "Proposed Rules of the Craft". Her

9 Philip Heselton *Witchfather Vol 2* (Thoth 2012) pp 514-515

scepticism increased when she read one of the 'Laws' on the first page, which read: "And the greatest virtue of a High Priestess is that she recognises that youth is necessary to the representative of the Goddess, so that she will retire gracefully in favour of a younger woman, should the Coven so decide in Council."

It struck Doreen that this whole exercise was just a way in which Gerald could get rid of her. She tells of her own reactions to seeing the 'Laws':

We were apparently supposed to be overawed. Our actual reaction was to be extremely sceptical. None of us had ever set eyes on these alleged 'Laws' before, though we noticed that they incorporated a preliminary passage from the 'Book of Shadows' commencing: 'Keep a book in your own hand of write ...' (This passage is reproduced in Gerald's book Witchcraft Today.) If these 'Laws' were so ancient and authoritative, why had Gerald never given them to us before? We discussed these matters, realizing that the question had become, by Gerald's own actions, one of confidence in him and the more we examined the alleged 'Laws', the less confidence we had in either him or them.[10]

Ned wrote back to Gerald, saying that he and Doreen were of the opinion that Gerald had made 'the Laws' up for his own purposes. According to Doreen, there then followed a heated exchange of letters between Gerald and Ned. After that, there was no further communication between Doreen and Gerald for over two years.

I don't know the extent to which Doreen, Ned and Derek formed their own coven and carried out rituals of their own. There is a hint in a letter which Doreen sent to Dafo in July 1958, a year after the split, where she writes:

[10] *The Rebirth of Witchcraft* p 70

... we now have a good meeting-place which we are very busy getting into the shape we want it; a matter I am very pleased about, though it will mean a lot of hard work.[11]

Two months later, in September 1958, Doreen notes:

Circular to be sent out now. Note: it is hoped to have the hut finished by Halloween. Will members make a note of the date (Oct 31st) as we have to have a meeting.[12]

I cannot be certain, but I think it probable that the meeting-place referred to was owned by Derek Boothby near the village of Sarratt in Hertfordshire, only six miles from Bricket Wood. He had built, or adapted, a wooden hut, which he called "The Spinney". It was on land which he had acquired, a depression in the ground which seems to have been an old quarry or pit which had been completely overgrown with trees. The hut was in the middle of this woodland, and he had somehow made it suitable for living in as well as a venue for rituals.

The fact that things seemed to be proceeding at a leisurely pace with the new coven was, I think, at least in part due to Doreen's illness. I do not know what was wrong with her, and whether it had been brought on in any way by the tensions resulting from the split in the coven, but she does say that her health broke down after breaking with Gerald. She was certainly in hospital for some time, and says that she experienced dying and coming back. This would probably have confirmed her existing views about life, death and the otherworld.

It seems as if any coven which Doreen, Ned and Derek were to form was never very successful. As evidence of this we have a letter from Dayonis to Gerald Gardner written in June 1959, two years after the original split:

[11] letter from Doreen Valiente to Dafo 17 July 1958

[12] Doreen Valiente *notebook no. 2* 22 September 1958

Some really fantastic news to tell you. Some weeks ago Jack had a letter from Boothby!!!!!!! Saying that he thought it was about time that the fighting was over and contact was re-established. Well you can imagine how astounded we were, coming from him. So, in order to find out how all the other folks were doing and what they were at, we went over to meet him. And, Oh Boy! did we hear tell a tale of rows and fights. It was incredible. Firstly, Derek and Ameth rowed and decided not to talk to one another. And then Derek and Ned ... rowed and decided not to talk to each other and so the only other two people we saw were C... and J... - who were so fed up with the whole business that they were thinking of chucking the whole thing up. Derek, of course, suggested, well nearly so, that we join forces again, but we had been bitten once before and did not make any comment. But he had a good suggestion to make that both covens (he said about four of his people would come) gather together at the Rollright Stones for Midsummer Eve. So we did. But of Derek's 'coven' only Derek was there, and, of course, that I am sure is the sum total of his 'coven'.[13]

'Dayonis' commented further:

... it was very interesting to find out what they had been up to and very gratifying to find out that although Ameth had once said she would pick up the pieces of our coven when it disintegrated, it is we who are asked to pick up the pieces of theirs. The Goddess works in odd ways sometimes but she certainly knows what she is doing as far as we are concerned.[14]

Indeed, looking back on the whole affair over 30 years later, Doreen remarked on a more positive note:

... it was really the events when the old coven run by Gerald Gardner and myself split open like a ripe seed-pod and

[13] letter from Dayonis to Gerald Gardner 28 June 1959 in Toronto collection
[14] ibid.

*many people went their separate ways, which caused the
dispersion of the seeds of many new covens and many new
ideas.*[15]

Doreen was indeed one of those who went her own way, as we
shall see.

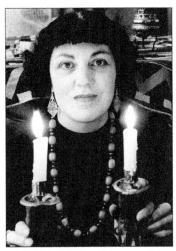

46. Doreen

[15] *The Rebirth of Witchcraft* op. cit. p 80

Chapter 8
Sussex: the county where witchcraft lives!

After Doreen moved to Brighton, it was not long before she found her way to the magnificent library in the centre of the town. She was in the middle of her research for Gerald Gardner on press allegations and made good use of the newspaper records which the library held.

But it was only after the split with Gerald's coven and her subsequent serious illness that Doreen began to use the library to research a new topic: witchcraft in the county of Sussex. She had been using the library in Bournemouth for more than ten years to research occultism in general, so had become quite familiar with the sources of information available. (And it should be noted in passing that in these days of the internet we often forget how much more limited those sources were in Doreen's day.)

As she quickly found out, Sussex was a county rich in witchcraft references. Indeed, it is traditionally supposed to have been the county where a dominant paganism survived for longest before being ousted by Christianity, as the title of Ralph Harvey's book *The Last Bastion*[1] dramatically states.

[1] Ralph Harvey *The Last Bastion* (Zambezi 2005)

Doreen very quickly started "delving into the lore of old Sussex", to use her phrase. As an integral part of her researches, she started to keep a notebook where she wrote down references, copied extracts from relevant books and journals, and jotted down her own ideas and speculations. The earliest notebook we have has an entry in October 1957, so subsequent to her split with Gerald's coven. She kept notebooks for the following thirty years, 75 in total, covering not just the results of library research but 'gossip' on members of the Craft and their associates, early drafts of poems and rituals, but also shopping lists, Christmas card lists and much more besides. Short original essays by Doreen on a variety of topics also make an appearance. They have been a valuable resource for me in writing this biography.

It is quite clear, however, that witchcraft in Sussex was the main focus of her research, including information on local witch trials and individuals who were identified by local folklore to be witches.

Doreen was particularly interested in places in Sussex associated with witchcraft and she accumulated a lot of material about them. These included churches with pagan carvings or built on ancient pagan sites, stones in the landscape which had acquired folklore about them, and other obvious ancient features, such as Chanctonbury Ring and the Long Man of Wilmington. Natural features, such as the rock outcrop, Big-on-Little, at West Hoathly, which had magical associations, folk traditions such as the Ebernoe Horn Fair and tales of witches turning into hares, which Doreen linked to the Moon Goddess, were all included in her notebooks.

She soon tracked down the most useful sources of information with the "courteous and untiring assistance" of the Reference Library staff. She seems to have started with the Collections of the Sussex Archaeological Society and continued with witchcraft references in historical editions of local and national newspapers. She had the ability to extract relevant information from a variety

of books, not just about Sussex but also on general esoteric subjects. Doreen also soon discovered the Barbican House Museum in the nearby East Sussex county town of Lewes, which had a wealth of local references.

And she was not content just to carry out research in libraries and archives: Doreen needed to go out and look at places for herself. As she had no car, this was something which could only be done by public transport. So she accumulated railway and bus timetables. In some cases she had to go right up to London before boarding a Green Line bus that would take her to such places as East Grinstead and Crawley in Sussex.

Whether Doreen had it in mind right from the start to write a book about Sussex witchcraft I do not know. But at some stage Doreen started to bring together her notes, ordering them into chapters and starting to write the book which would become *Where Witchcraft Lives*. At what stage she approached a publisher, I don't know.The first mention of a possible book is not until July 1960, when she lists various publishers to contact. For some reason, the firm that eventually did publish her book is not on that list.[2]

Anyway, at some stage Doreen remembered the book on which she had cooperated with Gerald Gardner. *The Meaning of Witchcraft*[3] had been published by Aquarian Press, an esoteric publishing house which had been founded in the early 1950s, issuing books by such authors as Ursula Roberts, Dion Fortune and W.E. Butler. Doreen wrote to Aquarian's Editor, Francis Clive-Ross, with a proposal for a book to be entitled *Where Witchcraft Lives*, which he accepted. In many ways this was surprising. Even when I first read it, I wondered why a book about witchcraft in a single county would promise sufficient sales for a publisher to be interested. However, I thought, it was a small book and it did hold

[2] Doreen Valiente *notebook no. 12* 12 July 1960
[3] G B Gardner *The Meaning of Witchcraft* (Aquarian 1959)

out the hopes that other counties, including my own, could be looked at in a similar way. As John Belham-Payne says:

> ... *having read the first couple of chapters I realised that the book was more about the research of an area rather than Sussex itself.*[4]

The book[5] falls naturally into four main categories of material: folklore and traditions of witchcraft in specific places in the county; accounts of witch trials; evidence for black magic; and accounts of present-day witchcraft.

The very first words of the book encapsulate for me its significance:

> *One beautiful summer's day my husband and I went out into the Sussex countryside, to a place called Rocky Clump, near Stanmer. This place, a cluster of trees on a hill, is the site of a former pagan temple. Local archaeologists discovered there a number of burials, and a huge stone which they think may have been an altar-stone. We spent a summer afternoon there, seated among the trees. The nearest other human beings were men working in the fields down in the valley, some distance away. Yet several times, close at hand and seemingly out of the air, we both heard strange chords of music, rather like that of a harp. We were unable to find any material explanation for it. The date was the anniversary of one of the festivals of the pagan Old Religion, Midsummer Day, June 24th.*[6]

We have here an experience of the 'otherworld' but one which is located at a specific time and place, both of which have been recognised from ancient times as being significant, numinous, special. In an important sense, *Where Witchcraft Lives* is about just such a relationship, one which was later to be called "earth mysteries".

[4] Doreen Valiente *Where Witchcraft Lives* Second Edition (Whyte Tracks 2010) Introduction p viii

[5] Doreen Valiente *Where Witchcraft Lives* (Aquarian 1962)

[6] op. cit. p ix

In Doreen's accounts of witchcraft in Sussex there is an implicit acceptance of the idea that there was a continuous history of a hidden Craft through from ancient times to the present day, following the ideas, now largely discredited, put forward by Margaret Murray, that those accused during the witch trials had actually been adherents of an Old Religion.

Nevertheless, one of the first and most thorough investigations which Doreen carried out was into historic witch trials in Sussex. She found that fifteen people had been indicted for witchcraft in that county between 1558 and 1736, only four of whom were convicted and only one sentenced to death. This work impressed Professor Ronald Hutton, who writes that the book:

> ... remains, until this date, the only one produced by a prominent modern witch that embodies actual original research into the records of the trials of people accused of the crime of witchcraft during the early modern period ... Doreen made the breakthrough of looking at the actual records (at least in publication), and therefore was in a position to be able to write genuine history herself ...[7]

One individual who had a considerable influence on Doreen during this period, and, indirectly, on her book, was Leslie Roberts, whom she describes as "a full-time impartial investigator of witchcraft and black magic". Doreen met him in about 1957 or 1958:

> At the time when I first met him, Leslie was living in a tiny flat in Burlington Street, Brighton. He was trying to form a collection of objects and books related to witchcraft and the occult. Brighton at that time was full of little shops devoted to bric-à-brac, curios and junk, and I was able to guide Leslie in what to look for ... When he found that I knew quite a bit about the world of the occult, Leslie enlisted me to help him in his investigations. I was able to persuade him of the difference between the Old Religion of witchcraft and the practices of black magic ...[8]

7 Ronald Hutton Foreword to *Where Witchcraft Lives* Second Edition p xvi

8 *The Rebirth of Witchcraft* p 138

Leslie accompanied Doreen on visits into the Sussex countryside to investigate sites of interest for the book. He could, however, be indiscreet and Doreen sometimes had regrets about what she had told him. There was, for example, one occasion when he spoke to a public meeting at the Adelphi Hotel, Brighton, during which he claimed that a human baby had been sacrificed on a black magic altar in a recent ceremony at Rottingdean. A subsequent police investigation found no evidence at all for this, but the police retained for some months witchcraft artefacts of Doreen's that Leslie had on display.

Doreen had, however, been convinced that black magic existed, following the research which she had carried out in the 1955-1956 period for Gerald Gardner, which was subsequently published in his book *The Meaning of Witchcraft*.[9] As a result of this, of her work with Leslie Roberts and her continuing study of modern newspaper reports, Doreen included a chapter on the subject of black magic in *Where Witchcraft Lives*, which is odd in that she was always quite clear that there was no connection between the two.

Professor Ronald Hutton comments on this:

> *The book also displays ... her unusual credulity in believing press reports. ... she depended rather heavily on them for some of her wider impressions of contemporary magic in Britain, with the occasional gossip heard from individuals whom she met. As a result, she felt able to declare in the book that the existence of a sinister and dangerous 'black' magic among the modern British could be denied only by the ignorant and the guilty: a belief which, though apparently based on no first-hand experience, might have been expected to have a significant impact on readers. Other prominent witches of the period displayed a much more sceptical public attitude towards such rumours and newspaper claims.[10]*

[9] op. cit.

[10] op. cit. p xvi

When I first read *Where Witchcraft Lives*, probably not long after it was published in 1962, the passages that struck me most vividly and which were of most interest to me were those contained in the chapter entitled 'Present-day Witchcraft'. These were accounts of rituals in Sussex, the first of which Doreen starts thus: "I have been given an eye-witness account of how a party of people climbed a height of the Sussex Downs one night at the full moon, to contact the ancient powers." [11]

Even when I first read it, I suspected that the author was giving a first-hand account, but for some reason wanted to distance herself from it: the description was just too vivid. Now I know that my suspicions were right. John Belham-Payne explains why Doreen presented herself as an observer rather than as a participant:

> *It is worth noting that Doreen referred to herself as a 'student' in this book even though at this point she was already initiated. The reason she gave to me when I asked her about this was that she did this out of respect for her aging mother who was still alive at this time and a very strict Christian; she did not want to offend her or have her mother face ridicule at the church where she attended.* [12]

Doreen describes three rituals, one up on the Downs, one in a house in an historic Sussex town, and one on the seashore. They really do give a feeling of being there. The following are extracts from Doreen's account of the ritual on the Downs:

> *Their purpose was partly to carry on a tradition, and partly to feel, if only for a moment, that kinship with the forces of life which is the deep root of primitive religion. ... It was a fine night of bright moonlight, with a strong wind, and a few flying clouds passing across the moon. My informant described the climb up the hill, and how they reached the summit already in a state of suppressed excitement. They*

[11] op. cit. p 86

[12] John Belham-Payne Introduction to *Where Witchcraft Lives* Second Edition pp viii-ix

lit their fire, choosing a slight dip in the ground so that it would not be visible to any watching eye in the village below. ... For a few moments all stood in silence. Then the leader gave a peculiar, long-drawn-out call, something like: 'EEE-OOO AAH-VOH-AIEE!' A thrill passed through the little group, and some of them instinctively linked hands. The leader began to recite an invocation. It called upon 'the Old Ones', and the powers of the elements, earth, fire, air and water, to bless 'this time and this place and they who are with us'. ... The old man who had tended the fire drew from under his coat an old-fashioned musical instrument, something like a recorder. He began to play upon it a slow, lilting melody. Then all the rest joined hands and began to dance in time to the music. They circled deosil (i.e. sunwise, turning to the right) about the embers of the fire. ... How long they danced my informant could not say. He told me that his senses were bemused by the moonlight, the wild night wind, and the scent of the fire. He felt that in this remote place he had taken part in a ritual which in its essence was as old as time. ... He believes that taking part in this ritual had a definite psychological effect upon him. He describes it as 'a heightened awareness of the unseen forces behind the visible world of nature'. For some time afterwards he had a number of vivid dreams. Usually these took the form of flying effortlessly through wild, moonlit country.[13]

The description of the seashore ritual was equally evocative for me:

This ritual was performed on the night of a midsummer full moon, by the seashore. The spot chosen was a lonely one, where the participants were unlikely to be disturbed. Those taking part included the old man who had played the recorder for the Esbat dance on the hilltop, and a young woman who was to dance to his music. Her dance would invoke the Moon-goddess who rules the sea to permit the spirits of the sea to manifest. Another man was to act as seer. ... The girl began a graceful, slow dance, deosil about

[13] *Where Witchcraft Lives* pp 86-89

the circle. The others stood in silence, watching the breaking waves. ... Her barefoot dance, with now and then her arms upraised to the moon, in those surroundings was remarkably effective. A sense of timelessness seemed to come over the little group. The music, the rhythmic movements of the dancer as she circled them, the sound of the waves, were having a hypnotic effect. ... The seer declared in a low voice that he could see a moving procession of shadowy forms passing over the tops of the waves. ... For some time they watched the play of the elemental spirits. Then clouds began to pass across the moon, and the incoming tide crept nearer. The forms became more indistinct to those who could see them. It was time to bring the ritual to a close. ... As the little party took its way from the beach, the sea covered the sigil upon the sand, the circle and the footprints. I was told that such ceremonies are not performed out of idle curiosity, but for a definite purpose. This purpose is to bring humans back into a living kinship with nature.[14]

Who were the others who were with Doreen during those rituals? They could have been Ned Grove, Derek Boothby and other members of the "breakaway" coven, but somehow I don't think so. My guess is that Doreen through the various contacts which she made on moving to Brighton in 1956 had got to know, and be trusted by, a coven of witches which had developed independently of Gardner, of which there were said to be several in the county of Sussex.

In the cover notes accompanying Doreen's book, *An ABC of Witchcraft Past and Present*, published in 1973,[15] there is a sentence referring to Doreen, which reads "She has been initiated into four different branches of the witch cult that flourishes in Britain today". We already know about Gerald Gardner's coven, and I shall be mentioning later in this book the Coven of Atho and Robert Cochrane's Clan of Tubal Cain, but what of the fourth?

[14] op. cit. pp 92-94
[15] Doreen Valiente *An ABC of Witchcraft Past and Present* (Hale 1973)

Were the reports of rituals which Doreen gave in *Where Witchcraft Lives* accounts of a genuine independent group into which she had been initiated? If so, it may well have been extremely secret as she never specifically refers to it in her writings, although others, such as John Matthews[16] and Ralph Harvey[17] have done so. This may well prove to be a fruitful line of research, although at present it is firmly shrouded in mystery. I suspect that there may have been several groups which had revived a form of witchcraft at the same time, but independently of, Gardner, or perhaps even earlier.

I think in the description of these rituals, Doreen came closest to what she really wanted out of her relationship with the land. Towards the end of her life, she rejected the elaborate intellectual magical systems and traditions into which she had been initiated and came back to the simple "communing with the Old Ones". This, for me, is why *Where Witchcraft Lives* is important.

A small book, long out of print until its re-issue by the Centre for Pagan Studies in 2010, *Where Witchcraft Lives* is important, not only as the first published book by someone whom Professor Ronald Hutton calls "the greatest single female figure in the modern British history of witchcraft", but also because it was the first time that the religion publicised by Gerald Gardner had been linked so firmly to the land from which it grew.

[16] John Matthews *Breaking the Circle* in *Voices from the Circle* ed. Prudence Jones and Caitlin Matthews (Aquarian 1990) pp 127-136

[17] *The Last Bastion*

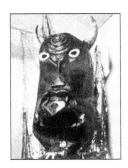

Chapter 9
The Psychologist and the Ancient Head

The affair of Charles Cardell and the Coven of Atho illustrates very clearly Doreen's approach to new ideas, an approach which was to be repeated several times during her life.

The process usually goes something like this: Doreen hears about some new idea, philosophy or subject matter and is immediately attracted to it. She proceeds to dig below the surface, investigating in ways about which the protagonists might not be too happy. Nevertheless she becomes fully involved in activities until at a time of her own choosing, she decides to break with the people involved, concluding that they have strayed from the original intentions.

In July 1958, an article appeared in the journal, *Light*, entitled "The Craft of the Wiccens". Its authors were Charles and Mary Cardell. In it, they described what they claimed to be an old witchcraft tradition. Alongside the article was a full-page advertisement asking for genuine witches to get in touch with Cardell. Doreen wrote back and, in reply, Cardell invited her to visit him. He was an enigmatic and rather contradictory figure. He claimed to be a

psychologist and had consulting rooms in a superior address in South Kensington. He seemed to specialise in helping those who were said to have been damaged by involvement with witchcraft and the occult. It turned out, however, that he had no formal psychological qualifications whatsoever. His main centre of operations was a house which he called 'Dumbledene' on a 40-acre estate in the Surrey village of Charlwood, not far from Gatwick Airport.

Probably in early July 1958, shortly after the article first appeared, Doreen and Ned both independently met Cardell and had long talks with him. Of her visit, Doreen writes:

> *I was invited to his 'consulting rooms' in Queen's Gate, London. They were quite splendidly appointed as a sort of private temple; but when Cardell showed me a bronze tripod which was obviously nineteenth-century and tried to tell me that it had been dug up from the ruins of Pompeii, I became rather unhappy. When he showed me a bronze statue of Thor and tried to tell me that it was of a Celtic horned god, I couldn't help myself pointing out that Thor was not a Celtic god - and then he became rather unhappy. There were a number of other things like this. And then Cardell crowned the performance by making a ham-fisted and unsuccessful attempt to hypnotize me. Well, I knew a trick worth two of that, and he didn't get anywhere. Now, give old Gerald his due, he never went in for that sort of 'deviousness'; so I was not favourably impressed. However, I kept on friendly terms with Cardell in order to find out what he was up to. And, of course, we eventually learned just how nasty he could be when he was thwarted.*[1]

Doreen subsequently wrote to Dafo about her meeting with Cardell:

> *We are in touch with Cardell, both Ned and myself have had long talks with him, and he asked us to forward to you*

[1] letter from Doreen to Aidan Kelly in *Inventing Witchcraft* (Thoth 2007) p 90

a copy of his "Open Letter to Gerald Brosseau Gardner", which I do herewith. He accompanies it with a letter to yourself, which is rather dramatically expressed and calls for some explanation from us.

Firstly, he says that I will vouch for his integrity. I will vouch for the fact that I have seen him once, and had a long talk with him; further than that, I cannot say. I can only repeat what he told me on that occasion.

It appears that, according to him, his mother was a member of the genuine Craft of the Wiccens (he pronounces this word "Witchens"), and that when she died she left her Athame to him and her bracelet to his sister Mary, together with her traditions. I have seen both the Athame and the Bracelet. They are not the same as ours, but bear sufficient resemblance to them to be worthy of our attention.

His family come from Wales, but he is now living in Surrey, and also has a flat in London. Here he contacted Gerald, and told me that he had proposed to finance the bringing of Gerald's museum to London. However, he became disgusted with Gerald's publicity-seeking and the general behaviour of his followers. ... He therefore broke with them, and wrote to Gerald the "Open Letter" enclosed.

... Now, there is no doubt of Cardell's enthusiasm for the Craft. I have this morning a letter from Ned, who is a shrewd businessman and nobody's fool generally, as well as having a great deal of experience of the occult, in which Ned says he is convinced Cardell is genuine. I am never convinced of anything nor prepared to vouch for anything on the strength of one meeting; however, I personally liked Cardell, and his sister. I will go so far as to say that. I have a completely open mind on the subject.

What the proposal is at the moment is that we get together with Cardell and pool our respective traditions.[2]

[2] letter from Doreen Valiente to Dafo 17 July 1958

Gerald's "followers" referred to in that letter were Jack Bracelin, his girlfriend Dayonis and Frederic Lamond. Dayonis remembers that they were taken into the room where he had his ceremonies. She says: "... it was the deadest room I've ever entered, as dead as a doornail, and it was obvious that nothing of significance had been going on there."[3]

After they had been sitting down for some time, Dayonis remembers that she heard "a terrible humming whining noise" and it was obvious to her that they were being recorded, so they just started speaking nonsense.

Frederic Lamond summed up their conclusions: " ... we didn't like the man: he was a creep".[4] He added: "... he didn't inspire us with any confidence, and we weren't going to join a man who had instigated this mess, nor abandon Gerald for whom we all had a great deal of affection for all his faults".[5] Dayonis' conclusion about Cardell was that: "... he was a rogue, and we really didn't trust him as far as we could throw him".

Doreen wrote: "the more both Ned and I saw of Cardell, the less favourably we viewed him".[6] They were particularly sceptical about Cardell's suggestion that they pool their respective traditions. This was clearly what Cardell wanted: the "secrets of the Craft". Whether his own tradition of the 'Wiccens' was genuine or just something he and his acquaintances had made up is probably irrelevant for the current purposes, but in the end he failed to get anything out of either Doreen or Dafo, who send a typically circumspect reply to Cardell, which read in part:

> *I have come to the conclusion that no useful purpose could be served by our meeting either at my home or in London; furthermore, dissention is maintained at such a pitch*

[3] Dayonis - discussion with the author February 2006

[4] Frederic Lamond - discussion with the author July 2006

[5] Frederic Lamond *Fifty Years of Wicca* (Green Magic 2004) p 36

[6] letter Doreen Valiente to Aidan Kelly op. cit.

throughout certain circles that I have no wish to be party to it.[7]

Cardell's claim to be the representative of "The Inner Grove" of the genuine Old Religion did not cut much ice with either Doreen, Ned or Dafo. They were clear that he was just out to get the 'secrets of the Craft' without giving anything himself.

However, as she told Aidan Kelly, Doreen "... kept on friendly terms with Cardell in order to find out what he was up to".[8]

Ashley Mortimer agrees with this, when he writes:

> *As early as 1959 she was digging into his identity, habits, acquaintances and activities and the notebooks reveal her trail of detective work as she follows up leads with reliable public records often reaching dead ends. It becomes clear she didn't trust Cardell from the beginning, her suspicion confirmed after Gerald's death when he published his scurrilous pamphlet[9] purporting to expose Gardner as a fraud ... Doreen was a terrier in her research, once she was onto something she didn't let go and in a time without Google, where researchers trod the streets, wrote letters, visited public records offices and libraries ... Doreen did all of this and she managed to do so via public transport![10]*

In the end, Cardell obtained a copy of Gerald's Book of Shadows by getting a young lady of his acquaintance, Olwen Greene, to get herself initiated by Gerald and obtain a copy of the book that way. When she finally told Gerald that she had been fooling him, Gerald was terribly upset - an event that was instrumental in bringing him back to be on speaking terms with Doreen. They seem to have been reconciled, probably in August 1959. I would imagine that, following his disillusionment with Olwen Greene, Gerald would

7 letter from Dafo to Charles Cardell 26 July 1958

8 op. cit.

9 'Rex Nemorensis' (Charles Cardell) *Witch* (Dumblecott Magick Productions 1964)

10 Ashley Mortimer *Doreen & Gerald - Humanity and History* (DVF article)

have written Doreen a reconciling sort of letter, to which she would have replied in a similar vein. Apparently they met in friendly fashion after the intervention of Eleanor Bone.

The whole episode culminated a few months after Gerald's death in 1964 with the publication of *Witch*[11] which set out Gerald's Book of Shadows and Olwen Greene's account of her initiation by Gerald Gardner.

Doreen had had several telephone conversations with Charles Cardell in the spring of 1959. This was a period when she received plenty of "gossip" from a variety of individuals in or on the edge of the Craft, some of which was far more reliable than others. It became clear during the course of these discussions that Cardell was ignorant of a lot of basic occult lore, that he was a fantasist and indeed frequently told blatant untruths.

Some of this gossip, of course, was about Cardell himself. Melissa Seims gives the following details:

Rumour had it that there was a secret underground temple at Dumbledene which had been made by converting an old air-raid shelter. In a woodland glade, on their 40 acre estate, there was an altar and a tree with seven wooden 'D's on it, underneath which was nailed a wooden fish engraved with the words 'Moon Magick'.

Esoteric and Pagan symbolism was scattered around their house. This included antlers above doors, an Ankh buried in the thatch and a large seven-pointed star (septagram) on the ceiling in one of the rooms; this same symbol could also be found freely decorating Charles' consulting offices in London. The metalwork gates of Cardell's estate also had large 'D's on them. This all seems to relate to the 7 'D's of Moon Magick; a list of principles, associated with strange words all starting with the letter 'D' and connected with the geometric symbol of the seven-pointed star.

[11] op. cit.

Charles had once written about the 7 'D's in one of his articles and it is clear that for him they summed up his personal philosophy on life.[12]

Another activity of Cardell was the manufacture of 'Moon Magick Beauty Balm' and other products for sale largely by mail order.

One of the rumours which Doreen received about Cardell in early 1961 was that he wanted to procure the daughter of one of the members of the Craft for sex rites. How true this was I do not know, but Doreen certainly acted as if it was.

She immediately intensified her investigations into Cardell's background, his contacts and those who might have attended rituals in the grounds of his house at Charlwood. She even reconnoitred the site of the ritual by catching the train to Redhill and then bus and taxi to Charlwood. She made a close note of everything, almost bumping into Cardell by mistake, though he didn't spot her.

It is clear that Cardell believed in his own form of witchcraft and that rituals were performed in his woodland glade. When one of the rituals was witnessed by a reporter from the *London Evening News*, who subsequently wrote it up for the paper,[13] Cardell sued the paper for libel, a case which he lost six years later and, from being fairly affluent, was impoverished as a result.

Patricia Crowther tells me that Doreen went to court to listen to the Cardell trial. Before the verdict, she visited St. Paul's Cathedral and stood on the pentagram on the floor and asked for whoever was guilty to be found guilty. Cardell was found guilty.

Doreen subsequently went by bus to Cardell's place and took a spell off: she considered that he had paid for what he'd done. Her assessment of him was as follows:

In spite of everything, I regard the whole Cardell business as being very sad. He had so much going for him - his own

[12] Melissa Seims - personal communication with the author

[13] "Witchcraft in the Woods" in *London Evening News* 7 March 1961

piece of woodland, a great deal of natural talent, money to support his projects - and all he could do was to slag everybody off. Eventually, of course, this was his downfall.[14]

Doreen continued this investigation into Cardell for several years, but in the end it proved somewhat inconclusive. However, it did bring her in touch with a former colleague of Cardell's, Raymond Howard.

Ray Howard was someone who once worked for Cardell as a 'handyman' but who subsequently broke with him. He was bound up with a mysterious group known as the Coven of Atho. I do not propose to go into detail about the teachings of that coven, since researchers such as Melissa Seims have undertaken that task comprehensively. It is, however, relevant to our present story since Doreen herself was initiated into and remained active in that coven for several years.

The origins of the Coven of Atho are confused. They definitely seem to have involved the Cardells as well as Ray Howard. Their God was called "Atho - the Horned God of Witchcraft" and was represented by a carved wooden head that was reputedly very ancient. Howard said that he had acquired it from a Romany gypsy woman called Alicia Franch, who also taught him her tradition of witchcraft.

The truth of it all is uncertain. Whether Howard received teachings from Alicia and passed them on to Cardell or whether he and Cardell concocted them between them and that Alicia was a figment of their imagination, I really do not know. The head was almost certainly a fake, perhaps carved out of ancient 'bog oak', and there are reports that Howard's son saw him carving it.

Anyway, the head was stolen in 1967. There are a few photographs of it, but Doreen painted a picture which Melissa Seims describes:

[14] letter from Doreen Valiente to Michael Howard 25 October 1993

One of the more interesting symbols on it can be seen on Atho's forehead. This image of five concentric rings is associated with the five circles of Witchcraft - a teaching that can be found in the Coven of Atho material. Furthermore, it is also highly reminiscent of Plato's description of Atlantis as having been comprised of a central island surrounded by two zones of land and three of water. This is quite interesting for it ties in nicely with some of the other Atho material which refers to the trident, sunken lands and the 'Water City'.[15]

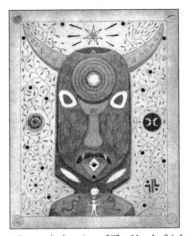

48. Doreen's drawing of The Head of Atho

Things came to a head when Cardell sent Howard a curse in the form of an effigy of him pierced with a needle. Howard took him to court, but Cardell won the case, later saying: "My sister Mary and I are trying to stop black magic. I am an authority on it. It is my job to treat people against this sort of thing. ... I am not a witch. I do not practise witchcraft." His sister, Mary, said: "We have been accused of holding magic rites in the woods on the farm but it is all wrong. Nothing like this has ever happened and never will."

[15] Melissa Seims - personal communication with the author

So, what was Cardell's approach to witchcraft? I suspect he wasn't really sure himself, and swung between explaining a traditional system to dismissing it all out of hand. It seems to me that the psychologist was probably in need of guidance from his own claimed profession!

Anyway, following his split with Cardell, Howard moved to Norfolk, and offered a correspondence course which Doreen enrolled on in, I think, early 1962. Throughout 1962 and 1963, Doreen kept up a correspondence with Howard and, at Halloween 1963, she was initiated into the Coven of Atho at the lowest rank of Sarsen. Where this took place I do not know, but Howard went to visit Doreen in Brighton.

I imagine it would be after her initiation into the Coven of Atho that Doreen was given their equivalent of the Book of Shadows to copy out, which she did faithfully, into two notebooks. Her critical faculties were undiminished, however, for she recognised material from such sources as Dion Fortune's *The Sea Priestess*, Rudolf Koch's *Book of Signs*, Gerald Gardner's *Witchcraft Today*, Charles Godfrey Leland's *Aradia* and Lewis Spence's books on Atlantis. Indeed, Ashley Mortimer has drawn my attention to this material as being a rich seam of inspiration for Doreen's poems, citing references to the Water City and the drowning of Khem.

In one of the manuscript books that Doreen copied, Howard gives an account of how he met the Romany woman and how she selected him as her heir. To give an extract from the book, firstly describing the Head of Atho:

> *At first sight it looks like a rather fierce sort of devil - nothing could be further from the truth! The chin represents the triangle of birth. The mouth is, in fact, a bird symbolising the element 'Air'. The nose is a wine goblet, and the forehead is the Five Circles, cast for various reasons at different times of the year. The Horns represent a crescent Moon, and on the top of the head is a carving of the Sun, with the Star of Office in its centre. The other*

carvings round the Head terminate with the Eight Paths of Magick (the eight roads to find wisdom). The reasons behind calling the head 'ATHO' are rather obscure, as this particular cult goes back some three thousand years many people must have the head, down through the ages. There are similarities with other names, like 'Hathor', 'A' Thor', and of course the fable of King Arthur.

The last words written to me by my old benefactress were "The time has come to bring our teaching into the open. The days of burning us at the stake are gone, and modern religions will eventually go to, because they are unnatural. We were born by a process of Nature. We live and eventually die to return to our mother, Earth. It is for us to show the people how far they have strayed from our mother, and how they can return. Pass on the things I have told you to learn. It is my dying wish Alicia Franch of the Romany's."[16]

The rest of the book is rather a mixture: some material on runes, some on numerology, some alchemy and some symbolism. Another manuscript book seems to be rather more erudite, containing material which appears to be written by Cardell, such as "The Purpose of the Craft of Wica":

Fundamentally, the design is to train to the highest degree possible the body, the mind, the emotions and the intuition, so releasing that life-force and power which is the birth-right of every living person who is willing to become a conscious entity.[17]

Following her initiation in October 1963, Doreen continued to have contact with Ray Howard and participate in occasional rituals for some years, probably well into the 1970s. There were, however, problems of transport, as he was by then living in rural Norfolk, but I suspect the main reason is that it wasn't really what

[16] Doreen Valiente *manuscript book*

[17] ibid.

she wanted and that there was too much of what a friend of mine calls "esoteric babble". She really preferred to go up on her own onto the Downs under a full moon and commune with the Gods. Before long, she would encounter someone who would offer just that.

Chapter 10
Magic On The Downs

On 12th February 1964, Gerald Gardner died of a heart attack on board the *S.S. Scottish Prince* in Tunis Harbour. He was on his way home following a visit to friends in Lebanon. His body is buried in the Cimetière du Borgel in Tunis.

Relationships are far from being purely financial, but it is perhaps significant that whilst Gerald left his other High Priestesses sums ranging from £1500 to £3000 in his will, he only left Doreen £200. This seems to indicate that, whilst he and Doreen were reconciled, there was never again the closeness which they had had before the covens split.

In fact, Gerald's death resulted in further disruption in the Craft. There were arguments and disputes between the various factions, an activity from which Doreen kept well clear. If anything, she wanted to bring the various elements in the Craft together, something which would gradually come to fruition in the ensuing years, as we shall see in the next chapter.

Three months after Gerald's death, Charles Cardell brought out his notorious publication, *Witch*, under the pseudonym of "Rex

Nemorensis"[1]. It reproduced Gerald's Book of Shadows and included an account by Olwen Greene of her initiation by Gerald, which showed that all the time she was working for Cardell and that she went through the whole process of initiation through three degrees merely to acquire a copy of the Book of Shadows.

Witch includes, strangely, a copy of the certificate of Doreen's marriage to Joanis Vlachopoulos, and, for some reason, Cardell always refers to Doreen as "Vlachopoulos" in his text. This undoubtedly contributed to Doreen's decision not to have anything more to do with Cardell, and she was thrown back very much on her own resources, which turned out to be considerable.

···············◆·············

Every midsummer, the Brotherhood of the Essenes held a gathering on Glastonbury Tor, to which quite a few individuals in the occult and esoteric world were invited. Among these were Doreen's friends, the occultist, Bill Gray and his wife, Bobbie. As usual, they attended the gathering in June 1964, where they met a man called Robert Cochrane. They told Doreen all about him:

> *They were impressed by his personality and told me that I ought to meet him, knowing of my interest in witchcraft. I agreed and we all foregathered later in London. Robert Cochrane proved to be a strikingly handsome young man, tall and dark and obviously highly intelligent. He was accompanied by his very attractive wife, and we all got on well together at that happy first meeting.[2]*

Cochrane told Doreen that his everyday name was Roy Bowers and that he had been born in London in 1931. Why he had chosen the name 'Cochrane' I do not know, but there is a long tradition of occultists incorporating or changing to a Scottish sounding name! He had had an interesting life, having been a blacksmith,

[1] op. cit.
[2] *The Rebirth of Witchcraft* p 117

and had also worked on the canal narrowboats. He was currently living in Britwell, a northern suburb of Slough, Buckinghamshire, where he worked as a draughtsman.

He told Doreen that he was a member of a coven which was called 'The Clan of Tubal-Cain' (traditionally the first smith), whose teachings and practice had been handed down through his family. Doreen continued:

> He had initiated his wife and a number of other people who now formed his coven. They worked, he said, sometimes in the countryside and sometimes at his home. They observed the Sabbats and the Esbats on the same dates as what he called somewhat contemptuously the 'Gardnerian' witches; but they did not follow their practices of ritual nudity and flagellation. Instead, they wore hooded black robes and were consequently known as a 'robed' coven. Most of their raising of power was done by dancing in a circle and chanting. If the ritual took place outdoors, the centre of the circle would be occupied by a small bonfire. Indoors, they work by candlelight. They worshipped the Goddess and the God as the ancient powers of primordial nature, going back into unknown depths of time.[3]

On getting to know Cochrane better, Doreen became more sceptical about his claims to be of the hereditary Craft. However, she liked the way he preferred if possible to work out of doors, and at Halloween 1964 she was initiated by Cochrane into the Clan of Tubal-Cain in a ritual held on the Downs above Brighton, possibly in a place that she had used before.

I think on some occasions Doreen may even have gone up on the Downs on her own for seasonal rituals, such as for Midsummer 1964. She got the bus to Pyecombe, and from there walked to an isolated and sheltered spot on the Downs to perform a simple seasonal ritual. I am unsure about this: perhaps there were others - the same ones who were with her for the rituals which she

[3] *The Rebirth of Witchcraft* pp 117-118

recounted in *Where Witchcraft Lives*. Anyway, Doreen was well aware of the time of the last bus home!

Although Doreen does not say it, the Halloween gathering which she describes in her book *The Rebirth of Witchcraft* is almost certainly the one in which she was initiated. She was delighted when she was asked to join the clan. This had probably been arranged about a month beforehand, because in early October, Doreen was busy making an athame, or ritual knife, dying the handle and inscribing it with symbols which had been obtained in spirit communication; a stang (a forked staff of ash tipped with iron) and a cloak with a hood, which she would make from material obtained in either Vokins or Hannington's shops in Brighton. She seems to have been refurbishing an existing athame but the other ritual items were made from scratch.

Cochrane came down with several members of the coven. Doreen's account gives such a feeling of atmosphere that I feel justified in quoting from it at length:

> We assembled quite a crowd of people, though not all of them were regular coven members. ... We had picked out a location on the Downs where we thought we could celebrate safely; and we made sure of this by doing a preliminary daylight reconnoitre. We had all assembled at my flat in Brighton, where most of the company subsequently bedded down rather uncomfortably in the sleeping-bags they had brought with them. But we did not mind a bit of hardship in order to have a really good Sabbat in the traditional way. We went by car to the site and parked our vehicles in a place previously looked out, off the main road. Then, carrying discreet lanterns and torches, we set off up a wooded hill to the higher part of the Downs. It was quite a long climb, and the night was dark, but we made it without mishap and set down our gear at the top.
>
> We had brought the traditional black-hooded cloaks to wear, together with our ritual tools and a small cauldron. We also had food and wine with us and the materials for a

bonfire, or at any rate enough to get one started. There was more dead wood lying around on the site. We lit incense in a censer and wafted it around the circle, which had to be of a wide circumference in order to accommodate our dance. ... The four quarters of the circle were marked by candles, protected from the wind by being placed in lanterns.

The scent of the incense mingled with the woodsmoke from the fire and the odours of the fallen leaves and the earth we danced upon. Above, the stars shone intermittently through the clouds, and the wind blew gently, with the chill of approaching winter. We were in a hollow, to screen the fire from any watchful eyes; so we could not see any lights of the surrounding countryside. The modern world seemed to have faded away and left us in a sort of timelessness.

We raised the stang to signify the presence of the Old God and placed the cauldron beside it to symbolize the Goddess. Into the cauldron we poured some water we had brought with us and mingled it with wine. Then we put the cauldron by the fire to heat and steam. ... Then we danced deosil around the bonfire, slowly and purposefully, chanting as we went - slowly at first, because we meant to conserve our strength and keep up the dance as long as we could. ... eventually, as excitement arose, we danced faster, with loud shrieks and yells. ... We felt that we were not alone on those wild hills. People from the past were with us, invisible but there. It seemed to me that the circle was growing lighter. A kind of green fire seemed to be spreading and sparkling over the ground.

... Eventually we fell exhausted to the ground and lay there, getting our breath back. There was nothing but the night and the silence, broken only by the soughing of the wind and the crackling of the bonfire. We had raised power and we knew it. Satisfied, we brought out our food and drink and distributed it. It was probably very much like the provisions the witches of old had taken to their Sabbats: bread and cheese, cold meat, bottles of wine, apples, small loaves with butter - anything easily portable that would

*not spoil. To us it tasted like a true feast, eaten round our
bonfire under the stars.*

*As the night wore on, it was time to go. We ceremonially
closed our circle and bade the old gods farewell. Then we
gathered up our possessions, carefully extinguished the fire
and made our way again down the hill and through the
dark hanging wood.*[4]

Following her initiation (and she probably deliberately gives no
details of what was involved), the next ritual that Doreen at-
tended was probably Yule 1964. Always one to find the cheapest
and most effective ways of getting places, Doreen got the train
from Brighton to Victoria, then a Green Line bus to Slough, then
a local bus and finally a bit of a walk to Cochrane's house in
Britwell.

Since he preferred working outdoors where possible, it is highly
likely that they would have gone to a location that they had used
before in Burnham Beeches, a large wood only a mile from their
house. It was an area of ancient woodland with not just beeches
but old oaks and other mixed trees. It afforded plenty of locations
where a group could perform a ritual undisturbed.

Doreen attended at least one other gathering at Burnham Beeches
which she describes as follows:

*... I once went to a small witch meeting in some woodlands
quite near London. It was a full moon Esbat of about half
a dozen people. We made our invocation, drank a toast to
the Old Gods, and then danced in a circle. By the time the
rite ended, we were all merry and exhilarated. It was a mild,
clear night, with a silver moon shining through the trees.
Somehow, instead of dispersing quietly, we continued to
dance through the woods. I had brought along an old
hunting horn, which the leader borrowed, and at the sound
of this we laughed, leaped, shrilled the old cries and ran
down the path between the trees, still attired in our hooded*

[4] *The Rebirth of Witchcraft* pp 126-128

*cloaks. Eventually, we came to a breathless halt at the edge
of the woods, where lighted roads and civilization began.
We looked at each other, and the leader said to us, 'You
know what we've been doing? We've been playing the Wild
Hunt!' We realised that he was right. Some atavistic
impulse seemed to have taken hold of us. It was a strange,
uncanny experience, and one that I shall never forget.*[5]

The Wild Hunt is a "phantom cavalcade of wildly galloping riders,
dressed in costumes of an earlier age", in Doreen's words. It can
sometimes still be seen and I know some who have seen it.

It is clear from Doreen's descriptions of these rituals that they
satisfied some deep longing within her. Two things which
Cochrane told her certainly found echoes within her own
experience:

*I remember Cochrane's telling me that he had once had a
vision of the Old God as a being vastly ancient, massive like
some great and ancient tree in a dark forest, brooding yet
all-sentient, smelling of dead leaves and newly turned
earth. He was lying in bed at night when he became aware
of this great presence in the room. He was not frightened,
but awed and unable to move until it faded away. 'He was
so old', he said to me, 'old from the beginning of the world.'*

*At another time he told me that he had first felt the
presence and reality of the Goddess when he was a small
boy. He had been upstairs alone in an old house at night.
It was full moon, and the wind was blowing high. He had
gone to the window to look out at the moon and had seen
the clouds flying past in the broken moonlight, while the
wind screamed over the roof and soughed in the trees.
Suddenly, something had happened. He could not tell me
what. He scarcely knew himself. But, he said, he knew that
the old gods were real and particularly that the goddess of
the moon was real and alive. This numinous experience*

[5] Doreen Valiente *Witchcraft for Tomorrow* (Hale 1978) p 51

[6] *The Rebirth of Witchcraft* p 124

134

had stayed with him for the rest of his life.[6]

This last experience was so similar to Doreen's own which I mention in Chapter 2 that I imagine it must have increased the rapport between them considerably. In her talk to the Pagan Federation conference in 1997 Doreen said:

> *Cochrane's way of working used much less [sic] words than that of Gerald Gardner. Much of it was meditational and performed in silence. I think myself that this was probably more in keeping with the ways of our ancestors, because the majority of people in the old days could scarcely read or write, and the rituals would have been learned by heart and passed on by word of mouth ... Wordless ritual chanting was a favourite means of raising power, as was circle dancing, often round a bonfire or a symbol of the God and the Goddess, such as the forked wand (known as the stang) and the cauldron. I have no doubt that there was much potency in this way of working...*[7]

Whether it was because she felt that Cochrane's approach drew her closer to the earth and to those who had practised the Craft in days gone by, I do not know, but in August 1964, Doreen started to note down some remarkable things. They seemed to be a series of accounts of "what purported to be the discarnate spirit of a traditional witch, who gave his name as John Brakespeare". As Doreen freely admits in her book *The Rebirth of Witchcraft*:

> *Just how to evaluate these communications I do not know. However, I am giving them here in view of the interest in their contents. Readers must decide for themselves whether the messages are indeed what they purport to be or whether they are simply the product of my subconscious mind.*[8]

[7] Doreen Valiente *A Witch Speaks* in *Pagan Dawn no. 128* Lughnasadh 1998
[8] p 99

Either way, they are a valuable insight into Doreen's feelings at that time. Brakespeare presented himself as the leader of a coven of witches living in the county of Surrey in the early 19th Century.

A vivid picture is built up through these "communications" of the life and activities of the coven members, including the ritual tools, the incense, which was hard to come by, and the rituals themselves - very simple and down to earth. As Doreen admits, it is difficult to assess these descriptions. Perhaps they are merely her imagination but, if so, they give a picture, to my mind, of how she saw the essence of the Craft that she thought she had found in the workings of Robert Cochrane.

She was, however, to be gradually disillusioned on that score.

Rather than focusing on the positive features of his own approach to the Craft, Cochrane became increasingly critical of what he called the 'Gardnerians': those who had learnt their witchcraft, directly or indirectly, from Gerald Gardner. He was one of the first to use the term, which has come to mean a very specific tradition, particularly in America. Anyway, Cochrane got more and more vituperative and, when he started talking about having a 'Night of the Long Knives' with the Gardnerians, Doreen had had enough:

> *I rose up and challenged him in the presence of the rest of the coven. I told him that I was fed up with listening to all this senseless malice and that, if a 'Night of the Long Knives' was what his sick little soul craved, he could get on with it, but he could get on with it alone, because I had better things to do.*[9]

That was the last time that Doreen worked with Robert Cochrane, but she had a role to play in what turned out to be a tragic episode. In 1966, the writer Justine Glass told Doreen that Cochrane was telling people that he was intending to commit ritual suicide at midsummer. Doreen was the only one to believe him. She told Justine:

[9] *The Rebirth of Witchcraft* p 129

'Look', I said, 'I think you should take it seriously. I'm not saying that Robert means to commit suicide; but I'm horribly afraid that he might stage some stunt which could go very wrong. I believe a lot of people die like that. They don't really mean to kill themselves; but things go too far and get out of hand. Please tell the persons who told you this to keep an eye on Robert.'[10]

Subsequent to this, while she was in hospital for a recurring health problem, Doreen had received what she called "quite a normal and pleasant letter" from Cochrane, apologising for his behaviour and hoping that they could be friends again.

When she came home from hospital, Casimiro drew her attention to a letter that had arrived two days beforehand. It was from Cochrane saying that by the time she received it he would be dead. She went out to phone Bill and Bobbie Gray, who confirmed that Cochrane had died, having swallowed a mixture of narcotic herbs and sleeping pills. The subsequent inquest returned a verdict of 'suicide while the balance of the mind was disturbed'.

Doreen was deeply affected by Cochrane's death. He was, she said:

... perhaps the most powerful and gifted personality to have appeared in modern witchcraft. Had he lived, I believe he would have been a great leader. ... Cochrane was a highly intelligent man as well as a talented one; he would have learned judgement and patience as the years went by.[11]

She wrote a poem in memory of Robert Cochrane, entitled "Elegy for a Dead Witch":

To think that you are gone, over the crest of the hills,
As the Moon passed from her fulness, riding the sky,
And the White Mare took you with her.
To think that we will wait another life
To drink wine from the horns and leap the fire.

[10] op. cit. pp 133-134

[11] op. cit. pp 135-136

Farewell from this world, but not from the Circle.
That place that is between the worlds
Shall hold return in due time. Nothing is lost.
The half of a fruit from the tree of Avalon
Shall be our reminder, among the fallen leaves
This life treads underfoot. Let the rain weep.
Waken in sunlight from the Realms of Sleep.

Chapter 11
A United Nations of the Craft

As far as I know, it all started when Gerald Gardner's death became known to the witches in Britain in mid-February 1964. There seemed to be general agreement that someone was needed to replace Gerald, though there was some doubt about precisely what his role had been.

First off the mark was Eleanor 'Ray' Bone, who is reported as saying:

> *The death of Dr. Gardner has shocked us all deeply. There have been discussions as to who should take his place in our craft. I am the leader of a coven here in Balham, and I have talked with my counterparts in Sheffield and St. Albans. I anticipate that I will take over Dr. Gardner's role. ... Our intention now is to form a central committee of English witches, and I shall probably be voted the liaison officer between all covens.[1]*

At the beginning of March, Monique Wilson, who had inherited the museum from Gerald Gardner, announced that this

[1] "Britain's chief witch dies at sea" in *News of the World* 23 February 1964

inheritance included the title 'Queen of the Witches'. This was quickly challenged by Eleanor Bone: "There is no such title as 'Queen'. But if there was, we other witches would have to approve the person appointed."[2]

Writing in May, Doreen is cautious about the whole idea:

> ... perhaps it is wiser to keep right out of it, and work on our own. After all, the old tradition was that each coven was self-governing. The leaders throughout the country kept in contact; but all went their own ways, within the framework of the old traditions. I think maybe this is still a good idea. However, I don't rule out the idea of a meeting, by any means. But I think I'd like to see how things boil up, for a while yet.[3]

However, discussions did apparently take place, after which Doreen wrote: "We suggest that covens of different types and with varying rituals should combine to present a united front in order to avoid adverse publicity."[4]

In the meantime, an organisation known as the Witchcraft Research Association was founded by Gerard Noel, who had trained for the Roman Catholic priesthood and had been a captain in the Royal Marine commandos during the war. He was the son of the Earl of Gainsborough.

Sybil Leek, a witch operating in the New Forest of Hampshire, was the Association's first president, but resigned her position in July 1964. This was, she claimed, because: "Many members of the association felt that my past associations with black magic are detrimental to the present-day participants."[5]

Although never formally given the title, Doreen took over in practice from Sybil Leek.

[2] *Daily Mirror* 9 March 1964

[3] letter from Doreen Valiente to Charles Clark 11 May 1964

[4] Doreen Valiente *notebook no. 29* 20 May 1964

[5] *Daily Sketch* 2 July 1964

In August 1964, the first edition of the Association's newsletter, *Pentagram*, was produced. It included a Letter of Welcome from Doreen, dated 9th July 1964, which read:

> *I am glad to have this opportunity of welcoming the first issue of the Pentagram.*
>
> *It is a curious coincidence that 1964 is just thirteen years after the repeal of the last of the Witchcraft Acts in this country, which took place in 1951.*
>
> *Ever since that date, the old Craft of the Wise has steadily progressed towards recognition as a genuine religious tradition. Nor is it merely a relic of the past; it has significance for people of the present day, disillusioned as they often are with more orthodox creeds, and "orphaned of the Great Mother", Nature, by the stresses of modern life.*
>
> *Like every live movement, there are differing opinions among us - and a good thing, too. From brainwashed uniformity, may we long be preserved!*
>
> *Owing to the years of persecution, the old traditions have become fragmented, with one coven or group of covens preserving certain aspects of the old beliefs, that have been handed down to them, while others retain and place emphasis upon other aspects.*
>
> *I think we should take this fact into account, and recognise that no section of the cult has the right to say, "We, and we alone, are the genuine article; anyone who is different from us is wrong". Rather, we should respect each other's views, when sincerely held, whether or not we agree with them.*
>
> *If we are willing to do this, then the way will be open for a truly great work to be performed; namely, the piecing together again of all the true parts of the ancient tradition, to make a coherent whole so meaningful in all its potentialities that it would at once command the respect of intelligent and thoughtful people.*

I hope the W.R.A. may be able to help in this aspiration, by acting as a kind of United Nations of the Craft. I hope it will promote research, and the recording of traditions that might otherwise be lost; and I hope also that it will work for mutual understanding and unity of purpose, that will make such research possible.

Good luck, and "Blessed Be ..."[6]

On 3rd October 1964, *Pentagram* held a dinner at a London hotel, which was attended by 50 subscribers. I would have attended it myself if it had not coincided with the start of my undergraduate course at the University of Hull. I obviously didn't miss much in the dinner itself, as Bill Gray commented:

... all the 'Gardnerian' witches [were] along one big table, and the independent or 'opposition lot' including Roy's [Cochrane's] group seated at another. We were at the top table with Gerard, Doreen, and some other notables.

Though the occasion was a fascinating one from a purely personal viewpoint, it was memorable for being one of the worst meals I ever ate in my life. It was so bad I can remember every item. A thin soup, made probably from Oxo cubes, a small lump of suspicious substance which might be meat from some unknown animal, flanked by two scoops of reconstituted potato powder and a single heap of boiled dried peas. This was completed by a thin wedge of cardboard-tasting tart part drowned by watery custard. Better meals are served in prisons every day.[7]

After the disappointing meal, Doreen gave an after-dinner speech which was anything but disappointing. In it, she put forward ideas that she would later develop at greater length in her published books. She spoke first about the seasonal rituals:

What witches seek for in celebrating these seasonal rituals is a sense of one-ness with Nature, and the exhilaration

6 *Pentagram* no. 1 - August 1964 p 1

7 Alan Richardson and Marcus Claridge *The Old Sod* (ignotus 2003) p 155

*which comes from contact with the One Universal Life ...
They want to get back to Nature, and be human beings
again, as she intended them to be.*

Speaking about the deities of the Craft, she said:

*I think we should recognise that Witchcraft as we have it
today is the synthesis of the traditions of many centuries.
And it is still a living and evolving tradition, and capable of
yet further evolution as the human race itself evolves.*

*Our worship of the Horned God and of the Moon Goddess
may well be on a more spiritual level today than it was in
centuries past. In the past, the cult needed to work for
material fertility, because without it the people faced
starvation. Today, we can take a broader conception of the
witch cult as a cult of fertility. We can work for fertility of
the mind, and fertility of the soul.*

After paying tribute to Gerald Gardner, Doreen ended her speech
with perhaps her most important message:

*Pentagram is now contacting surviving traditions from
covens which have never been in any way connected with
Gerald Gardner. In fact, it is becoming increasingly clear
that the old Craft has survived in fragments all over the
British Isles. Naturally, these different groups, which have
lost touch with each other over the centuries of
persecution, have to a certain extent grown apart. Each
has its own version of the tradition, in its own words; and
each has its own ideas of practice and ritual. It is proving
a tremendously exciting project, to compare these different
fragments of tradition, and see wherein they complement
each other, and wherein they differ.*

*I feel that the proposed Witchcraft Research Association
could do something really important and worth while in
this work, for the future of occultism in Britain. What we
need now, more than anything, is for people of spiritual
vision to combine together - not that all may think alike, by
any means; but that people of different ideas may be more*

tolerant, one of another, than they have always been in the past.

You know, if only people in the occult world devoted as much time and energy to positive constructive work as they do to denouncing and denigrating each other, their spiritual contribution to the world would be enormous!

The best answer to attacks upon Witchcraft is for all of us, whatever branch of the Craft we belong to, to stand together, to be united in a common constructive purpose. We do not all have the same way of doing things; but then, covens never did. The old idea was that each coven was self-governing, within a broad unity of tradition. The leaders of the different covens kept in touch, as far as they could, and helped each other. No one tried to seize power, and each respected the other's ideas, when they were sincerely held. This is the true old Craft tradition.

We have heard a lot about so-called splits in the Craft. Well, we have certainly had differences of opinion, like any other live body of people; and we shall be remarkably lucky if we never have any more!

But I hope this gathering tonight will agree with me, when I say that the things which unite us are very much bigger and more important than the things which divide us; and that our brotherhood in the Craft means far more to us than any personal differences. If we can realise that, and take it into our hearts, then there won't be any splits in the Craft that matter a damn![8]

Doreen's plea for unity seemed to fall largely upon deaf ears, however, since Robert Cochrane and his colleague 'Taliesin' (Tony Melachrino) used the pages of *Pentagram* not just to present the positive aspects of the Traditional Craft but to continue criticism of the 'Gardnerians'.

[8] *Pentagram* no. 2 - November 1964 pp 1-3

And the Witchcraft Research Association never really got going. In September 1965, Gerard Noel wrote to me that "... the W.R.A. has never in fact been constituted and therefore holds no meetings. My sole activity at the moment is the occasional publication of "Pentagram" ..." [9]

As well as writing the Letter of Welcome and speaking at the dinner, Doreen was certainly very supportive of *Pentagram* in other ways, most importantly through writing articles. In April 1965, she noted ideas for six different articles for the magazine, that on Witch-Balls being the only one which actually appeared in that publication. Other ideas she had, however, included an article on "The Horseman's Word", "The Good Man's Croft" in Scotland, and one on interesting items that turn up in antique shops, of which there were plenty in Brighton.

However, after its fifth issue, in December 1965, *Pentagram* seemed to change its policy, publishing little about witchcraft, and the Witchcraft Research Association seemed to vanish without trace, certainly by 1967.

———————————————

Things were quiet for a while until there came on the scene an ex-RAF officer named John Score (1914-1979). He had specialised in signals and communications and, after leaving the RAF, was in charge of the communication network for the 1948 London Olympic Games. He was a natural psychic and remembered several previous lives.

In the early 1960s, Score had been initiated and eventually formed his own "Order of the Golden Acorn". After falling victim to a tabloid newspaper that published a misleading story about him, he was determined to do what he could to counter what he saw as religious discrimination. What he did was to publish a newsletter, which he called *The Wiccan*, the first issue of which came out in 1968. Its opening statement read:

[9] letter from Gerard Noel to the author 16 September 1965

The editor believes that the Old Religion should become (once more) effective in public life to the latter's considerable betterment by application of those concepts which originally guided our peoples of the Western world.[10]

It is likely that Doreen was an early subscriber, but certainly by March 1969, Score had contacted Doreen about a new series of articles in the tabloid press, including one which describes infiltration into various covens, including Score's own. But, as Prudence Jones reports:

Doreen was less than sympathetic. She thought the witches concerned had brought it on themselves by failing to check the credentials of those who had asked to join them.[11]

Score then proposed to Doreen the setting up of a "Witches' Defence League", but she doubted whether it would be successful, as Prudence comments: "She explained that she doubted whether central organisation might make a difference unless those participating learned from previous mistakes."[12]

Doreen did, however, suggest that such initiatives as the Race Relations Act and the National Council for Civil Liberties' campaign for the Right to Privacy could be relevant in protecting the Craft from unwarranted intrusion by the Press. Indeed, she expressed this concern and a possible solution as early as 1964:

A person can be summonsed under the Religious Worship Act of 1812, for "wilfully and contemptuously disturbing a meeting of persons assembled for religious worship". Would this apply to anyone who tried to break up one of our meetings? Check on this.[13]

[10] *We Emerge - The Origins and History of the Pagan Federation including excerpts from The Wiccan 1968-1981* (Pagan Federation 1997) p 3

[11] Prudence Jones *In the Beginning - the PF's roots* in *Pagan Dawn* no. 178 Imbolc/Spring Equinox 2011

[12] ibid.

[13] Doreen Valiente *notebook no. 32* 13 November 1964

By July 1969, Doreen was still cautious about things:

I agree about the need for good intercommunication between covens - but of the leaders only, as the old custom was. This business that has been going on, of people being able to flit from one coven to another, comparing notes, has got to stop. There are too many people compiling information about the Craft, under various pretexts - what do they want it for? They should be asked, and made to come up with the answer, before they get any more co-operation.

What the Craft needs, in my opinion, is not public organisation, but confidential organisation. It should be like an iceberg - one tenth showing, nine tenths hidden. We have fulfilled our purpose in publicity, namely to let people know that the Craft still lives. Now let's shut up and do some serious organising! Of course, this will not be a palatable idea to those who like to pose before press and T.V. cameras as "Kings" or "Queens" of the witches; but I don't think these people are helping the Craft, but rather the reverse.[14]

By October, she was more forthright about matters:

I think the way the Old Religion is dragged along the gutters of Fleet Street deplorable, and I always did, and I bitterly blame those who by their folly and vanity bring this about. We have a lunatic fringe, let's face it - but what movement hasn't? If only we could persuade some of our self-appointed "leaders" to stop giving themselves fancy titles, and displaying their bare arses to the cameras of newspapers and television, and Belt Up! They could, I suggest, in order to fill in their time, actually practise some witchcraft - if they know how, which I doubt.[15]

There had been some concern nationally about the right to privacy with a Private Member's Bill introduced by Brian Walden MP

[14] letter from Doreen Valiente to John Score 8 July 1969
[15] letter from Doreen Valiente to John Score 21 October 1969

and there had been a report by the National Council for Civil Liberties. In response, the Home Office had set up a committee to look into this whole matter.

Prudence Jones says:

> Doreen wrote a rallying letter, delighted at the fact that the issue had reached Parliament. She was determined that all areas of the Craft should show a united front to the committee despite any internal differences. She was clear on the issue that, as Pagans, we had the right to practise our faith without derision.[16]

Score wrote a draft letter to the Home Secretary, which was discussed with Doreen and other Craft members before being suitably amended and dispatched on 21st March 1970. This was publicised in the press and Doreen urged witches who had been exposed in press articles to give evidence to the Committee.

However, the press still had plenty of opportunity. Alex Sanders, who many claimed to be 'King of the Witches', had appeared on television on the Simon Dee Show, where he claimed to have put a curse on a rival witch. Doreen takes up the story:

> Sanders produced an effigy stuck with pins which he said was of this man and boasted that by its means he could inflict heart attacks upon him. It was an exceptionally foolish thing to say to such a wide audience; but then people might think that someone who insisted that he was 'the King of the Witches' should not be taken seriously, anyway.
>
> Nevertheless, many people who saw this broadcast did take the matter seriously. As a direct result of it and the newspaper articles, the next month Mr Gwilym Roberts, the Labour Member of Parliament for South Bedfordshire, asked in the House of Commons if the Home Secretary would introduce legislation to provide penalties against

[16] Prudence Jones op. cit.

*individuals claiming to practise witchcraft. This was
reported in the press on 17 April 1970.*

*I immediately realized that this time we could be in serious
trouble. What could we do? I decided to lobby the House of
Commons and see if Mr Gwilym Roberts would give me an
interview. I wrote to Mr Roberts and he kindly agreed to
see me. He and his wife entertained me to tea at the House
of Commons [on 29th April], which was an interesting
experience in itself. I had feared that I might be dealing
with a bigot with a closed mind. I do not know what Mr
Roberts thought he might be confronted with, as I had told
him plainly I was a witch. However, in practice we got on
very well together. Mr Roberts proved to be an intelligent
and charming man who had genuinely been responding to
letters received from his constituents. We had quite a long
talk about the Old Religion, and as a result of it Mr Roberts
did not proceed with any further requests for legislation
against witches.*[17]

On 2nd September 1970, John Score published the 13th edition of
The Wiccan. In it, he announced the formation of the Pagan
Front, which, he wrote:

*... proposes to represent the interests of Paganism
(including those of the Craft) to the general public and to
the Administration. ... We affirm that the Old Religion has
a vital part to play in the formulation of humanities* [sic]
*future (if we are not already too late). To this end, in the
hope that we are in time, it is proposed to form what we
have been thinking should be termed, for the time being,
the PAGAN FRONT. This grouping, at least to begin with,
is open to all who support the Pagan concept of the
"godhead", i.e. a paired male and female deity, a God and a
Goddess ...*[18]

A month later, Doreen sent Score an exposition of what she called
a Pagan Creed, which turned out to be the first draft of what

[17] *The Rebirth of Witchcraft* pp 79-80
[18] John Score in *The Wiccan* no. 13 p 4

became the Pagan Federation's 'Three Principles':

I've been thinking things over ... and have come up with a few suggestions. I do agree with you, that we do not want a lot of "misty myth", but something that is relevant to people's problems today. Therefore I propose a sort of Pagan Creed, on these lines, which I have called "The Three Points of the Triad":

1 - The Pagan ethic, "Do what you will, so long as it harms no one". This is in fact the code which has been adopted by intelligent people generally today. It is a <u>positive</u> morality, as opposed to the usual list of "thou shalt nots"; and it is a code of personal freedom, for oneself and others.

2 - Reincarnation, with its implications of survival of bodily death, and Karma which we make ourselves, i.e. personal responsibility. Also, the <u>hope</u> it gives people of another chance, not in some dim and far-off "beyond", but here on this earth - "With sturdier limbs and brighter brain, the old soul takes the road again", a quotation from John Masefield which was a favourite of old Gerald Gardner's. If people really <u>believed</u> in this, there would be no need of the modern obsession with "Grab all you can get, you're a long time dead", which is most people's practical philosophy, whatever they may profess to the contrary.

3 - Love and kinship for Nature - seen as the interplay of <u>complementary</u> forces, which we symbolise as the Masculine and the Feminine, the Goddess and the God. The Horned God as the masculine side of Nature, the Moon Goddess as the feminine side. This is the same as the ancient Yin-Yang philosophy of China, on which the I Ching is based, and it appears in the Western Tradition as Chokmah and Binah on the Tree of Life, and all the other Sephiroth emanating from them. This Nature Religion would express itself in the old seasonal rituals, which the witches share with the Druids, and which are the natural divisions of the year, namely the Four Greater Sabbats and the Four Lesser Sabbats - though we need not call them "Sabbats", as that is a loaded word. Just call them by the

names they are most commonly known by, the Equinoxes and Solstices, and Candlemas, May Eve, Lammas and Halloween (the latter four being the Greater Sabbats and the others the Lesser). Though May Day is a good day to hold the first public meeting, because it will be public, in broad daylight - "in the face of the Sun, and in the eye of light", as the Druids say.

Also, this point 3 will include and imply respect for our natural surroundings, and the fight against the pollution and despoiling of our planet; and the interest in pure natural food, and natural methods of healing.

... I call the above "The Three Points of the Triad", because it is a very old tradition of the British Mysteries to express things in triads; and also, I wanted to keep this suggested creed as simple and all-embracing as possible, so that anyone who feels himself or herself in sympathy with this creed can join the Pagan Front, whatever other occult commitments they may have.[19]

Doreen also suggested the Egyptian Ankh as an emblem:

I suggest this because it is already adopted by many young people who are mentally in tune with the Aquarian Age, while at the same time it is one of the most time-honoured emblems in the world, going back to unknown antiquity. Also, by its form it implies the Masculine and the Feminine, the Goddess and the God; and it is linked with the Western Magical Tradition in that it can contain all the Sephiroth, when superimposed upon the Tree of Life.[20]

This was published in issue no. 15 of *The Wiccan* on 5th October 1970, which stated that the "Pagan Front seeks to relate in practical and effective fashion to the Administration, public bodies, institutions and the general public etc. in presenting the Pagan case and views within the framework of legitimate aspirations". This was obviously not written by Doreen!

[19] letter from Doreen Valiente to John Score 2 October 1970

[20] ibid.

Doreen was closely involved in the progress of the Pagan Front and wrote a full moon ritual which local groups, which were encouraged, could use for their inauguration.

She then began to envisage a large public Pagan gathering, similar to the Druid events at Stonehenge. This would be properly organised and be supervised by the police, with publicity from the British Tourist Board. Although there was some enthusiasm for this, in the end it never happened.

However, the Inaugural Members' Meeting of the Pagan Front was held at Madge Worthington's house in Chiswick, West London at 3.30pm on 1st May 1971. It was by invitation only and was chaired by Doreen. Her address to the meeting included the following:

> *Unity is strength; and I welcome the fraternal unity of all sincere people of goodwill who follow the pagan path. We may not always agree with each other, but we must support each other, in our struggle for our right to follow the religion and the lifestyle of our choice in the modern world.*
>
> *We rejoice in being heretics, because a heretic means "one who chooses". That is, we choose our own way, to live, to think and to worship; not only because it pleases us, but because we believe that human society needs the old pagan wisdom to restore it to health and sanity, in what people are increasingly recognising as a very sick world.*
>
> *[... we rejoice in] the ideal and the hope of collaboration between the different pagan groups in this country, between witch covens of different traditions, indeed between all pagan people who are sincere and of good intent; with the mutual recognition that, with our different functions as groups, we can be complementary to each other, like the different forces in Nature.*[21]

The Pagan Front grew, and in 1981 changed its name to the Pagan Federation, which today is one of the largest and most well-respected Pagan organisations in the world. Doreen's central role in its establishment should never be forgotten.

[21] Doreen's address to inaugural Pagan Front meeting op. cit. pp 6-7

Chapter 12
A Strange Interlude

We now come to another and striking example of how Doreen was initially attracted by a particular group, found out as much as she could about it, realised that she had some fundamental disagreements with its approach, but stayed on good terms with its members in the hope of finding out more, until she was able to extricate herself in a way least likely to arouse suspicions as to her motives.

This was the approach which Doreen took with Cardell and his practices. She also, I believe, took the same approach when she did something that many will find surprising and problematic: for a period of some 18 months in the early 1970s she was a member of the National Front, a far-right, ostensibly racist, political party, which was against non-white immigration.

If we look at what happened, and particularly the entries in her notebooks, it may shed some light on her thinking. On New Year's Day 1973, a leaflet came through Doreen's letter box: it was from the National Front. Perhaps the similarity of its name to the Pagan Front led Doreen to think that there might be something worth exploring and that it might have the potential to be the political equivalent of the Pagan movement. If so, she was to be

bitterly disappointed. Whatever the leaflet said, it interested Doreen enough for her to fill in the tear-off strip and send it back to the National Front headquarters in London.

In reply, she was told about the monthly meetings of the local branch, organised by Edward Budden, who later contributed regular columns in publications such as *Spearhead*, *The Flag* and *British Nationalist*, all extreme right-wing journals. The leaflet probably presented the party as being patriotic and embodying British values, which were just the sort of thing to attract Doreen, as she had been writing in a similar vein for several years previously.

Doreen had previously written about what she called "The British Ethos", which she referred to as the "concept of the sacredness of individual personal liberty", quoting such sayings as "It's a free country", "an Englishman's home is his castle" and "Britons never shall be slaves", to which she appended the Wiccan Rede - "An it harm none, Do What Ye Will".

> *We are "the Mother of Parliaments", the essential of parliamentary government being free elections. We preserved the Bardic Mysteries throughout the Roman period of empire. We fought the Peasants' Revolt against feudalism, even as Boadicea fought against Roman tyranny (and gained her point, even though she died in the struggle). We broke the power of Papal dominance (in so far as we had ever submitted to it); and the Spanish Armada against Protestant Britain failed. The Craft had a hand in all these things, traditionally, from the Peasants' Revolt to the defeat of the Armada.*

> *We broke the "Divine Right of Kings" and established constitutional government. We fought Napoleon and Hitler, and broke their power as Dictators of Europe. The "Ethos of Britain" is a kind of revolutionary impulse of the human spirit, which has spread all over the world. It has had many metamorphoses, but the root of it is the same, the impulse to human freedom.*

... It was in Britain that Karl Marx formulated his ideas; just as it was from Britain that men like Tom Paine arose to formulate the ideas of the American Revolution (which was essentially directed against the reactionary Hanoverian ideas of German George III).

I believe the demand for votes for women first arose in Britain. Britain has pioneered birth control, and much of the present day "sexual revolution". There is probably more real individual liberty and freedom of speech in Britain than there is anywhere else in the world. This is Britain's real rôle in the future, to be a beacon of true personal liberty to the human race.[1]

An aspect of this was, I think, for Doreen, that there was something "in the blood" which was inherited over the generations, as well as incorporated in traditional beliefs and practices. For her, these concepts were embodied in the idea of race: "Races are not "inferior" or "superior". They are different. Each race, at the height of its development, has a part to play in the whole. Each has its own contribution to make."[2]

She did not object to racial mixing, however, which she called "revitalising", provided it did not result "in a dull, materialistic sameness in which the traditions of both races are blurred and lost, [which] is not good for either race".

She refers to what is called The Theory of Positive Racialism, which postulates that "every race has something to contribute to the good of humanity as a whole, some purpose to fulfill". Doreen writes:

This may be what the Old Religion has needed, namely, to tell people that they are not only "orphaned of the Great Mother", earth or Nature, but also cut off from the group soul of their race; and that they need the community of

[1] Doreen Valiente *notebook no. 34* 30 March 1966

[2] Doreen Valiente *notebook no. 35* 13 October 1965

blood and soil in order to find again their health of body and soul.[3]

This was probably in part influenced by her friendship with Bill Gray, who referred to himself as a 'racialist' and who expressed similar ideas, saying, for example: "Each race carries its own unique record of superphysical and subjective phenomena through its bloodstream, and these memories constitute our fables, legends, gods, heroes and what have you."[4]

It is clear to me on reading Bill Gray's biography, *The Old Sod*, that he was not a racist, as the term is generally understood today, and neither, I believe, was Doreen. There was, however, some attraction for Doreen in the publicity material put out by the National Front, as patriotism would probably feature strongly. Initially, I believe that Doreen had great hopes for the National Front, but the more she looked into it, the more she became disillusioned.

Before attending any meetings, though, Doreen carried out some investigations herself. In these days of the internet, Google and Wikipedia, it is sometimes difficult to realise how hard it was to unearth information on a particular topic. However, Doreen was a frequent user of the library in Brighton and she managed to dig out information about, not just the National Front but the organisations and individuals who had connections with it. She had already researched the far-right Thule Society and had, only the previous month ordered *Secret Societies and Subversive Movements* by Nesta H Webster, a right-wing writer, from the library.

She looked into the firm that published some National Front literature, the Britons Publishing Company. Its founder, Henry Hamilton Beamish, was a Rhodesian, well-educated, the son of an Admiral, an early friend of Hitler, anti-Freemason and anti-Jewish. He died in 1948. Doreen noted that the company had also pub-

[3] Doreen Valiente *notebook no. 59* 25 January 1973
[4] *The Old Sod* op. cit. pp 225-226

lished material for Colin Jordan who, while he was never a member of the National Front, sometimes used a 'British National Socialist' armband with a white disc on which there was a red swastika.

As with anything that Doreen did, she investigated her subject thoroughly and, by the time she started to attend meetings, she probably knew far more than most of the members present. Yet, perhaps because of her practical nature, desire to be accepted, willingness to help and perhaps because of her gender, the first task given to her was that of designing a banner.

By August 1973 she had worked out what materials were needed and had done a drawing. The banner was intended to be ready for Remembrance Day in November that year. Whether it was ever made, I do not know.

As well as the investigation referred to above, she also found out more about the Thule Society, Alfred Rosenberg and 'The Protocols of the Elders of Zion' by reading, among other books, *The Myth of the Master Race* by Robert Cecil.[5] The Thule Society was a mystical group centred around the idea of a mythical northern land which was supposed to be the origin of the Aryan peoples. It was founded in 1918, admitting members of the Aryan race only. They included many early Nazi sympathisers. Rosenberg was an early member of the Nazi party who developed many of their ideas on race, persecution of the Jews and 'lebensraum'. 'The Protocols of the Elders of Zion' were forged writings intended to stimulate opposition to the Jews. She also acquired, and I am sure read, Hitler's *Mein Kampf.*

Doreen also found out about the Northern League, a neo-Nazi organisation which published the periodical *The Northlander*. The stated purpose of the League was to save the "Nordic race" from "annihilation of our kind" and to "fight for survival against forces which would mongrelise our race and civilisation". It was

[5] Batsford 1972

apparently considered extremist even among fascists. And yet, from the evidence of her notebooks, Doreen was a member of the Northern League. And she noted that: "Most, if not all, of the Fascist and Neo-Nazi groups in England have some association with the League."[6] She did, however, provide the Northern League with information on the Oera Linda Book, the revival of paganism in Iceland and the Viking ceremony at Lerwick.

What was going on? Why would someone who had devoted years of her life during the war to combating fascism want to join such organisations as the Northern League and the National Front?

I think that by the time she joined the Northern League, she was well aware of what its policies were, and that her instinct as an investigator took over. It was the same, I believe, as with Charles Cardell: "I kept on friendly terms with Cardell in order to find out what he was up to."[7]

By March of that year, Doreen was warned by the lady who ran the British Israel bookshop that some of their members had joined the National Front and subsequently "went completely astray". "She warned me that there were influences at work in the National Front that were not what they seemed."[8]

I think that, fairly quickly, Doreen began to realise that there were considerably less savoury aspects to the National Front than the ideas that had initially attracted her. Rather than resign immediately, however, I think she probably felt that she could be more use in collecting information "from the inside", as it were. Her experiences during the war meant that she was quite skilled at doing this and she probably knew exactly where to pass the information on. She certainly used her investigative techniques in finding out about the National Front and associated bodies and individuals. This does make me wonder whether she was covertly

[6] Doreen Valiente *notebook no. 59* 15 January 1973

[7] *Inventing Witchcraft* op. cit. p 90

[8] Doreen Valiente *notebook no. 60* 24 March 1973

carrying out investigations for some government department, which had kept her "on the books", so to speak. She was definitely interested in, if not actively involved in the practice of being a private detective. At one time she was thinking of applying for membership of the Association of British Detectives.

That, certainly for the latter part of her membership of the National Front, her attitude was one of investigation rather than enthusiastic support, is confirmed by what she wrote to Janet and Stewart Farrar about extreme right-wing involvement in occultism:

> *Now, it so happens that I have done some investigation into this myself in the past - and believe me, there is nothing mythical about it. Fascism is alive and sick and living in Europe and Britain.*[9]

I think with Doreen any mention of fascism and Nazism was totally unacceptable. She had played her part in the fight against such ideologies during the war, as had both her husbands, and her views on race in no way made her sympathetic to the atrocities that were committed in the name of Nazism.

And increasingly she found in the National Front's publications and by talking to members, ideas with which she not only disagreed, but disagreed profoundly. Neatly tucked into the pages of her notebook she had sheets prepared by some anti-Fascist group giving facts that the National Front would probably have wished to conceal, including names of members who had been convicted of violence. She may have obtained this at a "Stop the National Front" Public Meeting in Brighton at the beginning of September 1974. Only a month later, on 12th October 1974, Doreen wrote to Edward Budden, the local organiser. I quote her letter in full:

> *Dear Ted*
>
> *Thank you for your letter inviting me to Friday's meeting.*

[9] letter Doreen Valiente to Janet and Stewart Farrar 1 September 1982

However, I have to tell you that for the time being I do not propose to take any further active part in the National Front. My reason is that I cannot conscientiously support a policy or an attitude which I believe profoundly to be wrong.

As T... can tell you, I have not arrived at this decision suddenly. I have mentioned my misgivings to him before, when I saw the attitude which articles in "Spearhead" were taking to the new legislation passed by this Government, making contraception freely available to everyone. This I regard as being one of the most enlightened pieces of social legislation to be passed in this country for decades. Yet "Spearhead" saw fit to attack it, and in general to adopt an attitude of opposition to various other matters, such as sex education, women's liberation, and the repeal of the laws against homosexuals, which I regard as being important social advances. They say that politics is largely a matter of attitudes, and I cannot in good conscience go along with this one any longer.

I did not want to act hastily, however, because I think there is a big need in this country for a party which fosters patriotism, and stands up for the British democratic way of life, and the British nation generally. I know that "Spearhead" is privately published by its Editor, and states that its contents do not necessarily represent N.F. policy, and so on. Nevertheless, the fact remains that its Editor is the Chairman of the N.F.

I had hoped that this attitude to social legislation of this kind was simply a private opinion of the Chairman, to which of course he is entitled; and I have every respect for Mr. Tyndall's sincerity and integrity. However, I can no longer close my eyes to the fact that opposition to birth control is being promoted throughout the N.F., as evidenced by the article "The Real Conspiracy", by John Ball, in the latest edition of "Spearhead".

In my opinion, to describe population control as a "conspiracy" or a "fetish", as "Spearhead" has done at various times, is a grave error. The people who have made

these allegations are concerned about the survival of the white race; but if we do not support birth control, mankind on this planet is not going to survive - white, black, or any other colour. We shall perish as the result of our own reckless over-breeding and the pollution of our environment. This is not only my opinion, but that held, and frequently stated, by many eminent scientists. Moreover, as a woman, I am not going to support an attitude which has condemned many of my own sex to needless and preventable misery - I note that free abortion is also opposed.

Now, I know that all these are controversial matters, and many people hold strong conscientious views on them. Well, I hold strong conscientious views on them, too; and I'm sorry, but I can't stifle these views any longer.

I also found it very disturbing that "Spearhead" recently published an article in praise of the odious McCarthy regime in America - the so-called "Un-American Activities Committee"; and that Mr. Tyndall in his recent television appearance spoke of "getting the Reds out of the media and out of politics". How? By the denial of freedom of speech and expression? This is something else I couldn't support; because this would then no longer be the British way of life.

I therefore propose to let my membership of the N.F. lapse; though not, I hope, the friendships which I have made in the N.F. with yourself and the other members I've met. Maybe at some future time a different attitude in the N.F. may prevail, and things will change.

Meanwhile, I remain
Yours sincerely,
Doreen Valiente [10]

This letter is interesting in that, despite its forthright nature, it is somewhat muted. Doreen does not resign from the National Front: she just proposes to let her membership lapse. And she

[10] letter Doreen Valiente to Edward Budden 12th October 1974

refers to friendships she has made and valued during her time as a member.

She still wants a party that fosters patriotism, democracy and the British nation, but is clearly diametrically opposed to their ideas on social issues generally, as well as their support for the Mc-Carthy regime in America.

Doreen clearly held out some hope that the National Front might change in a more favourable direction as far as she was concerned, but there is no evidence that she ever again took any interest in the party.

I think this whole episode demonstrates clearly Doreen's approach to any situation. Give them the benefit of the doubt to start with, but find out as much background material as you can. I think she so **wanted** the National Front to be the political wing of the Old Religion, that she overlooked some fairly obvious stumbling blocks which she eventually came up against.

Then again it may be that, following her wartime service in what seems to have been intelligence gathering, she undertook investigations from time to time for the authorities. The early 1970s was a time of resurgence for the National Front and I suspect that Doreen may have been asked to keep an eye on the local branch. She was obviously good at avoiding suspicion and therefore of-- fered to design a banner and made friends with several other members.

Her resignation letter is, to my mind, cleverly designed to suggest a disagreement with certain aspects only of the Party so that her resignation could be achieved without anyone suspecting that she could have been a 'spy'.

Poet and biographer, Grevel Lindop agrees with this view:

> Intelligence departments never really let you go completely. They certainly collected information about both extreme right wing and left wing organisations at the

time, and they looked for people who could plausibly infiltrate these groups without arousing suspicion. Doreen would have been perfect. And ... she manages to detach herself eventually in a completely principled and yet inoffensive way that avoids any ostentatious 'break' with the group: her letter takes her completely out of the organisation, yet doesn't make a drama out of it; and at the same time a copy of the letter could have been produced at any time, if need be, to show that she was not in any way a fascist. There is careful thought and planning behind it.[11]

If Doreen were around now, and thinking of her expressed opinions about our relationship with the land and nature, she might perhaps look to the Green Party as being a more fitting political wing of the Old Religion. I like to think that, at any rate, she would have been pleased that Brighton was the city which elected Britain's first Green Party MP in 2010.

[11] email from Grevel Lindop to the author 23 March 2015

Chapter 13
Lines: on Land and Paper

Doreen is best known today for the books which she wrote about the Craft, and it was in the 1970s that her output flourished most fully. Anyone reading Doreen's books will testify to her skill: they are still some of the most readable on the subject of witchcraft and paganism. This is evident even in her first book, *Where Witchcraft Lives*[1], which strongly suggests that she was an accomplished writer well before that book was published.

Doreen had written articles about the Craft back in the 1950s when she was helping Gerald Gardner. One article, entitled "Witchcraft in Britain", was published in *Psychic News* on 23rd July 1955, and I am pretty sure that the article entitled "The Triad of the Goddess", attributed by some to Gerald Gardner, was actually written by Doreen. And I have already mentioned that several chapters of Gardner's book *The Meaning of Witchcraft*[2] were actually written by Doreen.

However, it was really only after her manuscript for *Where Witchcraft Lives* was accepted by Aquarian Press in 1961 that Doreen

[1] op. cit.

[2] op. cit.

started to seriously consider writing articles on a regular basis. In July 1961, she obtained details from *The Countryman* and *Prediction* magazines about the length of articles they required, and also found out some of the principles of copyright law.

Her early articles seem to have been based on her forthcoming book, *Where Witchcraft Lives*. In Spring 1960 she wrote an article for *Light* entitled "Witchcraft in Sussex" and in September 1961 she had an article published in the popular magazine, *Fate*, entitled "Does Witchcraft Still Live?"

Expanding on this, her next articles were largely general ones on the subject of witchcraft, such as one on "White Witchcraft in Britain" for *Fate*, but other articles which she planned in the 1961-63 period included "The Evil Eye", "Herbs of Magick", "History and the Zodiac", "Moon Magic and the Moon Goddess" and "Witchcraft at Your Window" about magical pot-plants and objects standing in a window, such as horseshoes and witch stones.

Doreen had always been interested in a wider field of study than witchcraft in Sussex. During the time she was collecting material for *Where Witchcraft Lives* she was also noting down in her notebooks and collecting cuttings in her scrapbooks on a wide variety of topics. Witchcraft, of course, but also anything of an occult nature.

As she accumulated material, Doreen got to the stage where she started to write about many of these ideas, both in possible articles and in projected books. With the added confidence of a few published articles, Doreen expanded the range of subjects which she wrote about, all linked, however, if only indirectly, with witchcraft.

Doreen used her notebooks to write 'mini-essays', some of which ended up as magazine articles or expanded into chapters of future books. These often started as a brief note giving a title and the comment "Suggestion for article". These became particularly frequent in 1968, numbering 19 in that year alone, and one magazine

stands out above all other: *Prediction*. Founded in 1936, it covered not just astrology, but all aspects of what might be called the psychic realm, and would definitely cover the topics that Doreen was interested in writing about.

The first mention of what became an unfulfilled project throughout the rest of her life was a proposal put forward in March 1963 for an article on 'Witchcraft on the Map', a study of place names with witchcraft associations.

From 1965 onwards, Doreen began to approach wider-circulation magazines such as *Prediction*, *Argosy* and *Reveille*, journals that would pay for articles. One typical note, for December 1967, read "Idea for article for Fiesta or similar magazine: "Naked Magic" (ritual nudity through the ages)".

With growing confidence, Doreen wrote articles in the late 1960s covering a wide range of subject matter, including Robert Graves' "The White Goddess" and the occultist, Aleister Crowley - "Was He the Wickedest Man in the World?" She still kept to her main subject, however, with "What is a Coven?" and started on a path which she would pursue for many years - "Paganism and the Future".

By the summer of 1968, the ideas were coming thick and fast. In the month of August alone, Doreen had suggested articles for *Prediction* on Sacred Caves, Sacred Mountains; the Saxon and Norse contribution to the Mystic traditions of this country; Antiques and the Occult; The Awen of the Druids; "White Magic - The Power of Thought" and "The Great God Pan". These were followed the same autumn by suggested articles for *Prediction* on "Amulets and Talismans" and "The Magic of Fire".

How many of these saw their way into print I am not sure, and I am leaving it to future investigators to produce a definitive list. What is certain is that, published or not, many of her articles provided much of the source material for Doreen's subsequently published books.

As well as writing articles, Doreen started to appear on radio and television. One of her earliest appearances was on the local television station quite some time before her first book had been published. On 3rd October 1961, Doreen was interviewed on Southern TV. She gave her interviewer, Dickie Davies, a witchstone amulet for luck. She wrote: "He said he wanted to be a star - nowadays he is! (as sports commentator)".

Doreen then became almost a regular on the local radio station, BBC Radio Brighton. And on at least two occasions, Doreen was heard throughout Britain and throughout the world. On Friday 22nd August 1975, Doreen appeared on the prestigious BBC Radio 4 series, Woman's Hour, where she was talking about "Natural Magic", presumably to coincide with the publication of her book of that name. "Doreen Valiente says magic is all around us - all we need is the ability to see and understand."

On 5th July 1976, Doreen appeared on a BBC World Service Feature radio programme - "More Things in Heaven and Earth - Part 4 - Witchcraft". Others who appeared on the programme included psychologist, Chris Evans and anthropologist, Jean La Fontaine. Doreen gave a general outline of witchcraft as she had experienced it:

> *Witchcraft is an intangible thing, very much involved with the emotions ... We do dance in the nude, and jolly good fun too! We enjoy it enormously, if it's not too cold, of course. If it's cold, we wear black cloaks, which originally were used for camouflage, to slip through the shadows in the moonlight, so we wouldn't be seen ... We drink a toast to the old Gods. We make up our minds beforehand just what we're going to do, that we're going to, say, try to help somebody who's in a jam, we're going to have some sort of magical experiment that we're going to do - scrying to perhaps get a glimpse into the future ...*[3]

[3] transcript of BBC World Service radio broadcast 5th July 1976

She continued:

> *The circle of the coven is between the worlds. But when you get a really good magical ritual going, you get into a kind of borderland, where one dimension, if you like, can communicate with others, because I think there are other dimensions, and we can communicate with these dimensions. People used to call them the Land of Faery, the Spirit World and that kind of thing, or the Astral Plane as some occultists call it, but there is a borderland, and when you enter a good magic circle you deliberately make for yourself a kind of intermediate space between the worlds, and strange things happen.[4]*

Following the death of her mother in August 1962, Doreen felt that she could be more open about being a witch herself. *Where Witchcraft Lives* was about to be published, so she couldn't change her stance in that book as the "interested observer", but by 1966 she had produced the complete manuscript of a book entitled "I am a Witch"! The concept of such a book dates back to at least August 1964, when she was planning an article for *New Dimensions* to be entitled "My Life as a Witch".

The book starts with Doreen's account of how it came to be written:

> *I have been a witch for thirteen years. All the poems in this book have been inspired by my feelings and experiences as a witch. This book started as a collection of poems. Then I decided to write an introduction to them, saying how they came to be written; and this extended itself into a Devil's Dozen of chapters.*
>
> *The first part of this book, therefore, is intended to give an outline of witchcraft today, as seen by one who is a witch herself. By reading it, people may be able to understand*

4 ibid.

what it feels like to be a witch in twentieth century Britain; and to know the circumstances in which my poetry has come to be written. They may gather from it also something of what witches really believe and do.[5]

The collection of poems mentioned is not with the manuscript, and it was only in the years following Doreen's death that such a collection was eventually published.[6] Some of these are numbered and these could have been intended for publication as part of "I am a Witch".

"I am a Witch" is, however, far more than an introduction to the poems, being a book in its own right, of some 50,000 words. It is very wide-ranging and includes material that Doreen subsequently brought into use in *An ABC of Witchcraft Past and Present*[7] and later books.

Whilst it is very interesting, it is not really that well structured, being largely just a compilation of the various topics upon which she made notes over the years. "I am a Witch" was never published.

As we shall see in Chapter 15, Doreen considered her poetry to be important and made several unsuccessful attempts to get it published. This is no reflection on its quality, as poetry is notoriously difficult to interest a publisher. So she seems to have shelved both the poetry and the introduction but to have used extracts from both in her future books.

———————————— ··••◆••·· ————————————

Doreen was always open to new subjects and topics which seemed to her to illuminate further the vision of witchcraft presented to her by Gerald Gardner and others.

[5] *I am a Witch*

[6] Doreen Valiente *The Charge of the Goddess* op. cit.

[7] Doreen Valiente *An ABC of Witchcraft Past and Present* (Hale 1973)

Following the death of her husband, Casimiro (see Chapter 20) in 1972, Doreen felt able to undertake new ventures: "Being on my own, I could start writing seriously. Also exploring pagan Sussex in the light of the new information in "The View Over Atlantis" about ley-lines".[8]

This was a topic which loomed large in her imagination during those creative days of the early 1970s: leys - the old straight tracks discovered by Alfred Watkins of Hereford some 50 years previously. These were viewed with great scepticism by orthodox archaeologists, but this fact alone would not have quelled Doreen's interest.

Doreen first noted in February 1969 an article about alignment of ancient sites which had been found in south Wales by one John G Williams of Abergavenny. But it was not until two years later, when Doreen read John Michell's *The View Over Atlantis*[9], that she realised the context within which leys could be seen.

It was a wide-ranging book, covering not just leys but sacred geometry, alchemy and legend, particularly relating to ancient sites. The implications of the book were that the Earth was alive, that the 'earth spirit' could be experienced at ancient sites and that therefore the leys were more than just trackways but conduits of this 'earth spirit'.

At some point in 1971, Doreen became aware of *The Ley Hunter*, a small magazine which I had started in 1965 and which by then was being edited by a journalist from Hartlepool, Paul Screeton. She took out a subscription and by November of that year she was writing an article for the magazine, though this appears not to have been completed for another two years.

It is perhaps indicative of Doreen's wide interests that the articles that she had published in *The Ley Hunter* were not exclusively

[8] *Have Broomstick Will Travel*

[9] John Michell *The View over Atlantis* (Sago Press 1969)

about leys that she had discovered. They included an article about the traditional game, Nine Men's Morris, and one about the old dragon effigies which are paraded on special occasions in Norwich. She notes that Alfred Watkins wrote about a ley which runs through Norwich, and links these two themes together by writing about the "dragon power" which was thought to flow along the leys.

Doreen also used her reviewing skills by assessing a rather strange magazine for *The Ley Hunter*, entitled *Witchcraft*. It was obviously not at all to her taste, as she ended her review by recommending a brief selection of books which, in her opinion, would help the reader to "learn something about witchcraft".

She also made comments on topics that were raised in issues of *The Ley Hunter*, including a response to an article about the ancient site of Brighton, giving a lot of the background information which she had accumulated and the connection of local sites with possible leys.

Reading through the pages of *The Ley Hunter* must have fired Doreen's enthusiasm, because she immediately purchased some large-scale Ordnance Survey maps of Brighton and the nearby South Downs. She describes this as being "for further research for 'The Ley Hunter'".[10]

In January 1972, Doreen had what I imagine was great fun drawing pencil lines on her maps of the Brighton area indicating possible alignments. She also read quite extensively and came across Donald Maxwell's *A Detective in Surrey*[11] which, amongst other things, gives an account of leys which he had found in the Newdigate - Charlwood area. This interested Doreen particularly, because of the connection of that area with Charles Cardell and the Coven of Atho (see Chapter 9), and indeed with her own childhood.

[10] Doreen Valiente *notebook no. 56* 23 November 1971

[11] Donald Maxwell *A Detective in Surrey - Landscape Clues to Invisible Roads* (The Bodley Head 1932)

Doreen discovered one ley, which she describes as follows:

> There are so many earthworks and tumuli out on the
> Downs above Brighton that one is confused by their
> abundance. Nevertheless, it can be shown that three
> tumuli, the one on the summit of Round Hill and two more
> beyond, may be joined in a straight line with the hill on
> which St Nicholas' Church, Brighton, stands; and this line
> may be continued to the Old Steine, passing by the stone
> that is set into the wall in Air Street. The other end of the
> line proceeds to the edge of the Downs, where it slants
> down to a crossroads. Exactly above this crossroads, on
> Edburton Hill, is something marked on the map as a
> "motte & bailey". But between this point and the first of the
> tumuli, counting towards the sea coast, rise two great
> shoulders of downland called Perching Hill and Fulking
> Hill. If more way-marks can be found in this area, we could
> consider this a possible ley; though, of course, it needs to
> be checked from nature, not merely drawn on a map.[12]

It was not until May of the following year that Doreen embarked
on her first ley-hunt. She had found on the map an alignment
which started at St Nicholas' Church, Brighton, went through part
of Hollingbury Castle Camp, ending at Rocky Clump, to which I
refer in Chapter 8. The line also went through another church
marked on the map, which turned out to be a large Victorian
Baptist Church dating from 1897. As Doreen says:

> ... it could occupy the site of something much older. It is
> on the side of a ridge of downland, rising between the hill
> of St Nicholas' Church and Hollingbury Castle. Ditchling
> Road runs along the summit of the ridge, and there are
> spectacular views into the valleys below, and across to
> Whitehawk Down.[13]

The line finished at 'The Gote' (an old Anglo-Saxon word for a
spring), a house at the foot of the Downs. Its resident told Doreen
that he had found the remains of an older building on the site.

[12] Doreen Valiente "More About Old Brighton" in *The Ley Hunter* no. 43 May 1973 pp 4-6

[13] Doreen Valiente *notebook no. 60* 16 May 1973

Doreen later revised the line, so that it went through Preston Circus, an ancient crossroads, rather than the Baptist Church. She thus had five points on the line and wrote: "According to Alfred Watkins, four points are the minimum to prove a ley. Here we have five."[14]

Doreen was convinced of the line's reality, although the accuracy of alignment and the significance of the points on the line would have left considerable doubts in the minds of most ley-hunters of the period that either of the lines presented by Doreen represented a valid ley.

Another landscape pattern which Doreen found on the Downs is the so-called "Dragon's Eye". She got the idea initially from a book by Janet and Colin Bord. Referring to the carvings on the pillars of Durham Cathedral, they write:

> *A vertical line of lozenge shapes with their points touching is a symbol of etheric energy, and has been likened to the double helix of the DNA spiral, a basic carrier for the subtle life energies. Some occultists also term the symbol of a lozenge divided by a horizontal bar as a 'dragon's eye', perhaps another link with the lifegiving 'dragon power' to be found on ley lines and at ley centres.*[15]

Doreen enlarged this concept to incorporate landscape patterns, and proposed a 'dragon's eye' shape on the Downs formed by the four ancient sites at Chanctonbury Ring, Cissbury Ring, Lancing Ring and Steyning Church, the site of an ancient standing stone. I don't think that Doreen's investigations got much further than map observation, for she states:

> *The line between Cissbury and Steyning passes over Steyning Round Hill. This looms above the little town, with roads leading to it. The line passes exactly over a place where four trackways meet. This should be investigated.*

[14] Doreen Valiente *notebook no. 62* 23 April 1974

[15] Janet and Colin Bord *Mysterious Britain* (Garnstone Press 1972) p 145

The line between Lancing Ring and Chanctonbury also passes over a meeting-place of trackways, at the side of something marked as the 'Cross Dyke'. Near Chanctonbury, at the other end, is yet another crossroads on this line, and this one is marked by 2 tumuli. The whole area is downland, that is, alternate hills and valleys, and strangely contoured countryside. But the old sites certainly make this figure.[16]

Doreen goes on to liken the pattern to a St Andrew's Cross, the saint to which Steyning Church is dedicated.

I remember, some 12 years before this, being excited by being told about leys by Tony Wedd, of Chiddingstone, Kent, who had discovered leys on the Kent-Sussex border, originating in the prominent pine clump of Gills Lap on the heights of Ashdown Forest.[17] He had associated what became known as 'earth energies' with the leys, and this is what interested Doreen. She believed that the witches had met at ancient sacred sites and speculated that the 'earth energies' could in some way augment the energy used in such rituals as the raising of the Cone of Power.

I was over-enthusiastic, drawing a lot of lines on the map, but it got me out into the countryside looking at ancient sites and observing their relationship to the landscape. Similarly, I think Doreen's imagination rather ran away with her in her claims for leys and other patterns in the landscape, but it did inspire in her a renewed interest in the land and she continued her investigations into the countryside of Sussex and surrounding counties for many years. Certainly, the interest in leys was, for a while, an important one for Doreen. She began afresh to explore pagan Sussex with the added insights which a knowledge of leys provided.

[16] Doreen Valiente *notebook no. 60* 19 May 1973

[17] Tony Wedd *Skyways and Landmarks* (The STAR Fellowship 1961)

Over a long period of time, throughout most of the 1960s and early 1970s, Doreen became a regular visitor to the Brighton Reference Library and got to know the librarians there very well. All the time she was making notes of items of interest, not just on her chosen subject of witchcraft but on all sorts of peripheral subjects.

Well before *Where Witchcraft Lives* was published, Doreen was already thinking of the possibility of another book, though it was to be a very long time in gestation. In a sense, it was a continuation of the articles which she had written, and was continuing to write, on witchcraft and allied topics.

Back in 1963, she had thought about possible publishers who might be interested in occult manuscripts. There were a dozen or so on the list, one of which was Robert Hale, who would become her publisher and remain so for the rest of her life.

By the summer of 1966, Doreen had enough material to start writing a book on it all. At first, I think Doreen was uncertain what approach the book would take, as her first suggested title - "Witchcraft and the Magic Arts" - would suggest. Various titles came to her mind: "A Little Book of Witchcraft"; "Witch Magick"; "The Witch's Craft"; "Witches' Cauldron" were among the possibilities. The form of the book also gradually came into focus. The title was to be "A Cauldron of Witchcraft" and Doreen noted that it "could be a mixture of fact and fiction" and that she aimed to "make it popular, not erudite".

Having accumulated such a wealth of material closely or indirectly related to witchcraft, I suspect that Doreen decided that the idea of a structured step-by-step exposition of the subject was too much for her to cope with, and fell back on an encyclopaedic approach.

Once Doreen had made this decision, the title of the book followed reasonably quickly. By October 1967, she was calling the book "The Witch's Word Book - A dictionary of witchcraft": it was to consist of articles on words connected with witchcraft.

At some stage, Doreen approached the publisher, Robert Hale, and they obviously liked what she presented them with: a book on witchcraft in the "ABC" format. It seems as if they required four subject-essays from Doreen before giving her the go-ahead. These were an abstract subject, a place, an object and a biography. Doreen chose and submitted essays on, respectively, "The Astral Plane", "Witchcraft in the Cotswolds" and "Fossils used in Magic". The biography was probably her own.

Her essays were obviously successful because Hale offered Doreen a contract, which was signed on 3rd March 1969, and she spent most of that year and the next compiling what was to become *An ABC of Witchcraft Past and Present*. In the autumn of 1970, she submitted a draft of the manuscript to the publishers.

There seems to have been no great hurry for the book to be published, as it was to be another two years before it appeared on bookshop shelves. Items continued to be added in and amended throughout 1971 and 1972, page proofs were altered and an index prepared.

On thinking of how to describe the book, my mind went back to a review which I wrote for *The Ley Hunter* in 1973. Re-reading it, it seems to me to still be relevant over forty years later. Admittedly, it is in parts over-personal and somewhat over-emphasises the significance of leys (not surprising considering where it appeared) but I think it is worth quoting in full, for which I hope the reader will forgive me:

> *When a book first makes its presence known to me impinging on my unconscious mind to the extent that I awake with the firm impression that if I go to the local bookshop I will find a new book on witchcraft, that it will be hardback and that it will be a certain size, and that the impression was later verified in detail when I find the very book in question the same day, I may be justified in thinking that the book may be worth reading. The above incident happened to me previous to buying "An ABC of*

Witchcraft Past and Present" by Doreen Valiente. I was at the same time surprised yet not surprised to see the book there before me on the shelf.[18]

Indeed, I discovered recently that Doreen herself had had a similar experience. Writing about precognitive dreams, she says:

... to take a typical example, which happened to me some years ago. At the time, I was making a close study of the Tarot and the Qabalah, and was anxious to acquire any books on the subject I could get.

I dreamed one night that I went to a second-hand bookshop I often bought books from. Looking along the shelf where the books on occult subjects were kept, I saw a large, though thin, red-covered book which contained information upon the Qabalah; and as it was very moderately priced in the dream, I bought it.

Awakening the next morning, I remembered my dream. I had had a number of precognitive dreams, and learned to take notice of them. So as soon as I could, I got down to the bookshop and searched along the shelf marked "Occult". But though I looked there carefully, there was no sign of the book of my dream. I went home again rather crestfallen. The oracle had not worked.

A fortnight later, I went into the same shop, and looked on the same shelf. There was the book! It was a copy of Knut Stenring's translation of the Sepher Yetzirah, or Book of Formation. Its appearance was exactly that of my dream, and I got it for a few shillings.[19]

To continue my review:

I knew from my previous knowledge of the author that the book would be a good one. Having read her earlier book about witch legend and reality in Sussex, "Where

[18] Philip Heselton review of *An ABC of Witchcraft Past and Present* by Doreen Valiente in *The Ley Hunter* no. 45 July 1973 pp 11-12

[19] *I am a Witch*

Witchcraft Lives", her address to the "Pentagram" dinner and her recent articles in such publications as "The Ley Hunter", I knew that the book would present a fair, sensible, interesting and knowledgeable account of the Wiccan religion, both its historical background and its standing as we enter the last quarter of the twentieth century. And so I bought it, and so the book proved to be.

A normal book relies heavily on its pattern to reveal its message - the necessary form of the ABC type of volume means that it can only rely on the emphasis given to various items by the author to give it overall shape or coherence. In this Doreen Valiente succeeds well. The range of subjects covered is really immense and reveals the breadth of studies into which the author has delved. It would be impossible even to touch on these: ley hunters tend to be interested in the whole scope of witchcraft as being one of the channels by which knowledge of the occurrence and purpose of the ley power has been handed down to us. Nevertheless there are some items which seem of particular relevance.

There is much mention of places and powers - powers which Doreen Valiente brings together under the name "Quintessence", one used by the ancients for the same force that today we might call prana, orgone energy, mana, vril, odyle, vis medicatrix naturae and by many other names, including ley power. It is the fifth element, beyond earth, air, fire and water. It is the universal life energy which is sent out by the sun and reflected by the moon. The energy which Wilhelm Reich saw glowing blue inside his orgone accumulator and which the witches see glowing with the same colour within their magic circle, rising above it to form the silvery blue Cone of Power.

The places of Britain too are here in force: places which have become familiar through other associations - ley ones. Hill tops and standing stones, tree clumps, stone circles and crossroads - the very marks which guide us along the leys are those which have been, and in some

cases still are, significant witch meeting places. What better evidence could we have of the way in which our two subjects are interwoven? The Rollright Stones are here, of course, and Pendle Hill, scene we are reminded of George Fox's vision of a people in white. Was there indeed some psychic atmosphere lingering from days of long ago? Sussex and the Cotswolds are strong in witch tradition and in leys and both are featured: Chanctonbury Ring and Wych Cross on Ashdown, Seven Wells near Chipping Campden and the Bambury Stone on Bredon. The New Forest is represented too by the Wilverley Post and the Naked Man. It is strange now I come to think of it that over 12 years ago I camped in successive summers on the slopes of Bredon and within a mile or so of the Naked Man. On the first occasion we missed the rival attraction of the Sunday evening church service because we had climbed to the top to see the Bambury Stone at close hand - an odd place altogether and I wouldn't mind going back again some time. They say one can see 12 counties from the top. I still think we made the right decision that day - must be something deeply imbedded in the unconscious.

And there's plenty of that in this book as well - the way in which modern psychology, and particularly that of Jung with his concept of the "collective unconscious", throws light on the reasons for many of the old witch beliefs in a way which is acceptable to present day readers. I would personally welcome a further book by Doreen Valiente on this very aspect, on the present practices and beliefs of witches in Britain, of their links with the land and the ley power, and an assessment of the likely future of the Old Religion. This present volume, however, really does contain a wealth of useful and interesting material, of which the above words must fail to be considered even an outline.[20]

It is perhaps rather presumptuous on my part, but I like to think that Doreen may have read those last comments on the present practices and likely future of the Old Religion (for she was a

[20] op. cit.

subscriber to *The Ley Hunter*) and that this may have been the inspiration for what eventually became *Witchcraft for Tomorrow*.[21]

There is, of course, a lot more to *An ABC of Witchcraft Past and Present* than was covered in my brief review. I suspect that Doreen had three immediate resources to work with as she compiled the book (and "compiled" here is probably a better word than "wrote"). I have already mentioned her notebooks, where she noted down points of interest during her library researches, in some cases turning them into mini-essays, which could be used without much alteration as entries in the *ABC*.

I have also mentioned her scrapbooks, where, since the early 1950s, she had been collecting newspaper and magazine reports and stories, and, as these accumulated, they formed a valuable resource. They also form a valuable resource in that they show what items Doreen considered of sufficient interest to stick in her scrapbooks.

The third resource would have been some sort of loose-leaf file where Doreen would have gradually compiled entries to go into the book. I have not found such a file, but that is the way I would have gone about it! Indeed, once a typed first draft had been completed, Doreen would probably have recycled such a file to avoid being overwhelmed by piles of paper!

Doreen's essential purpose in writing the *ABC* was to provide the reader with more information about the different aspects of witchcraft, its history and revival, some of its beliefs and practices and a selection of the multitude of people, places and ideas which have been associated with it. The publicity material accompanying the book put it succinctly:

> *It is intended to be not merely a history, but a guide to the many strange byways of a vast and fascinating subject. Witchcraft is as old as the human race, and it is actively*

[21] Doreen Valiente *Witchcraft for Tomorrow* (Hale 1978)

practised today, by people of all classes. To its devotees,
witchcraft is more than spells and charms, or even secret
meetings and rituals; it is a philosophy and a way of life. It
claims to be the oldest form of religion, that of nature-
worship and magic.[22]

To give even some idea of the topics covered in the book requires me to impose some sort of structure to the entries. When this is done, we can perhaps discern some categories into which the book could be subdivided.

Firstly, there is an examination of witchcraft as a historical phenomenon, covering such topics as the Evil Eye, the Devil's Mark, Flying Ointments, Charms and Amulets, and Cats as Familiars. Deities such as Diana, Aradia, Artemis, Janicot, Baphomet and Lilith are dealt with, together with historical figures such as John Dee, Dame Alice Kyteler, Matthew Hopkins and Sir Francis Drake. A broad range of magical and esoteric topics are covered, including the Astral Plane, Reincarnation, Ceremonial Magic, Palmistry, Tarot cards and Numerology.

The greatest number of entries in the book is devoted to the various aspects of present-day witchcraft, covering its basic beliefs; the coven, initiation and ritual nudity; ritual tools such as the athame and cauldron; seasonal rituals such as Halloween and Yule; the sabbat and esbats; and magical techniques such as divination, scrying and hypnosis. As I mentioned in my review, there are also references to places associated with witchcraft, and individuals who played a part in its revival, such as Gerald Gardner.

When I first read the book in 1973, it was the details given about present-day witch practice which interested me most. At the time, such information was difficult to obtain, and therefore the book had more impact on me than it would do to the present generation of enquirers, who have far more material available, on the internet and elsewhere.

[22] Flysheet for Doreen Valiente *An ABC of Witchcraft Past and Present* (Hale 1973)

Nevertheless, it is a good book, one that was a worthy outlet for the store of material which Doreen had spent the previous 15 years accumulating.

Chapter 14
"Who Initiated the First Witch?":
A Personal Manifesto

All the while that she was writing, Doreen was gaining in knowledge and confidence. Her experience with characters like Gerald Gardner, Robert Cochrane and Charles Cardell made her, I believe, turn increasingly inwards to her own thoughts on the Craft and on the land from which it grew. And I suspect that she kept in some sort of loose contact with independent practitioners of the Craft in Sussex and learned from them, not detailed rituals, but an approach to magical practices and to the land itself which blended well with her own feelings.

As acknowledgement of her growing confidence in her own view of the Craft and the land, Doreen wrote two books which really sum up her ideas: *Natural Magic*, which was published in 1975, and *Witchcraft for Tomorrow*, which followed three years later.

These are, in many ways, Doreen's own personal manifesto, where she felt completely free to express what she thought about things, unencumbered by orthodoxies of any description.

I think it is significant that *Natural Magic*[1] is the only book of Doreen's which does not have the word 'Witchcraft' in its title. This is, perhaps, indicative of the inclusive nature of the book. It is, however, clear from what Doreen writes that she recognised magic as being at the heart of witchcraft.

At the time it was published in 1975 I think it is fair to say that there were no other books which gave good practical advice about working ordinary everyday magic using objects and concepts which were part of our normal life. This is what has sometimes been called 'low magic', to contrast it with 'high magic', which involves much elaborate ritual and magical paraphernalia. The book cannot be placed exclusively in either of these divisions, although there is a definite bias in favour of the former. Its subject is, indeed, the magic of nature.

Doreen was therefore appealing to a wider readership than those who might be witches or be primarily interested in witchcraft. The book was intended to appeal to all who wanted not just to understand how the subtle energies worked in our environment, but to practise magical techniques in their everyday lives. She acknowledged that magic was at the heart of witchcraft but saw it as underlying a far wider approach to life.

Doreen reveals her purpose in writing the book in its Foreword, where she says: "I wanted to show people that magic is for all, as nature is for all".[2] She made clear that magic does not require one to join a secret fraternity, acquire a lot of expensive paraphernalia or pay a lot of money for training in basic techniques. Rather, she emphasised that magic is all around us and that it can be practised by using everyday objects and experiences. A sensible approach was, however, called for:

[1] Doreen Valiente *Natural Magic* (Hale 1975)

[2] op. cit. p 10

Many people will tell you that occultism, witchcraft and magic are dangerous. So they are; so is crossing the road; but we shall not get far if we are afraid ever to attempt it. However, we can choose either to dash across recklessly, or to use our common sense and cross with care, and so it is with magic. It is often argued, too, that magic can be used both for good and for evil. Of course it can; so can electricity, atomic power, television, the power of the press, indeed anything that has any power in it at all.[3]

It is significant that the first chapter of the book is entitled "Magic of the Mind", and the chapter starts by explaining why:

What does one need to work magic? Many of the old books called grimoires, secretly handed down through the centuries, tell their readers of most elaborate requirements for the rites of magic. They describe consecrated swords, wands, pentacles and so on, together with rare incenses and other strange formulae. But the greatest adepts in the magical art have also made it clear that all these things are but the outward trappings. The real magic is in the human mind.[4]

Doreen refers to the mind as "the greatest instrument of magic" and gives as examples not only the way in which clouds can be split by the power of the mind, but also the way the witches of the New Forest raised the Cone of Power in 1940 to send a thought form to Hitler to counteract his threatened invasion.

Doreen shows how the origin of magic in the power of the mind was known about in ancient Greece and Egypt amongst other cultures, in the secret teachings of the magical order of the Golden Dawn in the late 19th Century, and in the writings of the American folklorist, Charles Godfrey Leland. She implies that this knowledge, that the mind underlies all magic, was prevalent in many other cultures and ages.

[3] op. cit. p 11

[4] op. cit. p 13

Taking this view of magic as being the result of the workings of the human mind, Doreen devotes the rest of the book to examining the various fields of everyday life in which it can operate and some of the techniques which can be used.

Having given due precedence to the magic of the mind, Doreen proceeded to examine an ancient way of seeing the universe, and that is in terms of the four elements - earth, air, fire and water - and the principle of aether, which lies beyond.

Doreen showed how one can use the elements in a practical way when working magic. For fire, candles are a key feature of most Pagan rituals and activities and Doreen gives a method of candle magic in sufficient detail for anyone to follow. She also mentions the even older techniques of scrying in the embers of a fire.

Just as ancient was scrying in a bowl of water, something which pre-dated the crystal ball, but which used the same technique. Air magic was the act of meditation and becoming aware of one's breathing and the subtle energy of prana, and earth magic could be felt by walking or dancing barefoot on the grass and following the shapes in nature with one's eyes. The sounds of fire, flowing water and the wind can help us to attune to the individual elements.

Doreen ends her chapter on the magic of the elements by stating: "By using our five senses rightly, the inner sixth sense is added to them."[5]

Another abstract principle is used in the magic of number. Doreen explores the underlying meaning of different numbers, something which is eternal but which can manifest in human terms, and shows how the practice of numerology has emerged from this to have practical application in terms of names and dates.

The magic of colours is something which surrounds us constantly and Doreen shows how colour can be used in magical practice.

[5] op. cit. p 33

Colour has an effect on us and individual colours can be used to achieve a particular magical effect. She mentions the parallels in the human aura and the chakra system, each colour having its characteristic influence.

Traditional country people used plants and flowers, not just for a huge variety of different methods of healing but for what Doreen called "green magic": using plants and trees and extracts from them where their particular characteristics could be used magically.

People have lived interdependently with birds and animals since ancient times and many of their gods and goddesses have incorporated the nature of those birds and animals, such as Pan. To take on the character of such beings, people have dressed up in cloaks and masks to imitate them. Doreen also mentions the Abbots Bromley Horn Dance, where ancient antlers were used in imitation of the horned god. Indeed, the Head of Atho, to which I refer in Chapter 9, was one such example. She mentions witches' "familiars": animals (often cats) which would play an important part in a witch's magic.

Weather magic is one of the most established of magical techniques, dealing as it does with something that is essentially fluid and thus more easily influenced. As well as mentioning a variety of weather lore and the traditional ability of witches to raise winds, as with the wind which scattered the Spanish Armada in 1588, Doreen also refers to the interesting idea that Morris dancing was originally intended to influence the weather.

An important section of the book is devoted to the magic of sex. Doreen starts by emphasising that in ancient times sex was considered a positive thing, referring to the carvings of sexual congress in ancient India and the underlying meaning of the Yin and Yang symbols. She refers to the prevalence of ritual nudity and magical rituals involving the mingling of sexual fluids.

Dream interpretation had been a feature of several ancient

civilisations, such as the Greeks and the Romans. Doreen, however, appreciated from her own experience that precognitive element that sometimes appears in dreams, and we have already seen in her own life dreams that she had about the flying bombs in London (Chapter 4) and her vision of a book on the Qabalah (Chapter 13). Doreen proceeded to tell of where ideas or inspiration could come through in a dream and gave further examples of precognitive dreams.

Talismans and amulets, objects with magical properties which can protect those holding or wearing them, are very ancient magical devices and I suspect that Doreen got much of her knowledge about them from Gerald Gardner, who had given a lecture on the subject to the Folklore Society. She describes the use of precious and semi-precious stones and different symbols in the preparation of talismans and amulets devoted to specific magical purposes for an individual needing them.

The use of cards is an old divinatory technique. Whilst the Tarot pack is commonly used by magical practitioners, the normal pack of 52 playing cards can be, and has been, used for divinatory purposes by the ordinary people.

Doreen then briefly examines traditional spells contained in grimoires or enshrined in folk custom. She finishes the book in the same way that she started it: with the importance of the mind in magic:

> The list of traditional charms and spells could be continued almost indefinitely. One principle, however, emerges clearly. That is, that what matters in casting a spell is the amount of personal effort, faith and belief that the person concerned puts into it. There is a certain old proverb that is true, both for good luck and bad: There is no one luckier than he who thinks himself so.[6]

The monochrome illustrations are of variable quality, one or two per chapter. Most are taken from 19th Century books on

[6] op. cit. p 144

witchcraft and associated subjects, but four are drawn by Doreen herself, being magical designs incorporating much of the symbolism of the subject matter of the particular chapter. They are printed with a blank page on the reverse, which does not make a lot of sense with the thickness of paper used in the book.

In a recent poll on a social networking site, there was one book of Doreen's that was overwhelmingly chosen as the readers' favourite, and that was *Witchcraft for Tomorrow*, published in 1978. Indeed, in some ways this might be considered her 'magnum opus'; the work which represents what she wanted to say to those who were interested in finding out more about the Craft.

The first mention of such a book is in the summer of 1974, when Doreen's notebook entry reads: "Idea for book "Start Your Own Coven". If people want to worship the Old Gods and make magic, why shouldn't they? After all, who initiated the first witch?"[7]

The following month, Doreen had clarified her ideas, although the title was still to be decided:

> *Idea for Book - The Private Witch. How to initiate yourself and practise witchcraft ... if such a book were written, using only my original material (rituals, poems, etc.) and if this were admittedly so, its contents could be simply my copyright.*

> *All the information contained in the book would be a re-statement of what is already available, scattered throughout other publications; but now presented simply, understandably, literally, and purged of errors, inaccuracies and undesirable elements.*

> *It would cut out the ground from under the feet of the ego-trippers and commercialisers; because it would put the Craft of the Wise within the reach of all persons of good*

7 Doreen Valiente *notebook no. 62* 9 July 1974

will, and enable them to worship the Old Gods with
guidance. At the same time, it would enable Wisecraft to
take its place as part of the Western Mystery Tradition.

Isn't this worth doing, as a project for 1975 - the beginning
of the last quarter of the century, when traditionally an
impulse comes from the Inner Planes to speed up
evolution? [8]

By January 1975, the book was to be entitled "The Book of Wise-
craft: Start Your own Coven (Liber Umbrarum)" and the following
month, Doreen had sent a synopsis to Robert Hale. There must
have been a positive response to this, for on 5th March 1975,
Doreen writes: "Possible title for new book: "Witchcraft for To-
morrow". Required length about 70,000 words. Emphasis on
rituals."

And so, "Witchcraft for Tomorrow" it became.

Doreen spent the rest of 1975 and the first half of 1976 writing the
book. In July of that year she had the manuscript typed and the
following month it was accepted by Hale. *Witchcraft for Tomor-
row* was finally published on 24th February 1978.

Doreen had long emphasised in her writings that witchcraft had
its origins in humanity's most ancient religions, dating back to the
Stone Age, even if there was no direct and continuous line
through to modern beliefs and practices. However, it is clear that
this book lives up to its title in that it describes how witchcraft can
be a thriving religion in the future. This theme is emphasised right
from the start, where the Introduction begins with a forthright
statement: "This book is written as a contribution to the Aquar-
ian Age." Doreen then explains what she means by this:

Our planet earth has three kinds of motion: its rotation
upon its axis every twenty-four hours, giving day and night;
its orbit round the sun, giving the seasons of the year; and
the slow circling of its axis, like the motion of a spinning

[8] Doreen Valiente *notebook no. 62* 1 September 1974

top, which gives the apparent alterations of the poles of the heavens, and the shifting of the equinoctial point known to astronomers as the precession of the equinoxes.

This gives the Great Year, consisting of about 25,920 earthly years, during which the equinoctial point moves right around the Zodiac. The Great Year is reckoned to have twelve 'months', one to each zodiacal sign, each of which consists of about 2,160 earthly years. The equinoctial point is observed to move at the rate of about one degree in seventy-two years, the average span of a human life. This makes one 'day' of the Great Year, which has 360 'days', divided into twelve 'months' of thirty 'days' each, corresponding to the 360 degrees of the circle.[9]

Doreen then explained that this equinoctial point, which has been going through the constellation of Pisces for the past 2000 years, will shortly be entering the constellation of Aquarius, though opinions vary as to when this change will actually occur. She did, however, describe what she thought was happening:

All over the world, human society is in a state of flux. The forms of the old order are breaking down, so that those of the new order may be built up. The characteristics of Aquarius, the fixed sign of air, are very different from those of Pisces, the mutable sign of water.[10]

And, indeed, Doreen considered that the current revival of interest in witchcraft, magic and the occult was one manifestation of the start of the Aquarian Age.

Having put the Craft into the context of what she saw as changes in people's consciousness, Doreen devotes the rest of the book to what can best be described as a course of instruction. It is certainly something which can be, and has been, used as such by individuals or small groups.

It is important to remember that in 1978, it was very much more

[9] *Witchcraft For Tomorrow* p 11

[10] ibid.

difficult than it is today to make contact with others interested in witchcraft or even to get much practical information on the subject. Doreen felt very deeply that all who wanted to worship the Old Gods and practise the Craft should be free to do so, and she did what she could to encourage them by writing *Witchcraft for Tomorrow*.

It was not, I think, that she undervalued the advantages of being trained and initiated by others, albeit she had had some mixed feelings about such encounters in her own life. It was rather that she felt strongly that if individuals were attracted to the Craft, it was better if they were to come into contact with a sensible approach rather than some of the more outlandish ideas which had received publicity in previous years.

So, the book consists of eleven chapters, each on a different aspect of the Craft, and ends with what Doreen calls a Liber Umbrarum, or Book of Shadows. This is not to any extent copied from Gerald Gardner's Book of Shadows, but is Doreen's own work and is intended to give the reader something to work from rather than anything intended to be definitive.

Deities are central to most, though not all, religions, and Doreen states emphatically in the first sentence of her chapter on The Old Gods: "The gods of the witches are the oldest gods of all".[11] She refers to the horned god and the goddess of the moon in their various guises throughout recorded history, including the gods Pan and Cernunnos and the goddesses Artemis and Diana. After giving other examples of similar deities, Doreen puts an intriguing question:

> *Why should these two cult figures, the horned god and his consort, the goddess of the moon, have such importance that they, of all the pagan divinities, should survive as the deities of the witches?*[12]

[11] op. cit. p 23

[12] op. cit. p 27

She attempts to answer this and, in so doing, explores the nature of deity. The clue, to her, seems to lie in their primordial nature, their relationship to virility and human fertility.

She draws a parallel with the ancient Chinese system of Yin and Yang, with the twin pillars of the Qabalah and Freemasonry, and Jung's archetypes of the collective unconscious, amongst other religious systems.

Doreen praises the work of the occult writer, Dion Fortune (1890-1946). Citing her two novels, *The Goat-Foot God*[13] and *The Sea Priestess*[14] as bringing these two deities to life, Doreen says that Dion Fortune:

> *... discusses the real nature of the gods as 'magical images', made not out of stone or wood, but shaped by the thoughts of mankind out of the substance of the astral plane, which is affected by the energies of the mind The gods and goddesses are personifications of the powers of nature; or perhaps one should say, of super-nature, the powers which govern and bring forth the life of our world, both manifest and hidden. In other words, we live upon a plane of forms, superior to which is a plane of forces, upon which the gods move, because by personifying those forces to ourselves as gods we can establish a relationship with them. Moreover, when such a magical image has been built up and strengthened over the course of centuries by worship and ritual, it becomes powerful in itself, because it becomes ensouled by that which it personifies.*[15]

It is perhaps significant that, early on in the book, following the chapter on the deities, Doreen introduces the topic of Witch Ethics. She starts by dismissing Satanism as being a warped form of Christianity and nothing whatever to do with witchcraft. She goes on to show that most witches accept the principles of

[13] Dion Fortune *The Goat-Foot God* (Williams and Norgate 1936)

[14] Dion Fortune *The Sea Priestess* (privately printed 1938)

[15] *Witchcraft for Tomorrow* op. cit. p 30

reincarnation and karma and that the most fundamental witch ethical statement is the so-called Wiccan Rede:

> As Gerald Gardner says in his book 'The Meaning of Witchcraft', witches in general are inclined to accept the morality of the legendary Good King Pausol[e]: 'Do what you like so long as you harm no one'. This idea has been put into a rhymed couplet called the Wiccan Rede:
>
> Eight words the Wiccan Rede fulfil:
> An it harm none, do what ye will.
>
> This quite honestly seems to me to be the only moral code that really makes sense.[16]

After chapters on the eight witch festivals which make up the cycle of the year, and on witch signs and symbols, Doreen devotes a chapter to the Magic Circle. As she says: "Dancing in a circle is perhaps the most primitive and universal magical rite".[17] She then gives various reasons why this may have been so; that a circle is the most perfect geometrical figure, it signifies the human aura and that, with the four cardinal points, it becomes the circled, or Celtic, cross.

Doreen shows that the magic circle is used to raise and contain a power which has been called many things over the years, including prana, odic force and orgone energy, and was the energy which was raised when the witches raised the Cone of Power to help stop the threatened invasion in 1940. She explores landscape features, from stone circles to turf mazes, which may have been used for such magical purposes.

Doreen then looks at the practicalities of what might be called the inbreath and the outbreath of magic.

Divination can be thought of as ways of focusing the psychic sense such that information not obtainable by normal means

[16] op. cit. p 41

[17] op. cit. p 74

may be got through. Doreen gives prominence to the method known as scrying, which she defines thus:

Scrying is the old word for all kinds of clairvoyance involving the use of some object, such as a crystal ball, a vessel of water, a magic mirror and so on, in which the seer gazes and in which, or by the aid of which, visions appear.[18]

Elsewhere, Doreen has emphasised that magical working is essentially a function of the mind and the will, but she devotes a chapter to witch tools such as the ritual knife, or athame, and the wand. She describes these as being an expression of that will and the capacity to carry that out.

Doreen then has chapters on Witches' Attire (largely naked, or 'skyclad', as the witches say) and Witch Alphabets. She was an advocate of working out of doors when at all possible, because it is closer to nature. She understood the difficulties, however:

Unfortunately, such outdoor rituals are seldom a practical possibility in these days. The countryside is so much more thickly populated than it used to be that it is difficult to find a suitable place which is sufficiently private for such a purpose. Nevertheless I feel that all covens and individual witches should attempt at some suitable opportunity to get out of doors and seek communion with the living forces of nature at first hand.[19]

Doreen then gives a lot of practical advice about finding suitable sites and how to take care of them. She also describes how Alfred Watkins and subsequent writers on the 'ley' system, including Dion Fortune, related to the land.

And after propounding James Lovelock's Gaia Hypothesis (which at the time was relatively newly published) that the earth 'is a self-controlling organism, a vast living creature, which is somehow

[18] op. cit. p 86

[19] op. cit. pp 123-124

able to regulate the conditions of its own biosphere, so as to enable life to exist and evolve within it', [20] Doreen concludes:

> *When witches today go outdoors to perform their rituals, however simple the rite may be, whether they go as a coven or as individuals, these are things to be mindful of: the communion of the living earth, the inner causes of things, the perception of the realm of form as a veil before the realm of forces. They should bring us to a respect for nature, not in a sentimental way but with a deep feeling of kinship which will manifest itself in attitude and actions.* [21]

Doreen concludes by returning to a subject dealt with in her previous book - that of 'Witchcraft and Sex Magic'. She starts on a positive note:

> *Witchcraft does not need to apologize for involving sex magic. It is other religions which need to apologize for the miseries of puritanical repression they have inflicted on humanity.*

> *We are today in the commencement of a sexual revolution. People are at last beginning to wake up to the fact that they have a right to sexual satisfaction in this life; that they have no need to feel guilty about being human beings. I believe that one of the most important tasks of the Old Religion in our day is to help nail the Great Lie which humanity has been told for so long: namely, that sex is something which was 'ordained' solely as a means of procreation within 'holy wedlock' and nothing else.* [22]

After making a very perceptive comment that: "It is often said today that we live in a violent society. (We always have done, but people are beginning to notice it.)",[23] Doreen goes on to postulate that one of the causes of mindless violence is the denial of natural sexual desire by the bondage in which human society keeps its

[20] op. cit. p 132

[21] op. cit. p 133

[22] op. cit. p 134

members, even when they are not conscious of it.

Doreen then goes on to state that: "There is an indefinable magical element about sex ..." [24] and continues by giving an introduction to the Tantric ideas of ancient India and to those who brought them to the west, including Sir John Woodroffe, and other traditions, including Sufism and the Knights Templar. She also covers the role of sex magic in Aleister Crowley's Ordo Templi Orientis and his influence on Gerald Gardner, and sums all of this up by saying:

> ... how naturally it has followed, in accordance with the evolving trends of the Aquarian Age, that modern witches should adapt the Tantric sexual magic for use in their own private magical circles, instead of the mass seasonal orgies of ancient times ... What appears to be borrowing from another tradition is really the reuniting of many things which have proceeded from a common source. [25]

In her concluding paragraph of the main part of the book, Doreen writes:

> ... I have endeavoured in this book to trace some, at least, of the shadowy outlines of the magical path, travelling as it does through the realms of witchcraft, ritual magic, alchemy and mysticism, back to our earliest beginnings in the cave sanctuaries of the Stone Age. Yet I feel that we still have a great deal to learn about our own history and the past of the human race. The witches have a tradition that their craft came from the East; but who knows? If you travel far enough east, you will find yourself back on your own doorstep. 'What is here is elsewhere. What is not here is nowhere.' WISE AND BLESSED BE. [26]

As an appendix, Doreen has included what she calls: "Liber Umbrarum - A Book of Shadows". The most important word here is

[23] ibid.

[24] op. cit. p 135

[25] op. cit. p 151

[26] ibid.

also the shortest: 'A'. She is not giving here a definitive 'Book of Shadows', handed down through the generations. It is just something to get readers started on the path of witchcraft which they can use for as long as they want to or relinquish in part or in whole as they go further along the path.

There are instructions for casting the circle and for the basic elements of ritual. Rites for self-initiation and consecration of ritual tools are given. There are also rituals for the Full Moon Esbat and Sabbat rites.

Doreen concludes her 'Liber Umbrarum' with a ritual for initiation into a coven, plus several examples of her ritual poetry which she gives as items that could be included in a ritual.

Witchcraft for Tomorrow was published almost forty years ago. Nowadays there are several very good introductions to witchcraft by such authors as Patricia Crowther, Janet and Stewart Farrar, Vivianne Crowley and Marian Green. But in 1978, this book came as a revelation to many that they could practise witchcraft without having to be initiated into an established coven. As Stewart Farrar told Doreen:

> *Thank heaven there is at last a book we can recommend to all the covenless people who write to us, but whom we've rarely been able to help much ... It should really set the cat among the pigeons and inaugurate a new stage in the Craft ...* [27]

I'm sure Doreen felt that if you could find an established coven then that would be a desirable way to go. But when she was writing it was often difficult, if not impossible, to find such a coven. And so she presented an alternative way of proceeding, for she did not see why anyone should be prevented from worshipping the Old Gods by mundane circumstances.

[27] letter from Stewart Farrar to Doreen Valiente 30 May 1978

Chapter 15
Anointed by the Poetic Muse

The plaque which was unveiled in 2013 described Doreen as "Poet, Author and Mother of Modern Witchcraft" and I think it is significant that her role as poet is given priority over her role in the rebirth of witchcraft, for she was a very good poet. It was clearly an important part of her life and of her magical practice, for she writes that "... poetry is essentially a magical art, and has its origins in magic".[1]

John Belham-Payne emphasised the importance of her poems to Doreen when he wrote of a request which she made to him shortly before she died:

> *... I asked her if there was anything that she had really wanted to do but hadn't. I was surprised to hear that there was an enormous amount of her poetry that had not been published... . She explained that she wanted to put her poems in a book but her publishers were not keen on becoming known as poetry publishers. They had told her that if they had been, Doreen's book would have been at the top of their list. I saw that this was something she*

[1] *Natural Magic* pp 11-12

*greatly regretted and I made her a promise to publish such
a book so the world could enjoy her poetry and know just
how talented she was.*[2]

Unfortunately, books of poetry are notoriously bad sellers and I
am sure that her usual publisher, Hale, was well aware of the fact.
In 1978, Doreen expressed her frustrations to Janet and Stewart
Farrar in one of her rare undated letters: "I wish I could get my po-
ems published, as I have quite a few now but my publisher doesn't
want to know, and I don't know where else to take them."[3]

The importance which Doreen placed in wanting her poetry pub-
lished and her obvious fondness for writing it led her naturally to
including her poems in all of her published books.

The earliest poems, in her notebooks from 1958 onwards and as
published in *Where Witchcraft Lives*[4], show that Doreen was an
accomplished poet and suggest strongly that she had been writ-
ing poetry for many years previously. Doreen became good at
languages probably when she was at school and it is even likely
that she started to write poetry at that time. Indeed, her amend-
ments to Gerald Gardner's Book of Shadows started back in 1953,
and her completion of the Charge of the Goddess, probably in
1954, are by someone already very accomplished in the use of
words.

I suspect that Doreen may well have had poems published, pos-
sibly under a pseudonym, in a variety of magazines for at least 15
years before that date. It will be for future researchers to investi-
gate this possibility, but, for the moment, Doreen's earliest known
published poem is "The Witch at Halloween", which appears as
a preface to her first book, *Where Witchcraft Lives*, published in
1962:

[2] John Belham-Payne Foreword to Doreen Valiente *The Charge of the Goddess* op.cit.

[3] letter from Doreen Valiente to Janet and Stewart Farrar - received 24 April 1978

[4] op. cit.

THE WITCH AT HALLOWE'EN

She passes through the village street
As twilight shadows fall.
The full moon climbs the winter sky,
The trees are bare and tall.
What is the secret that they share,
Shadow and moon and tree,
And little laughing breeze that makes
The dead leaves dance with glee?
They know their kin. The owl cries
His greeting out to her.
Now the last house and garden's past,
The Down's ridge rises bare.
A climbing moonlit path she sees
That was a trodden road
Ere conquering Rome or Norman proud
O'er Downland ever strode.
It leads to where, beneath the turf,
The outlines she can trace
Of barrow and of sacred ring
That mark the old gods' place.
The moon rides high. The years roll back,
Are with her garments shed.
Naked she dances out the ring
First wrought by hands long dead.
The blood leaps wild within her veins
As swifter spins the dance,
Her wide eyes fixed upon the moon,
Her senses rapt in trance.
And though no feet of flesh and blood
Walked with her to that ground,
She knows she does not dance alone
That magic circle's round.[5]

[5] op. cit. p vi

This demonstrates convincingly the way in which Doreen tends to place her description of witchcraft in the context of the landscape in which she lived. Just as her preference was for outdoor rituals, so her often vivid depiction of 'the Old Religion' is always set in and intimately connected with the landscape. It grows out of and is 'earthed' in the land. And it is a landscape which is alive with spirit and subtleties that are not immediately obvious.

The highlight of her poetic career was when Doreen gave a lecture to the Poetry Society in London. Founded in 1909 to promote "a more general recognition and appreciation of poetry", the Poetry Society has been described by former Poet Laureate, Sir Andrew Motion, as being "the heart and hands of poetry in the UK".

The Society's records do not, unfortunately, contain details of talks given to its members over the years, but we do have a complete typescript of the twelve poems which Doreen recited during the course of her lecture plus some introductory remarks. This, and the heading in Doreen's handwriting stating "Lecture given to the Poetry Society, London" makes it quite clear that the event did actually take place. She indicates that the lecture was given on 3rd February, the day after Imbolc/Candlemas. The only clue I have so far found is in an article which appeared in 1972 which states that: "Some of her poems have been read at the London meetings of the Poetry Society".[6]

Whilst it would be reasonable to assume that Doreen would choose what she considered to be her 'best' poems to present to the Poetry Society, she had clearly selected those that in their content gave a clear overview of the Craft and its beliefs and practices. And, as always with Doreen, they are set in a living magical landscape.

The first poem was, she told members of the Poetry Society, inspired by her own experiences of witchcraft:

[6] *Brighton Argus* 1 March 1972

THE WITCH'S BALLAD

Oh, I have been beyond the town,
Where nightshade black and mandrake grow,
And I have heard and I have seen
What righteous folk would fear to know!
For I have heard, at still midnight,
Upon the hilltop far, forlorn,
With note that echoed through the dark,
The winding of the heathen horn.
And I have seen the fire aglow,
And glinting from the magic sword,
And with the inner eye beheld,
The Hornéd One, the Sabbat's lord.
We drank the wine, and broke the bread,
And ate it in the Old One's name.
We linked our hands to make the ring,
And laughed and leaped the Sabbat game.
Oh, little do the townsfolk reck,
When dull they lie within their bed!
Beyond the streets, beneath the stars,
A merry round the witches tread!
And round and round the circle spun,
Until the gates swung wide ajar,
That bar the boundaries of the earth
From faery realms that shine afar.
Oh, I have been and I have seen
In magic worlds of Otherwhere.
For all this world may praise or blame,
For ban or blessing nought I care.
For I have been beyond the town,
Where meadowsweet and roses grow,
And there such music did I hear
As worldly-righteous never know.[7]

7 op. cit. p 48

That Doreen recognised magical power in the forces of nature is clearly shown in the next poem, which she also chose to recite to the Poetry Society. This captures magical power in the form of words. It is in free verse but full of the power of rhythm, of which Doreen was acutely aware:

PRESENCES

Listening to the great elemental voice of the sea,
Speaking in no tongue and all tongues,
While above the clouds are crowding,
Gathering into night and storm,
Who are the watchers of this scene, beside myself?
Whose are the gay, indifferent presences
Writhen in cloudrack and outshaped by air?
They feel no chill as I, only exultation.
Their pulse is in the surging of the tide.
They lie silent in stone,
Yet have speech among themselves.
Their life is in shapes and shadows;
We cannot know them,
And we to them are equally unheeded.
The mist on the sea is their veil,
And yet not, for they are in no thing,
And so in all things,
They, the presences of life;
Angels and demons both, and gods of faery.
Sometimes, for sport, they will approach us,
Shaping their power in clouds
And shapes of water,
Looking a sudden face from the bole of a tree,
Or sigil printed on a coloured stone.
The Moon is their lady and ours,
And leads their blithe dancing
As they move invisible, mocking and mastering
The hardness of our world.[8]

[8] op. cit. p 100

Doreen then presented to the Poetry Society poems on the deities of the witches, firstly, one about the White Goddess of the Moon:

THE HAUNTED LAKE

The haunted lake turns up its eye
Unto the white and leprous moon.
A cold air whispers through the sky
That She is coming soon.
A twisted thorn with pointing hand
The path to that wan water shows,
And in fantastic saraband
A dancing elf-light glows.
The midnight wood is dark and deep,
And underneath the branches bare
The printless footsteps rush and creep
To greet her presence there.
A herald owl cries before,
As in her garments glistening white
She walks upon that faery shore,
The Goddess-Queen of Night.
The mortal man that doth Her see
Shall go enchanted all his days.
No fairer love shall for him be,
Nor equal to her praise.[9]

Next, a poem on the God, which first appeared in the pages of *Pentagram* in 1965:

THE HORNED GOD

By the flame that burneth bright,
O Hornéd One!
We call Thy name into the night,
O Ancient One!
Thee we invoke, by the moon-led sea,
By the standing stone and the twisted tree.

[9] op. cit. p 130

Thee we invoke, where gather Thine own,
By the nameless shrine forgotten and lone.
Come where the round of the dance is trod,
Horn and hoof of the Goatfoot God!
By moonlit meadow, on dusky hill,
When the haunted wood is hushed and still,
Come to the charm of the chanted prayer,
As the moon bewitches the midnight air.
Evoke Thy powers, that potent bide
In shining stream and the secret tide,
In fiery flame by starlight pale,
In shadowy host that rides the gale,
And by the fern-brakes fairy-haunted
Of forests wild and woods enchanted.
Come! O come!
To the heart-beat's drum!
Come to us who gather below
When the broad white moon is climbing slow
Through the stars to the heaven's height.
We hear thy hoofs on the wind of night!
As black tree-branches shake and sigh,
By joy and terror we know Thee nigh.
We speak the spell Thy power unlocks
At Solstice, Sabbat and Equinox,
Word of virtue the veil to rend,
From primal dawn to the wide world's end,
Since Time began -
The Blessing of Pan!
Blessd be all in hearth and hold,
Blessd in all worth more than gold.
Blessd be in strength and love.
Blessd be, where'er we rove.
Vision fade not from our eyes
Of the pagan Paradise
Past the Gates of Death and Birth,

Our inheritance of earth.
From our soul the song of spring
Fade not in our wandering.
Our life with all Life is one,
By blackest night or noonday sun.
Eldest of Gods, on Thee we call,
Blessing be on thy creatures all.[10]

The central part of this came from an "Invocation of Pan", which Doreen wrote in 1962:

Evoke thy powers that potent bide
In wild water's glittering pride,
In fire a-shine in secret vale,
In shadowy host that ride the gale,
And in the fern-brakes fairy-haunted
Of forests wild and woods enchanted.
May the Blessing of Pan be upon all here. So mote it be.[11]

To be invited to lecture to England's premier poetry society does indicate that Doreen's poetry was valued, not just within the Pagan community but by a more general audience. It is therefore strange that she told John Belham-Payne that the Poetry Society had turned down her membership application because she was a witch.[12] It would be in keeping with what we know of Doreen's character if this refusal was the impetus to her offering to give a recital of her poems to the Society.

Doreen's poems exhibit a great variety of metre, rhyme and form. What they have in common is that many of them have a strong rhythm: they are meant to be recited. This is naturally most obvious in her ritual poetry.

[10] Doreen Valiente in *Pentagram no. 3* March 1965 p 12

[11] Doreen Valiente *notebook no. 20* 21 March 1962

[12] John Belham-Payne Foreword to Doreen Valiente *The Charge of the Goddess* op. cit.

Dr. Amanda Greenwood, of Wilberforce College, Hull, has given me her thoughts and observations on Doreen's poetry. Not all of the poems she refers to are included in the present chapter, but they are in the book of Doreen's poetry entitled *The Charge of the Goddess (Expanded Edition)*, published in 2014. She immediately identified a problem in applying conventional analytical techniques:

> *Overall, critical analysis of these poems seems to add very little to their impact. It is not that they are unworthy of analysis - they certainly are. Very simply, it is difficult to identify 'deeper' meanings because of the lack of figurative language in these poems. When Valiente refers, for example, to the "Moon" as a "lady" in 'Presences', this is not conventional personification flagged up by capitalisation; for her, the moon is 'our lady'. Recurrently, Valiente uses observation of landscape and the elements without recourse to figurative devices such as metaphor and simile. This absence of literary ego directly conveys what she referred to in her Poetry Society lecture as "the unseen life and soul of nature".[13]*

She emphasises the importance of metre and rhythm in Doreen's poetry:

> *'The Witch's Ballad' and poems intended for ritual usage, such as 'A Chant for Beltane' and 'Draw with sword the circle's round' are written in catalectic (or incomplete) trochaic tetrameter, i.e. four metrical feet per line (much like bars in music), each comprising a strong followed by a weak 'beat'. This form was used by Shakespeare in 'supernatural' chants - for example, the witches in Macbeth and fairies in A Midsummer Night's Dream and is a very practical metrical form to aid movement/footsteps within a ritual.[14]*

She draws attention to the wide range of forms that Doreen experiments with:

[13] Amanda Greenwood personal communication with the author

[14] ibid.

... in 'The Sussex Witch' and 'The Gathering for the Esbat', she deploys alternating lines of iambic tetrameter (4 feet of weak/strong beats) and iambic trimester (3 feet of weak/strong beats). Whilst not so conducive to ritual movement as trochaic tetrameter, this allows some pause for reflection - the shorter lines, on the whole, develop the focus of the preceding longer lines. This form was used by Thomas Hardy in poems such as 'The Darkling Thrush', a nature-oriented reflection on New Year's Eve 1899. On a simpler level, the meter makes poems such as 'The Sussex Witch' easily memorable ...[15]

These forms included the sonnet:

A curtailed sonnet form is used in 'Ye Olde Maye Game', or 'Lost in the Celtic Twilight'. A sonnet is conventionally written in 14 lines of iambic pentameter (the 'high' metrical form used in the sonnets of Shakespeare, Dante and Petrarch); this has 12. It is possible that the 'lost' two lines reflect the eponymous 'loss' and/or Valiente's intriguing note that "anyone seeking for a mystical significance in this poem is cordially invited to seek one"! 'Elegy for a Dead Witch' is also a 12 line sonnet; its most obvious canonical precedent is Ben Jonson's 'On My First Sonne', written in 1603 after the eponymous boy's early death. In both of these sonnets, the 'missing' end couplet could also be interpreted as signifying loss.[16]

She comments further:

... it is unsurprising that Valiente frequently chose ballad form - most obviously in 'The Witch's Ballad'; also 'The Haunted Lake' - as this is a 'folk' form, ideal for narratives, and for setting to music. The rhythms created through a combination of iambic tetrameter and 'easy' rhyme schemes meant that ballads could survive through oral as well as written tradition.[17]

[15] ibid.
[16] ibid.
[17] ibid.

Finally, Amanda Greenwood draws attention to the fact that:

Valiente seems, through time, to have experimented more widely with 'free' verse, such as 'A Visit to Glastonbury' and 'Farewell'; freedom from the restrictions of rhyme and meter allows more intimate - even trance-like, meditative - reflection, and perhaps also indicates her growing confidence as a poet.[18]

Ashley Mortimer told me that:

Doreen's ritual poetic style is informed and enhanced by her natural abilities as a poet. It is an easy constraint which she handles well and does not fight. There's no conflict in her writing and this is not an easy thing to achieve, especially when writing with a purpose that the author knows may not be obvious to the reader.

One has to consider who she envisaged as the reader of her poetry. Perhaps she never intended pieces like "The Charge Of The Goddess" to be heard outside the circle of initiates of the Craft when she first wrote it. Certainly she accepted later that it would be and even published it herself. She sent poems for publication from time to time. Moonstone [the Pagan poetry magazine] *seems to have been a popular choice for her, and it would seem that the lines are blurred as to what she considered secrets and what she considered suitable for publication. She used her poetic abilities to good effect in the rituals she wrote for herself and her working groups. There are some examples of these in the Doreen Valiente collection and it is under consideration by the trustees of the Doreen Valiente Foundation to publish these as a collection of specifically 'ritual' poems.*[19]

We have already seen (in Chapter 6) how Doreen's best-known and loved piece of ritual writing, "The Charge of the Goddess", has inspired and been used by witches and others throughout the

[18] ibid.

[19] Ashley Mortimer personal communication with the author

world. But the evidence in her notebooks shows that she was able to put together a suitable piece of ritual for any occasion and for whichever group she happened to be working with at the time.

An example from the time Doreen was working with Robert Cochrane went initially thus:

> *I call Earth to bond the spell,*
> *Air to speed its travel well,*
> *Bright as fire may it glow,*
> *Through and through like water flow.*[20]

Two days later it became:

> *Power arise from Earth below.*
> *Water, give life unto the spell.*
> *Brightly as fire shall it glow.*
> *Air shall speed its travel well.*[21]

Another example from the same period is as follows:

> *Draw with sword the circle's round.*
> *Powers of witchdom here be found.*
> *By the sword all ill dispel.*
> *May the Old Ones speed it well.*
> *Hallowed be this circle's span,*
> *By power of Hecaté and Pan.*[22]

Looking through the varied examples of poetry and ritual verse in her notebooks, it is striking how often Doreen seems able to write things down without many changes, which indicates to my mind that she was frequently inspired and wrote what came into her mind directly. There *are* alterations, enough to confirm that she was composing it herself and not copying it from another source, but they are usually just the odd word.

[20] Doreen Valiente *notebook no. 32* 6 August 1964

[21] Doreen Valiente *notebook no. 32* 8 August 1964

[22] Doreen Valiente *notebook no. 25* 27 July 1963

One piece that she did revise substantially was 'A Witch Meditation' (Lammas 1979):

Set the scene on the wild heath,
Miles from any town.
Above on high in the cloud-wracked sky
The moon is shining down.
Feel the bracken beneath your feet
As you wrap your black cloak round,
For the air is fresh and the night is cool
Upon this lonely ground.
Haste to the hollow where we meet,
Kindle the balefire's light,
For we the ancient gods will greet
Upon the Sabbat night.
Now gather those ancestral souls
Who have passed on before,
For the Lord of Death and the realms beyond
Has opened wide the door.
And come the elemental powers
Earth, water, wind and flame
Your lords at the four quarters stand,
We call you in their name.
To guard the circle that we cast
In name of witchdom here.
All spirits who can aid our spell,
Be friendly and appear!
A light we see of silver-blue
Beyond the circle gleam,
And witchdom's powers this night be ours,
That shall fulfill our dream.[23]

Doreen had added: "Use this as a form of meditation. Visualise the scene. And when the blue light appears, see what form it takes and what message it has for you".[24]

[23] Doreen Valiente *A Witch Meditation (Lammas 1979)* manuscript in Doreen Valiente collection

[24] ibid.

"Autumn Equinox" is another poem which relies heavily both on
the rhythm and metre and also on the strong evocation of the
spirit of place. It is typical of Doreen's poetry:

AUTUMN EQUINOX

I stood in a chapel of thorn-trees,
Upholding an old horn cup
And the quiet cows beside me,
With gentle eyes looked up.
Breeze from the sea was blowing
Across the autumn sky.
But under the thorn was silence
Upon that hill-top high.
A moment of echoed voices,
And the touch of hands unseen,
When a hidden door was opened,
And light shone through the green.
And it seemed the cup was filling
With more than earthly wine,
When the spirit in its exile
Cried out to the Divine.
Beside the twining hawthorn,
Across the windswept grass,
I knew the breath of magic,
I felt a Presence pass.[25]

An often unacknowledged example of Doreen's skill in writing rit-
ual is the piece which is known as the Dryghtyn Blessing, which
runs:

In the name of Dryghtyn, the ancient providence,
Which was from the beginning, and is for eternity,
Male and female, the original source of all things;
All-knowing, all-pervading, all-powerful, changeless, eternal.
In the name of the Lady of the Moon and the Lord of

[25] Doreen Valiente *notebook no.49* 25 September 1969

Death and Resurrection;
In the name of the Mighty Ones of the Four Quarters, the
Kings of the Elements,
Bless this place, and this time and they who are with us.[26]

It is an entry in Doreen's notebook dated 15th December 1959. She told Don Frew:

I wrote the blessing 'In the name of Dryghtyn ...' in its present form; but this was a long time ago, and I have a feeling that I copied it from earlier material somewhere. The trouble is that I can't offhand remember what, except that it was something that Gerald showed me ... I connect it somehow with a time when I visited him in the Isle of Man.[27]

Julia Phillips told me that Doreen said that she saw the opening line in a book in the museum on the Isle of Man and found it so inspiring that she wrote the rest of it. Doreen was, however, insistent that 'Dryghtyn' should be pronounced in the same way as the town in which she lived!

John Belham-Payne told me that:

Doreen always refused to have her words put to music. Whenever anyone wrote to her she always said no. Even worse, when people just went ahead and recorded her words without permission, she became very hurt and angry that they did not even bother to consider her feelings. She never gave permission and never would. She explained to me why: "Everything I have written in poetry form was for a reason. Each poem has a particular metre and meaning and none of them was meant to be accompanied by instruments or put to a rhythm."[28]

Doreen was adept at applying the principles of 'reverence and mirth' to her poetry and wrote some very good humorous verse,

[26] Patricia Crowther Witch Blood! (House of Collectibles 1974) pp 39-40

[27] letter from Doreen Valiente to Don Frew 20 June 1994

[28] John Belham-Payne personal communication with the author

most notably "The Ballad of Sir Roughchops" - a masterpiece of 'double entendre' - and the story of Charles Cardell and Olwen Greene in comic verse form in "How Green was my Olive?"

The limerick was a favourite form of Doreen's and She wrote them about several individuals in the Craft. Typical is "An Unsolved Problem of Psychic Research":

> *There was a young lady named Freeman*
> *Who had an affair with a demon.*
> *She said that his cock*
> *Was as cold as a rock -*
> *Now, what in the hell could it be, man?*[29]

One she wrote about Charles Cardell was as follows:

> *There was an old man called Cardell,*
> *Who never could learn how to spell.*
> *He dashed about Surrey*
> *Writing books in a hurry*
> *And got most of his facts wrong as well.*[30]

Doreen was also quite prepared to enter poetry competitions, and the following limerick was submitted to the BBC for one such, but I think without success:

> *My Auntie who lives up in Eccles*
> *Tried witchcraft to banish her freckles.*
> *As the black cauldron stewed,*
> *She danced in the nude*
> *But she's still covered over with speckles.*[31]

Unlike Gerald Gardner, Patricia Crowther, Ray Buckland and Stewart Farrar, Doreen never wrote a full-length work of fiction. She did, however, write a series of linked short stories which she

[29] Doreen Valiente *Charge of the Goddess* (Hexagon Hoopix 2000) p 66
[30] Doreen Valiente *notebook no. 56* 22 February 1972
[31] ibid.

218

entitled, from the first of these stories, "The Witch Ball". The story starts with a young businessman, Jeremy Blake, who had been attending a conference, finding himself sitting at the same table in a Brighton hotel as retired antiques dealer, Charles Ashton. The conversation gets on to the subject of antiques and the existence of "finds, fakes and frauds and things a young buyer should know." Ashton then continues:

> 'There is one other risk in my profession. A remote risk, admittedly; you may never come across it; you may indeed scoff at it; but I and others have encountered it.'
> 'What risk is that?' Blake asked.
> 'The risk, you might say, of an object having too much history,' Ashton replied.[32]

After establishing that Ashton is referring to the occult, Blake replied:

> 'Do you believe in that? You know, I've always wondered if there was really anything in it. But the people I've met up to now who professed to be occultists - well, frankly, they haven't inspired much confidence.'
>
> 'I not only believe in it,' replied Ashton gravely, 'I think that experiences of what people call the occult or the supernormal are much commoner than is generally supposed. But those who have experience of such things hesitate to talk about them for fear of being classed as fools or impostors. And so a whole area of human life gets hidden behind a curtain, so to speak. That is what the word "occult" really means, you know - hidden.'[33]

There follows a series of eleven stories with an occult theme, mostly set in the towns and countryside of Sussex, where out-of-the-ordinary events occur which enable the older man to instruct the younger in various aspects of the occult. The stories are well-written, as one would expect from Doreen, but have so far

[32] Doreen Valiente *The Witch Ball* (unpublished manuscript)
[33] ibid.

remained unpublished. In 1982, Doreen approached her publishers, Robert Hale, sending them the manuscript of "The Witch Ball". She was, however, unable to convince them that it was an economic proposition. They told her that short stories as a genre do not sell well and with even the library market for fiction declining, they could not justify what they saw as the risk of publishing "The Witch Ball".

Doreen told Janet and Stewart Farrar:

> *Sorry to say that Robert Hale's don't want my book of short stories. They say that the stories are very good but they just don't want books of short stories. Oh, well! I wonder about that agent of yours? I've never used an agent. What does one have to do? What do you think?*[34]

It is my definite feeling, however, that there are sufficient numbers of people now interested in the work of Doreen Valiente to make publication of these short stories an economic proposition and I hope we will see them in print in the not-too-distant future.

I am far from being qualified to give an informed opinion on what influences there are on Doreen's poetry. We don't know what she read and was influenced by. A careful examination of her library might provide some clues. Some have likened her work to Thomas Hardy's landscape poetry and others to the work of Aleister Crowley. But in many ways she developed a distinctive style of her own, and it is probably unfruitful to look too closely for similarities with the work of more established poets.

As one becomes more familiar with Doreen's poems, one comes to recognise their own special character, and to accept that Doreen Valiente was a very good poet. Certainly, Katy Jennison, in reporting on a speech by Professor Ronald Hutton at the "Day for Doreen" held on 13th September 2009, noted that he had said of Doreen that one of her strengths was her "amazing poetic talent":

[34] letter from Doreen Valiente to Janet and Stewart Farrar 3 August 1982

She wrote seasonal rituals for the solar festivals; she wrote the Charge of the Goddess; she wrote the Dryghten Prayer; and she wrote a complete Book of Shadows, containing the invocation which starts "Black spirits and white ...". She was very modest about all this: she rested, she said, on older sources such as the Carmina Gadelica. Certainly there are echoes, but what she wrote, Ronald pointed out, was actually very different. The Charge of the Goddess may have been inspired by Apuleius, but her words are completely original. "Dryghten" is an Anglo-Saxon word for "God", but all the rest is hers. The first line of "Black spirits and white" is a quotation from Dekker, but everything else is pure Valiente.[35]

The market for poetry was generally even less than that for short stories and so Doreen was unable to achieve within her lifetime the publication of her poems.

Amanda Greenwood told me:

... it is a great pity that, in seeking a publisher for her poems and short stories, Doreen Valiente did not try women's presses such as Virago. Virago republished Mary Webb's Gone to Earth (first published in 1917) in 1979; Valiente's lament that "Purity has veiled the pure/And the virtuous have blackened virtue" ('The Door') echoes Mary Webb's passionate nature-mysticism and vision of sexuality as a meeting of souls within nature, which in turn echoes Thomas Hardy's subtitling of Tess of the d'Urbervilles as 'A Pure (rather than 'fallen') Woman'.[36]

Doreen's wish that her poetry be published was finally realised in the year 2000, when a collection of her poems appeared under the title Charge of the Goddess[37]. It included reproductions of Doreen's original typed versions of her poems, was profusely illustrated and

[35] Ronald Hutton talk given at 'Day For Doreen' conference 13th September 2009

[36] op. cit.

[37] op. cit.

included both explanatory notes and memories of Doreen by those who knew her.

An expanded edition, with new and previously unpublished poems, was published by the Doreen Valiente Foundation in 2014.[38] It is a much longer volume and contains almost 80 poems: a worthy chronicle for posterity of a truly inspired poet.

[38] Doreen Valiente *The Charge of the Goddess* op. cit.

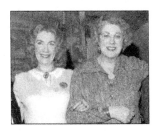

Chapter 16
Record of a Friendship

The publication of her first book, *Where Witchcraft Lives*, in 1962 meant that Doreen became known amongst the wider witchcraft community in Britain, and in the following years she started exchanging letters with various individuals with whom in some cases she later became firm friends.

One of the longest friendships which Doreen developed was with fellow witch and High Priestess from Sheffield, Patricia Crowther, with whom Doreen maintained a close friendship for over 35 years. She first became aware of Patricia and her husband, Arnold, when they appeared on the BBC Television programme, "Tonight", on 1st May 1961. In view of the date, it was probably a feature on May Day customs and such like. In her notebook, Doreen commented as follows:

> *Claimed to be 1st degree witches, and said there were 7 covens operating in Britain. Showed sword, black and white hilted knives, and ivory wand (All Gardner's stuff) ... She is good-looking blonde. He is older, plump, dark, smoothie type.*[1]

[1] Doreen Valiente *notebook no. 14* May 1961

I'm not sure exactly when Patricia and Doreen started corresponding with each other. It was possibly the result of some letters adverse to the Craft published in *Fate* magazine in the early 1960s and was probably intensified by the events following the death of Gerald Gardner in February 1964 to which I refer in Chapter 11.

It was, however, not until 5th June 1965 that the two met for the first time. Arnold and Patricia were working at Bracklesham Bay in Sussex. They had Saturdays off, and Doreen had invited them to visit her at her flat in Lewes Crescent in Brighton.

As they were nearing their destination, Patricia saw a woman in the street who looked at them. She immediately felt that this was Doreen, which subsequently turned out to be the case. Doreen had, in turn, felt that the woman she saw had been Patricia.

This was just the first of what I feel was a strong psychic link between the two women, which was to manifest in several different ways.

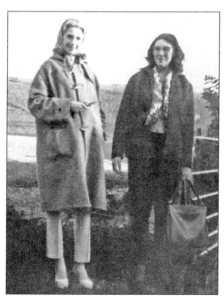

56. Patricia and Doreen with Long Man - Wilmington

Patricia and Arnold used to try to visit Doreen whenever they had a summer show on the south coast, and occasionally they spent a holiday in Brighton at the end of a season.

On one such visit, on 25th September 1968 a dramatic event occurred. At the request of a London witch, Andrew Demain, it was decided to conduct a night-time ritual in the hollow above the Long Man of Wilmington, an ancient chalk carving on the South Downs between Eastbourne and Lewes. Patricia describes this hollow as being:

> ... ideal as a working site. A hollow of flat ground, with two small hillocks at the back, suggests that it was man-made in the image of the Earth Mother.[2]

She gives us an account of what happened on that occasion:

> Leaving the car safely parked, we climbed the steep sides of the tor in the last vestiges of daylight, and had not gone far when it started to rain. By the time we had gained the summit it was coming down in stair-rods, but we persevered and performed the rite. Our candles were safely inside lanterns, and above us, the grey clouds, illumined by our small flames, enveloped us in a dark canopy. It seemed as if we were inside those clouds. The candlelight projected and magnified our shadows onto them; it was as though we were in the company of the Gods, themselves!
>
> The rite completed, we packed everything away and set off down the hill. It was pitch-black and the rain had churned the ground into a squelchy morass of clay, which made the steep slope difficult to negotiate. My own torch was of little use in that kind of weather, but I realised it was not the route by which we had ascended the hill. Doreen was some way ahead when I suddenly shouted, "Stop!", for no reason I could think of at the time. She obeyed my instruction, and when I caught up with her, the light from my torch showed where the ground disappeared, a few steps further on. We

[2] Patricia Crowther *Lid off the Cauldron* (Frederick Muller 1981) p 66

had certainly lost the track because my friend had nearly walked off the edge of a quarry!

We were all visibly shaken, not least Doreen, herself "What made you call out to me?" she asked "How did you know?" I said it must have been my sixth sense, and I recalled a foggy night in Birmingham [in the early fifties] when my landlady's husband walked me home, and a similar incident occurred. Doreen said, "It's funny, but when you shouted 'Stop!', I seemed to feel a hand on my shoulder, but you were some way behind me." I said the Gods must also have helped in saving her life, and everyone agreed.

We struck off in another direction, where the welcoming sight of car headlights strobed the darkness of the valley. Soon, we were heading for Brighton, and despite protective clothing, quite soaked to the skin.

Back at Doreen's flat, we peeled off our sodden clothes and wrapped ourselves in warm blankets, Cassie (Doreen's husband), plied us with mugs of hot tea and plates of toasted muffins, but rather tactlessly commented upon how wet we all were, whereupon Doreen replied, acidly, "Well, Dear, one does tend to get wet when it rains."[3]

Arnold and Patricia were late in bed that night and it was not long before they were awoken by the breakfast bell. Patricia had the words of a poem in her head, which she managed to write down. This became "Awakening", which she included in her book, *Lid Off the Cauldron*.[4] It was as if the rite of the previous night had brought this poem through from the Inner Planes.

As Patricia told Anthony Stiso: "It must have come from the ritual we'd done. We'd been with the Old Ones".[5]

Remarkable coincidences seemed to occur when Arnold and Patricia visited Doreen, as Patricia recalls:

[3] Patricia Crowther *From Stagecraft to Witchcraft* (Capall Bann 2002) pp 162-163

[4] p 67

[5] Anthony Stiso private communication with the author

It was not long before I was once again heading for
Brighton. Dorothy, a friend of mine, drove me down, and
upon arrival we booked into an hotel. Of course, we called
round to see Doreen, and during the conversation I
happened to mention that we were staying at 16 Oriental
Place. Doreen exclaimed, 'Why, that is the house where
Charles Godfrey Leland used to live!' Leland had been a
prolific writer on many subjects, not least, witchcraft. His
book Aradia, or the Gospel of the Witches *(1899) resulted*
from his meeting with Maddalena, a gypsy sorceress in
Florence, through whom he was initiated into La Vecchia
Religione (the Old Religion) of Italy, which had survived in
wild and remote regions of that country (handed down
through family ties, much the same as in Britain and
elsewhere). Choosing that particular hotel was, I thought,
a meaningful coincidence.[6]

One of the problems with the Lewes Crescent flat was that it had
mice. There had been just one mouse to start with, but when it
brought all its friends and relations, Doreen had had enough and
told them "We don't want you here! You'll have to go away". Once,
when Patricia was staying with Doreen, she offered to help with
this and they both carried out a ritual, which involved Doreen
playing the recorder to them whilst telling them quite firmly
"We can't have you here!"

This action seemed to have worked, as Doreen found out later that
they had migrated to the woman two doors away, who was com-
plaining that mice had suddenly appeared!

It is perhaps an indication of the depth of their friendship that
Doreen made two of her rare trips since the War out of southern
England when she twice made the journey north to Yorkshire to
stay with Arnold and Patricia in their Sheffield home. Patricia re-
counts one of these visits:

On one occasion, the Sheffield coven did have fourteen
witches in the Circle. That was when Doreen Valiente came

[6] Patricia Crowther *One Witch's World* (Hale 1998) p 89

to visit us [at Halloween 1965]. The Circle did not seem too crowded and we managed very well. And on that night I had a deep trance experience which I shall never forget.[7]

Patricia remembers that to obtain trance they performed the Dance of the Lame God. She describes this in *Lid Off the Cauldron*:

This is a very slow circling, with the witches crossing their arms and linking hands. Could the performance of 'Auld Lang Syne' be a memory of this ancient witch dance? Especially, as it is sung at the time of year when the God of Death and Regeneration is ruling.

The dance is enacted by dragging the left (lame foot) behind the right, and moving slowly, deosil or sunwise, round the circle. The trance-state induced by this form of dance is preceded by a coldness which creeps up the body from the 'lame' foot. This coldness eventually overcomes the recipient and produces a deep trance. The person should be attended during the trance-state by an experienced witch, but should not be disturbed unless there are signs of distress. This is a very rare occurrence, but if it manifests, a gentle rubbing of the hands and feet, together with the person's name spoken softly and continuously, will bring him or her out of the trance.

Usually, there will be an Inner Plane experience for the entranced, or verbal messages which should be recorded. Much depends upon the reason behind this dance, as to any potential results. The movement should be accompanied by a slow-worded chant, invoking the Horned God, and, ideally, performed at Samhain (Hallowe'en). In this way, contact can be made with the beloved dead and communication established.[8]

Patricia remembers that on the occasion when Doreen was visiting there was plenty of 'nerve power' and she had a cold feeling rising up from her feet until she found herself on the inner planes in a forest and found the God Pan rushing towards her.

[7] Patricia Crowther *Covensense* (Hale 2009) p 131

[8] *Lid off the Cauldron* op. cit. p 87

Patricia enjoyed walking around Brighton during her visits to Doreen. This included walks on the beach:

I ... have [a necklace] made with the stones that Doreen and I found on Brighton Beach, little stones - fossilised sponges [Porosphaera globularis] *with a natural perforation through the centre and they make a perfect necklace! In fact, they have one in the Whitby Museum ... called "the oldest necklace in the world", which could be true. They look like stones, but they're not really. They're thousands of years old and Doreen had one too.*[9]

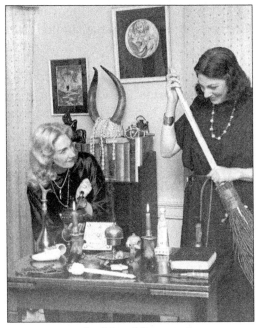

57. Patricia and Doreen 1965

And the numerous antique shops in The Lanes area of Brighton were a particular attraction. John Belham-Payne tells that on one occasion, when Patricia was visiting Doreen, she told Patricia

[9] Anthony Stiso op. cit.

that a nearby antique shop had some Egyptian figures which the owner said were not for sale. Doreen was busy but asked Patricia to go and see if the situation had changed. Patricia duly visited the shop and was told upon requesting the price of the figures they were £1.50 each, so she bought two of them, and hurried back to tell Doreen, who went off and secured two statues, of Isis and Horus. After Doreen died, John sent the two statues to Patricia, so they were re-united.

Doreen could be quite mischievous. Patricia recalls the occasion when Arnold took Doreen to the market in Sheffield. She spotted a handbag on the top shelf and asked the trader to get it down. He got some steps and took it down for her to look at. After examining it, Doreen remarked "I like that, and if I had any money, I'd buy it!"

In the early days of their friendship, Doreen did not have a telephone installed, so they arranged for Doreen to be outside a certain public telephone box in the vicinity at a particular date and time in order for Patricia to telephone her.

When they were not able to meet, they wrote to each other, sometimes incorporating a magical alphabet where they were corresponding on matters that were secret and where they didn't want them to be read by anyone else if they happened to go astray. Doreen's familiarity with and previous experience in dealing with codes and ciphers probably proved invaluable in developing such an alphabet.

Patricia's husband, Arnold, was a talented artist, and, with her permission, I used Arnold's portrait of Gerald Gardner for the cover of my book, *Wiccan Roots*.

On one occasion, Gerald Gardner commissioned Arnold to do a painting of the Goddess as a present for Doreen, who obviously liked it as she had it prominently on display above her fireplace at Lewes Crescent.

After she had moved to Tyson Place, Doreen couldn't hang pictures on the walls because of their method of construction, and so she had wrapped the picture in brown paper and put it on top of her wardrobe.

During a visit to Doreen's, on 7th August 1965, Patricia and Arnold met psychic investigator and friend of Doreen's, Leslie Roberts. During the evening by use of the Ouija board they received a message from Gerald Gardner. He asked if his picture could be hung up again, as he did not like it being put away in the back room. He said that it was broken but that Arnold could soon mend it. Doreen was not on the board, but writing down the messages, and only she knew about this. She fetched the picture out and showed it to us, and subsequently Arnold repaired it and it was duly hung back on the wall. (This was not the picture of the Goddess painted by Arnold Crowther.)

Some time later, Doreen was visited by Justine Glass (Enid Corrall), who was interviewing her for a book she was writing, which came out in 1965 under the title of *Witchcraft, The Sixth Sense - and Us*.[10] Justine was so impressed with Arnold's painting of the Goddess that she asked whether it could be used on the cover of her book, for which he and Doreen duly gave permission.

Patricia told me that the launch party for Justine's book was held at Ye Olde Cheshire Cheese public house in Fleet Street, London on 7th February 1966. Doreen had brought the painting up from Brighton and displayed it prominently on a table. The same night, Justine, Doreen, Patricia, Arnold and two other witches were taken to the BBC Television Centre and were featured on the BBC news programme, "24 Hours", that was broadcast at 10.30 pm.

Several years later, Doreen asked Patricia if there was anything of hers that she wanted. Patricia replied: "Only that painting of Arnold's". Doreen said to Patricia, "You can have that!", so, having given Patricia's husband, Ian, its dimensions, Ian made a box,

[10] Justine Glass *Witchcraft, the Sixth Sense, and Us* (Neville Spearman 1965)

sent it down to Doreen and, in due course, it came back with the painting in it, which is now on display in Patricia's living room. She later realised that it had been hung up on 1st August (Lammas) 1983.

One event to which they were both invited on more than one occasion was the Sangreal Foundation days at the Savoy Hotel, London in 1982 and the Goldsmiths' Hall, London, in 1983. These were for occult writers, and were organised by Carr Collins (1918-1985), American businessman and biographer of Dion Fortune. Patricia and Doreen brought Ian and Ron respectively. I shall be writing more about Ron, Doreen's partner, in Chapter 20. The occultist, Dr. Israel Regardie, "who looked in fine fettle for his years" according to Doreen, was also present. In a letter to Janet and Stewart Farrar, she writes "we all had a really good time ... and there was a lovely friendly atmosphere in general."[11]

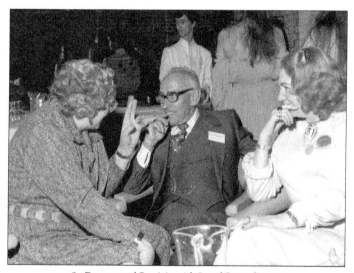

58. Doreen and Patricia with Israel Regardie 1982

[11] letter from Doreen Valiente to Janet and Stewart Farrar 3 February 1982

Chapter 17
Lighting the Shadows and Searching for Dorothy

One of Doreen's most fruitful friendships was with Janet and Stewart Farrar. Stewart had become known to the Pagan community for being the author of *What Witches Do*[1], which was published in 1971 describing the witchcraft tradition started by Alex Sanders.

So when Doreen received a letter from Stewart dated 14th March 1978, she already knew of his existence. In his letter (which was forwarded to Doreen by her publisher) Stewart told her that he and his wife, Janet, had just finished writing a book to be entitled *Eight Sabbats for Witches* and he wanted permission to use Doreen's poem, "Before Caer Ochran" in the Midsummer ritual.

Doreen's reply was both prompt and positive in tone. On the specific request, she writes: "... I hope you will not be offended if I say that I would rather you did not make use of my poem, because I want to use it myself in a similar way."[2] She then compared her

[1] Stewart Farrar *What Witches Do* (Peter Davies 1971)
[2] letter from Doreen Valiente to Janet and Stewart Farrar 24 March 1978

book, *Witchcraft for Tomorrow*, which had just been published, with the Farrars' proposed volume:

This is rather curious; because I have set out to give newcomers some simple, basic ritual, and you have been working on the rather more advanced Sabbat rites, to be used by already established covens.[3]

Doreen does, however, comment on some of the content of *What Witches Do*:

Actually - once again, I hope you will not be offended - most of the ritual, or at any rate a great deal of it, which you published in WHAT WITCHES DO was written by me! As I said in my A.B.C. OF WITCHCRAFT, in the article on Gerald Gardner, the rituals he received from the old coven were fragmentary, and had to be expanded to put them in workable practical form. I helped him to do this. I wrote "The Witches' Rune"; I wrote "The Charge"; and I wrote the rhyming version of "The Great Rite", among other things. This - and once again, I do not write to be contentious or to offend anyone, but simply to get the record straight - is why I find it quite impossible to accept Alexander Sanders' statement that he copied these rituals from the book of his witch grandmother.[4]

She continues:

However, I of course accept that you did not know this when you published them; how could you? Actually, I get quite a kick out of thinking of my words which have gone all over the English-speaking world. As I say in my new book, I bought a paper-back version of "The Book of Shadows" by someone called Lady Something-or-Other, hailing from the U.S.A., supposed to be centuries old and now published by special permission of the Gods themselves; opened it - and literally the first words upon which my eyes rested were those of my poem, "Invocation

[3] ibid.
[4] ibid.

of the Horned God", which had already been published over my name and copyright mark, in "Pentagram" in 1965! As a fellow-writer, I'm sure you can imagine my feelings; but if you can't do anything about it, which in practice you can't if it is done in U.S.A., then all you can do is laugh.[5]

In his reply, Stewart wrote: "I sometimes wish somebody would publish a definitive text of the original Book of Shadows as you and Gardner wrote it, and be done with it; it's been misquoted so often ... that maybe the time has come ..."[6]

Doreen responded (in a rare undated letter) to this:

I think the idea of publishing a definitive text of the Book of Shadows, as you suggest, is a very interesting one. I too think that times are changing, as you will see if you read Witchcraft for Tomorrow; and I intend to think seriously about this.[7]

Later in the letter, she added: " ... the more I think about it, as your letter has made me do, the more I feel that a definitive edition ought to be considered."

In June 1978, Doreen met Janet and Stewart for the first time when they visited her in Brighton during a trip to London from their home in Ireland. During that visit, they presented Doreen with a manuscript copy of their book, *Eight Sabbats for Witches.* They were still trying to find a publisher, and Doreen suggested that they contact her own publisher, Robert Hale.

After reading it, she wrote to them: "I'm sure that "Eight Sabbats" is going to be an important book ..."[8] and proceeded to make detailed comments, including sending them copies of her versions of the rituals.

[5] ibid.

[6] letter from Stewart Farrar to Doreen Valiente 30 March 1978

[7] letter from Doreen Valiente to Stewart Farrar - received 24 April 1978

[8] letter from Doreen Valiente to Janet and Stewart Farrar 16 June 1978

There was then a period of quite frequent correspondence, with Janet and Stewart asking questions, which Doreen answered, often with copies of rituals and other material.

Meanwhile, Robert Hale had accepted *Eight Sabbats for Witches*, which was finally published in 1981.

In late 1980, as "Eight Sabbats" was well on the way to publication, Stewart put a new proposition to Doreen:

> ... *one idea we do have in mind would depend on your cooperation, similar to the absolutely invaluable help you gave us over EIGHT SABBATS ... Like it or not, (a) the basic Gardnerian rituals have long been "in the public domain" and no longer secret; (b) interest in the Craft is growing faster than responsible covens can cope with it, so that a lot of people are getting into the hands either of well-meaning people with confused material to work on, or worse ...* [9]

> *Janet and I were wondering if this* ["Eight Sabbats"] *leaves the job half done; should we now write a second book (called perhaps MORE RITUALS FOR WITCHES) which gives the remainder of the rituals (initiations, consecrations, and so on) in the same way as we did the Circle-casting, banishing, and Great Rite rituals in EIGHT SABBATS - namely, giving in full our own way of doing these rituals but sticking firmly to the authentic Gardnerian Book of Shadows, with explanatory material and also footnotes giving the sources of the various elements; and adding (as we did with Wiccaning etc.) some more of the rituals which we ourselves have devised to fill in what we feel to be gaps. (We have quite a few of these - for example, one for "Drawing Down the Sun" where the work in hand requires the High Priestess to invoke the God-aspect into the High Priest.)*

> *The two books together would thus provide a complete liturgy, all in the same style, based very firmly on the*

9 letter from Stewart Farrar to Doreen Valiente 3 November 1980

authentic Book of Shadows. It would also, with your help, complete what we did in EIGHT SABBATS by clearing up all the doubts and arguments about the sources of the Book of Shadows and the circumstances of its compiling. Isn't it time for this?"[10]

Doreen replied in a positive way:

... I am bound to agree with you in your proposition to publish the suggested MORE RITUALS FOR WITCHES; but I think such a publication will arouse a lot of mixed feelings ... But when we have such stuff as Lady Sheba's so called "Grimoire" on the market, are people to take their inspiration from such publications as that or from a responsible publication such as you propose?"[11]

Doreen then makes a convincing point:

However, I am the co-author with Gerald Gardner of the Gardnerian "Book of Shadows", and therefore, it seems to me, I am entitled to say whether or not it should be published - whether we attract a lot of criticism or not. Times have changed and we have to face the fact of things as they are rather than how we may think they ought to be.[12]

I think that Doreen saw all this as being a positive development. As Ashley Mortimer remarks:

She was sensible, practical, decent, honest and, perhaps most importantly, pragmatic. One example is her embracing of Janet and Stewart Farrar's publications which were hugely controversial and caused great consternation within the Craft, many thinking that they were breaking oaths. But Doreen somehow managed to support and assist them without losing the goodwill of the community. There are many letters in the collection to and

[10] ibid.
[11] letter from Doreen Valiente to Stewart Farrar 26 November 1980
[12] ibid.

238

from Janet & Stewart as well as manuscripts with Doreen's meticulous suggested amendments and comments. I think she realised that someone was inevitably eventually going to "break ranks" and publish and I think she feared this being done badly or inaccurately, the memory of Cardell still fresh. She clearly felt that with her help Janet and Stewart would go on to at least make a good job of it. From Doreen's pragmatic approach friendships were made that lasted lifetimes.[13]

60. Doreen with Janet and Stewart Farrar 1989

Whilst Doreen was asserting her right, as joint author of the Gardnerian Book of Shadows, she was also very practical about remuneration. In a post-script to the above letter, she asks: "What arrangement do you propose for payment for material of which I am the author? Can we work something out ... ?"[14] In reply, Stewart suggested a 50:50 split of the royalties.

Having been encouraged by Doreen in the book which eventually became *The Witches' Way*[15], Stewart sent her a copy of the Book

[13] Ashley Mortimer *Gerald & Doreen - Humanity and History* (unpublished manuscript)

[14] letter from Doreen Valiente to Stewart Farrar 26 November 1980

[15] Janet and Stewart Farrar *The Witches' Way* (Hale 1984)

of Shadows he had received from Alex Sanders, asking her to let him know of the differences between the two books. Doreen replied:

> There isn't really all that amount of difference in the Alexandrian Book of Shadows and Gerald's original version; which is why I was very interested indeed to receive these two MSS. you kindly sent. There is certainly nothing in it which seems original to me, which is another reason for my strong doubting of old Alex's story about his witch grandmother.[16]

There then followed another intense period of correspondence where Doreen sent the Farrars transcripts of sections of her Book of Shadows.

The Witches' Way was eventually published in 1984, the centenary of Gerald Gardner's birth, and it was a worthy memorial to his life and work. Moreover, it had a fascinating appendix by Doreen, as we shall now see.

I think that the help which Doreen gave the Farrars in producing an accurate version of the rituals which Gerald Gardner used gave her some idea of the role which she could play in clarifying and unearthing the history of the Craft, which would ultimately result in her book The Rebirth of Witchcraft.[17]

A spur to action was provided when Doreen read Professor Jeffrey Russell's book A History of Witchcraft: Sorcerers, Heretics and Pagans.[18] A passage in Chapter 9 of that book seemed a challenge to her. She wrote that he:

> ... describes how the followers of Gerald Gardner 'tell the story that he was initiated into witchcraft in 1939 by Old Dorothy Clutterbuck, a witch of the New Forest'. He adds

[16] letter from Doreen Valiente to Stewart Farrar 10 December 1980

[17] Doreen Valiente The Rebirth of Witchcraft (Hale 1989)

[18] Jeffrey Russell A History of Witchcraft: Sorcerers, Heretics and Pagans (Thames and Hudson 1980)

the remark, 'In fact there is no evidence that Old Dorothy ever existed,' the implication being that Gerald simply invented her, together with the rest of the alleged tradition of the Craft of the Wise.

Now, I was initiated as a witch by Gerald Gardner in 1953, and he often used to talk to me about Old Dorothy. By the way he spoke of her, she certainly sounded like a real person. I therefore found myself unable to agree with Professor Russell. But was there in fact any evidence of Old Dorothy's existence? And if so, how could I prove it?[19]

In typical fashion, Doreen started her investigation with a ritual, at Halloween 1980. And, for her, this meant going out into the countryside. Vivianne Crowley tells how this came about:

When my husband Chris and I were married in 1979, our wedding reception brought together many coven leaders. While they ate wedding cake, the elders plotted. The idea was born to revive the Grand Sabbats of the south of England covens, which had been in abeyance for some years.

A meeting in Doreen's flat in Brighton a few weeks later saw the launch of a series of Grand Sabbats in a Surrey wood rented from a witch-friendly farmer ...

In the Surrey wood on Samhain Eve 1980 just after sunset, assisted by Madge Worthington and Ron, Doreen called upon the spirit of 'Old Dorothy'.[20]

Doreen continues the story:

I knew that the candles and the pumpkin lanterns were glowing, the naked dancers were treading the circle and the cakes and wine were being passed around. But I longed for the dark wood, with the autumn leaves beneath my feet and the stars peeping through the topmost branches of the trees.[21]

[19] *The Witches' Way* p 283

[20] Vivianne Crowley *Doreen Valiente* in *Pagan Dawn* no. 189 (Samhain/Yule 2013)

[21] *The Witches' Way* p 285

Doreen was accompanied by Ron, whose witch-name was 'Dusio', and another female witch, 'Fiona'. She describes the scene:

> We formed our circle and proceeded with our Hallowe'en rites of invoking the Old Gods. The bonfire blazed and mingled its scent of woodsmoke with the incense that burned in the censer. At the four quarters, east, south, west and north, stood lanterns containing candles which made the little clearing a place of glowing light within the surrounding darkness of the trees.[22]

As part of the ritual, Doreen wanted to call on Old Dorothy's spirit, asking if she wanted her to succeed in her quest, whereupon a lantern turned right over and shattered the glass. Obvious reasons having been ruled out, Doreen concluded:

> We were compelled to consider at least the strong possibility that this was a supernormal occurrence. I myself believe that it was, because I also heard a voice outside the circle, seeming to come from the southern quarter. It called my name, 'Doreen!' The others did not hear this; but I heard it plainly and it sounded like Gerald Gardner's voice ... I was therefore heartened in my resolve to search for Old Dorothy ... [23]

In this search, all Doreen's investigative skills were brought into play. It is in many ways a lesson in how to explore the many sources of information available and gradually piece them together. It was certainly an inspiration for me in my own researches. In "The Search for Old Dorothy", Doreen's account of her investigations which was included as an appendix to the Farrars' *The Witches' Way*, she wrote: "I knew that, however private a person may be, there are two marks that he or she has to make upon public records, namely a birth certificate and a death certificate."[24] 1980 was, of course, before the days of the internet, and

[22] ibid.
[23] ibid.
[24] op. cit. pp 283-284

investigations had to be carried out by post or personal visits, a much more time-consuming enterprise.

Doreen immediately realised her good fortune to be investigating someone with the relatively unusual name of Clutterbuck. As she wrote: "If she had been Dorothy Smith or Dorothy Jones, my search would have been hopeless."[25]

She knew from Gerald's account that Dorothy lived somewhere in the New Forest area, and a postal enquiry to the Bournemouth Reference Library produced a positive result:

> *The Reference Library staff have searched the local directories for Miss Dorothy Clutterbuck and have found the following: 'Street Directory of the Extended Borough of Christchurch, 1933' 'Clutterbuck, Dorothy, Mill House, Lymington Road, Highcliffe. Fordham, Rupert, Mill House.*[26]

Doreen realised that Highcliffe was the place where she had first met Gerald Gardner back in 1952, in Edith Woodford-Grimes' house. Inwardly, she knew that she had found Dorothy.

61. Dorothy St. Quintin Fordham (née Clutterbuck)

[25] op. cit. p 287
[26] op. cit. p 286

The directory seemed to indicate that Dorothy had married Rupert Fordham, and Doreen was determined to track down her birth, marriage and death records. The only way she could do this was to search the national indexes at the General Register Office in London. As Doreen commented:

The sheer physical labour of this search had by this time brought me to the end of my tether! I don't know if you have ever tried this lark, but if you haven't I can tell you that there are four huge registers (that is, indexes of registers, literally) referring to the four quarters of each year. You have to pull them out of the racks yourself and then return them, and it's rather like heaving sacks of coal. Some of the war years had only two, but they were naturally even more huge! So I heaved and lifted four of these things for each year ... [27]

At least when I was investigating such matters in the late 1990s, these indexes were all on microfiche in my local library!

There then followed a gradual process of discovery, notably Dorothy's death record in 1951 and her death certificate, which gave her father's name as 'Thomas St. Quintin Clutterbuck, Lieutenant-Colonel, Indian Army (deceased)'.

Now that she had her death certificate, Doreen could send for Dorothy's will, which confirmed that she was indeed, as Gerald had described her - 'a lady of note in the district' and 'very well-to-do'.

So far, Doreen's investigations had been largely by post or in archives, but she felt that she needed to go back to the area where Gerald had lived and been initiated. She told Janet and Stewart Farrar:

I am trying to egg Ron on to take me down to the New Forest to do some more searching for Old Dorothy and to try to pinpoint the actual spot in the Forest where they

[27] letter from Doreen Valiente to Janet and Stewart Farrar 7 May 1981

used to work. I may be able to take some photographs to be used as illustrations. I already have a good one of the tree called the Naked Man, where they used to meet.[28]

By May of that year, she had succeeded in her mission:

... last week I finally got Ron to drive me down to the New Forest. We took photographs of the place where the witches used to foregather, at the old tree-stump called the Naked Man. We also found the house where Old Dorothy was living at the time Gerald was initiated - and I have probably stood in the very room where it took place.[29]

In a subsequent letter, Doreen reported:

I spoke to the present occupant's wife, Mrs. Ferguson, who happened to be in the front garden as we arrived, and asked her if she would mind me taking a photograph of the house. She very kindly asked me in, and I explained to her that I was interested in the lady who had once owned the house. We chatted away, and I eventually decided to tell her something of what I knew, as she said she was interested herself in the history of the house (it is actually an old mill converted into a private dwelling); but that she had never been able to find out much about it. I told her that it had once been the dwelling-place of a lady whom I believed to have been a leading member of the New Forest white witches. I wondered how she would react, but she seemed not at all shocked, only interested; so I ventured further and told her I was writing a book about these old traditions and would she be willing to let me publish the photograph? And she said, yes, certainly! So I'm very pleased about that. I took a number of photographs, and I am having some enlargements done of the best ones - I took some in the Forest, too.[30]

[28] letter from Doreen Valiente to Janet and Stewart Farrar 8 February 1982

[29] letter from Doreen Valiente to Stewart Farrar 17 May 1982

[30] letter from Doreen Valiente to Stewart Farrar 10 June 1982

62. Mill House, Highcliffe

Not having any success with finding her birth records, Doreen wondered whether Dorothy might have been born when her parents were in India. Acting on a suggestion, Doreen visited India House in London and tracked down Dorothy's birth record. She relates what happened next, after being told she would have to wait some twenty minutes for this:

I said I would wait and went to look for somewhere to sit. And now ensued a curious incident. There were several chairs nearby for visitors, but they were all occupied. So I wandered into a further part of the library, just looking for somewhere to rest. I had had a long and tiring day. I found myself standing in front of a bookcase full of neat volumes of indexes entitled 'Marriages. Bengal.'

Suppose Dorothy's parents had been married in India? If I could find the entry, that would give me her mother's maiden name. I took out a volume. It immediately *fell open in my hands and I saw the name 'Clutterbuck, Thomas St Q.'. I admit that I was both tired and excited; but I will swear that that book opened itself.*[31]

Having ordered this certificate as well, Doreen waited for them to arrive by post, which they did, on 30th April 1982 - one and a half

[31] *The Witches' Way* p 293

years altogether, from Halloween to Beltane. Doreen concludes: "For the time being my search was ended."[32]

It was this simple statement, as much as any other, plus an appreciation of Doreen's investigative methods, that inspired me to continue her work of investigation into the origins of the Craft. Here were facts rather than vague beliefs and I began to realise that there was no reason why I should not adopt a similar approach. I almost felt as if Doreen was handing me the baton with her statement "For the time being my search was ended". Inspired by Doreen's example, I have myself been on many visits to Highcliffe and Christchurch over the last seventeen years and have made new friends as a result, most notably Ian Stevenson, the local historian in Highcliffe.

Doreen once said that, if she had the resources, she would 'make her base' in the New Forest area for a while and really find out what had been going on. I think that with her investigative skills she would have succeeded.

[32] ibid.

Chapter 18
Correspondence, Visitors
and Friends in High Places

Doreen was never one to, as the phrase goes, 'suffer fools gladly', but she was more than willing to help those who came to her in need of genuine advice or assistance, provided they treated her with respect. Her door would often not be answered to those who turned up at her home unannounced and without permission. She wrote:

> *so many time wasters tried to contact me that I refused to see anyone without appointment. The typical middle-aged ladies who were "afflicted by black magic".*[1]

Michael Howard confirmed this when he told me:

> *In 1967 I met an elderly man called Wilfred South who claimed to be a 'Fen witch'. This was because he was inducted into an Old Craft coven in the Cambridgeshire fens when he was a young man. When I met Wilfred he was living in Brighton and claimed to be a friend of Doreen's. He offered to take me to see her. In those days she was*

[1] *Have Broomstick Will Travel*

living in a basement flat in one of the large houses near the sea front. When we arrived Wilfred knocked on the door and at first there was no answer. Then Doreen shouted through the letterbox that she was not receiving visitors and told us to go away, which we rather sheepishly did![2]

And she did not appreciate those letter-writers who did not extend the courtesy of including a stamped addressed envelope or an International Reply Coupon, who would frequently not receive a reply. A typical example is someone I shall call "Mr D." who had written to Doreen, mentioning Janet and Stewart Farrar. She writes to them:

This person threatens to descend on me next week. Do you know anything about this? ... In case you do know this man please tell him I'm going to France next week - tell him anything, but keep him out of my hair![3]

Doreen follows this a week later:

"Who will rid me of this turbulent priest?"

For the last week I have been bombarded with postcards (which the postman must be getting quite interested in by now!) telling me how he had had wonderful circles with you and Pat Crowther, and how he was coming down to visit me. Yet in all this correspondence there was never any use of just one little phrase: "May I please come down and see you?"

Instead, he informs me of when he proposes to descend on me, and adds, not his address, but his mother's telephone number ... , which I am permitted to ring to finalise arrangements. I notice that, while very anxious to gather everyone else's address, he is quite shy about revealing his own.

Well, I have rung this number twice, and informed his long-suffering mother (who of course is not responsible for

[2] email from Michael Howard to the author 16 January 2013

[3] letter from Doreen Valiente to Stewart Farrar 12 January 1981

any of this nonsense), that I cannot see her son at the moment because I am on the point of going away on holiday and shall be away for some time. This has succeeded in keeping the ineffable Mr. D ... away for the weekend; but I have received another communication this morning, enclosing a greetings card, a £1 note for my telephone bill, and informing me that he is now coming down on Wednesday!

Well, that's it, I'm afraid. Quite honestly, I have had enough. I am not going to make any more phone calls, and if he turns up here on Wednesday he will be asked firmly to go away. And if he still won't take no for an answer, I shall call the police. Alternatively, I might actually go away and leave Ron here to deal with him; much as I resent being driven from my home...[4]

Doreen softens her approach later in the letter:

... perhaps I won't actually call the police to your friend Mr. D... I will just hide under the bed until he's gone.[5]

The issue seems to have been resolved satisfactorily, as Doreen reports to Stewart a fortnight later:

Well, when I'd cooled down, I reflected that the proper course of action for a witch was to use witchcraft. So I referred the matter to my familiar; and I don't know what happened, but D... just didn't turn up. He's all right, though, because I got a letter from him with a copy of my book Natural Magic, asking me if I would write something in it for him and post it to his home address ... Well, I thought, a bit of friendliness costs nothing, so I did - just a few words of greeting to him and his coven, and posted it off. I'm still getting postcards from him! ... As you say, he means well![6]

[4] letter from Doreen Valiente to Stewart Farrar 19 January 1981

[5] ibid.

[6] letter from Doreen Valiente to Stewart Farrar 4 February 1981

John Belham-Payne told me of another occasion when Doreen was bothered by unwanted attention:

When I first got to know Doreen I didn't realise her telephone was a recent acquisition. It had proved a mixed blessing however and I later found out from Patricia Crowther that it was she who had insisted that Doreen got one. Patricia and Doreen were very close friends but whenever Patricia wanted to talk to her she had to write in advance and tell her what time to be at the public phone box on the corner of the street. Apparently one cold winter Doreen gave in and had a phone installed in her flat. One evening when I arrived to see her she was very agitated, "Ah John, I want you to punch somebody's lights out for me," she said, "This guy keeps phoning me up and saying he is Gerald's nephew and wants to come and see me. I told him that he can't be but he's trying everything to get in my flat. I find him creepy and he won't leave me alone. I don't know who gave him my phone number but I want you to punch him for me and tell him to stop phoning me up". I knew the person and I did stop him phoning but, for the record, I did not punch him! It turned out that Doreen wasn't aware you could choose not to be listed in the public telephone directory and, unsurprisingly, there was only one entry under 'Valiente, D' for Brighton & Hove![7]

Doreen could sometimes be rather strong in her criticism of individuals. In a letter to Janet and Stewart Farrar about a well-known author, she writes:

... I have, just occasionally, got a vague impression that he doesn't altogether like me. I wish I knew what I'd done to upset the little man - I'd do it again![8]

Melissa Harrington stated Doreen's approach as she saw it:

There was a rumour going round that she was unfriendly. She was unfriendly if you turned up at her house uninvited

[7] John Belham-Payne personal communication with the author

[8] letter from Doreen Valiente to Janet and Stewart Farrar 18 June 1981

in the middle of the night wanting to talk about Gardnerian history. If you just approached her normally like a normal person she was so friendly and helpful.[9]

Lois Bourne saw the truth of Doreen's approach:

She had the remarkable ability to discern quite quickly the difference between truth and fiction, but no one in genuine trouble or misfortune was ever turned away. She was a true friend, faithful and loyal to her calling.[10]

I think Doreen was also somewhat ambivalent about having photographs taken of her. On the one hand, there is a great variety of photographs taken over the years by press photographers and others, some of which are reproduced in this book. On the other hand, she told Janet and Stewart Farrar:

I ... have to go and have a black and white portrait photograph taken for Robert Hale's publicity department - I'd almost sooner go to the dentist (in fact, definitely sooner as we've got a very nice dentist!) But they insist they want it, so I'd better comply and keep them happy.[11]

As time went on, Doreen received an increasing level of correspondence from America. A typical example is that of Aidan Kelly, subsequently author of *Crafting the Art of Magic*[12], which became *Inventing Witchcraft*[13]. He had written in the magazine *Iron Mountain* that he believed that the evidence indicated that Gerald Gardner and Doreen had, between them, invented the Craft and that the New Forest Coven had never existed.

After an initial rather frosty reception from Doreen to this pronouncement, their joint passion for finding out the truth

[9] Melissa Harrington - interview by the Centre for Pagan Studies/Doreen Valiente Foundation - November 2014

[10] *Charge of the Goddess* p 25

[11] letter from Doreen Valiente to Janet and Stewart Farrar 8 April 1983

[12] Aidan A Kelly *Crafting the Art of Magic - Book 1 - A History of Modern Witchcraft 1939-1964* (Llewellyn 1991)

[13] Aidan A Kelly *Inventing Witchcraft - A Case Study in the Creation of a New Religion* (Thoth 2007)

about the origins and development of the Craft shines through their subsequent correspondence, although not without some setbacks along the way.

Doreen wrote a conciliatory letter back, which ended:

> *It is a pity that we have never got together to exchange ideas long ago, because in fact we share the same interest, even though we have approached it in different ways. I trust that this exchange of letters may clear the air and lead to a better understanding in future.*[14]

Kelly, in a later letter to Doreen, excused his initial beliefs as follows:

> *I think one thing that has been confusing the situation is that you had no way to know how bad the communication was between England and the USA about Craft matters. The fact is, no one in America had an inkling of what your real role in the Craft had been, until 1979.*[15]

He did his best to placate Doreen by stating:

> *The stories told by Alex Sanders, Sybil Leek, Lady Sheba, and the people claiming to be "traditionals" independent of Gardner were clearly pure fabrications, since they were contradicted at every point by the chronology I had worked out from the documents. Your accounts, in contrast, dovetailed with that chronology exactly, and shed light on many details that had seemed strange when I first encountered them.*[16]

Unfortunately, their next contact did not get off to a good start, as Kelly appeared to Doreen to be suggesting that she had used some of his work without acknowledgement, in her latest book, *The Rebirth of Witchcraft*. As a result, she wrote him a letter saying that she did not wish to continue the correspondence.

[14] letter from Doreen Valiente to Aidan Kelly 31 July 1986
[15] letter from Aidan Kelly to Doreen Valiente 26 March 1990
[16] ibid.

However, Doreen later relented and sent Kelly what he describes as a "wonderful, friendly letter". Doreen subsequently gave him some useful comments and information in connection with the book of his that was about to be published: *Crafting the Art of Magic*.

As far as I am aware, the correspondence ceased at that point, but it illustrates well the way in which Doreen could, perhaps justifiably, be offended by someone, but would later be magnanimous enough to make it up with them and continue to help them as much as she could.

This happened at least twice in her correspondence with Aidan Kelly. It also happened, of course, in her relationship with Gerald Gardner.

Doreen had long been one who was quick to condemn child abuse, particularly if it was being presented in a ritual context. We have seen how she spent a long time finding out who had been present at a ritual in the grounds of Cardell's premises, where it had been rumoured that child abuse had occurred.

In the early 1980s, an article appeared in an occult magazine which seemed to suggest that sexual intercourse between parents and their children had occurred as part of an initiation ritual. Whether this was of a historical nature, was actually occurring in the present or was purely a theoretical idea, seemed irrelevant to Doreen. She firmly believed that this sort of thing would give the Craft a bad name, and she was determined to do something about it. As she wrote to Janet and Stewart Farrar:

> *I'm a bit worried ...; because if people take this nasty rubbish seriously and think that this is the real, genuine article and all else is fake, then they are bound to think that witchcraft is a very mucky business indeed and ought to be eradicated ...*[17]

[17] letter from Doreen Valiente to Janet and Stewart Farrar 3 August 1981

The original article had appeared under a pseudonym, but Doreen's investigative skills were put to work, and eventually she tracked down who the authors of the article were.

When Janet Farrar told Doreen that she had a journalist friend who worked for the *News of the World*, Doreen was all for tipping them off about this possible news story, and so this is what Janet did. In due course an exposé appeared in the paper.

64. & 65. Doreen 1970s

More than one person has told me that they suspected that Doreen had "friends in high places". Certainly in one case this was true: Doreen was friends with the Queen Mother.

Janet Farrar told me how Doreen had invited her and her coven maiden, Virginia Russell, for a trip in a private jet to visit the Queen Mother at her home in Scotland. The main subject of the conversation was that the Queen Mother had heard that, arising out of the 'ritual abuse' scares, there would be attempts to proscribe the practice of witchcraft.

It was obvious that Doreen and the Queen Mother knew each other well. How had this come about? We really don't know, but perhaps it started with correspondence between the two,

instigated by Doreen, perhaps at the time when she had tea on the House of Commons terrace with Gwilym Roberts MP.

Then again, Ray and Lynda Lindfield did provide one clue and it concerns the 'witch mirror' in Doreen's collection. Lynda told me that:

> There's a story that there were two of them and at Balmoral the Queen Mother would have a clear-out every so often and put stuff in the local jumble sale, raising money for charity, and she'd often be on the stall. And that mirror of Doreen's apparently came from Balmoral.[18]

Ray added:

> When they wanted to track it down to find out if it actually was the one from Balmoral, the researcher that came back said "Yes, Balmoral has got one, and did have two and the Queen Mother, although she agrees that, yes, this is possibly the one from Balmoral, she can't remember being on the stall and selling it" but the person who bought it said obviously that is what happened.[19]

This could well have been the initial point of contact between Doreen and the Queen Mother. As with many aspects of Doreen's life, this relationship still remains shrouded in secrecy.

[18] Lynda Lindfield personal communication with the author
[19] Ray Lindfield personal communication with the author

Chapter 19
Literary Adventures

In the years following the publication of *The Witches' Way* (which included Doreen's appendix on "The Search for Old Dorothy") in 1984, Doreen had several ideas for books which she put to her publisher.

Her enthusiasm seems to have been transferred to a book on "The Goddess of Witchcraft". However, in one of those remarkable examples of synchronicity, Hale's were about to sign a contract with Janet and Stewart Farrar for *The Witches' Goddess*, so they had to turn down Doreen's suggestion. She wrote to Stewart:

> *Thank you very much for the synopsis of THE WITCHES' GODDESS. Now, this is really extraordinary, because I had got the very same idea, and actually put it up to Robert Hale's, who told me they had a very similar idea from you. But I didn't realise just how similar until I read your synopsis. We must really have been tuned into the same thought-wave, and as you know I couldn't have got the idea from you because I hadn't heard from you. It's an example of how this can happen.*[1]

[1] letter from Doreen Valiente to Stewart Farrar 30 September 1985

Hale declined to publish "The Witch Ball", for reasons which I gave in Chapter 15, but were interested in a suggestion by Doreen for a book on sites in Britain associated with witchcraft.

By April 1985, Doreen submitted a synopsis of what, by then, had the title of "Landscape of Witchcraft". In June, Hale had asked for a sample chapter, but the following month Doreen seemed to have lost interest in the project. Hale tried to persuade her not to give up:

> *I really do think you have something to offer here and it would be a shame not to pursue the idea. Do please give it some more thought and let me know.*[2]

By September 1985, however, Doreen confirmed to Stewart that she was no longer interested in that project, but that she had another one in mind:

> *Carmel Elwell still wants me to write a book about witchcraft sites in Britain, but I honestly don't think it would work along the lines she has suggested. I have got another idea, which I am chewing over. I just might do my autobiography! Well, Lois Bourne did, so why shouldn't I?*[3]

The enthusiasm for finding out about Craft history that grew in Doreen during her search for Old Dorothy may well have ignited the idea that she could go further and write a history of the Craft. This was probably encouraged by an obvious lack of awareness that many seemed to have of the true story and, specifically, of Doreen's own role in the development of the Craft.

When she began to write this history, Doreen may well have been surprised at the extent to which she was herself a part of the story, so that for a while she pondered on turning it into an autobiography. This was certainly the focus of the book during 1986:

[2] letter from Carmel Elwell of Robert Hale to Doreen Valiente 16 July 1985

[3] letter from Doreen Valiente to Stewart Farrar 30 September 1985

... I've been arranging my ideas about my autobiography. It's amazing how many memories come flooding back when one sets one's mind to it.[4]

By June, Doreen had obviously mentioned the idea of an autobiography to Hale, because they had written to her:

I am, of course, wondering if you have given any further thought to your autobiography, which you know I and your many admirers are very anxious to see. I would be delighted to arrange a contract once I have seen a brief synopsis.[5]

That August (1986), Doreen was invited up to London to have a discussion with Carmel Elwell of Hale's about the proposed biography, with the added enticement of lunch "in one of Clerkenwell's many prestigious restaurants". Elwell had written:

I think it would help to discuss your feelings about the autobiography rather than try to commit too much to paper at this stage.[6]

The result of that discussion (and the lunch!) was obviously positive, since by November that year, Doreen was:

... getting totally absorbed in writing my autobiography. I started scratching about for material for it and found a suitcase full of old notebooks and papers that I'd forgotten I had. Also the manuscript of a book that I'd totally forgotten having written! All this has been very useful and I have now submitted a synopsis to Robert Hale's which I hope they will find interesting.[7]

The manuscript that Doreen had forgotten about was probably "I Am A Witch", dating from 1966, which I mention in Chapter 1.

[4] letter from Doreen Valiente to Janet and Stewart Farrar 4 April 1986

[5] letter from Carmel Elwell of Robert Hale to Doreen Valiente 26 June 1986

[6] letter from Carmel Elwell of Robert Hale to Doreen Valiente 15 August 1986

[7] letter from Doreen Valiente to Janet and Stewart Farrar 24 November 1986

And her notebooks I have already referred to as a valuable resource for future researchers into Craft history.

I am guessing that it was at this time (late 1986) that Doreen prepared the synopsis of the book which was at that stage to be entitled "Have Broomstick, Will Travel". That synopsis still exists and I have found it extremely useful in writing this book, although it is intensely frustrating that intriguing topics are mentioned without any details being given!

Writing the book seems to have taken its toll on Doreen as, by April 1987, she was writing to Janet and Stewart Farrar:

> ... I think my planned autobiography might have contributed to this feeling [not being able to get around to things]. In the course of my preparation for it, I tried more seriously than I have previously to recall my previous incarnations. I think I had some success; but perhaps it would be better if I hadn't, as I have really been very depressed. Stirring up the deep pool of the Inner Mind can stir up rather more than one bargains for.[8]

The scope of the book is summed up on its flyleaf:

> The Rebirth of Witchcraft traces the lineage of present-day witchcraft from its forerunners through to modern feminist neo-paganism and the new wave of interest in ecology and holistic medicine.[9]

The book is, in fact, a very well-written account of how the embers of traditional witchcraft were re-ignited by such individuals as Gerald Gardner and chronicles faithfully the author's own role in this process. It also includes what she sees as growing points for the future of the Craft.

The book starts with the background to the Fraudulent Mediums Act of 1951, which abolished the last of the old Witchcraft Acts and

[8] letter from Doreen Valiente to Janet and Stewart Farrar 20 April 1987

[9] Flysheet for Doreen Valiente *The Rebirth of Witchcraft* (Hale 1989)

which accelerated the witchcraft revival in England and subsequently in many other parts of the world:

> If the average person were asked, 'When was the last big witch trial in Britain?', they would probably reply, 'Oh, I suppose about two or three hundred years ago.' They would be wrong. It took place at the Old Bailey in 1944.[10]

This was the trial of spiritualist, Helen Duncan.[11]

After an overview of some of what Doreen calls 'the forerunners': Charles Godfrey Leland, Margaret Murray, Robert Graves and Charles Seymour, Doreen quotes Seymour's co-worker, Christine Hartley's magical record for 28th June 1938: "Started when I walked over the threshold of the house and felt witchcraft all round me. Went upstairs extremely desirous of being a witch." Doreen concludes the chapter:

> I think that in the midsummer month of 1938 something was stirring upon the Inner Planes because its time had come.[12]

It is in the following chapter on Gerald Gardner that Doreen introduces her personal story as it intertwines with that of the Craft, as I chronicle in Chapter 5 of this book.

The following six chapters are very clearly a record of Doreen's own life in the Craft, describing as they do her own working with Gerald, press attacks on the Craft and her own encounters with Robert Cochrane and Leslie Roberts, all of which were very useful to me in writing this current book.

And, as well as the intensely personal "Voice from the Past?" communications, which I refer to in Chapter 10, there is, amongst these chapters, interestingly, one on Traditional Witchcraft,

[10] *The Rebirth of Witchcraft* p 9

[11] Malcolm Gaskill *Hellish Nell - Last of Britain's Witches* (Fourth Estate 2001)

[12] *The Rebirth of Witchcraft* p 33

which, to me, is added confirmation that Doreen was involved in a local Sussex tradition over a considerable period of time.

There is, however, no mention of Charles Cardell and the circumstances surrounding him. Doreen told Michael Howard, editor of *The Cauldron*:

> *I wanted to include an account of the Cardell affair in my book THE REBIRTH OF WITCHCRAFT; but my publishers weren't happy about it. They were afraid they might get sued for libel, Cardell being the sort of bloke he was - and the trouble is that, even if you win the case, as I think we certainly would have done, you can get landed with a big bill and a lot of hassle. So, reluctantly, I cut that chapter out. However, I'd still like to know the truth behind the whole Cardell story.*[13]

In fact, Charles Cardell had died in October 1977 and Mary Cardell had died in October 1984, so they could not have sued for libel. But, unfortunately, Doreen's account has now been lost.

The remainder of the book shifts to some extent away from Doreen's personal experience with a chapter entitled "The Kingship of Alex Sanders". This is emphasised by the first sentence, which reads:

> *I never met the extraordinary man known as Alex Sanders, 'King of the Witches', although in the latter part of his life he lived near me, in Bexhill, Sussex.*[14]

This is followed by a chapter on 'The Pickingill Material', an examination of the claims of 'Lugh' (Bill Liddell) to have received information from his initiators that one George Pickingill (1816-1909), a 'cunning man' from Canewdon, in Essex, had actually founded nine covens in south-east England, including the New Forest coven in Hampshire into which Gerald Gardner was initiated.

[13] letter from Doreen Valiente to Michael Howard 25 October 1993
[14] *The Rebirth of Witchcraft* p 163

As always, Doreen approaches both of these with fairness. Whilst highly critical of many aspects of Alex Sanders' activities, she admits that:

> *If it had not been for him, the old Craft would not be as strong in adherents as it is today. For instance, it was through him that Janet and Stewart Farrar first became witches and went on to found their own coven.*[15]

Of Lugh's claims, Doreen is more equivocal. She concludes:

> *Only further research can tell us whether, in fact, 'Old George' Pickingill was really the man who adapted the ancient ways of the hereditary witch cult in Britain to be perpetuated in modern times.*[16]

Doreen was always looking to the future in her writing, and this is exemplified in her concluding chapters on "Feminist Witchcraft" and her favourite topic, "Into the Age of Aquarius". The former starts this way:

> *For many years now, there has been a general belief among occultists that in about the last twenty-five years of each century, a special impulse comes from higher planes to regenerate this planet ... Perhaps I am not impartial, but it seems to me that the feminist movement as it has begun to move into the world of the occult may well be the manifestation of this impulse. It is notable how many of the most influential spiritual movements of modern times have been founded or advanced by women.*[17]

This is certainly true of the modern witchcraft revival, as I have already pointed out.

Doreen gives a robust promotion of feminism, states clearly its absence in most religions, and writes about individual women such as Szuzsanna Budapest and Starhawk (Miriam Simos) who have

[15] *The Rebirth of Witchcraft* p 177
[16] *The Rebirth of Witchcraft* p 206
[17] *The Rebirth of Witchcraft* p 179-180

made a real contribution to the development of the Craft. Whilst never visiting America, Doreen was clearly much influenced by the feminist movement there and the way in which the link with witchcraft was forged.

She writes:

> *Starhawk's book The Spiral Dance: A Rebirth of the Ancient Religion of the Great Goddess, ..., is practically a new 'Book of Shadows'. Although founded on the traditions of witchcraft as we have come to know them from Gerald Gardner, these books have a freshness of approach and an abundance of poetry and magic which have taken the Old Religion a step further in its advance in the modern world. No feminist witchcraft coven today need be without rituals or guidance from these sources.*

> *I had the great pleasure of meeting Starhawk recently, on one of her trips to Britain. We talked about the Old Religion, and I was impressed by her aura of strength which was at the same time entirely feminine. The concept of powerful women, women who have power in themselves, is what seems to me to be new about feminist witchcraft. In the past, the idea of a powerful woman was a woman who imitated men. Feminists today, especially feminist witches, are not like that any more. They do not want to imitate men; but nor do they want to play the roles men design for them as sex-objects, either within the Craft or outside it. They want to manifest their femininity fully and be proud of it.[18]*

Doreen ends the chapter by remarking that:

> *... women can show the world a set of values different from those we have today. They can bear the influence of the incoming Aquarian Age to the human race.[19]*

This leads naturally on to the last chapter which explores the way in which the witchcraft revival related to modern society.

[18] *The Rebirth of Witchcraft* p 186-187

[19] *The Rebirth of Witchcraft* p 195

Doreen wrote:

In a sense, the rebirth of witchcraft is a rebellion. It is being carried out by those both young and old who are no longer content to get their religion from the churches or their opinions from the newspapers ...[20]

She points out that at the time she was writing the book there were outside threats to the Craft accusing members of any number of unpleasant practices. These threats have now largely ceased because, I think, there is greater understanding of the beliefs and practices of witches amongst members of the press and, indeed, amongst the public at large.

Doreen was, however, not averse to criticising witches themselves, particularly where they were engaging in what she called 'ego-tripping' and, in some cases, 'occult bullying'. She advises standing up to such people as 'the bully is always a coward at heart'.

Doreen ends the book with a more positive look at modern witchcraft. She sees the interest in such topics as ecology, alternative healing, earth energies and the esoteric landscape as being encouraging signs among modern witches.

Doreen's closing remarks give her vision of the future of the Craft:

It will be a happy, constructive religion, and what we now call magic will be part of it. It will be involved with nature and the whole biosphere of our planet. It will be in communication with Mother Earth and with the changing seasons and the elements of life. It will take its stand against greed, cruelty and social injustice. Its rituals will have colour, music and dancing but also quiet times of meditation and healing for mind and body. It will help every man to be his own High Priest and every woman to

[20] *The Rebirth of Witchcraft* p 207

266

be her own High Priestess. It will be part of the Aquarian Age.[21]

She signs off forthrightly: "THE END - OF THE BEGINNING"

————————————•·◆·—————————

Throughout the period that she was writing *The Rebirth of Witchcraft*, Doreen was continuing to have ideas about future books, as is exemplified by this entry in her notebook in 1987:

> *Idea for book - "The Lone Witch". How a practitioner working alone and in secret can be more powerful than a coven ... Also, bring in the "Grimoire of Atho" material, in revised and updated version. Quote material from Canada, also letter in "Prediction", as instances of abuses of coven system by self-appointed leaders. Also, tell how covens have broken up, causing much personal distress, because of unfaithfulness between couples.*[22]

Perhaps the rather negative tone of this note meant that Doreen decided not to proceed with this project. Indeed, her next (and final) book was of a very different kind.

Hale had been in the habit of sending manuscripts to Doreen to read and give her opinions on, for a fee. Quite a few books subsequently published by them, and some that were not, underwent this process, to the probable benefit of all concerned.

In August 1988, Doreen received from Hale a manuscript entitled "The Rites of Tubal Cain" by one Evan John Jones. She already knew the author, because they had both been members of Robert Cochrane's coven in the 1960s. Moreover, Jones lived in Brighton, quite close to Doreen. It seems likely that Doreen had had a hand in writing the manuscript before Hale had approached her. Their initial reactions to it were as follows:

[21] *The Rebirth of Witchcraft* p 218

[22] Doreen Valiente *notebook no. 74* 24 January 1987

(1) it seems almost as if it is written by two people with some parts of it literate and others far less so.

(2) some of the rituals themselves are very complex and we feel that more explanations are called for. Perhaps indeed there is no real demand for a book of such complex rituals.

(3) is there in any event a market now for a book dealing with the rites, the working details, coven regalia etc?[23]

I suspect strongly that Doreen had helped Evan John Jones to put the book into some shape and had actually written some sections herself, as she had done with Gerald Gardner's *The Meaning of Witchcraft* back in the 1950s. This would help to explain the comment about it appearing to be "written by two people".

The book was about the rituals and beliefs of the Clan of Tubal Cain, which was a continuation of the group originally led by Robert Cochrane, but it was clear that the author needed considerable help in making the book publishable. Doreen undertook this role willingly, as the cover of the book as finally published makes clear. Firstly, the title was changed to the much more catchy "Witchcraft - A Tradition Renewed" and the authors are given as "Evan John Jones with Doreen Valiente".

67. Doreen

[23] letter from Hale to Doreen Valiente 30 August 1988

There has always been considerable debate about the extent to which Cochrane created the Tubal Cain tradition himself and how far it was what he claimed it to be - an old tradition.

For Doreen, the reality was that it worked. As she wrote:

> ... I have to give credit to Robert Cochrane for having given me the opportunity to take part in some of the best outdoor Sabbats I have ever attended.[24]

So, Doreen made some detailed comments to Hale about the manuscript, including:

> It might, I think, also need a foreword, perhaps by someone else (I'd be willing to do this), explaining a bit more about the book and its author.[25]

Hale obviously took Doreen up on this suggestion, as she explains in her Preface to the book:

> My task in helping to produce this book has been to edit John's manuscript, to rearrange its contents and here and there to add what I felt were some points of interest. I have also put some of his incantations into verse. However, the ideas and rituals in this book are mainly his. I have been glad to help it find publication, because I feel that it is an important book and unlike any other which has appeared on this subject. In fact, it is the only book I know which is devoted entirely to traditional witchcraft, as opposed to more modern versions of the Old Religion.[26]

Doreen commented:

> He wrote what I thought was a very interesting book, and so I helped him get it published by editing it a bit. He wrote a lot of it from inspiration and he didn't really know how it was going to come out until he'd written it down. It is based on the ideas that he and I developed when we worked with

[24] *The Rebirth of Witchcraft* p 125

[25] Doreen Valiente *Notes on "The Rites of Tubal Cain"*

[26] Evan John Jones with Doreen Valiente *Witchcraft - A Tradition Renewed* (Hale 1990) p 8

Robert Cochrane. Some of those he has modified a bit to make them more suitable for the present day, to be more forward-looking rather than backward-looking. But this is quite a different sort of ritual from what I think most people do ...[27]

Doreen does, however, emphasise that the book makes no claims to include the rituals used by Robert Cochrane. As she says:

... it would not be possible ... because, as I remember them, most of Cochrane's rituals were spontaneous and shamanistic.[28]

The book is, as the start of Doreen's Preface explains:

... a deeper and more serious book about witchcraft than most of the books on the subject on sale today ... There is no doubt that 'Wicca' has brought much enjoyment and enlightenment to many people; but there is an older witchcraft, and it is the latter that this book is about.[29]

The book itself is a description of the Craft as practised by Evan John Jones and commences with a section on the philosophy of the faith and the essence of the rites. The practical aspects of the organisation of the coven and its working tools and regalia are covered, and the book ends with the composition of the rituals and examples of the rituals for 'the four great Sabbats' of Candlemas, May Eve, Lammas and Hallowe'en, the names by which those festivals were long known in England.

Whilst there are now several books on 'traditional' (i.e. pre-Gardner) witchcraft by such people as Michael Howard, Nigel Jackson and Andrew Chumbley, *Witchcraft - A Tradition Renewed*, published in 1990, was one of the first to open awareness that such traditions did exist, even if Cochrane's version was a mixture of old and new.

[27] Doreen Valiente Interview in *Fireheart* No. 6
www.earthspirit.com/fireheart/thdv2.html

[28] *Witchcraft A Tradition Renewed* p 8

[29] *Witchcraft A Tradition Renewed* p 7

Chapter 20
A Cottage with Roses round the Door?

In the summer of 1968, after having lived in Lewes Crescent for over 12 years, Doreen and Cassie moved to 8A Sillwood Place, a flat rather nearer the town centre. This was in a terrace of houses dating from 1827-29, designed by the architect, Amon Henry Wilds. The houses were three-storey with iron balconies on the first and second floors.

I don't really know the reason for moving. Perhaps the rent was cheaper, or it was more conveniently located, or perhaps there was a recurrence of the mouse problem. Anyway, Doreen was cautious about the new property and had a long list of queries which she wanted the answers to before agreeing to move in:

> *Kitchen floor in need of repair. To whom does the garden belong? Toilet needs new seat. Kitchen wall in need of repair. What is means of heating - open fire or otherwise? Strong smell of gas round meter. No washbasin? Bathroom wall needs resurfacing. Surround of door into bedroom damaged. No fire-basket in grate. Front door very easy to burgle, and could need mesh or wrought iron over glass to*

make it safe. What arrangements are there for collecting
dustbins? (No dustbins there). Gate broken off and lying
in garden. No letterbox. Back area has no access to street
except fire escape, and appears to be damp (bathroom wall
damaged by damp, apparently). Contains what appears to
be drainpipe in broken condition.[1]

There are a further two pages of similar comments. One wonders
whether all these items were dealt with before they moved in.
Knowing Doreen's character, I imagine that they would be!

The occultist, Bill Gray, gives an account of visiting Doreen and
her husband after they had settled in:

Doreen was a very genuine scholar with one of the best
private libraries on occult topics which I have encountered.
She was a very tall woman of just over six feet, who married
a very small Spaniard who worked as a chef, and had been
a rebel in the Spanish Civil War. This was Cassie, short for
Casimir [sic]. Although he understood English perfectly,
his pronounced accent was so strong and fast that I could
never understand him. He took no part in Doreen's
'witchcraft', but made no attempt to interfere with it, being
of atheistical persuasion. She sometimes called him her
dear little gnome, lifted him by both elbows to kiss him and
then sat him in his favourite chair to watch TV while we
would follow her into their bedroom, to talk without its
interference. His great passion was watching all-in
wrestling, and his pet budgerigar would fly out of its cage
to join him on his shoulder, and the sight of the small man
and his tiny bird bouncing up and down with excitement
together while horrendous howls came from the box was
highly amusing.[2]

Doreen told Sally Griffyn that whilst Casimiro was supportive of
her various esoteric pursuits, he had no interest in them himself
and, indeed, had been quite emotionally damaged by his

[1] Doreen Valiente *notebook no. 45* 22 July 1968

[2] *The Old Sod* p 148

experiences during the Spanish Civil War. She told her that it was not a good marriage; in fact it was a long unhappy marriage and that she was really clear that she should have left him.

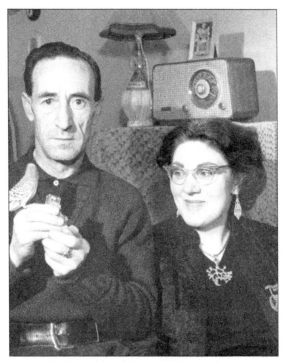

69. Casimiro and Doreen Valiente at home

Nevertheless, when Casimiro died of heart failure and chronic bronchitis on 10th April 1972, it was clearly a blow to Doreen, but it was followed, less than three weeks later, by a Closing Order served by Brighton Council under the Housing Act 1957, stating that it was satisfied that the property was unfit for human habitation and that it prohibited the property to be used for housing. It would appear that it had been allowed to deteriorate for some time to the extent that such an order was issued. Following Doreen's move, the houses at Sillwood Place were derelict for many years until their restoration and conversion to flats started in 1989.

Doreen must have had prior warning that such a notice was to be served, as Patricia Crowther writes:

> On one occasion the Sheffield coven worked to obtain a new flat for Doreen Valiente, and in the middle of the working I received the vision of a coffin that refused to be banished. None of the other witches sensed this depressing portent, which was most disturbing to say the least. However, a week later, Doreen rang with the sad news that her husband, Cassie, had passed away. A lecture in Nottingham prevented me from being present at Cassie's funeral, but Arnold and I drove down to Brighton afterwards. We were able to stay with Doreen for a few days, at the time she most needed the company of friends. I was really sorry about Cassie, he was such a straight, no-nonsense type - a really good egg!
>
> Eventually, Doreen obtained a nice modern flat - exactly what she required - and the flurry of moving to new surroundings may have helped, in a very small way, to take her mind off her bereavement.[3]

In fact, the Council, as was its duty, re-housed Doreen in the flat she was to live in for the rest of her life - 6 Tyson Place, Grosvenor Street, off Edward Street in Brighton - within reasonable walking distance of the town centre shops, library and other facilities, although it is up on quite a hill, which would have kept Doreen and the other residents fit! Tyson Place is a council-owned block of flats, 13 storeys in height, built in the mid-1960s. It was probably named after Charles Tyson, who was Mayor of Brighton in 1957-1958.

Doreen's flat was on the first floor - just a living room/bedroom, kitchen and bathroom. As Janet Farrar told me: "She was just an ordinary lady living in a tiny one-bedroom flat - so small you could hardly move ... because of all the books she collected."[4]

3 *One Witch's World* pp 88-89
4 Janet Farrar - discussion with the author February 2013

70. Tyson Place, Brighton

John Belham-Payne described her flat to me:

[It] was limited to a single room where she had her bed, a small, but ancient, rented television, her word-processor (not even a computer, really), and one armchair. Unfortunately there was little room for anything else, as the rest of the 15ft. x 15ft. apartment was taken up with racks of metal shelving with over 2000 books on the shelves that she had collected over the years and which formed the basis of her research. The books were often stacked three deep, and the rather cheap shelving bowed in the middle with the weight.

If I ever asked Doreen what she knew on a topic, she would say: "Oh, yes, John. If you go to that rack over there, second shelf down in the middle, then on the second row back, you will find a book with a red cover. If you turn that to page 187, or maybe 188, you will see that on the second paragraph there is a mention of what you are looking for."!!! She did this so many times that I started to test her on this ability and she picked me up on this too!

Off the sitting room/bedroom/library/office was a very small kitchen, not even big enough for a normal-sized fridge, so she kept a bottle of milk and a few other things in

a camping fridge that was stacked on top of the sink. There was a bathroom off the entrance hall that had a half bath and a toilet but little room for anything else. The only other area was the entrance hall, where there was a wardrobe with some of her clothes and about twenty crocodile skin handbags![5]

Ray Lindfield told me:

It was fabulous going into her flat. When we took everything out [after Doreen's death] you could not put it back in. Because over the years she was there, everything was in place.[6]

Even the space under the bed was used for storage. Ray continued:

... there was the holdall which was the "get-up-and-go". She said "If you get my walking stick, under my head, if you reach in and pull the bag out, in there is old Gerald's Book of Shadows"... There were quite a few bits and pieces under that bed.[7]

Certainly, books were the dominant feature in all parts of Doreen's flat, but, as she told Stewart Farrar:

New books of all kinds are getting so expensive that I have been collecting all the good second-hand books on witchcraft that I could lay my hands on ...[8]

Conditions in the flat were not ideal and the bay window area suffered from damp, as Ray told me about the occasion when they had to clear the flat after Doreen's death:

There was a pile of new books, coffee table type. There must have been eight or ten of them, all stacked out in the bay

[5] John Belham-Payne personal communication with the author

[6] Ray Lindfield discussion with the author April 2013

[7] ibid.

[8] letter from Doreen Valiente to Stewart Farrar 26 November 1980

window. When I went to pick them up they just fell to pieces. It was only books in this corner of the room. I don't think there was any paperwork. It was just books. These books were stood on the floor, up in that corner.[9]

Brighton was, and still is, known for its antique shops, particularly in the area known as The Lanes. Doreen used to frequent these shops and surprisingly often she used to find items which she suspected had been used originally in witchcraft and magic. Sometimes the circumstances under which she acquired them were indeed unusual. She tells a story of how some rather strange candlesticks came to her:

I had an amusing experience once ... It was in a little second-hand furniture shop on the borders of the New Forest. Passing by and looking in the window, I noticed some remarkable candlesticks in the shape of a pair of cloven hoofs. They were real hoofs, either deer or goat, cleverly adapted; and they had evidently been used, as some drippings of wax still clung to them.

Here was an undoubted find. So I pushed open the door of the shop, and ventured in. The proprietor, a little man in a storeman's overall, came out, and I enquired the price of "that pair of candlesticks down in the corner of the window".

He said nothing for a moment, but stared at me with great suspicion, and retreated behind the counter. He didn't seem to favour either me or my request.

"You know", I said, "the pair of cloven hoofs". He continued staring silently, and literally edged away from me. Was he working himself up to ask some outrageous price? Or was he, as he looked, just plain scared?

Then he suddenly seemed to come to a decision. Diving out from behind the counter, he rapped out, "Couple of bob!" And without waiting for any answer, he seized some old

9 Ray Lindfield discussion with the author April 2013

newspapers, grabbed the candlesticks from the window, wrapped them up, and thrust them into my arms. Then he took me by the elbow, and literally propelled me out of the shop. I managed to put a two-shilling piece in his hand as I went; but I don't think he really cared whether he got it or not. All he wanted to do was to get rid of those baleful candlesticks - and of anyone who enquired after them! ...

Whether they had in some way signified their displeasure at being in his shop, I don't know; but they have been quite happy with me - and restored to their original use on a witch's altar.[10]

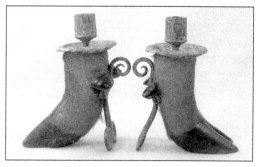

71. Doreen's cloven hoof candlesticks

And then there was Hob! He had very special significance for Doreen, as John Belham-Payne told me:

In the far corner of Doreen's flat was a carved face in a coconut. I was formally introduced to Hob on my first visit when I had only known Doreen for a few weeks so I did not know what to expect. She went over to the shelf where this small figure sat and said "Hob, this is my new friend John, I'm going out now so Hob's in Charge!" and with that she rubbed his nose and we left for lunch. I must admit I was wondering if the rumours that Doreen had gone a little gaga might be true. Julie had prepared lunch at our house and we found Doreen to be very good company and

[10] *I am a Witch*

perfectly sensible, normal and funny so when I took her home she went inside and straight back over to Hob, rubbed his nose and said "I'm back Hob, I'll take over". By this point it seemed entirely natural for her to be talking to a little coconut man. Later on, as we got to know each other better, I asked her about Hob. She said that she had been passing an antique shop in The Lanes in Brighton when, from the corner of her eye, she saw Hob who 'winked at her'. She tried to walk on but felt a strong compulsion to rescue this strange coconut-faced man. We think that many years ago Hob may have come back from the Caribbean with a sailor but little else is known. So leaving Hob in charge whenever we went out became quite normal and I thought little more about him until Doreen died. I phoned Janet Farrar who was going through similar circumstances caring for Stewart in the last months of his life and the first thing she said was "How has Hob taken the news?". I was taken aback until Janet started telling me the first time she met him at Doreen's apartment and he had winked at her. Later when we moved the items that Doreen bequeathed me back to our house, for some reason I cannot quite fathom, I did not put old Hob in a storage box in our barn with the rest but placed him on top of one until we had chance to sort things out properly. A couple of weeks later, Janet phoned and again she asked after Hob. When I told her he was in the barn she said "Oh he won't like that, he needs to be with people and near a television. He loves TV, especially 'Coronation Street' (a popular UK soap opera)". So I moved him to our office (also in the barn) where we had a TV and the mood of the barn totally changed. I cannot explain how but the office also changed, especially when the TV was on, it felt warmer. So we started leaving the TV on just for Hob. We still weren't convinced things were quite right, however, so one day I sat down facing him and told him how sorry I was that he had lost Doreen too and I started to ask him where he thought he might be happiest. When I mentioned perhaps he might like to stay with Janet I swear his face lit up! So he now lives in Janet's kitchen because Janet phoned me

recently to say that he had surprised one of her students who suddenly exclaimed "That coconut just winked at me!!!". There is a further mystery concerning Hob. He has a cord that runs below his chin and over his head which holds the top of his head on and if you pick him up you can hear something moving inside his head. We never felt it was right to remove the cord to look inside and neither does Janet, so Hob continues to hold his secret and lives happily with Janet with a growing reputation as a bit of a 'ladies coconut man'.[11]

Another item which Doreen found in a local art shop inspired her to think about an idea for a book on the Goddess of the Witches:

It was the day of the Full Moon, July 1st [presumably 1977], when I saw in this little shop a beautiful icon of the Goddess. One really couldn't call it anything else. It is a wooden panel, carved and coloured - stained rather than painted, I think. I thought it was modern, but they told me in the shop that it had come from an old house where it had been for at least 75 years, and when I examined it more closely I realised that this could be true. I bought it and now have it hanging on my wall. My feeling is that it was made for some goddess-worshipping cult which must have been rather akin to us. It has an unmistakable yoni symbol in the centre which makes it rather like a more tasteful version of the Shiela-na-Gig. Moreover, the goddess is depicted crowned with the crescent moon, and standing upon a green hill. I am very thrilled to have acquired this, and hope to find out more about its provenance in due course.[12]

John Belham-Payne told me about some very distinctive items that Doreen possessed:

While we were clearing her flat we opened her old Victorian wardrobe that almost blocked the front door and discovered about twenty very old crocodile skin handbags.

[11] John Belham-Payne personal communication with the author

[12] letter from Doreen Valiente to Stewart Farrar 30 September 1985

I never remember her ever taking one of them when she went out, in fact most of them were rather tatty but she did seem to have a fascination for crocodile skin. In the collection is Gerald Gardner's original Book of Shadows with its crocodile skin cover and, oddly, a pair of crocodile skin shoes. Doreen told the story of how she purchased them. Someone asked her if she would ever work magic to get something for herself. "Mmm" she said, "I don't see why not, but be careful what you wish for!". She then told the story about seeing a pair of crocodile shoes in a shop in Brighton. She could not afford them so she went away and, as she put it, 'did a little somethings in the normal way.' A few days later she went back to find the price of the shoes greatly reduced in a sale. Feeling rather pleased with herself she immediately bought them and took them straight to a shoe repair shop and paid to have them fitted with new soles and heels. "Now" she said in her talk, "here's the rub, I was so excited at the price I didn't try them on in the shop and when I finally got them home they didn't bloody well fit!" She continued "So here is the lesson, whatever you do with your craft, make sure you are 100% careful what you wish for and make sure that the end result is going to be the one you really want".[13]

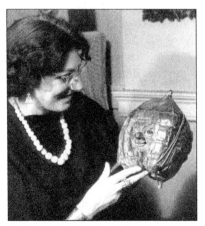

72. Doreen with Hob

13 John Belham-Payne personal communication with the author

As well as items found in local antique shops, there were ritual items which Doreen had accumulated over the years, most notably from Gerald Gardner. These items, which include crowns, athames, chalices, scourges, wands and swords, will form the basis of the museum which the Doreen Valiente Foundation and the Centre for Pagan Studies hope to open in the near future.

Doreen was also good at making things of a practical nature for outdoor rituals, and there are many examples in the Doreen Valiente collection which attest to her skills in this direction.

Mention has frequently been made in previous chapters of "Ron". He became a very important part of Doreen's life from shortly after they first met. John Belham-Payne told me the background to this:

> *Doreen actually hated being on TV but she quite liked radio interviews. She thought one radio broadcast on BBC Radio Brighton might cause problems with her neighbours if they found out there was a Witch living amongst them. Shortly after she had walked home from the interview there was a knock at her door. "Here we go", she thought when she opened the door and there were two women standing there. "Mrs. Valiente", they began, "We heard you on the radio and wondered if you would like to join the residents' committee". Doreen said she was so shocked that she unintentionally said "Yes."! However, this proved to be a good move, because this is how she came to know Ron Cooke, her last partner and great love, who happened to be the Chairman.[14]*

It was not long before Doreen was roped in to type out the committee minutes. Her notebook entry for 10th November 1975 indicates: "See Mr. Cooke Thursday evening 7.30 re. Christmas arrangements (P.T.A.)"[15]

Although I suspect she didn't know it at the time, William George

14 ibid.

15 Doreen Valiente *notebook no. 63* 10 November 1975

Cooke, commonly known as Ron (16th June 1912 - 22nd September 1997) was to become the love of her life. He had served in the Royal Air Force during the war and had been a painter and decorator before he retired, and he lived in the block opposite Doreen and subsequently at 23 Tyson Place. As Doreen wrote in the synopsis to her planned autobiography:

> *I first met Ron Cooke, and knew at once that we have met before in previous life. His wife died in December 1975, and we became close friends thereafter.*[16]

He and Doreen very quickly realised that they found each other's company congenial and that, in fact, they were falling in love.

By October 1976, Ron had asked to be initiated into the Craft by Doreen, and she had been undertaking various preparations, including mending, cleaning and painting ritual items that would be needed for Ron's initiation ritual. She acquired an athame for him, and carved symbols on the hilt. She also wrote out a Book of Shadows for him.

73. Ron Cooke

16 *Have Broomstick Will Travel*

284

Exactly when and where Ron's initiation took place I do not know, but presumably it was at Hallowe'en and at a site in the countryside around Brighton that was special to them both.

From that moment on, Ron accompanied Doreen on most occasions where rituals were involved. Vivianne Crowley paints a picture of their attendance at one ritual:

> *Doreen and her High Priest Ron Cooke would arrive in Ron's three-wheeled Reliant Robin, valiantly chugging along at 30 miles an hour until it reached its destination; with Doreen and Ron stopping every few miles to drink strong tea from a thermos flask. It was wonderful for we young coven leaders in our glamorous black velvet robes to see Doreen casting a circle skyclad, save for woollen cloak, witchy regalia, and rubber boots. 'Neither clothed nor naked' took on a wholly new meaning. But Doreen's outfit epitomised her attitude; at once at one with nature, loving 'witchiness', but ever practical, and never pretentious.*[17]

Jean Williams remembers how Doreen:

> *... cast the circle with her broomstick, taking command of the space. She then appeared to grow to immense stature as, broomstick in hand, she summoned the Mighty Ones to guard the circle. I have never before, or since, witnessed such natural authority.*[18]

Marian Green gives a vivid description of one such ritual, as Katy Jennison reports:

> *One of her stories had Doreen wrapping all her ritual equipment in the then newly-invented plastic bags, and the whole coven chasing after them as they blew away in the pitch dark. This attracted the large number of cows which lived in Doreen's chosen field, who gathered round the witches, their eyes gleaming green and their breath rapidly*

[17] Vivianne Crowley *Doreen Valiente* in *Pagan Dawn* no. 189 Samhain/Yule 2013

18 Jean Williams in *The Charge of the Goddess* p 4

becoming a not-very-mystic fog. Doreen, Marian said, didn't like cows very much.[19]

Katy continued:

The point, though, was that she and Doreen and the rest of the coven were doing their rite for the living earth: magic lived in the woods and hills and wild places. They worked in the dark, so everything was unscripted: you couldn't read in the dark, you had to act from your spirit and connect to the power of the land, or on a seashore to the power of the ocean ... For Marian and Doreen in those days the power of the elements was really there: they inspired us, she said, and they brought such power - she seldom experienced anything as powerful as the evenings with Doreen in the Sussex hills.[20]

Doreen set out her own views back in 1966:

In modern days, we have the position that some covens insist upon conducting their rites in the nude upon all occasions, while others wear robes; and there are die-hards on either side. To me, it seems reasonable to use one's commonsense, and work either robed or naked, whichever in our notoriously uncertain climate is the most natural and comfortable. There is nothing natural in insisting on being half-frozen; or in confining witchcraft to the drawing-room, instead of getting out into the woods and on the hills.

I have had experience of both kinds of working, and both have their merits. But I shall never forget the excitement of the outdoor rituals I have attended; the scent of the bonfire, the midnight wind in the trees, the occasional cry of an owl in the dark woods around, how different the bread and wine and meat tasted from ordinary food, as we sat around the fire. We danced wildly, and leaped the fire again and again, yet curiously enough, my robe was not even

[19] Katy Jennison www.tryskelion.com/aut_day_for_doreen_valiente.html

20 ibid.

286

scorched. I do not profess to explain this; I merely record it as a fact.[21]

By Yule of 1977, Doreen rather overwhelmed Ron with presents. Her list of things to give him included: "Wild flower book; silver ring; 2 model kits; corduroy cap; sweets (Chocolate Neapolitans); Good shaving stick (Yardleys) and Old Spice after shave (Pagan?)"

Doreen and Ron used to go out frequently into rural Sussex exploring the countryside and the many sites of interest therein.

In the summer of 1977, a week's holiday was planned. This involved hiring a car for £60 (£25 deposit and £5 per day), and seemed to involve staying at home and going out for trips every day.

These trips Doreen had carefully organised, from the Saturday to the Thursday. Friday was to be a free day. Places to visit were the New Forest (including the Rufus Stone and the Wilverley Post, to which Doreen has added "if fine"); Chichester Cathedral and Kingley Vale; Ashdown Forest including Wych Cross; Winchester Cathedral, including King Arthur's Round Table, and the Roman Villas at Bignor and Fishbourne. Newdigate Road, Charlwood was also on the list, presumably because Doreen was still fascinated by the whole Cardell affair.

They started to have holidays in Glastonbury. Anticipating a summer holiday in 1978, Doreen wrote:

The trouble with Glastonbury is that lots of Americans go there and the local hotels naturally prefer to cater for such well-heeled guests and charge accordingly. So much as we would like to put up at the historic Pilgrims Inn, their prices are a bit too hot, and we shall have to seek something smaller.[22]

[21] *I am a Witch*

[22] letter from Doreen Valiente to Janet and Stewart Farrar 27 July 1978

It was obviously a popular area for them, for in October of 1978, Doreen wrote:

> *Ron and I have made another short visit to the West Country recently; but we went in another direction this time, to Wookey Hole and the Mendips. What a place! I had never been there before - not actually in to the old cave sanctuary, that is. Unfortunately, you have to go with a guide and other people; but even so, it has quite an atmosphere.*[23]

In September 1982, Doreen wrote to Stewart Farrar telling him about a holiday in Glastonbury that she and Ron were taking later that month:

> *I don't know if you know Glastonbury, but it is a very interesting place. Ron won't go anywhere else now! The last time we were here, we got caught up in the Church of England Pilgrimage, which was quite a sight, and we ended up in the Abbey ruins listening to the Bishop of Bath and Wells. Actually, food was what attracted us; the pilgrims had refreshments laid on for them in the Town Hall - so we became pilgrims for the day. We had to pay for the grub, of course; but it was cheap and plentiful, so we piled in! (As I'll bet quite a few pagans have done throughout the ages).*
>
> *An interesting point which I would like to find out more about in connection with Glastonbury is that Margaret Murray was living here in the early 1920's when someone suggested to her the idea from which she developed her theories about the witch cult. I'd like to know who that someone was. Also, I have found out recently from the writings of the famous Christian exorcist, Dr. Donald Omand, that at one time the Chalice Well was exorcised because the local practitioners of what he calls "black magic" had been foregathering there. The present-day guardians of the Well are not likely to be forthcoming on this topic, but I might be able to find out something from*

[23] letter from Doreen Valiente to Janet Farrar 9 October 1978

the older local people. I think that Glastonbury Tor and the Chalice Well are actually pagan sanctuaries and probably used by the Somerset witches.[24]

By 1983, Glastonbury began to have a particular attraction for them. Doreen wrote:

We are not going away until later, over Midsummer, which we hope to spend at Glastonbury, as usual. I've tried in vain to get Ron to go anywhere else, now that he has fallen in love with the place. We would move down there if we could, and may yet do so if we can get anyone to exchange homes with us.[25]

The exchange of homes was the only way that those who lived in council accommodation could really contemplate moving.

At the beginning of 1984, at the age of 62, Doreen began to take driving lessons, probably so that she could help Ron, who by that time was in his 70s. In February she told Janet and Stewart Farrar: "The driving lessons are going O.K. and I enjoy them. I wish I'd started years ago." [26]

By December, Doreen was about to take her driving test:

I am in the throes of trying to pass my Driving Test, and having extra lessons from my long-suffering instructor. I haven't been able to think about much else lately ... I applied for the Test back in July, and this is the earliest they could give me. I think the long wait has un-nerved me ... I just hope I don't get some old grouch of an examiner.[27]

She added:

Old Ron won't let me drive Cynthia [his car - a blue Reliant Robin], *even though I've been learning, until I have passed*

[24] letter from Doreen Valiente to Stewart Farrar 1 September 1982

[25] letter from Doreen Valiente to Janet and Stewart Farrar 8 April 1983

[26] letter from Doreen Valiente to Janet and Stewart Farrar 15 February 1984

[27] letter from Doreen Valiente to Stewart and Janet Farrar 6 December 1984

[the Driving Test]. *I believe he just won't lower himself to go out with L-plates on her.*[28]

In common with many, Doreen failed her test:

My driving test, alas, was a total disaster! I couldn't do a damn thing right. Never mind, back to the drawing board ... perhaps one should be prepared to chalk it up to experience.[29]

After that, we hear no more about driving. Melissa Harrington doesn't think Doreen ever did learn to drive.

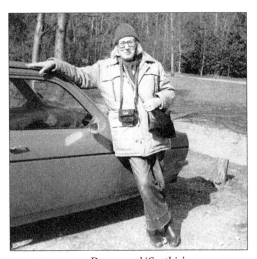

74. Doreen and 'Cynthia'

Over the years, from her time living in London, Surrey, the West Country, Hampshire, Buckinghamshire and Sussex, Doreen had got to know the countryside of southern England very well indeed. And, apart from her stay in South Wales during the war, a visit to the Museum of Witchcraft in Bourton-on-the-Water in Gloucestershire, two trips up to see Arnold and Patricia Crowther in Sheffield, and a solitary visit to Gerald Gardner on the Isle of Man, she never, as far as I can tell, went anywhere else.

[28] ibid.

[29] letter from Doreen Valiente to Stewart and Janet Farrar 7 May 1985

The reasons for this are perhaps rather complex. Raven Grimassi told me that he had once asked Doreen why she had never been to America: she replied that she had never been asked. In fact, she had been asked, several times. Doreen goes into a bit more detail when replying to an invitation from Janet and Stewart Farrar to visit them in Ireland, when she writes:

> We have a certain difficulty in travelling abroad. Ron won't go by air, and I won't go by sea! His war-time experiences put him off aeroplanes. Understandable, when his duties frequently consisted of recovering dismembered bodies from burning wrecks. And I do _not_ trust the sea. I have always believed that it is _alive_, in some peculiar non-human way of its own - and sometimes a very sinister way. So we prefer _terra firma_, but thanks for the invitation.[30]

Doreen's attitude is equally understandable when one remembers that her first husband was drowned at sea during the war. One does, however, wonder whether this is the complete story since surely Doreen could go by air and Ron by sea. Also, one could wonder whether the opening of the Channel Tunnel in 1994 might have opened up the possibility of European travel for them both, but they never availed themselves of it.

Doreen had indeed been invited over to America several times. They would have paid for her flights and accommodation, but she would not go. Lynda Lindfield told me: "She couldn't take that kind of adoration, I think. She would have been welcomed with open arms. But that wasn't her." She told Lynda: "I can't be doing with it! If we'd been meant to fly, we'd have had wings!"

Yet there is some evidence that on at least one occasion, Doreen visited Gerald Gardner on the Isle of Man, when she probably took the plane from London or Liverpool to Ronaldsway Airport, which was only a mile or so from his home in Castletown.

[30] letter from Doreen Valiente to Janet and Stewart Farrar 29 February 1984

Writing to Stewart Farrar in 1985, Doreen was more equivocal:

> *They* [the Pan-Pagan Writers' Symposium, to be held in Seattle in 1986] *did make me a very kind invitation, and if I were twenty years' younger I would have jumped at it; but one has to be realistic and say that I don't think these old bones would stand it ... I don't feel like undertaking anything so ambitious as a trip to Seattle, much as I would love to see that wonderful stone circle they have built in the woods there.*[31]

Aside from the witchcraft-related activities, Doreen lived a fairly normal life in Tyson Place. At the ceremony in 2013 when the plaque to Doreen was unveiled, Ann Ewings, Chairperson of the Tyson Place Residents' Association, said she had known Doreen since 1972. She said that Doreen was a very unassuming person. For example, Ann didn't know that she had written five books.[32]

Indeed, some of Doreen's interests were very "normal". From at least the late 1950s, she was interested in betting on the horses, and developed all sorts of systems. An example in her notebook for August 1958 was very technical and involved various methods and partial methods, such as which courses had been best over the previous ten years for non-handicap favourites. She notes that: "3-year-old handicaps are very difficult to forecast. Form is likely to be upset by soft going caused by rain."

A system which she recorded is as follows: "Back any 2-year-old horse with the form 1 2 2, each way. In handicaps, back the fourth horse on the card, each way."[33]

Doreen's gambling interests were not just limited to racing. Football was something else that she followed, and she obviously did the football pools, which were very popular in those days:

[31] letter from Doreen Valiente to Stewart Farrar 30 September 1985

[32] Ann Ewings speech at the unveiling of the plaque to Doreen Valiente 21 June 2013

[33] Doreen Valiente *notebook no. 2* 10 August 1958

Choose 9 matches. Mark each with 'o'. Write alongside: "Perm any 8 from 9=9 lines at 2d. = 1/6 staked." If all 9 are draws you win 9 first dividends. If 8 are draws and the 9th is an away, you get one 1st and 8 second dividends. If 8 are draws and the 9th is a home, you get one 1st and 8 thirds. 7 draws and 2 aways give you 2 lines of 23 points, normally 2nd dividend, and 7 lines of 22 points.[34]

I don't claim to understand what any of that is about, but it does show the technical side of Doreen's character which came out in her war work and investigative techniques.

Doreen's interest in football reached a maximum every four years, when the World Cup was on. During that period she would not answer the door to anyone. Janet Farrar told me:

*There was one part of the year when nobody, and that included Stewart and me, was welcome at Doreen's house. When the World Cup was on, that was it! The door of the flat was locked and nobody got inside until the World Cup was over. She was a football fanatic. We knew that was the one time you did **not** disturb Doreen Valiente. And unfortunately, poor old Ray Buckland made the fatal mistake.*[35]

As we have seen, Doreen did not like unexpected callers. Patricia Crowther was a witness to this when Ray Buckland, Gerald's first American initiate, ended up unannounced on her doorstep. She refused to see him and did not answer the door.

Ron certainly seemed to be equally interested in the World Cup as Doreen. She explained to Janet and Stewart Farrar: "... I'm afraid there's not much point in expecting coherent thought out of this household while the World Cup contest is being played! The only time I have ever heard my Ron really swear is when Masson missed that penalty."[36] This was during the 1978 World Cup in Argentina when Scotland were playing Peru.

[34] ibid.

[35] Janet Farrar discussion with the author February 2013

[36] letter from Doreen Valiente to Janet and Stewart Farrar 16 June 1978

Several of those who knew Doreen commented on what she liked to eat and drink and one thing that came up more than any other was cucumber sandwiches! She loved them and served them on all possible occasions. Cauliflower cheese and baked potatoes were also favourites, and to drink she liked Stone's Ginger Wine.

Tyson Place was not the sort of environment where one might expect a prominent witch to live. As John Belham-Payne said at the ceremony to mark the unveiling of the plaque to Doreen in 2013:

> *I always expected that Doreen would live in a cottage somewhere with roses growing around an arch, so I was quite surprised when I came here that first day to pick her up and take her for lunch. But she loved it. She loved Tyson Place, she loved living here, so it's great that she has a plaque here: it's the right place.*[37]

Doreen's 27 years at Tyson Place were the most creative and happiest period of her life, particularly after she had formed a relationship with Ron. As John Belham-Payne said:

> [It was] *the time when her life really blossomed. In Doreen's own words, she had met her "soul mate": Ron Cooke, who she loved more than anyone else in her life. Whenever she mentioned Ron her eyes would light up. It was in this period that she wrote most of her books.*[38]

Indeed, in many ways, Ron could be considered Doreen's muse: someone who encouraged the creative spark within her.

[37] John Belham-Payne speech at unveiling of plaque to Doreen Valiente 21 June 2013

[38] John Belham-Payne *Doreen Valiente's Funeral Rite*

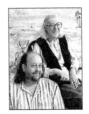

Chapter 21
Towards the Summerlands

Doreen was not so engrossed with her work and her relationship with Ron that she neglected to make new friendships within the Craft. One individual with whom she developed a friendship was Sally Griffyn, who was a writer and professional photographer. Back in 1994, she had been commissioned to write a book on Wicca, which eventually came out as *Wiccan Wisdomkeepers* in 2002.[1]

Sally arranged to go down to Brighton to see Doreen. What Doreen did not then know was that Sally was an initiated Wiccan. Their interview was a success: Sally took some very good photographs of Doreen and they got on well together, despite their 50 years' difference in age. In fact, Sally was in the process of moving down to Brighton, where she was setting up a coven called the Silver Malkin, a reference to a Scottish witches' familiar, a silver cat or hare and related to shape shifting. The coven was set up to work a mix of Alexandrian and Gardnerian magical method with Sally's own shamanic knowledge incorporated into it.

[1] Sally Griffyn *Wiccan Wisdomkeepers* (Godsfield Press 2002)

Suzanne Rolfe was a member of this group. She was someone who came to know Doreen through a Witchcraft Workshop which Sally had organised in the attic of the Cornerstone Church, Palmeira Square, Church Road, Hove. Sally had invited Doreen to help with the workshop, though it took some time before Suzanne recognised that this was the author of *Natural Magic*, a book that she particularly liked. Suzanne was subsequently initiated into the Silver Malkins, in a ritual at which Doreen was present.

At the time that she met Sally for the first time, Doreen had not worked with any groups or covens for over 20 years, being quite content to raise a glass on the sabbats with Ron. Sally remembers Ron as being incredibly active and healthy when she first met him.

In 1996, however, Ron fell ill, by which time he was 84 years old. Sally explained to me:

> ... *He was very supportive but he was much older than her and he'd had enough, really. He was an incredibly lucid active man and very funny and talked a lot about sex. But he just didn't want to practise any more. It was quite fine to be in the flat.*[2]

So Doreen joined and participated in Sally's group. Sally gave me a flavour of its activities as follows:

> *The most profound thing was that the rituals were outdoors. We stayed up all night. It was on some occasions quite cold, but we had a big fire and, doing the Charge of the Goddess, speaking it with Doreen behind me speaking it in unison was amazing.*[3]

In 1997, on the day after the Autumn Equinox, Doreen's companion for the previous 20 years, Ron Cooke, died in Hove General Hospital of heart failure. He was 85 years old. His ashes were scattered at a spot in the Sussex countryside which was special to both of them. Doreen told Michael Howard, editor of *The Cauldron*:

[2] Sally Griffyn discussion with the author March 2013

[3] ibid.

I miss him a good deal, of course, but I regard his death as a liberation from a worn-out body. He always said that if he could not recover sufficiently to have any real quality of life, he would like to die in his sleep, and that is exactly what he did. He had been in and out of hospital all the summer, with a heart condition being the basic cause of his illness.[4]

Indeed, Ron was, in Doreen's phrase, "the love of her life". After he died, the Silver Malkins, consisting of Sally, Doreen and Jan Arnold plus Melissa Harrington, went out to a site in the countryside where they performed a 'Goodbye to Ron' ceremony, which Sally refers to as 'profound': "It was so moving because it was Doreen saying goodbye to her magical partner and we were aware he was watching her." Doreen gave Michael Howard an account of the ritual:

Last Thursday, October 2nd, a few witch friends and myself took part in an informal ritual on the Sussex Downs to commemorate him, in the heart of the countryside that he loved. We wished also to say fare-well to him - literally that he should fare well on the next stage of his spirit's journey. It was one of the sunniest and most beautiful days of this autumn. We went to the Long Man of Wilmington, and carried out our little ceremony at the feet of this great figure, outlined on the grassy hillside.

We had candles, incense, flowers, music, a little reading from "The Book of Shadows" that Dusio [Ron] and I used to use, and ended with a picnic feast. It was a happy occasion, and there was one rather odd little incident, whether supernormal or not I do not know. The candle that I was holding went out - and then re-lit itself! I think it was a sign, certainly symbolic if nothing more. The candle continued to burn, in spite of a fresh breeze, until the end of the ceremony.[5]

[4] letter from Doreen Valiente to Michael Howard 5 October 1997

[5] ibid.

They left food and other offerings and meditated upon Ron, and the whole thing seemed to inspire Doreen to become more actively involved in the new group. Sally told me:

> She was fired up about it and got into a different mode where she was actually wanting to work circles. And it was amazing, because even younger people have trouble staying up all night, and Doreen was really OK with it. We found out later that she was actually frozen, but there was so much energy and magic around ...[6]

Suzanne told Jonathan Tapsell:

> Doreen enjoyed the fact that she was able to re-engage with Wicca again ... Doreen applied herself in the coven with gusto, teaching the group many techniques that she had learnt from Cochrane, the Regency coven and other sources.[7]

Following Ron's death, Sally, Doreen and Jan carried out quite a few rituals. As Sally commented to me:

> ... there was a lot of female working went on. Doreen was very balanced: it was always male/female, but in a way I don't think she'd had many girl friends - really strong sisterly connection.[8]

They also visited a lot of sacred sites, leaving offerings for Ron. Sally told me: " ... there were bizarre episodes where it was quite clear that Ron was still around."

One organisation that Doreen became involved with was the Centre for Pagan Studies. This had been formed in 1995 by John Belham-Payne and his wife, Julie, and was based in an 18th Century barn in the grounds of their home in Maresfield, Sussex.

[6] Sally Griffyn discussion with the author March 2013

[7] Jonathan Tapsell *Ameth - The Life and Times of Doreen Valiente* (Avalonia 2014) p 106

[8] Sally Griffyn op. cit.

They had seen the growth of opportunists and charlatans charging high prices for courses on various types of magic and paganism, and felt that there was a need for something more realistic. To quote John Belham-Payne, the Centre was:

> ... *put together as a resource facility for those wishing to learn for themselves more about the ancient religions of the world. The CFPS did, however, provide accurate information in lecture form from a number of eminent speakers on a variety of Pagan (mostly historical) based themes. It also provided a sheltered working space for small groups wishing to use the grounds for rituals. The CFPS was at that time used for a number of weekend conferences. The beautiful grounds and unique atmosphere made it an obvious venue for handfastings. It also held the first ever Pagan Art Exhibition by the renowned Visionary Artists Group.*[9]

John told me the story of how he got to know Doreen:

> *One day in October 1997 we had a phone call from Tony, one of our regular attenders, who told us that Doreen Valiente had heard about the work we were doing and wondered if she could come along and have a look. Tony is an unsung hero and for many years was Doreen's friend and unofficial taxi service, taking her on her weekly shopping trips. He was an animal activist, something Doreen was very keen on. He stayed a close friend right up until the end of her life.*

> *We were running an event for Samhain, complete with a firework display. Doreen came along and, to be honest, I tried not to meet her. I was not sure of what I would say, other than "I have all your books"! I gave a talk during the event in the barn and was horrified to see her at the back of the room. I have since likened this to the Pope turning up to a local village church and the priest being as nervous as I was. However, she came up to me at the end and said how much she had enjoyed the evening and my talk. She then*

[9] John Belham-Payne Centre for Pagan Studies website

asked if it would be OK if she had my phone number. I wrote it down for her, never expecting a call, assuming she was just being polite.

A few days later there was a phone call and the person on the other end of the line had a soft West Country accent. "My name is Doreen Valiente. I came to your event the other evening. I do hope you remember me." "Of course I do, Mrs Valiente", I replied. "Well, I have been looking at the work the Centre has been doing and I am very impressed. Would you mind if I got a bit more involved?" I was so shocked and for the want of something sensible to say, I said "That would be lovely. What do you think you could do for us?" "Well" she said "I am not too good on my pins these days, but if you sat me at the sink, I could wash the dishes." This was, I felt, a great lesson.[10]

John obviously persuaded Doreen to undertake rather different roles from just washing up. She got to know John and his wife, Julie, very well. As John says:

Most of our conversations were about anything but Witchcraft and I'm sure that's why she took to me as a friend. She was very close to my wife, Julie. She would phone Julie and they would talk for hours on the phone as a couple of pals.[11]

Finally, Doreen agreed to become Patron of the Centre, and she gave various talks, including, on Sunday 5th July 1998, "An Afternoon with Doreen Valiente". Doreen's last ever talk was also at the Centre, which was on the very subject for which she became known to the general public with her book, *Where Witchcraft Lives*, in 1962. It was entitled "Sussex Witchcraft". On that occasion, it was writer and lecturer, Marian Green, who did the washing up after lunch! This was the event where the money raised was supposed to go on a new carpet for Doreen's flat, but which she wanted to spend on books!

[10] John Belham Payne personal communication with the author

[11] John Belham-Payne interview for *Wiccan Pagan Times*
http://web.archive.org/web/20140818015805/http://www.twpt.com/payne.htm

Doreen had never been a person who liked appearing in public, but she was persuaded to speak at the annual Pagan Federation Conference, which was held at Fairfield Halls, Croydon on 22nd November 1997. Sally Griffyn told Doreen: "I will hold your hand. I will be on stage with you. I think you've got a lot to say to people. It's worth it to go through that and out again. Come on! Tell it how it was!"

I was present at that talk, the only time I ever saw Doreen. She seemed very lonely sitting in an armchair on stage. The hall, however, was packed, and many of the stallholders had closed up in order to have an opportunity to hear her speak.

Doreen started by saying that some had accused her of helping to found a new religion. This, she explained, put her in an embarrassing position, as she had always believed that organised religion was nothing but a curse to humanity. However, she did feel that witchcraft, as revealed by Gerald Gardner, was an idea whose time had come. She said:

> *People like old Gerald and myself were simply the means through which* [such an idea] *manifested, thanks to something which stirred upon the Inner Planes. Why, I don't know, but most probably something to do with the incoming of the Aquarian Age.*[12]

After explaining how she came into the Craft through reading a magazine article back in 1952, Doreen made it clear that she did not, as some have suggested, "introduce the concept of the Goddess into present-day witchcraft", and quoted that very article:

> *The gods of the witches are the oldest of all - fertility and death. A coven is nowadays led by a woman officer because of a shift in emphasis towards the life-goddess - a woman - and away from the lord of death.*[13]

[12] Doreen Valiente *A Witch Speaks* in *Pagan Dawn* no. 128 Lughnasadh 1998

[13] Allen Andrews *Witchcraft in Britain* in *Illustrated* 27 September 1952

Doreen told those assembled to hear her how much had changed since she had become involved in the Craft:

> *People today have no conception of how uptight and repressive society was, back in the 1950s, when old Gerald first opened up the subject of witchcraft as a surviving old religion. You could not go into a shop then and buy a pack of Tarot cards or a book on the occult, without getting curious looks and usually a denial that they stocked any such things. There were no paperback books on the occult ...* [14]

She continued:

> *... in those days, such a Conference as this would not have been allowed. You would have been closed down by the police! Times have indeed changed, and only the older generation like myself realise by how much.* [15]

She was, however, encouraged by the Human Rights Bill, then going through the House of Lords, which would outlaw discrimination on grounds of religion, and said: "We may be able to claim our civil rights in the British courts." [16]

Doreen then recounted some of her memories of Gerald Gardner:

> *... he was a truly singular character, impressive in appearance, with his wild white hair and sun-tanned face, tattoos on his arms and a big bronze bracelet on one wrist. However, he was a very kindly man, not bombastic as some would-be leaders of the occult world, but full of real out of the way knowledge and experience ...* [17]

She did not, however, go along with Gerald's prejudices, particularly his attitude to gay people. She said:

[14] *A Witch Speaks*

[15] ibid.

[16] ibid.

[17] ibid.

In every period of history, in every country in the world, there have been gay people, both men and women. So why shouldn't Mother Nature have known what she was doing, when she made people this way? I don't agree with this prejudice against gay people, either inside the Craft of the Wise or outside it.[18]

Doreen then talked of Robert Cochrane and his way of working, with affection and I am sure that she felt more in tune with his approach to the land and the hidden powers than she ever did with Gerald Gardner.

Indeed, Doreen then asked "We talk about means of raising power; but what actually is the witch power that is raised?" She saw it as identical with what has variously been known as mana, prana, odyle, animal magnetism and orgone energy, and she went on:

... perhaps today when people's minds are more open, we may begin to study this realm of subtle energies more closely, and perhaps rediscover what really happens when witches gather together to raise the Cone of Power ...[19]

Doreen asked what we should do with this power, once raised. Whilst acknowledging the Craft as a fertility cult, she went on to say:

... the idea of fertility is something that goes much deeper than the hope for good crops and increase of livestock, and I am sure that it always did. There is a spiritual as well as a material fertility. There is the need for people to be alive and vital and creative. Life is here to be enjoyed, not just endured.[20]

Doreen closed her talk in the same way she had done at the Pentagram dinner in 1964, over thirty years previously:

[18] ibid.

[19] ibid.

[20] ibid.

... as witches, Pagans, or whatever we choose to call ourselves, the things which unite us are more important than the things which divide us. I was saying this back in the 1960s, in the days of the old Witchcraft Research Association, and I repeat it today. However, since those days we have, I believe, made great progress. We have literally spread world-wide. We are a creative and fertile movement. We have inspired art, literature, television, music and historical research. We have lived down calumny and abuse. We have survived treachery. So it seems to me that the Powers That Be must have a purpose for us, in the Aquarian Age that is coming into being. "So Mote It Be".[21]

John Belham-Payne told me:

When she was asked to take part in the conference, she had no idea that she was going to be the main event of the day. She phoned me the following morning to see what I thought of her talk, and genuinely said "I thought all those young people wouldn't know who I was. I thought I might be talking in a small room somewhere to ten or fifteen people who would be interested in what old Doreen had got to say, but no idea so many. I thought at first they had come in to see someone else. I was so surprised. All those people, John! How did I do?" My instant reply was "I think 2000 people giving you a standing ovation says that you did all right, Doreen!" It was the Pagan Federation's biggest ever event.[22]

As he commented: "Sometimes the greatest people among us do not realise how much they have done for us all." [23]

[21] ibid.

[22] John Belham-Payne personal communication with the author

[23] ibid.

Lynda Lindfield told me what happened next:

> *She desperately missed Ron. That was the start of her downhill run. I was walking with Doreen somewhere and she said: 'I've got a bit of a lump here'. And she'd not been well. That was the start of her illness. And it was almost as though she didn't want to get well because she wanted to be with Ron.*[24]

John Belham-Payne confirmed this:

> *On several occasions, Doreen told me that she wished she had gone at the same time as Ron, and I believe that without him her life ceased to have the same meaning and when her recent illness came upon her it was almost welcome.*[25]

John was with Doreen during much of her final days. He gave a very moving account in the pages of *Pagan Dawn*, which I use and quote from in this chapter. He begins:

> *At the start of her illness she phoned me to say that she was unwell and that the doctor had told her to fast because he thought she had a tummy bug. A few days later I spoke to her and found to my concern that she was still on the fast.*[26]

The next John knew was that she had fallen and had been taken into hospital for tests:

> *She phoned and asked us to visit, but humorously warned me that she, in her own words, 'had turned an unfashionable shade of primrose'. When we arrived, she said that she was being kept in for a couple of days, but we knew as she held our hands that it was serious. She was weak from the fast and was given a blood transfusion to help deal with the jaundice.*[27]

[24] Lynda Lindfield discussion with the author April 2013

[25] John Belham-Payne *Doreen Valiente's Funeral Rite*

[26] John Belham-Payne *The Last Days of Doreen Valiente* in *Pagan Dawn* no. 133 Samhain/Winter 1999

[27] ibid.

The following day, John was told by Ron's son that Doreen had pancreatic cancer, that it was inoperable and that she did not have long to live. He also told him that she wanted John to perform her funeral ceremony.

As John and his wife, Julie, sat with her, Doreen's thoughts went back to the time she had been seriously ill in 1958. She had had what is often called a "near death experience" and what she recalled for John was walking the path to the Summerlands, the place that we go after we die.

Doreen came home from hospital and for a while, John, Julie, Ray, Lynda and others looked after her there. John told me:

> She wanted to die at home with me holding her hand and we were willing to make sure this happened. Lynda and Ray Lindfield, Julie and I took it in turns to be with her, with Julie and I doing most of the time because of work commitments. Julie would sit all night in that one chair Doreen had, and I would be there in the daylight hours.[28]

However, he recalls:

> The time came, however, that Doreen's physical needs outweighed what we could do for her. She had lost most of her strength and could no longer cope at home and asked me one night to be moved to a nursing home. [This was the Sackville Nursing Home, 2-4 Sackville Road, Hove] Her mind remained very much in control but she was in a lot of pain and the move to the nursing home was the right move. She was in need of 24-hour nursing care ...

> Her final morning came on the 1st September. She had a good night's sleep and awoke at 6.00 am. I awoke at the same time to find that Doreen was upright. I knew instantly that something was different. She had what I can only describe as a 'bright moment'. She was more aware than she had been for days.

[28] John Belham-Payne personal communication with the author

I sat holding her hand and asked if she was alright. She said that she was, so I took a few deep breaths, looked deep into her eyes and said that it was time to make the journey we had rehearsed. She knew and smiled at me. She was very ready and so, hand-in-hand, we walked what for us both was a very familiar path.

Forty years before, the guardians of that path had turned Doreen back. Now they led the way. When the doors opened, there was the most incredible light, and I had difficulty in keeping myself from going in with her. We finally looked at each other, I let go of her hand, and Doreen Valiente - looking radiant and very much as though she was going home - walked into the Summerlands. I reluctantly turned away and left without her.

I became aware of being back in the room and Doreen's hand losing its grip and her last breath leaving her body. I sat and looked at her for a while before closing her eyes. I called the nurses who came and laid her out and I waited until the funeral company came to collect her. The experience changed me for ever.[29]

When the formalities, such as issuing her death certificate, had been completed, it was arranged for Doreen's body to 'lie in state' in the Old Barn at the Centre for Pagan Studies, as she had requested. Ronald Hutton described the scene:

Her heavy coffin of gleaming polished wood stood upon trestles within a circle of about twenty candles, kept burning constantly. At its head was her altar, lit by taller candles and set with her working tools and carved images of goddess and god, while her sword and pentacle lay upon the lid.[30]

[29] John Belham-Payne *The Last Days of Doreen Valiente*

[30] Ronald Hutton *The Funeral of Doreen Valiente* in *By Standing Stone and Twisted Tree* website

As well as the candles, Doreen's coffin was surrounded by woodland flowers, and incense was burnt. Hutton continues:

> *The day of the funeral, the ninth of the ninth month in the ninety-ninth year of the century, was unseasonably hot. Those who were able to arrive at the Centre before the cortege departed passed from the brilliant sunlight and grilling temperatures of the noontide into that shadowy, fragrant, candlelit and silent world in which she lay. John allowed those who wished to pay their personal farewells, removing the coffin lid to reveal Doreen laid out with her long silver hair finely combed, a rich oriental robe tucked up to her chin. The last arrangements to be made before the hearse arrived were devoted to completing the form of the ritual; John had written it and already secured the agreement of specific people to undertake some parts. The rest were distributed among those who were present.[31]*

Doreen's body was to be cremated, and the Funeral Rite was to be held at the Woodvale Crematorium, off Lewes Road in Brighton. To quote Ronald Hutton again:

> *The journey from Maresfield to Brighton, and the crematorium, took forty-five minutes in a six-car cortege, once again baking under that fierce sun. It ended at a small chapel, surrounded by wide lawns and cypresses, where the rest of the company was waiting and which became the setting for the rite. Small it may have been, but it was still only half filled, the whole group present numbering just over twenty. Of these I think that thirteen were witches, the rest being made up by Doreen's relatives and non-pagan friends.[32]*

Hutton's description of the rite itself is very moving and I make no apology for quoting him again:

> *The chapel was decorated for the occasion with pentagrams outlined in red on card, and candles in tall*

[31] ibid.
[32] ibid.

sticks, to indicate the cardinal points. Those positioned at them to call the quarters also spoke for four phases of Doreen's life, holding up photographs of her to represent those stages. A short and vivid piece of theatre was performed to illustrate the nature of reincarnation. A succession of people read Doreen's poetry, including her elegy on the death of Robert Cochrane, or provided personal anecdotes about her to illustrate her nature. All illustrated her remarkable modesty and humanity, and impatience with pomp and restrictive rules. The Charge of the Goddess was read by a priestess, and a priest read the Legend of the Goddess. The coffin was committed to the flames while a favourite piece of music to Doreen - Elgar's 'Nimrod' - was played. Cakes and wine were served, the latter being particularly welcome in the stifling heat which the sun was giving the chapel. When the quarters were thanked at the close, each element was released from its relationship with the dead woman in this life.[33]

Writing specifically of John Belham-Payne, Hutton says:

In addition to putting the whole sequence of ceremony together, he opened it with a short speech of welcome which filled the auditorium with human warmth. As his own contribution to the speeches of tribute in the centre of the rituals, he told the story of how she died. It was the most moving and impressive account of companionship to a dying person which I have ever heard.[34]

John wrote: "The whole day went off very well and I hope that she would have approved of the service; I did my best for her ... "

Lynda Lindfield told me that Doreen had wanted to go to Stonehenge again, because she hadn't been since the day following her initiation in 1953. However, her final illness had made this impossible. So, on a private visit to the stones, Lynda, her husband and John Belham-Payne had taken the urn with Doreen's ashes hidden inside a rucksack, so that her wish could be fulfilled.

[33] ibid.

[34] ibid.

Doreen was quite specific about what she wanted doing with her ashes, but she was insistent that she didn't want the precise location to be made known, as she didn't want it to become a shrine. They were to be scattered around the roots of an old oak tree in an ancient wood in Sussex. I will not be more specific in order to respect Doreen's wishes, although with a bit of effort those who are determined to find the location can actually do so fairly straightforwardly. It was somewhere that she and Ron liked to visit and I suspect that Ron's ashes are also scattered there.

Doreen also insisted that her ashes should be scattered when the bluebells were out, because that's the time she used to enjoy. So, exactly eight months after her death, Doreen's ashes were scattered. Lynda Lindfield told me:

> *We went there, myself and Ray* [Lindfield] *and John* [Belham-Payne], *and this other chap, Kevin. We went there at dawn on Beltane morning and went to this particular tree and scattered her ashes there in the shape of the symbol that's on the Chalice Well at Glastonbury* [two interlocking circles - the so-called 'vesica piscis']35

And so, Doreen's remains were laid to rest, though her presence is with us still, as I know from my own experience. And Doreen's legacy in terms of her influence on the Craft is profound and far-reaching.

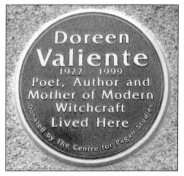

76. Heritage Blue Plaque - Tyson Place, Brighton

35 Lynda Lindfield discussion with the author April 2013

Endword:
The Spirit and the Land

I hope it is not too much of an exaggeration to say that Doreen's legacy is multi-faceted. She left us much, not least her library and collection of artefacts, now in the guardianship of the Doreen Valiente Foundation and which will form the heart of the museum and archive to be established in her honour.

The five books written by Doreen are probably the most visible legacy of her life. Their intrinsic merit is extremely high, as I have tried to indicate in these pages, and, if the royalties received from her publisher are anything to go by, they also sold extremely well throughout the English-speaking world. And they are still, in some cases over 50 years after their initial publication, on reading lists and recommended widely as good introductions to the subject of modern witchcraft.

For many, and perhaps especially for those who have been initiated into the Craft, Doreen's legacy has been the wealth of ritual material in use within witchcraft circles. This includes not just

such well-known and loved pieces as The Charge of the Goddess and The Witches' Rune, but also a variety of lesser pieces written for several different groups and occasions, some of which undoubtedly remain hidden or unrecognised in various Books of Shadows and other notebooks.

And Doreen's poetry is at last being given the recognition which it deserves. Doreen herself considered her poems to be among her finest achievements, and it is good that a collection has at last been issued showing the quality of her writing and the variety of forms which she espoused.

And yet, to my mind, Doreen's greatest achievement and her potentially most long-term contribution lies not solely in her books and other writings, but in her personal approach to the Craft.

Doreen was sensible in a way that Gerald Gardner was not, and she brought a level of maturity to the theory and practice of witchcraft that had been, at times, severely lacking in Gardner's ideas and ways of doing things. It is almost as if this sensibility had skipped a generation. The members of what some have called The New Forest Coven seemed to have an intellectual ability which Doreen instinctively understood. They were also strongly rooted in the New Forest, and this link to the land was something that Doreen cared passionately about.

Doreen's greatest achievement is, to my mind, linked firmly with this connection to the land. Essentially, I feel that Doreen was happiest going out at midnight under a Full Moon, up onto the chalk Downs, and communing with the Old Gods. If the weather was such that she could go skyclad, then all well and good, but if not, then she had no objection to wearing a cloak.

She was one who saw and wanted to be close to the magical in nature, and her inclination was closer to the natural magic of generations of country-dwellers than the ceremonial magic of the intellectual elite.

And Doreen was happiest when in her native south of England, on the chalk hills and woodland of the Weald and the New Forest. Her witchcraft was rooted in that land, and I think that she was never entirely comfortable with its export to other parts of the world, and certainly never wanted to leave the landscape that she loved so much, not even for a short time.

Yet Doreen felt strongly that the Craft should be open to all who had the inclination towards it. If this were achieved through initiation into an established coven, then that was fine, but she never felt that that should be the only way. If anyone wished to worship the Old Gods, then they had every right to do so. And Doreen, in her writings and her personal life, gave guidance and encouragement to such individuals whenever she could. Doreen wanted the Craft to survive, as much as did Gerald Gardner, although she used different methods to ensure that it happened.

But ultimately it is as an individual that Doreen is most fondly remembered by those who knew her. As Rufus Harrington remarked at the unveiling of the plaque to her in 2013:

> *"Doreen was one of the great High Priestesses of our time ... [She] was one of those priestesses who sometimes steps from between the worlds to open the pathways for all of us to follow. The gift she has given to us all is a gift of vision which opens into spirit. Each and every one of us are here in some way because of Doreen ... [who] set in motion magic of profound wonder."*[1]

[1] Rufus Harrington speech at unveiling of plaque to Doreen Valiente 21 June 2013

Appendix I
Doreen As I Knew Her

Some personal reflections by John Belham-Payne

Doreen is passing into history, the people that knew her are getting older and before too long she will become part myth as well. The most common question people ask me is "what was she like as a person?" I meet people who have heard she was a mystic recluse, an eccentric, a radical feminist, an ex-hippie and (her favourite) a Born again Christian! But let me tell you about the Doreen whom I knew.

I think the first thing to say is that she did not like being called the Mother of Modern Witchcraft. "I never wanted children", she once told me. "The world's too cruel to bring little ones into so the idea of being the mother to a whole bunch of people is beyond me". However she was privately flattered, if bemused, that people held her in such high esteem.

My first impression of Doreen was that she was very tall, rather reserved and preferred to be in the background. She was not a drinker, though she did like the occasional glass of wine and could not resist champagne if thrust upon her. She had given up smoking many years before and rumours that went around about

her smoking drugs were simply untrue - when we cleared her flat after her passing there was no evidence of any such thing - though I think the most comfortable period of her life was the 1960s when Doreen was a bit of a 'hippie chick'. With revolution in the air I think she felt the promise of freedom of expression and thought and, for Doreen, that never went away. Neither did the clothes! She possessed a very wicked and dry sense of humour, she was great company and extremely funny to be around. Sometimes when looking through photographs I notice Doreen through her different eras and I smile because I think she is one of those un- usual people who become more attractive as they get older. Then again maybe I am biased. Another trait that may have come from Doreen's free-thinking was her vegetarianism. Her favourite food was cauliflower cheese, especially when prepared by my wife, Julie, and Lynda Lindfield. Incidentally, Lynda cooked her last meal before she died and Doreen surprised us all by asking for chicken!

I have told the tale of how I first laid eyes on Doreen in the in- troduction to this book but when we first met properly she had been out of the Pagan/Witchcraft scene for a long time. She had stopped writing, though her books remained highly relevant and continued to sell in good numbers. When I asked her why she had been so quiet, she said that she had been busy 'looking after her man'.

Doreen's flat might have appeared rather gloomy to outsiders, my- self included. The wallpaper had not been replaced since she moved in and the floor had red and grey Marley tiles with no car- pet. In the kitchen there was always washing up to be done, but nowhere to put it to dry. After we got to know her, we (the Cen- tre for Pagan Studies) decided that we wanted to do something nice for her, buy her some luxuries - for certain she needed a new computer as the one she had was just a word processor and was all but steam-driven - but we decided on carpeting instead. We also knew that she would not accept charity so we persuaded her

into a speaking engagement in the barn at our house in Maresfield which served as the headquarters of the CFPS. We called the mini-event 'An Afternoon with Doreen Valiente'. We were bombarded with ticket requests and we had to move the venue to the larger Fairwarp Village Hall. I picked Doreen up while Julie and Lynda prepared a garden lunch. The author Marian Green and a local artist were also invited. The afternoon was for Doreen to meet people personally and talk about anything she wanted to and there was a really great question and answer session at the end. Half-way through the afternoon we served tea and cakes and I spotted Marian Green in the kitchen washing up. "What are you doing?" I asked her. "Well it needed taking care of so I am taking care of it", she replied. This was a reminder to me that in spiritual and magical matters it is the work itself that is important, not the person doing it or the ego involved.

At the end of the day Lynda, Ray, Julie and I gave Doreen the £500 that we had taken. "Whats all this for?", she asked. "We thought it would buy you some carpets for the apartment" we told her. "Hard to clean are carpets, that's why I have never bothered with them," she replied, "but there are a few books I could do with..." So we learned it was not poverty but choice that accounted for her flooring and we felt relieved.

You will have read in this book the amazing story of Doreen's work during the Second World War. She signed the Official Secrets Act and, like many people of her generation, treated this as meaning 'for life'. To my knowledge she never talked about her wartime work but one night I think she came quite close to doing so with me. It was one of those light hearted evenings where we were trying to outdo each other with stories of our past. Doreen went on about biting a prefect at school and being thrown out of the convent and I told a string of rock and roll musician stories. She told me the story of the bomb hit and the knickers (see page 45) and we had a great laugh but when I asked her about what she was doing in South Wales she just said "Ah, yes, I had a

rather boring secretarial job for the government" and quickly moved on to the next story.

One of the strangest things I learned about Doreen was that she was a huge fan of American actor Gary Cole. He played the main character in a TV series that ran from 1988 to 1991 called 'The Midnight Caller'. There were dozens of his photographs around her apartment that she had sent away for and most of them were signed. There were a few that she had framed and even more stuffed into drawers. I often wonder what her fascination for this guy was. Maybe it was just his rugged good looks and soft, deep voice.

Another surprise was when I asked her about her musical tastes. When I meet new people I always try to find out about their musical tastes and what kind of art they enjoy. Looking through people's records and CDs tells you a lot about a person but Doreen had no room for a stereo and her music collection amounted to just a handful of cassettes. I did learn that she was keen on the classical piece 'Nimrod' from the 'Enigma Variations' by Edward Elgar and as she did not have a copy Julie and I made her one on a cassette for Yule 1999 but she passed over in September and we weren't able to give it to her. It happens to be one of my favourite pieces too and I used it for the committal section of her funeral. Of the cassettes I did notice in Doreen's flat the first was called 'Music for Witches, Fairies and Magic' and the next was a compilation of works by Mendelssohn, Mussorgsky, Berlioz and Gluck. This all seemed to fit her profile, 'bought for research' she told me, but next to them were several by Marc Bolan and T-Rex. "Surely not for research" I said and added, rather boastfully, "I knew him quite well, you know". "Me too" was her reply, "What a lovely guy, I was very fond of Marc". There was nothing I could really say to that and it just goes to show that you never quite knew what Doreen would come out with next. The feeling of not quite knowing Doreen is something her friends all shared and a theme very much proved by the contents of this book.

I think most people are aware that Doreen left her magical legacy to me in her will. I have to say that I was as shocked as everyone else that she did. In fact I felt so uncomfortable about it, that I tried to refuse and I asked her "why me?". Her cryptic reply was "Because you are big enough and ugly enough for it". What she meant was that she knew it was going to cause me problems later as other people also wondered "why him?" Wise old Doreen foresaw this and I'm afraid I have been trolled on the internet for years. She also insisted that she elevate me to my 3rd degree. She felt I was ready and that I would need the authority it would give me. I had already been in the Craft for twenty-eight years and had reached 2nd degree so I had been working with her as her High Priest but there was no obligation on her to leave me such a treasure, she used to tell me she was just pleased to have me around and to be able to teach me some of the things she knew. But eventually she did say that she had waited a long while for me to come along and she often quoted the maxim 'When the teacher is ready, the student will appear'. When I finally agreed to accept her collection I asked what she thought I should do with it all. "That is up to you John. You can burn it, sell it or dump it. There are places I do not want it to go to but, in the end, I know that you will do the right thing". Over the years there have been stories about me selling it all on eBay or running off to Spain with it so I could keep it all to myself. Yet nothing could be further from the truth. I knew of course that the collection was important but I had no idea just how significant it has become. It is a huge resource for anyone interested in paganism and witchcraft and I have spent the years since her passing finding ways to share its knowledge by giving exhibitions and talks. In 2011 I passed on the complete ownership of the whole legacy to the charitable trust we formed, The Doreen Valiente Foundation, so that it will now be protected for all time, never sold or split up and always used for education about its themes and contents. Most of the artefacts, the books and her documents and writings are kept together in safe and secure storage in readiness for exhibition to a truly

international audience when we can launch our museum. Meanwhile a few items from the collection are in the UK being used by my fellow trustee, Ashley Mortimer, for talks and exhibitions.

Despite being bequeathed all of her magical estate there were a few things that I did not receive. One of these was her filing cabinet of correspondence. Towards the end she insisted on going through the contents with me so that I was aware of how important the contents were. Although there were some things like bank books and utility bills and receipts there were also the many letters she had received from all over the world, all in their separate files including those from some very famous occultists. The one she was most keen to show me was the Gerald Gardner file. She pulled it out and, expecting I would frequently refer to it after she had gone, she said "whenever you hear that Old Gerald made it all up, this here proves he did not". In the file were several very ancient-looking handwritten documents that I am sure were some of the papers that Gerald claimed were passed to him when he first entered the Craft. He knew these documents, like his old Book of Shadows, were in safe hands with Doreen. I never did get to study those documents fully. It was not the right time to do so when she first showed me and I did not get the filing cabinet as part of the 'magical possessions' I was bequeathed in her will. Her other executor deemed the whole filing cabinet to be personal rather than magical and at the time we both made our points to each other but agreed that arguing further would not have been dignified. So the cabinet and her word processor (which incidentally had another book on it she had written but not published) was thrown on the council dump and lost forever. I did persuade the other executor that her daily notebooks (over a hundred of them) contained magical as well as personal material and he agreed that I should keep them but only on my solemn promise that they would only be used for research and never published or made publically available on account of the personal information in them. There was also a damp area in one corner

of Doreen's room containing hundreds of pieces of paper, some letters, some research and some magazines she had collected or had been featured in but they were so wet they had to be thrown away too.

Doreen was very keen on all aspects of divination and was very good at it, her collection of rare Tarot cards and many other divination tools are in the collection. She also knew a lot about numerology and she proved to me how accurate this could be. Actually she made me feel uncomfortable with some of the things that she said would happen though all have so far proved true. It must be some thing in one of my past lives that makes me nervous about knowing the future though Julie has a gift for it and Doreen always said I had great potential though she never pushed me. But there was one funny occasion when Doreen suddenly said to me "John, were you and I born on the same day?" "I hope not Doreen, you were born in 1922!" "No you silly bugger", she said, "when is your birthday?" My birthday is the 5th January and Doreen's is the 4th so she was almost spot on ... apart from the thirty years between us! We often laughed about that. Doreen had a very wicked sense of humour and many of my memories of her are of laughing and telling really bad jokes. She correctly guessed Julie's birthday too on their first meeting as being 13th of June and was very pleased as the 13th of June is a recurring date in Doreen's life.

Doreen's final illness was thankfully short and she faced it with great courage. Julie and I were the first people she told when she knew she was dying but she wanted it to be kept a secret from all but six people and made me swear them all to keep quiet until she had gone. Only after the funeral was I to inform anyone else of her passing. Doreen had attended the funeral of Alex Sanders where one notorious local pagan (non-initiate) turned up trailing the press with him and Doreen was worried either he or someone like him might do the same again. She made a list of exactly who should be invited and gave me explicit instructions that if someone not on the list asked I was to lie and say the funeral was on a

different day at a different place. I ended up having to do exactly this because one person broke their promise of secrecy. It made mine and Doreen's life hell and the task of having to lie like that to keep people from the funeral was especially difficult and embarrassing. But, as I evaded my way through this minefield for Doreen's sake, I felt obligated to most of the people I spoke to to somehow do something, as they were very upset at the sad news and wanted an opportunity to pay their respects to Doreen. So I suddenly found myself saying that I would organise a day of celebration of Doreen's life and work. It felt easier and kinder to say this, rather than a straight 'she does not want you to come to the funeral'. As the weeks went by, people kept asking when this event would be. Julie and I had already been planning a move to Spain and this and the rest of our lives had been on hold while we cared for Doreen but the idea of a 'Day for Doreen', however much I never really intended to do it, was a good one that we couldn't ignore. Finally, in 2009, a full ten years after she passed over, it came to be. From my experience of organising large Pagan conferences for the Pagan Federation I knew that if we invited fifteen people to speak at the event we would probably get the eight we really needed and I applied this proven method to the 'Day For Doreen'. I hadn't factored in the high esteem that Doreen was held in by her peers so I ended up asking fifteen people to speak and sixteen said yes! It was a logistical nightmare but the day was a huge success. We sold out of tickets immediately and the only complaint we had was that no one had time for a break between speakers. Many in the audience didn't miss a second of every one of those sixteen famous people's talks. The event became known as the largest gathering of Craft elders ever in one place. We thought we had fulfilled our promises at last but by the end of the day people were asking 'who are you going to honour next?' so, at the time of writing we have now also held days for Gerald Gardner, Professor Ronald Hutton and Patricia Crowther. Other 'Day For...' events will follow in due course.

Since she passed over, Doreen does not speak directly to me. I make no claims to be a great magician but I am a sensitive and from time to time I help others with those who have passed over. Maybe it does not work with Doreen and me directly so she gets others to pass on her messages. Janet Farrar is in regular contact and recently she was very excited to tell me that one of her foreign students had received a message that a lady called Doreen had had a message for someone called John. This gentleman later made a special journey to England to meet me at Witchfest in 2014. Another time I was giving a talk at Pagan Pride day in Nottingham and was taking a few questions before wrapping up when a lady burst into the marquee at the rear and exclaimed "Is there a John in here?". Everyone pointed in my direction and chorused "he's John". Rather embarrassed, and with everyone staring, the lady said "Well I have a message from someone called Doreen for you and the message is this: I am very proud of you, but can you just get on with it please?" I knew exactly what she meant on several levels!

A lot of people interested in magic, witchcraft and the occult particularly respect Doreen as a very traditional witch. I am unashamedly one of those people but probably more traditional in my views about the craft than Doreen as she always strove not to be old-fashioned or stuck in her ways. Of course she respected the old ways and believed in the traditions of the Craft but she did recognise a need for evolution and development. One idea she held was that, in certain very exceptional circumstances, it is technically possible to self-initiate (though even then the Craft's degree system made perfect sense to her and she stuck to it). She used to say that the initiated Craft is not right for everyone though she strongly believed in everyone's right to follow a spiritual path with the old gods and goddesses. I agree but I believe that if someone is not initiated then they should not call themself a Witch. Maybe that's a bit hardline and while Doreen too was very firm on things magical being right and proper she had a way of helping you to see things in a different light if she thought it

would help you develop a broader or deeper view or an interesting angle on something. Sometimes she would employ shock tactics to make you think differently (or at all) about things. An example might be the time she suddenly asked me if I had ever been to a gay circle or presided over a gay handfasting ceremony. Even though Brighton is sometimes called the gay capital and we had both lived there to be very aware of the vibrant gay scene, my truthful answer was "I've not really thought about it, Doreen". "Well think about it then" she said and continued without pausing, "Have you thought yet?". Before I could reply she pressed me further still, "Well what is your answer?" "I guess it would be alright, I cannot see a problem" I told her. "Good" she said, "what are you doing on Saturday?".

Towards the end I spent a lot of time sitting with Doreen trying to think of something positive to talk about. I asked her about what she had learned from the Craft. She thought for a long few moments and then replied, "I think that I scratched the surface". She continued "But now it is your turn to take the work forward". At that point I had no idea what she meant or what she thought I really had to offer. Doreen saw something in me that I did not see. I never had those great magical skills she had or the ability to carry out serious historical research like Ronald Hutton, Philip Heselton and now Ashley Mortimer, but she gave me a vision of what the Craft should be, showed me the beauty of what can be achieved with the written word and left me the most fascinating collection in the world of Witchcraft history to work with. I believe I have put together the very best team that I can to help me, a team with the skills I do not have and I thank them all for sharing my vision. I particularly thank the current CFPS volunteers and the former trustees and partners that we have had in this long venture, a venture that still feels as though it hasn't really even started yet. As I said, Doreen does not speak directly to me since she passed over (although Philip Heselton has had visions of her as he was writing this book). In many ways I am not sure she really wanted it written, but hers is a story that needs to

be told and when she and I eventually do meet again in the Summerlands I will be able to explain to her my reasons for wanting to share her remarkable story with others. Doreen gave me the opportunity to 'do the right thing' with her legacy and I hope that by publishing her biography we have made a start and have at least honoured her memory.

John Belham-Payne
October 2015

Oh, just one more thing. I'd like to give you a tip: When you read Doreen's books or poetry, try doing it with a soft West Country accent. It works much better.

Appendix II
Foundation: The Legacy of Doreen Valiente
by Ashley Mortimer

"Tell YOUR story", John Belham-Payne urged me just before my first speaking engagement on behalf of the Doreen Valiente Foundation. "If you can show people how and why you are involved with Doreen then maybe they will be able to see that they are involved with her too". And he's right. Doreen's presence pervades every aspect of the entire modern Pagan community, from the words spoken in ritual to the very way we think about our Paganism and look outwards to the rest of society. Since its formation in 2011 the Foundation has tried to engage with Pagans, Paganism and the wider community to fulfil our charitable objects which are: "To protect artefacts important to the past, present and future of Pagan religions" and "To make the artefacts available for education and research". This is the formal way of saying 'Doing the right thing', which is what John promised Doreen he would do when she left him her magical legacy in 1999.

My story is straightforward really. I was working on the organisation team for a regional Pagan Federation conference in Lincoln back in 2003. Two of the speakers booked were Patricia Crowther, whom I considered to be the most famous living Witch, and a man to whom Doreen had apparently left her

collection of magical items whose name I didn't recognise at the time. There was an air of excitement that we would get to see some of the original artefacts of the modern Craft which were part of Doreen's legacy. I found myself on security duty in the exhibition room with an amazing array of artefacts displayed in specially made glass cases including Doreen's ritual robes, her altar tools and even Gerald Gardner's wand and his old Book of Shadows, about which I had been reading in books for many years and which (I am duty bound to note) was never referred to by Doreen as a 'Book of Shadows' but as 'Gerald's old book'. One of my colleagues on duty was the rather unassuming and gentle John Belham-Payne, the man who owned the artefacts. John's talk had fascinated me, I felt caught up in his quest to 'do the right thing' and to discover what that might be. It appealed to my sense of drama and adventure, I think. At the end of the day I was helping John to pack away the exhibition when, before I really knew why I was doing, I found myself opening my mouth and offering him my card and phone number, saying, "if I can ever do anything to help you, I will".

I confess I thought little more of it, the months passed, the conference faded to a happy memory and then, one night, the phone rang. "Hello, this is John Belham-Payne, do you remember me?" said the gentle voice at the other end of the line. I virtually tugged my forelock down the phone, "Oh, yes, Mr. Belham-Payne, I certainly do ..." I stammered. "Do you remember offering to help me once?" he asked and continued before I could reply, "Because I think you're going to regret that, I want to call that favour in!". He went on to explain to me that he had been feeling a growing worry over the responsibility for Doreen's collection. He'd received substantial financial offers for some of the items including eye-watering sums for Gerald's book alone and he said, with frankness and honesty, "I'd be lying if I said I didn't consider for just a moment how may sports cars that much money would buy!" But he went on to say that he knew deep down that 'the right thing' was to resist such offers and keep the collection

complete and together and that was what he'd decided to do. I remember likening his plight to that of Bilbo and the Ring, and we laughed. We remind each other of this comic analogy sometimes, and I'm quick to imitate John, saying in Gandalf's voice: "No, Frodo, do not give the Ring to me!"

John had been thinking about whom he would leave the collection to after his own passing and whether, being another generation removed from Doreen, that person might find financial offers harder to resist than he had. Even when not for personal gain we agreed that the sum offered for Gerald's old book would have funded the preservation of the rest of the collection for a very long time to come, not therefore to be dismissed lightly. John said he knew I was a business, accounts and legal type of guy and did I perhaps know anything about charitable trusts and how to form them? Again the compulsion was on me and I thought to myself "no, not really ... but I'll bloody well find out!" We talked for quite a long time that night and more still over the subsequent weeks and months. We discussed the idea of him irrevocably handing legal ownership of the whole collection over to a charitable trust whose equally irrevocable governing policies could be created specifically to permanently prevent the sale or the splitting up of the collection and remove any dangers and temptations from generations of custodians of the collection to come. I did a lot of technical reading about charitable trusts, took some expert advice and we eventually hit on the plan to form such a trust and for John to sign over legal ownership of the collection to it. He would still be heavily involved, becoming the trust's chairman along with, say, four or five other suitably chosen trustees. The trust would be essentially passive, it's purpose would be to own the collection and protect and care for it and make it accessible to the public in some way. We started to talk about the formation of a separate legal entity (probably another charitable trust) which would become front-facing and active. It could carry out activities like running events, exhibitions, conferences and publishing books and even found a

museum. The second entity would incur all the possible legal and financial risks and the original trust would agree terms to loan the artefacts for exhibition, grant other rights as necessary and simply take back the collection into safe keeping if anything went wrong. This way the collection itself would never be at financial or legal risk.

After a few months it happened that John was visiting the UK and I invited him to stay with me in Lincolnshire. Little did I know he'd been busy checking me out, enquiring into my background, my activities in Paganism etc. and he'd decided to drop something of a bombshell on me during his visit. Late one night as we sat up swapping anecdotes (we have both had long careers in the music industry and we can both tell a tale or ten) John showed me some of the artefacts he'd got tucked in with his travelling luggage. There were several which held a wow-factor, Doreen's diamanté pentacle necklace which she said had previously been owned by Gerald for instance, but I was drawn to a small paper-bound script Doreen had written for a private Spring Equinox ritual - John told me that this had probably never been seen by more than a handful of people and it contained a beautiful poem. I was blown away by its significance. It dawned on me that the legacy wasn't just a collection of objects. The written material demands many years of proper research and documentation which will perhaps, one day, uncover some of the secrets of the history of modern Paganism (and, knowing Doreen, a fair few ancient ones too). John watched me carefully as I reverently handled the items, caught up in them and thoroughly, in the true meaning of the word, "enchanted". His timing was impeccable as he said, in his customary understated way, "I want to ask you something. Would you do us the honour of becoming a trustee?" I told him I'd always imagined it would be 'proper', famous, celebrity pagans, big names in the scene and so on, why would a non-entity like me become a trustee? He fixed me with a stern gaze. "Wouldn't you do your very best for the cause? Protect the collection with every bit of yourself and always strive

to 'do the right thing' with it?". "You know I would", I replied, the penny finally dropping. "Well, that's why I'm asking you." he said simply.

And so, a few months later, on a warm spring morning in bright sunshine, I found myself at Malaga airport meeting John and Julie and their friends Brian and Trish Botham whom John had also asked to become trustees. In my luggage were the newly typed trust documents ready for signature. We'd worked hard with many hours of consideration and expert consultation to produce legal contracts that would form the charitable trust itself and also the irrevocable and binding legal instrument for John to put complete ownership of the entire collection into the hands of what we'd decided to call "The Doreen Valiente Foundation". John and Julie took us to see the collection itself and the enchantment was upon us all. So many artefacts, items, magical tools, books, documents, storage boxes full of letters, poems, manuscripts, jewellery and many more mysterious items with unknown history and significance. It really dawned on me just how vast Doreen's collection is, just how many lifetimes of work there are ahead in delving into it, protecting it, making it accessible and available for people to research, learn from and enjoy.

It was decided that we should sign the documents in a proper and solemn ceremony, among items from the collection, with John and Doreen's working tools and altar present. I stood in the little room that night with the incense began to fume around us in the gathering darkness, watching John carefully lighting the candles. He says he's not a great magician, but it's plain to see that magically he knows what he's doing even to my eye. I could feel the gentle air of authority about him and I remember thinking to myself "I can see why Doreen chose him for a High Priest!". John thought for a moment then said, almost to himself, "No, we won't have a circle, this act is inclusive. This is not just for us, what we're doing is for the whole world." Then "Yes, ok,

we'll call the spirits to witness it and then we'll send the current out to everyone". And so we did. I listened to Doreen's own words for the calling of the spirits ring out. I reflected that I stood with ritual items around me just as she must have done and waited for my turn to step forward and sign the documents. It struck me what a monumental moment it must have been for John and Julie, they were literally signing away the greatest treasure they would probably ever own. But there wasn't a moment of hesitation in either of them. The time for such doubts was past. Now there was just their calm act carried out with the serene knowledge that they were, at last, 'doing the right thing'. As we stood for a few moments, feeling the enormity of what we had done, I was facing the altar looking at the iconic original picture of Doreen by the artist Marc Potts where it hung on the wall. It is a very evocative piece anyway but the candlelight that night enhanced the hypnotic effect of her intense gaze. Then I heard it, a voice on my shoulder, soft West Country accent, unmistakeable. "I'm watching you" it said abruptly. I bowed my head, not really knowing how to reply. "You seem like a nice young man." it continued. "Well, YOU seem like a nice lady," I silently replied, perhaps too cheekily. "We'll be all right then" it said and I breathed out as I felt its presence move to my left. I realised it was going round the circle taking a moment to size up each of the five of us and the witnesses to the signatures as they stood to one side of the altar after they too had fulfilled their duty. In that moment I knew my life had changed for ever. I recognise that feeling however, I've had it before. It starts with that strange compulsion, the act of finding myself saying or doing something I know is my 'will' but which seems, somehow, not completely a conscious act. It culminates in a moment of understanding such as this one. I realised I was being handed the chance to give back something in return for the wonderful, terrifying, enlightening, beautifully industrious, mirthful, reverent and, dare I say, meaningful spiritual journey I have been making though this incarnation.

I asked John later if Doreen had spoken to him. "No, not tonight, I think she was too busy with you all" he said. "She usually only speaks to me when I'm about to do something wrong!" he added, "I hear her voice on my shoulder and it says (in John's West Country imitation of Doreen): "Oh, no, John, I DON'T think so!"". This time she had been silent. She must have been pleased.

And so the future beckons. The Foundation has begun the work. We've used the Centre For Pagan Studies as our 'active' entity. We've raised funds and campaigned successfully to have heritage blue plaques erected in Brighton and Highcliffe for both Doreen and Gerald. There will be more. We've put on conferences under the "A Day For..." theme, honouring Doreen, Gerald, Patricia Crowther and Ronald Hutton. Again, there will be more. We've published some books, including Doreen's previously unpublished poems, which fulfilled another promise John made to her. We are constantly working our way through the process of establishing a permanent home for the collection, a museum fitting for its contents. We want the museum to be publicly owned, not a private venture or for anyone's personal profit. We need the world to understand that Doreen Valiente's legacy belongs to everyone and, unfortunately, this means a lot more red-tape and bureaucracy to get there. It's a constant frustration that the process is so slow with so many wrong turns and dead-ends but, in the end, we believe that 'doing the right thing' sometimes just takes longer. Many people around us have helped tremendously. Social media has further widened the circle of those who now consciously know that they are "involved" and whose support is as humbling as it is astonishing. We've given many talks and displayed mini-exhibitions from the collection, always receiving enthusiastic responses and meeting many excellent people with offers of help and support. We've worked with the collection, cataloguing, photographing, documenting and we've gathered additional items and documents for our ever expanding archives. We've been able to provide Philip Heselton with the research materials he needed to enable him to write this

book - he remains one of the staunchest believers in 'doing the right thing' - and we've also been conducting our own research. My partner, Sarah Kay, has spent countless hours transcribing documents, diligently and patiently deciphering handwriting (yes, even Gerald's and even worse, she says, his wife Donna's!) As a result we are regularly discovering new information and insights about Witchcraft history. We've also been involved in the Pagan and wider spiritual community, taken part in various initiatives and built a strong network of contacts and communication with other Pagan (and non-Pagan) organisations. We've helped to establish The Symposium, a forum for Pagan and Heathen leaders to meet, communicate and collaborate. We've represented the Pagan community in the media, on television, radio and print and we've been involved in interfaith and other community, social and artistic projects on behalf of Pagans and Witches. We try, as best and as sincerely as we can, to do as an organisation what Doreen did as an individual: to help the world around us by acting with honesty, skill and humility to provide genuine, authentic and accurate knowledge and to 'do the right thing' in a sensible, inclusive, pragmatic and practical way.

The work goes on. The future stretches out before us and we know that we are truly, as Doreen told John, "only scratching the surface". One day it will be the task of others to carry the torch forward and we hope that when the dust settles and people look back on what has been achieved to date since Doreen's passing, someone will be able to at least say, "well they tried to do the right thing".

Ashley Mortimer
(Trustee, The Doreen Valiente Foundation)
October 2015

Appendix III
Doreen Valiente - Chronology

This chronology is only a first attempt at a rough outline of Doreen's life. It will doubtless be expanded by those who will continue to carry out research into that life in the future.

1922	January 4, Doreen Edith Dominy born at 1 High Street, Colliers Wood, Mitcham
1923	living at 56 Pitcairn Road, Colliers Wood/Tooting
1927	living at 4 Renshaw Corner, Mitcham
1931	living at Parkhurst Road, Horley, Surrey
1933	living at 18 Walsingham Road, Mitcham
1933-34	possibly living at 1 Fortescue Road, Exeter
1934	Doreen and her mother move to 6 Claremont Crescent, Millbrook, Southampton
1935	they move to Rutland Lodge, 118 Waterloo Road, Freemantle, Southampton
1935	Doreen attends Ursuline Convent, Worple Road, Wimbledon
1937	leaves Convent and gets a job in Southampton
1939	working for Unemployment Assistance Board as Clerk/Typist
1939	July, obtains Certificate of Qualification
1940	April 7, Doreen's father dies in Bristol
1940	Doreen employed at Bletchley Park
1941	living at 17 Dock View Road, Barry
1941	January 31, marries Joanis Vlachopoulos in East Glamorgan Register Office
1941	June 13, Joanis is drowned at sea
1942	August 6, commences employment in Cardiff
1943	March, ISOS section moves into Hut 18
1943	May 31, employed at Capital Cafe, Queen Street, Cardiff

1943	June 26, becomes unemployed
1943	July 10, living at 32 Beauchamp Street, Cardiff
1943	July 15, employed at Lancashire Books, Leckwith Place, Cardiff
1943	July 24, living at 98 Kings Road, Cardiff
1943	August 12, reports being unemployed
1943	October, ISOS section moves to Block G
1943	Autumn, transferred to Berkeley Street, London
1944	March, working for J V Rushton Ltd, Whitcher Place, London
1944	March 15, living at 14 Harrington Square, Mornington Crescent, London
1944	May 29, marries Casimiro Valiente
1944	June, living with Casimiro at 108 Evelyn Road, Winton, Bournemouth
1944	November, gets job as handworker at Maples, Boscombe
1945	April, living at 106 Ensbury Park Road, Winton, Bournemouth
1952	January, acquires Golden Dawn documents from Henry Kelf's widow
1952	November, meets Gerald Gardner at Dafo's house, Highcliffe
1953	July, initiated by Gerald Gardner
1953	December, writes ritual verses for Gardner for Yule celebration
1954	August, visits Austin Osman Spare on Gardner's behalf
1955-56	collaborates with Gardner on *The Meaning of Witchcraft*
1956	March 29, moves to 20 Lewes Crescent, Brighton
1957	February, leaves Gerald's coven, along with Ned Grove and Derek Boothby
1957	July, prepares "Proposed Rules of the Craft"
1958	Doreen serious illness and near-death experience
1958	July, first meets Charles Cardell
1962	August, death of Doreen's mother in Brighton
1962	publication of *Where Witchcraft Lives*
1963	October, initiated into Coven of Atho
1964	February 12, Gerald Gardner dies
1964	May, *Witch* by "Rex Nemorensis" (Charles Cardell) published
1964	August, first edition of *Pentagram* magazine
1964	October 3, gives speech at *Pentagram* dinner

1964	Halloween, initiated into Clan of Tubal Cain
1965	June 5, meets Arnold and Patricia Crowther for the first time
1966	June, death of Robert Cochrane
1966	prepares manuscript of "I am a Witch"
1968	August, moves with Casimiro to 8A Sillwood Place, Brighton
1971	May 1, chairs first meeting of the Pagan Front
1972	April 10, Casimiro Valiente dies
1972	moves into 6 Tyson Place, Grosvenor Street, Brighton
1972	reads her poems to the Poetry Society in London
1973	January, joins National Front
1973	publication of *An ABC of Witchcraft Past and Present*
1974	October 12, resigns from National Front
1975	publication of *Natural Magic*
1975	meets Ron Cooke
1975	August 22, appears on *Woman's Hour*
1976	Halloween, Doreen initiates Ron Cooke
1978	March 24, first correspondence with Janet and Stewart Farrar
1978	publication of *Witchcraft for Tomorrow*
1984	starts driving lessons
1984	June 28, publication of *The Witches' Way* by Janet and Stewart Farrar (including Doreen's appendix)
1989	publication of *The Rebirth of Witchcraft*
1990	publication of *Witchcraft - A Tradition Renewed*
1994	meets Sally Griffyn
1997	September 22, Ron Cooke dies in Hove
1997	October, meets John and Julie Belham-Payne at CFPS
1997	November 22, talk to Pagan Federation Conference at Croydon
1998	July, "An Afternoon with Doreen Valiente" at CFPS
1999	September 1, Doreen dies at Sackville Nursing Home, Hove
1999	September 9, Doreen's funeral, Woodvale Crematorium, Brighton
2000	May 1, Doreen's ashes are scattered in a wood in Sussex
2009	September 13, "A Day For Doreen" conference, London
2011	March 6, Doreen Valiente Foundation formed
2013	June 13, Blue plaque to Doreen unveiled, Tyson Place, Brighton

Appendix IV
Doreen Valiente - Bibliography

Published Books

Where Witchcraft Lives (Aquarian 1962 112 pp hbk; Second edition - limited to 1000 copies - Whyte Tracks 2010 127 pp ISBN 978-8792632-09-8 hbk; Third edition - Whyte Tracks 2011 119 pp ISBN 978-8792632-17-3 pbk)

An ABC of Witchcraft Past and Present (Hale 1973 377 pp hbk ISBN 0-7091-3164 X)

Natural Magic (Hale 1975 184 pp hbk ISBN 0-7091-4916 6; St. Martin's Press, New York 1975 Library of Congress Catalog Card Number 75-4210)

Witchcraft for Tomorrow (Hale 1978 205 pp hbk ISBN 0-7091-6412-2)

The Rebirth of Witchcraft (Hale 1989 236 pp hbk ISBN 0-7090-3715-5)

Published Books (with others)

Witchcraft - A Tradition Renewed - Evan John Jones with Doreen Valiente (Hale 1990 203 pp hbk ISBN 0-7090-4139-X)

Appendix A - The Search for Old Dorothy in *The Witches' Way - Principles, Rituals and Beliefs of Modern Witchcraft* - Janet and Stewart Farrar (Hale 1984 349 pp hbk ISBN 0-7090-1293-4)

Foreword to *A Case for Reincarnation* - Christine Hartley (Hale reprint 1987 159 pp hbk ISBN 0-7090-2960-8)

Posthumously Published

Charge of the Goddess (Hexagon Hoopix 2000 94 pp pbk ISBN 0-9539204-0-2)

The Charge of the Goddess - The Poetry of Doreen Valiente - Expanded Edition (The Doreen Valiente Foundation in association with The Centre for Pagan Studies 2014 139 pp pbk ISBN 978-0-9928430-0-7)

Unpublished Manuscripts

I am a Witch (1966)

The Witch Ball (short stories) (1982)

Articles

Doreen wrote many articles, a large number of which were published in a variety of magazines, most notably *Prediction*. It will be a matter for future researchers to compile a definitive list.

Appendix V
General Bibliography

Janet and Colin Bord *Mysterious Britain* (Garnstone Press 1972)

Lois Bourne *Dancing with Witches* (Hale 1998)

J L Bracelin *Gerald Gardner Witch* (Octagon 1960)

Alexander Carmichael *Carmina Gadelica Vol 1* (Norman Macleod 1900)

Arthur G Credland *Shipping Posters and Graphic Works: Harry Hudson Rodmell 1896-1984* (Hull City Museums and Hutton Press 1999)

Aleister Crowley *The Law of Liberty* (OTO 1940)

Patricia Crowther *Lid off the Cauldron* (Frederick Muller 1981)

Patricia Crowther *One Witch's World* (Hale 1998)

Patricia Crowther *From Stagecraft to Witchcraft* (Capall Bann 2002)

Patricia Crowther *Covensense* (Hale 2009)

Robin Denniston *Thirty Secret Years* (Polperro Heritage Press 2007)

Stewart Farrar *What Witches Do* (Peter Davies 1971)

Janet and Stewart Farrar *Eight Sabbats for Witches* (Hale 1981)

Janet and Stewart Farrar *The Witches' Way* (Hale 1984)

Dion Fortune *The Mystical Qabalah* (Williams and Norgate 1935)

Dion Fortune *The Goat-Foot God* (Williams and Norgate 1936)

Dion Fortune *The Sea Priestess* (privately printed 1938)

G B Gardner *Witchcraft Today* (Rider 1954)

G B Gardner *The Meaning of Witchcraft* (Aquarian 1959)

A O Gibbons *Cerne Abbas - Notes and Speculations on a Dorset village* (privately printed 1962)

Justine Glass *Witchcraft, the Sixth Sense, and Us* (Neville Spearman 1965)

Kenneth and Steffi Grant *Zos Speaks!* (Fulgur 1998)

Sally Griffyn *Wiccan Wisdomkeepers* (Godsfield Press 2002)

Raven Grimassi *The Witches' Craft* (Llewellyn Publications 2005)

Ralph Harvey *The Last Bastion* (Zambezi 2005)

Philip Heselton *Witchfather Vol 2* (Thoth 2012)

Captain Günter Hessler and Lt Cdr Andrew J Withers (eds.) *German Naval History - The U-boat war in the Atlantic 1939-1945* (HMSO 1989)

Ronald Hutton *The Triumph of the Moon* (Oxford 1999)

Prudence Jones and Caitlin Matthews (eds.) *Voices from the Circle* (Aquarian 1990)

Aidan A Kelly *Crafting the Art of Magic - Book 1 - A History of Modern Witchcraft 1939-1964* (Llewellyn 1991)

Aidan A Kelly *Inventing Witchcraft - A Case Study in the Creation of a New Religion* (Thoth 2007)

Frederic Lamond *Fifty Years of Wicca* (Green Magic 2004)

Charles Godfrey Leland *Aradia or the Gospel of the Witches* (D Nutt 1899)

Edna Lyall (Ada Ellen Bayly) *Doreen: The Story of a Singer* (Longmans Green 1894)

Donald Maxwell *A Detective in Surrey - Landscape Clues to Invisible Roads* (The Bodley Head 1932)

Sinclair McKay *The Secret Life of Bletchley Park* (Aurum 2010)

John Michell *The View over Atlantis* (Sago Press 1969)

A S Neill *A Dominie's Log* (Herbert Jenkins 1917)

'Rex Nemorensis' (Charles Cardell) *Witch* (Dumblecott Magick Productions 1964)

Barry Peckham *Barry Peckham's New Forest* (Halsgrove 2001)

Alan Richardson and Marcus Claridge *The Old Sod - the odd life and inner work of William G Gray* (ignotus 2003)

Jeffrey Russell *A History of Witchcraft: Sorcerers, Heretics and Pagans* (Thames and Hudson 1980)

'Scire' (G B Gardner) *High Magic's Aid* (Michael Houghton 1949)

Michael Smith *Station X - The Codebreakers of Bletchley Park* (Pan 2004)

John Symonds *The Great Beast: the life of Aleister Crowley* (Rider 1951)

Jonathan Tapsell *Ameth - The Life and Times of Doreen Valiente* (Avalonia 2014)

James Thirsk *Bletchley Park - An Inmate's Story* (Galago 2008)

Tony Wedd *Skyways and Landmarks* (The STAR Fellowship 1961)

Index

The Doreen Valiente Foundation & The Centre For Pagan Studies

The Doreen Valiente Foundation is a charitable trust dedicated to the protection and preservation of material relating to Pagan practices, spirituality and religion. The Foundation is also dedicated to researching and interpreting this material and making such research and the material itself accessible to the public for the benefit of wider education and the advancement of knowledge in this unique landscape of living cultural and religious heritage.

The Foundation was established in 2011 and received legal ownership of Doreen Valiente's entire legacy of artefacts, books, writings, documents, manuscripts and copyrights under a deed of trust that permanently prevents the sale or splitting up of the collection and prohibits the making of profit through exploitation of the collection. This means that every penny earned by the Foundation (including the publishers' proceeds of the sale of this book) is spent on persuing its goals and charitable objects as above.

The Foundation runs a number of ongoing projects, working towards the establishment of a permanent museum home for the collection and the physical creation of a Centre For Pagan Studies which is the organisation of which Doreen was patron shortly before her death in 1999. The Foundation succeeded in campaigns to have Heritage Blue Plaques placed on the former homes of Doreen Valiente and Gerald Gardner with others to follow. The DVF and CFPS also organises conferences, talks and exhibitions as well as engaging with the global community in matters of religious history and spirtual heritage.

More information about Doreen Valiente, The Doreen Valiente Foundation and The Centre For Pagan Studies, including foundation membership, details of events and activities, purchase of Doreen Valiente merchandise, books etc and donations can be found at:

www.doreenvaliente.org
and
www.centre-for-pagan-studies.com

CPSIA information can be obtained at www.ICGtesting.com
Printed in the USA
BVOW06s1842210216

437543BV00004B/5/P

9 780992 843069